10/23/08

Dear Garland,
First let me congratulate you on your success since leaving Bristol, Tenn. many years ago. Now it's retirement time & I know good things are in your future. Take time out and enjoy this book about your home town. God bless you & your family is my prayer. Much love,
Aunt Nina

A Good Place to Live
BRISTOL, TENNESSEE / VIRGINIA

THE BRISTOL SESQUICENTENNIAL SERIES

V. N. (Bud) Phillips

The Overmountain Press
JOHNSON CITY, TENNESSEE

ISBN 1-57072-314-1
Copyright © 2006 by V. N. Phillips
Printed in the United States of America
All Rights Reserved

1 2 3 4 5 6 7 8 9 0

Contents

A Note of Appreciation ... iv
Introduction ... v
Foreword ... vi
Bristol, a Good Place to Live ... ix
A Sesquicentennial for Bristol .. xii
Foundation Faults .. 1
A New Century Dawns ... 8
The Healers .. 12
Medicine Makers ... 31
Hospitals .. 56
Bristol on Wheels .. 94
Weather .. 137
Food for Bristol ... 156
The Fourth Estate ... 178
The Public Library .. 185
Back Where It All Began .. 203
An Invitation to the Faithful .. 214
Finis .. 234

A Note of Appreciation

It would not be feasible, or even possible to mention every person who contributed in some manner to the production of this book. Over the years, so many have shared their knowledge with me. The writings of others at various times have also aided me.

I am especially indebted to Tim Buchanan, who contributed the story on Bristol's evangelistic campaigns, and Joe Tennis, who wrote the stories on music and Bristol newspapers. Both men are gifted writers and have much to share with those who seek historical information.

And I would have been greatly hindered in the final preparation of this manuscript had it not been for the expert assistance of Mr. and Mrs. Gary (Debbie) Rose, who typed the manuscript.

I am also indebted to all the helpful folks at The Overmountain Press. They have helped make me what I am, and for that, my gratitude knows no bounds.

Dr. William J. Wade always puts a fitting capstone on my books by writing appropriate forewords. I appreciate his great help and encouragement through the years.

In no way can I fully express my gratitude to Mrs. Louise Rutherford and her son Tom, for having supplied me with a 65-year wedge of the bound files of the *Bristol Herald Courier*. Those files helped add to the richness of detail in parts of this book and will contribute much to the completeness of other books to come.

Of course, many others in some way helped make this book possible, and their contributions are remembered with deep gratitude.

The glory of a finished mansion cannot be claimed by one person. Many workmen of varying degrees of capability are necessary to bring such a project to completion. From the lowly foundation digger to the master carpenter, from the mortar mixer to the highly skilled brick mason—all are necessary and must work together to produce a sturdy and beautiful work.

So it was with this book. Countless persons, extending back through the years, helped to make up the whole. To all of them, known and unknown, I am humbly grateful. Whoever they were or wherever they lived, they have done a good service for this and coming generations.

Introduction

When I began writing this sesquicentennial history of Bristol, I faced a major decision: Should I do a sketchy work, touching briefly on numerous subjects ordinarily found in a work of this type, or should I follow my usual practice of going into much detail on the subjects presented. I decided the latter course would be of more value to those who read this book, especially those who use it for research now and a hundred years hence.

With that decision made, I determined I would need two or more volumes to, in any measure, present a work covering the topics usually expected in a city history. I then had to decide which subjects to include in the first volume. Essentially I made that decision by a "vote" based on the number of unsolicited inquires I have received over the past several years on various historical subjects of local concern. The vote was rather clear, but lack of inclusion in this book does not necessarily reflect on the worthiness or unworthiness of such subject matter.

If you do not find your favorite historical topic in this volume, be patient. There is a good chance that it may be covered in the next. Please feel free to make your wants known to me. I fully expect to continue gathering, writing, and publishing Bristol history for as long as I live and am able.

You may think that much detail is included here; however, I have barely scratched the surface. In doing intensive research, I have learned that quite a bit remains untapped out there. Much of it is held in the memories of yet living persons. Time passes quickly, so I am making an effort to obtain and record as much of their recollections as I can.

Looking back, I well remember so many who lived here some fifty years ago and took time to share with me countless personal memories. But now most of them have passed on, and I know that much went with them. Local people often beg me to "empty my head" and record what may be stored there and not yet written and published, so this book is a major part of that effort.

I was in Bristol during the centennial celebration, and I am thankful I can do something for the sesquicentennial. While I harbor no hope of being here for the bicentennial, I do hope to leave writings that will be of value then and through the years beyond that time.

Foreword

Within recent years, V. N. (Bud) Phillips has earned a well-deserved reputation as the "historian of Bristol," and his several books retracing the city's past are required reading for anyone wanting to know and understand Bristol's historical heritage. Let a group of local citizens gather, and some question will arise about a detail of Bristol's past; invariably the response is, "Ask Bud Phillips; he will know." Scores of local residents eagerly look forward to his annual walking tours of East Hill Cemetery and the Solar Hill District, and his talks on these occasions are not only exact and authoritative, but are also spiced with personal and anecdotal stories that delight his listeners.

In his previous histories, Mr. Phillips concentrated upon the earlier years of Bristol's history; this volume turns to the story of the 20th century. And reading it is like taking another one of his personally conducted tours, but here the entire town becomes his stage. With him we stroll the thoroughfares of Bristol, but it is not the modern city we know today. Instead, it is the town of the early 20th century, a place of largely unpaved streets outside the central business district and a municipality where the utilities that we take for granted, such as electricity, telephone, and water service, have only recently been introduced. Automobiles are a rarity, and streetcars rumble down State Street. One hundred years ago the railroad station was a beehive of activity, for there were no paved roads leading out from Bristol in any direction. Even a short trip to Johnson City or Abingdon would have been taken by rail, and there were numerous express and local trains arriving and departing daily with connections to all the major cities of eastern North America.

As is his custom, Mr. Phillips has amassed an astonishing amount of detailed information for the reader, much of it gathered through a half-century of meticulous research and interviews of former residents. But the book contains more than just factual detail, for he has woven through his manuscript a surprising number of fascinating stories about the heroic deeds as well as the foibles of our predecessors who lived in Bristol a century before. So much information requires a good organizational structure if the account is to be comprehensible, and Mr. Phillips has wisely chosen to arrange his

material topically. Thus we proceed through various chapters that deal with medical care, hospitalization, and the manufacture of medicines.

The early 20th century was a time when horse-drawn vehicles slowly gave way to the automobile, and Mr. Phillips chronicles how that transition impacted both the economy and the social customs of our municipality. In one of his earlier volumes, the author informed us that Joseph R. Anderson, the town's founder, had considered naming the town Paradise, but opted instead for Bristol. Perhaps it is wise that he did so, for in this book we find that Bristol was no paradise.

Readers of this volume will come away with a greatly enhanced appreciation of modern medical care when they learn of the limited states of technology and hygiene that prevailed in the primitive hospitals and medical facilities a century back. And there is heroism in this volume also; the reader will learn of the sustained and determined efforts of former citizens to establish a public library, and one can hope that the memory of those who worked so heroically at their cause can be visibly acknowledged and given proper recognition in the new building whose completion will parallel the appearance of this volume. Prominent individuals from our city's past spring to life in this book, and older citizens will smile with nostalgia when they remember some of these figures from our history.

This book will serve many purposes. A number of readers will enjoy perusing its pages from beginning to end simply to learn the stories that make up the pageant of Bristol's history from the early 20th century to the present day. Those who are older residents may find long forgotten memories of individuals refreshed, and for them it will be a memory book of the past. More recent residents are likely to be intrigued and perhaps amused that the modern city we know today seemed so primitive a century ago. And there are others who will find this book invaluable as a reference tool. Who owned the first automobile in Bristol? What was the name of that hotel that once stood at the corner of State and Front streets? Was there a hospital in Bristol before the building of the Kings Mountain structure, and if so, where was it? For all of these questions, and hundreds more, Mr. Phillips provides us with ready answers.

There is both good news and bad news with the publication of this volume of Mr. Phillips's series on the history of Bristol. Originally he had intended to conclude his history with this book, which would cover all aspects of life in the 20th century. But he soon recognized that the vast amount of material he had amassed could not be condensed into a single volume, and consequently

he has left several aspects of our urban history out. There is nothing, for example, about our schools or our churches. That is the bad news.

The good news is that he will continue his history with at least one more volume, including those topics he could not fit into the present work. And that is good news for all of those who have bought and enjoyed his earlier books. For, as they put down this work after having read it through, they will have the satisfaction of knowing there is more to come.

Bristol, a Good Place to Live

I have entitled this work *A Good Place to Live*. In so doing, I have never spoken or penned a more sincere and true statement. I write as one who has considered no other place to be home for more than fifty-two years. Bristol is my home by choice, not by birth. The city has been and is so pleasing to me that I almost shudder when I remember how close I came to not moving here.

In the summer of 1953, I lived in Perry County, Kentucky, having moved there from Russellville, Pope County, Arkansas. While in Kentucky, I developed a strong desire for more education, and I corresponded with 32 schools scattered over a wide area of the United States. I finally chose one in Delaware and made plans to move there before the school term began in September.

Long ago, I came to the conclusion that the gates of fate swing on small hinges. In July of that summer, I went over on Big Creek near Avawam, Kentucky, to house sit while a family took an extended vacation. One hot Saturday afternoon I became a bit bored and perhaps lonely. Thus, I began to search around the house for something enjoyable to read. I happened to see a stack of magazines on the lower shelf of a small living room table. I selected one that looked interesting, not knowing at the time that I was selecting Bristol as my future home.

I don't remember the name of that magazine, but I do remember it was published somewhere in New Jersey. The magazine included an article on Bristol and educational opportunities offered in the area. I somehow felt that this was the way to go, and I immediately began correspondence that led to my coming here.

As I look back on the events of that life-changing period, I often think of some what-ifs and cringe to think what might have happened. What if I had not gone to house sit on Big Creek? What if I had chosen to take a walk rather than seek reading material? What if that magazine had not been there, or what if I had selected a different stack? What if someone had come by for a visit and diverted my attention to other matters?

The longer I live, the more convinced I become that some things are just meant to be. Everything was in the right place at the right time. Indeed, a

large gate did swing on a small hinge, and what a pleasant future awaited me beyond that open gate.

I arrived in Bristol by bus at 4:00 p.m. on Thursday, August 20, 1953. Strange how the memory of certain feelings come back to me now. I recall that when approaching Bristol on U.S. Highway 11—I think somewhere near the old Robert E. Lee Motel—I suddenly had the distinct feeling that I was nearing home. Indeed, I was!

I left that bus and stepped into Bristol at 41 Piedmont Avenue. At that time, I knew no one in the then-strange city, and not one person knew me. I knew virtually nothing about the city or its history. Apprehensive and anxious, I was almost overwhelmed with feelings of insecurity. All my worldly estate consisted of a billfold in my pocket, containing about $35.00, and two battered old suitcases and their contents. I would soon learn that Bristol was teeming with kind, helpful friends; I just hadn't met them yet. And I am still meeting them today!

"Bristol, a good place to live," proclaims the unique sign over State Street. I believe the statement to be true, so very, very true.

Bristol is a good place to live because of her people. I have traveled this nation over and have lived in various locations, and I can say without reservation or qualification that no better people can be found anywhere. The friendliness and helpfulness of Bristol residents played a major role in my decision to stay here; their friendliness is sincere and their helpfulness comes from genuine concern rather than because of duty. Their sincerity truly pleased me then, and does cheer me now. More than anything, those commendable qualities of her people sustain and increase my love for Bristol.

Bristol is a good place to live because of the beauty of the area. I was born and reared in mountainous country and lived the first fifteen years of my life in a narrow valley overshadowed by towering mountains. Today I would not enjoy being that closed in, but I do like to live near or within sight of mountains. Bristol is located in low hills, but the big mountains are not far away. From my front porch of old Pleasant Hill, I have a pleasing view of the distant mountains. I see them daily and am content. A trip to the ends of the nation will reveal vistas no more beautiful than what I may see traveling within a hundred-mile radius of Bristol. Indeed, there is more to be seen in that limit than can be fully taken in and appreciated in a lifetime of vacations. In all my time here, my delight in viewing this area has not in the least become diminished. I find both the familiar and the newly discovered to be delightful. Truly, we have a beautiful city in a superb location.

Bristol is a good place to live because of her climate. Not often here do we have the extreme, humid heat of the Deep South or the frigid cold of the northern parts of the country. We usually have abundant rainfall. Bristol is often lush green when other areas of the nation are brown with drought. Heavy snows are infrequent and do not long cover the ground. Our spring often comes early, compared to some other places in the country, and golden autumn lingers long.

Bristol is a good place to live because of her history. Few cities or towns have as unique a past as does our own. And to study that past is to develop an appreciation for what we now have. Accepting her as she was and is, we become more proud to call her home.

Bristol is a good place to live because of the future. She has come a long way from a lone house in the midst of fields and meadow, to her present evidence of past progress. Her past progress is a good foundation upon which to base our hope of an even more progressive future. Bristol is indeed a city of promise. Join with me in going forward to the full realization of a grand future.

Indeed, Bristol is a good place to live.

A Sesquicentennial for Bristol

The purpose of the yearlong celebration of Bristol's 150th anniversary is to look back and see from whence we came. This book—and the volumes that will follow—is an effort to give a clear view into Bristol's past.

The sesquicentennial observance is based on the 1856 incorporation date of the twin cities. Though the Town of Bristol, Virginia/Tennessee, was laid out and lots offered for sale in 1852, the centennial event was based on the incorporation date, so it seems fitting to continue the practice. I well remember the Bristol centennial in 1956 and the impact it had on the city. Hopefully this present commemoration will have a similar impact and will long be remembered.

Though I decided to write a new history of Bristol at this time, this work is actually an extension of the series of Bristol books I began in 1992. To get a broader view of the historical picture of Bristol, I encourage you to read those books along with this volume. Let them all be part of your sesquicentennial celebration, so you may develop an even greater appreciation for the city so many of us delight to call home.

To have a worthwhile sesquicentennial celebration, much planning and work was necessary. The idea originated with Tim Buchanan, local historian and archivist, and he enlisted the aid of others and contacted the councils of both cities. Those councils soon appointed a steering committee, with Tim Buchanan as chairman, John Gaines as vice-chairman, Richard Ball as treasurer, and Joan Hilbert as communications chairman. Members include Linda Brittle, Vicie Dotson, David Dowell, Margaret Feierabend, Les Hilbert, Jon Lundberg, Bruce Martin, V. N. (Bud) Phillips, Bev Sharrett, Joel Staton, Beth Stockner, William J. Wade, and Doug Weberling.

PROCLAMATION

WHEREAS, the border town of Bristol, Tennessee/Virginia was founded in the year 1852 by Joseph Rhea Anderson, and bordered to the north by the town of Goodsonville, Virginia founded the same year by Colonel Samuel Eason Goodson, and

WHEREAS, Bristol, Tennessee was incorporated February 22, 1856 and a composite town of Goodson, composed of Bristol, Virginia and Goodsonville, was incorporated March 5, 1856 on the Virginia side, and

WHEREAS, the Cities of Bristol, Tennessee & Virginia, having celebrated their centennial in the year 1956 following the dates of incorporation of 1856, and

WHEREAS, having organized an effort to celebrate the sesquicentennial, the 150th anniversary, of both cities with the theme "Celebrating 150 Years of Heritage & Harmony,"

NOW THEREFORE, We the City Councils of Bristol, Tennessee and Bristol, Virginia, do hereby proclaim March 3, 2006 as

"Charter Day"

and the opening of the Bristol Sesquicentennial celebration extending through December 31, 2006, and call upon the citizens of Bristol, Tennessee & Bristol, Virginia to participate in this special & historic observance.

Dr. James E. Messimer
Mayor
Bristol, Tennessee

Dr. Douglas R. Weberling
Mayor
Bristol, Virginia

A Good Place to Live
Foundation Faults

Bristol has a most unique and interesting history, and my intention is to enlarge upon what has already been written, both by others and by myself. But first, we must straighten and repair the foundation.

In the fields of engineering and architecture, no building can be better than its foundation. The first duty of builders is to make sure the foundation is true and solid. With a faulty foundation, a builder has little justification to proceed unless and until remedy is made. Neither would it be of real value for me to proceed with this history if I do not attempt to make sure I am building upon the truth.

After long years of thorough research using primary sources, I am convinced that the commonly used and accepted version of the early history of Bristol is filled with numerous errors. And those errors could have been so easily avoided and may yet be corrected by doing true documentation. Unfortunately, most writers of local history have been content to copy from the previous writings of others, who copied from writers before them, thus perpetuating mistakes.

A few years ago, I likely would have done the same thing. Fortunately, I began examining primary sources, and to say that I received quite a jolt is putting it mildly. I was truly appalled to find blatant errors previously recorded about Bristol's early history. I was also puzzled as to why no one had yet brought the mistakes to light and corrected them.

Too easily, we make assumptions and hearsay part of supposedly correct history. Traditions, however far from truth they may be, are often more regarded than the truth. In writing accurate history, we cannot unquestioningly accept as fact what we read and hear. Make that statement a part of your unbending policy if you will be an honorable student or writer of history.

A Good Place to Live

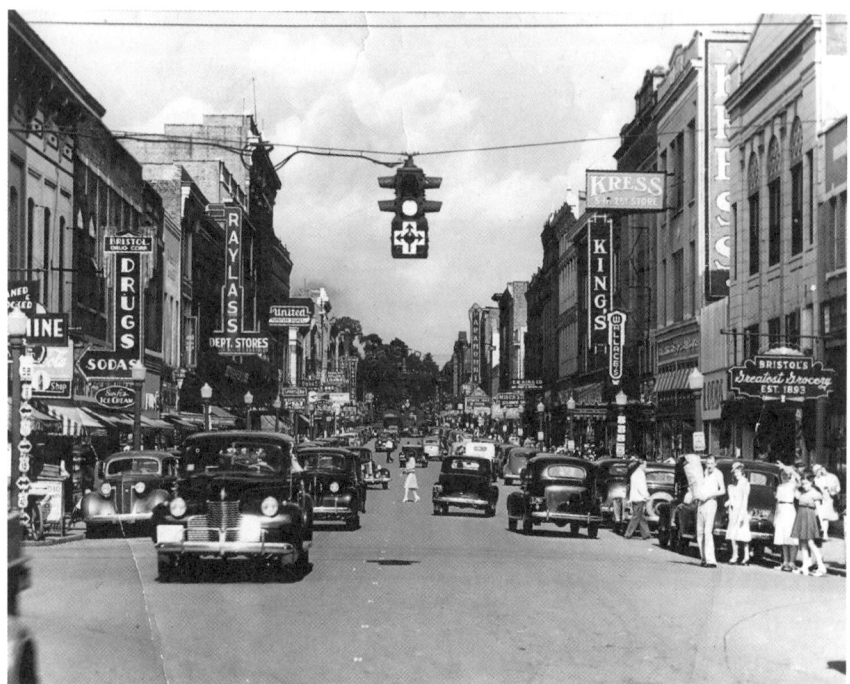

Bristol had come a long way from one building located in a meadow to a thriving city when this photo was made about 1940.

During any period of revived interest in local history, old misconceptions usually surface, as happened during Bristol's centennial celebration, and I am sure they will resurface during the observance of Bristol's sesquicentennial. Be that as it may, it is my duty to present a version of local history that can truly be documented. I well know that much of what I write will conflict with what many traditionalists hold dear, but with good conscience, I can do no other.

Now let us bravely look at the faults in Bristol's historical foundation.

A few years ago, I read an article that gave Gen. Evan Shelby credit as the founder of Bristol, simply because he had a noted fort here and he once owned the 100 acres where the original Bristol was located. However, in his lifetime he never had a deed to the land in question; and besides, others owned the land before he did. Shall we say that John Tayloe of Eastern Virginia was the founder of Bristol? Or shall we go back farther and name the Indians as founders? We are told that they had a flourishing camp here long before General Shelby ever came to the area, and I own several artifacts found locally that prove such a claim.

Though General Shelby's fort happened to be near Bristol's final location,

it had nothing to do with the placement thereof. Bristol is where it is because of railway terminal points. If the terminal location had been up the way at, say, Wallace, Virginia, or down the way at Vance's Tank, that is where Bristol would have been. The site of the fort would likely still be in the midst of a pasture, all but forgotten save by a few avid history seekers.

Another myth that I must lay to rest before the twin cities can have a solid historical foundation is the claim that Bristol is an outgrowth of Sapling Grove. I was almost amused to read in a 1956 article written in conjunction with the centennial celebration, "Bristol has come a long way since it was the sleepy little village of Sapling Grove with its dusty and muddy streets." There is not a word of truth in this statement. There never was anything even slightly resembling a village of Sapling Grove.

To begin with, Sapling Grove was a tract of land so named because of a grove of saplings standing on a hillside near what is now 54 King Street. When a rural post office was established in Sapling Grove in 1839, the area could hardly be called a community, certainly not a village. Just like General Shelby's fort, that post office had nothing to do with the founding or placement of Bristol; it happened to be near, but not in the original Town of Bristol. Again, had it not been for the railway terminal location, few people today would even know about Sapling Grove. And fewer still would have ever heard of the tract.

After all, there were other tracts of land in the vicinity that had been named in the 1700s. Somewhere here at my home, Pleasant Hill, I have an old deed for a tract of land known as Timber Grove. I venture to say that not one in a thousand of my readers has ever heard of it. It is all but lost in obscurity. So would it have been with Sapling Grove had the tract not become confused with the beginning of Bristol. If our city had been located between Wallace and Wyndale, it would have been on the Mulberry Grove tract. Would we then be saying that Mulberry Grove was the reason for the founding of Bristol?

Our area was sometimes called Kings Meadows, but because a portion of Bristol is now located on those meadows is no justification for claiming that we are an outgrowth of such a place. Kings Meadows were noted areas on the James King plantation. One of the meadows on the plantation included the area where now is located Cumberland Square Park.

In a highland area covering most of what we now know as Solar Hill is another meadow—now covered with homes—containing a stand of oak trees known as Noon Grove. Shall we then say that Bristol was an outgrowth of

Noon Grove? It would be as reasonable a claim as those giving Kings Meadows or Sapling Grove that honor.

All these places were part of pre-Bristol history and, as such, are due their honor. But let us forever lay aside the often repeated myth that we are here because of one or more of them. Bristol was a deliberately planned and founded town with a clearly defined cause and purpose. It is here because of one thing—the termination of the Virginia and Tennessee Railroad and, later, of the East Tennessee and Virginia. After extensive and exhaustive research, I am well convinced that there would not even be a village where our city is now located had it not been for its favored position as a railway terminus. I can find no other reason for a city to have developed here. I fully believe that the land where Bristol now lies still would be cultivated fields and pastures had it not been for the railroads.

Just a little research makes it clear that Joseph R. Anderson was determined to found a city at a favored point on the proposed railroads—wherever that point might be. One rail survey more or less followed the famed Island Road that led to Long Island in nearby Kingsport. For that reason, Anderson bought a large farm in the general vicinity of the present Moore's Potato Chip plant and Valleydale plant. There our city would have developed had the railway been built on that survey. Another railway survey ran through Paperville, and Anderson was desperately trying to buy several acres there as early as 1847. Bristol might well have originated there had this survey been followed.

When it became certain that the railroads would terminate upon the plantation of his father-in-law, Rev. James King, Anderson immediately began to negotiate for land there. He was finally successful, thus we have Bristol where it is today.

This brings us to another inaccuracy. It has often been said and written that the depot in Bristol, Virginia, is upon land donated by Rev. James King and his first cousin Col. Samuel E. Goodson, but maps and deeds of the period show that King alone donated the depot tract. Colonel Goodson did offer the railroad a seven-acre tract as an inducement to have the depot built in his Goodsonville, but they did not accept the offer. Later he did sell (not donate) a few acres to the railroad company, who used the land for the roundhouse and a portion of the switchyards.

The following incident demonstrates how misconceptions are sometimes perpetuated. A few years ago, a local group was preparing a historical work on Bristol for publication, and they asked me to check their facts for accuracy. When I discovered the depot lot mistake, I pointed it out to the preparation

Bristol had her beginning on what is now the southwest corner of State and Edgemont. Joseph R. Anderson, the founder of Bristol, built his home and store on this corner in 1853.

committee, citing primary sources. The chairman of that committee finally said, "Well, I guess you're right, but it's generally believed that both King and Goodson gave the lot, ten acres by King, and seven by Goodson, and we've published it that way before, so I think we'll just go ahead and leave it that way." And leave the error they did! This makes us wonder just how much purportedly correct history we read is presented by choice regardless of the facts.

Another railroad myth that needs to be exposed states that the Virginia and Tennessee Railroad and the East Tennessee and Virginia Railroad met in Bristol in 1856. There was supposedly a great celebration during which a golden spike was driven to complete the joining of the rails. This claim contains not one word of truth! The East Tennessee and Virginia was not finished until 1858, with the joining of its two sections at Midway between Greeneville and Morristown in Tennessee. And though that line extended to Bristol, there was a gap of about three feet between where it ended and the other began. Their rails were joined approximately twenty years later.

I have more than once seen the so-called golden spike used in the mythical ceremony and joining. It is clearly of much later vintage, at least 1900 or later, but no one knows its actual origin. And the "gold" can easily be identified as having come from a dime store in the form of a cheap paint. So much for another crack in the foundation of Bristol history.

A Good Place to Live

Now we come to the town itself, where most of those who write or speak on the subject became derailed. One version of the town's founding is that Joseph R. Anderson owned the land on the Tennessee side of the state line and thus became the founder of Bristol, Tennessee. The story goes on to say that Col. S. E. Goodson owned the land on the Virginia side of the state line and thus he founded Goodson, which in 1890 became Bristol, Virginia.

The first provable fact we must face is that early maps of the town, along with surveys and deed records, clearly show that Colonel Goodson's land ended at Beaver Creek, some distance north of the state line. Fact two is that Anderson's land did extend across the state line into Virginia to join the town of Goodson at Beaver Creek.

If you study the maps available in the office of the Circuit Court Clerk in Bristol, Virginia, you will see that the Bristol founded by Anderson included land on both sides of the state line. Records for 1853-1856 in Abingdon, Virginia, show deeds for the area from the state line north to Beaver Creek bearing the description of lot number such and such in the Town of Bristol, Washington County, Virginia. I have numerous old documents that also call that area Bristol, Virginia.

Yes, Virginia, there was indeed a Bristol, Virginia, before 1890!

Now let us go back to Colonel Goodson, who laid out the Town of Goodsonville, Virginia, upon a portion of his land north of Anderson's Bristol. It was bounded on the south by Scott Street, on the north by Mary Street, on the east by Goodson Street, and on the west by Lee Street. The map on record has no date, but it bears indications that Goodsonville was laid out at about the same time as Bristol.

In 1856, Goodsonville and Bristol, Virginia, combined and incorporated as Goodson, Virginia. This composite town was founded by a coalition of prominent citizens who desired to honor Colonel Goodson for his service in obtaining the railway for the area. But it was not done without strong opposition from the Tennessee side of town.

The Town of Goodson always had an identity problem. The newspapers and official documents of the period show that people called it Bristol far more often than Goodson. Even some deed records still carried the old name of Bristol, Virginia. Perhaps the greatest blow to an accepted identity was the fact that the depot also continued to use the name Bristol. Finally, Goodson surrendered her always-shaky identity and again became Bristol in 1890.

Another error frequently repeated about early Bristol history is a claim that the post office is a direct continuation of old Sapling Grove. Again, we

face an easily exposed mistake, one that came about because until recently no one had researched the official postal records. According to those records, the Sapling Grove post office was discontinued October 1, 1853. Then on November 5, 1853, the new Bristol post office was established. Clearly one office was discontinued, then five weeks later a new office was established.

There are other mistakes, but the ones covered here are considered to be the major faults in Bristol's historical foundation. There is no excuse for the mutilation of early Bristol history that has so often occurred. The only way to repair this gaping crack in the foundation is by accepting documentation that leads to a well-researched history of which our city is worthy. Anyone willing to disregard the traditional assumptions and misunderstandings that have been perpetuated as fact for so long can easily verify the version presented here. I do not ask that my word be believed without reason or understanding; I only ask the reader to lay aside blind loyalty to shaky traditions and be guided by open-minded research of primary sources.

A Good Place to Live

A New Century Dawns

Step back with me now to the Bristol of 1901, a city only 49 years old, counting from the time it was laid out and lots offered for sale. Her population had barely reached 12,000. Her official limits did not reach far. A healthy person could have walked completely across town in less than 30 minutes.

Old Main Street had just become State Street. Virtually all the business houses at that time were on that street or just off of it. There were no malls or shopping centers. There were no supermarkets. Grocery stores were located all over the business district, with a few small ones in residential neighborhoods. They were not self-service; you were waited on by the merchant or one of his clerks. Your sugar was weighed for you and placed in brown bags. Coffee was ground when needed. Eggs did not come in fancy packages; they were counted out one by one from the merchant's bin or peddler's wagon. Milk was not displayed in a shiny cooler; it was dipped from a pail or keg and poured into a vessel supplied by the customer, and sometimes street dust and insects were poured up with it. Bread was baked at home; no one ran downtown for a loaf wrapped in a colorful plastic bag.

Prices of all goods and services were very, very low. Men's fine suits could be had for less than $10.00. Ladies dresses could be bought for $2.00 or less; there were better ones, but few women bought them. Shoes cost a dollar per pair and up—but not far up. Good cloth could be bought for 10¢ per yard, sometimes less. Milk was 20¢ to 25¢ per gallon. Butter sold for 12¢ per pound, and you were lucky if it was not "antique."

A good house could be rented for less than $10.00 per month. If you were in good position to buy, a modest home could be purchased for less than $1,000. A near mansion might run $5,000.

A New Century Dawns

Bristol's main street was a dust bowl in summer and a seemingly endless mudhole in winter and during times of heavy rainfall. Here and there, stepping stones or blocks of wood had been laid across the street to keep people from going up to their knees in mud. One prominent merchant erected an over-street bridge for the benefit of shoppers. It was not uncommon for a wagon and team to mire down in the mud and thus block traffic for long periods of time.

Despite the oppressive heat of summer, merchants usually kept their doors and windows closed so their wares would not become covered in dust. But, alas, mud was carried in on the boots and shoes of customers until it all but thickly covered the floors. And, of course, that mud soon turned into dust. Even a small degree of cleanliness required a never-ending and seemingly losing battle with dust.

Downtown Bristol had streetlights, feeble as they were, but the residential sections of town had none. No one had ever heard of traffic signals at busy intersections, for no real need for such had yet developed. The era of the automobile had not come to Bristol. State Street in 1901 was usually filled with horses and horse-drawn vehicles, intermingled with numerous pedestrians. It was not unusual for folks to walk several miles to town. On Sunday mornings there were sometimes parking problems in the churchyards, but some families left buggies and carriages at home and walked long distances to church rather than go through the hassle of parking in an overcrowded churchyard. The town had a streetcar system at that time, but it was limited to certain areas. And in 1901 Bristol was served by over twenty passenger trains per day.

A few residences still stood on State Street, especially beyond Seventh. Some of them were wedged close between large brick business houses. Homes were heated by wood or coal. In winter, a grayish black pall of smoke hung over the town. Pollution was certainly here at that time. Housewives fretted over soot falling on the laundry drying outside, but what else could be done? They had never heard of clothes dryers.

The town then boasted four or five large hotels, but motels had never been heard of. Sleeping rooms could be secured in private homes all over town, and boarding houses were plentiful. A good room could be had for $1.50 per week, and board ran about $4.00 for the same period. Entire families frequently boarded out, while living in their own homes. Some went long distances to do so, which was easier than finding a good and faithful cook.

Wages were dirt-cheap, with labor often found for 50¢ per day. Store clerks earned about $5.00 per week for a 10- or 12-hour-per-day shift. Employees

had no coffee breaks and only a short period for lunch. Schoolteachers earned about a dollar per day. Doctors received no more than a dollar for an office visit and made house calls for $2.00 to $3.00 dollars. All night on a maternity case might bring in $10.00. Dentists might receive 50¢ for a tooth extraction and $5.00 to $10.00 for a complete set of false teeth.

Bristol did have electricity and piped-in water, neither of which was very dependable. And available electricity did not mean every home was thus lighted; far more oil lamps were in use than electric lights. The power often failed, and turning on a water faucet often had no results, or the water might be muddy and heavily polluted. Many a person died in those days after drinking germ-filled water. The water bill, a flat $1.00 per month, was the same in winter as in summer whether you took a bath or not! (So states advertising of the water company at the time.) By 1901 telephones had been with us for nearly 20 years, but they were certainly not in every home. Indeed, it was somewhat of a status symbol to have one.

There were more distinct lines between the rich and poor at that time. There was little middle ground. There was no Social Security or unemployment check to rely upon, no welfare system. Old age was a time of poverty for many in Bristol at the time. Not a nursing home existed. Most homes had at least one aged, sick, or indigent relative in its care. For many folks, the only help available came from kind family members, friends, or, in some cases, from local churches. There was no health or dental insurance, and Medicare and Medicaid were both far in the future. There was a local Salvation Army, but its help was limited.

Can you imagine Bristol without a single radio or TV? Both were years away. The town had an opera house for occasional entertainment, and a lecture hall did exist, but there was not a single movie house. Folks then enjoyed home visiting and parlor games, something that has almost passed with the century. Much entertaining was done around old family pianos and reed organs.

Not one house in 10 had bathrooms. Instead, a privy house "graced" the backyard, many within a block of State Street and perhaps a few on it. Several Bristol homes still had milk cows and chickens in the backyard, and most all had small vegetable gardens.

The moral and civic climate of Bristol in 1901 was not good. Lawlessness and immorality ran rampant. Violent crimes were common, and prostitution flourished unmolested by the local authorities. There were several open brothels in and near the downtown section of the city.

Bristol did have three fine colleges, two high schools, and several smaller

schools, but many local young folks went to work before completing the fourth grade. No matter the distance, no student had the convenience of bus service. School hours were long, usually beginning at 8:00 A.M. and ending at 4:00 P.M. There were no such things as snow days or snow schedules. Students waded through deep snow, and once there, they often shivered in underheated rooms as the school day progressed.

An effort was on to establish a public library, but it would be a while before the dream would be realized. Illiteracy was common among the local citizenry.

The city did not then provide garbage pickup service. Much trash was burned in the backyard. Hardly a day passed by but that smoke from burning trash piles could be spotted here and there over the city. Sometimes garbage was picked up by area farmers who fed it to their hogs, and occasionally someone in town had the same need for it. Nonburnable trash sometimes wound up in ditches or even unused wells or cisterns. Many discards were simply carried to an attic or outbuilding. There was a common dumping ground on Euclid Avenue where now stands the former Goody's building. (The building was used as temporary housing for the Bristol Public Library until 2006.) There was another dumping ground across Euclid Avenue at the western edge of what is now a parking lot for the Little Creek Shopping Center.

Bristol was a city without a single computer, and typewriters were uncommon. Most business and personal correspondence was handwritten. All bookkeeping and accounting, right on up to the largest bank in town, was done by exacting handwork.

There was not a hospital in town. No going to an emergency room in those days. Emergencies were handled in your home or wherever an accident might occur or where sudden sickness might overtake you. Virtually all deaths occurred at home. There were undertakers, but a large percentage of the local citizenry buried their own, usually with the help of friends and relatives.

When comparing Bristol at the beginning of the 20th century with the city of today, the first impression is that of so much change. In the 1900s, achievements were made that no one had dreamed of. To those who think that all the major accomplishments have reached their limits, stay around a while. You may be surprised at the real changes the 21st century may bring.

Who knows, perhaps someone a hundred years hence may write of the changes that have taken place within the century we have now entered. I think that person will have much to write. Bristol is moving forward. No one fully knows how far she will go.

A Good Place to Live

The Healers

Professional medical services began in Bristol when Dr. Benjamin Frederick Zimmerman established his practice here in June 1854. The second doctor to settle in Bristol was Dr. Richard M. Coleman, who arrived in the late spring of 1855. Shortly he was followed by Dr. Flavius Hartman.

In the light of modern medicine in Bristol today, the best word to describe medical treatments during the early years of the city is *primitive*. Those who practiced the healing arts in the 19th century simply did the best they could with what knowledge, equipment, and medicine they had. Bristol had no hospitals. The sick, however severe their cases, were treated at home, usually under conditions far from ideal. In winter, those with colds, flu, and even pneumonia often stayed in frigid and drafty rooms.

Dr. Hartman once wrote to a fellow doctor, stating, "I was called this morning to see a Mr. Kelton, whose several days of severe flu is now, I think, pneumonia. It was bitterly cold outside, and inside his room was no better, if anything it was worse. I retained my outer cloak and still shivered as I treated him. I noted that a glass of water that had been placed by his bed during the night had frozen solid from top to bottom. I think he will die shortly."

In her memoirs, Judith Strong, who lived in early Bristol, wrote that her young son developed chills one cold winter. She heated bricks and placed them around him, but he continued to shake and tremble.

While many of the sick shivered in winter, others sweltered during hot summers. Fevers of various kinds were quite common, with typhoid by far the most prevalent. Bouts of this prolonged fever often occurred in midsummer. The late Dad Thomas once told me how he assisted in caring for a family who had the much feared malady. Here is the story in his usual straightforward manner:

They was five or six of them Purdys down with hit all at once. They lived in a little, low-ceiled shack rat there in the back side of Circus Bottom [back of the present Bristol, Virginia, jail]. Hit whar late July and plumb hot and sticky. Them folks all had high fevers. We that was waitin' on them was soaked in sweat, and they was worse. We finally got to wettin' sheets in Beaver Creek—hit was rat at the back door. Now that hoped [helped] some, but not for long. About half uv that bunch died, as I recollect.

Long before Bristol had commercial ice plants, a few of the more elite residents had ice cellars where they stored winter ice (mostly taken from Beaver Creek) for summer use. At times of fever epidemics, those owners received many appeals for ice to cool fevered brows. Virtually all of them kindly granted such requests, even to the point of complete exhaustion of their summer ice supply.

All births took place at home, and often the mother or baby, or both, died from complications of childbirth. Midwives, sometimes called "granny women," offered assistance more frequently than doctors. Whenever a delivery required a doctor, he seldom charged more than $5.00 or, in later years, $10.00, fees that remained the norm well after 1900.

Dr. C. W. Fleenor, who started his practice soon after 1900, first charged $5.00 for a maternity case. A few years later he raised the price to $10.00. Shortly before his death in 1936, he upped the price to $20.00. He used to tell that soon after the second fee increase, he delivered a child for a lady who was already the mother of a sizeable brood. When he named his price, she seemed a bit shocked. Then she told him to tell Isaac, her husband, "We can't have no more babies, for the price has gone up!"

Many of Bristol's early residents had moved in from rural areas,

Dr. B. F. Zimmerman, Bristol's first physician, and his wife, Martha Buchanan Zimmerman

bringing with them the knowledge of home remedies and methods of treating disease. Continuing the practice long after they were well in reach of local doctors, they made many trips into nearby fields and woods for roots, barks, and plants from which they concocted remedies they swore by.

In the latter half of the 19th century, several persons known as herb doctors practiced in Bristol. Two of the most noted were women, Mrs. John N. Bosang and "Aunt" Polly Taylor, who was also a midwife. Virtually all the herb doctors used strong whiskey as the base of their brewed-up medicines, which soon left their patients feeling no pain. Whenever a patient gave credit to a home remedy, the herb doctor's fame quickly spread.

Many readers may be surprised to learn that herb doctors continued to practice in Bristol through the 20th century, and even to the present time. I recall one herb doctor in the mid and late 1950s who claimed he could tell what was wrong with someone simply by looking at the person's face, hands, and feet. Having made his diagnosis, he would then come forth with one of his herbal remedies. A friend once let me taste one of his concoctions. I never in my life tasted anything more horrible and said so to my friend. He replied, "It was bad tasting, but it was powerful strong and would cure most anything that ailed you." He went on to say that when he took a good dose of the medicine, he could sleep soundly for 12 hours at a stretch. I suspected that it contained a strong moonshine base.

Bristol has had several faith healers, some religious, others far from it. Many locals strongly believed in them, and there may be those who yet do. Among the unorthodox healers were blood stoppers and fire drawers. Perhaps the strangest manner of "magic" healing practiced here many years ago was by a man who said he was not religious in any degree. He supposedly healed by "staring one down," that is, he told the patient to refrain from blinking as long as possible, while looking steadily into his eyes. When the patient blinked, supposedly the healing would take place.

Mind over matter was a theory often investigated and discussed. One local druggist (my informant had forgotten the name) became so convinced of it that he left a good position with a drugstore and went out to practice that form of healing. His conversion came about in an unusual way. The intelligent, handsome young man, after graduating from King College as an honor student, became a pharmacist and a partner in the Pepper Drug Store that stood near the present site of the Paramount Theatre.

Perhaps a year later, a nervous young man who seemed a bit angry and dazed came into the store and asked for a bottle of carbolic acid. The phar-

macist sized up the situation and, concluding that the customer was planning suicide, stepped behind the counter and took down a bottle containing a harmless substance and handed it to him.

Hardly had the purchase been paid for when the agitated young man screamed out that he would just end it right then and there. He turned the bottle up and drank about half of its contents. He then placed the bottle on the counter and backed up against a wall, yelling out curses against himself and the world around him. In moments he slumped down and fell to the floor, appearing to have convulsions, and struggling for breath. From all indications, he was truly dying, exhibiting signs of a poisoned man in the final agonies of swiftly approaching death.

The druggist jumped down by the apparently dying man and explained that the bottle had contained not poison but a harmless fluid. A few moments later, the "dying" man seemed to suddenly come to the conclusion that indeed he was not fatally poisoned. Almost instantly his agonies ceased. He sat up, then jumped up and ran out the door.

The young man arrived home calm and serene, and from that day on he showed no signs of suicidal tendencies. This was long before shock treatments were given as quick cure for depression, but the shock he received in that drugstore must have had a similar effect.

While the customer may have received a shock, the druggist received what he termed a sudden, life-changing revelation. That night at home, he thoroughly pondered and carefully evaluated the experience, and came to the conclusion that if the mind, when totally convinced of something, can create the reality of that of which it is convinced, then indeed there was something to the theory of mind over matter. Deciding that if the mind can create disease, it can also create health, he immediately became an apostle of the theory. From that day forward he taught and practiced the mind-over-matter form of healing. He eventually traveled all over the Southeast, lecturing and holding healing sessions based on his claimed revelation.

He had many followers in Bristol, some of whom were still living when I arrived in 1953. I well remember one of them; indeed, she was one of my first acquaintances in the city. Nearly 100 years old when I met her, she fully believed that if she could hold the faith, as she expressed it, she would live forever. I suppose her faith finally wavered; she died, but not until she was 105!

While so many unusual forms of healing were being practiced in Bristol, Dr. Henry Quincy Adams Boyer came from Wytheville, Virginia, in 1873 to take up residence and begin a standard practice of medicine. When he

A Good Place to Live

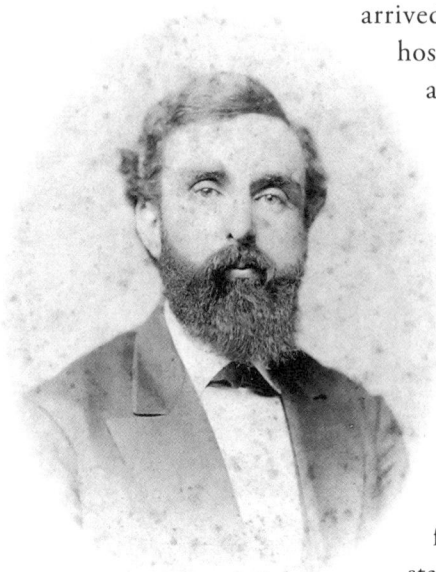

Dr. Henry Quincy Adams Boyer, who founded Bristol's first civilian hospital

arrived, he set up Bristol's first civilian hospital—an army hospital had operated here during the Civil War—in the former Thomas House Hotel, which stood on the present site of the Paramount Theatre. Bristolians who had delighted in having their first hospital were disappointed when he closed it about two years later and moved away. It would be nearly 30 years before another would open.

Several local doctors kept severely ill patients in their homes from time to time. Some patients stayed for weeks before recovering or dying. Dr. John J. Ensor had a room that nearly always held a patient or two in his home (now headquarters for SESCO Management Consultants) on the southeast corner of Seventh and Cherry streets. Soon after the house was built in 1871, he performed an operation on former President Andrew Johnson. Dr. Ensor continued his practice until shortly before his death in 1909.

Dr. William Whitten, whose house still stands at 203 Solar, also kept home patients from time to time. And Dr. M. M. Butler sometimes took in patients to board and treat in his home, old "Butler Hill." This fine house at 848 Anderson Street was demolished in the early 1960s to make way for Volunteer Parkway.

As the population greatly increased toward the beginning of the 20th century, the need for a suitable hospital became more evident. Many clamored for such an institution, but need and desire were slow in translating into reality.

BRISTOL'S EARLY DOCTORS

Bristol's first physician, Dr. Benjamin Frederick Zimmerman, arrived in June 1854. He died a few months later on November 11, leaving the town without a doctor until the spring of 1855, when Dr. Richard M. Coleman began his practice. Since that time, Bristol has always had the services of at least one physician.

The Healers

Bristol entered the 20th century with 26 doctors, 14 of them carry-overs from the 1800s. Those who had practiced here before 1900 were:

Dr. Joseph S. Bachman	Dr. John J. Ensor
Dr. Matthew M. Butler	Dr. John F. Hicks
Dr. Alfred M. Carter	Dr. W. B. St. John
Dr. James A. Delaney	Dr. M. M. Pearson
Dr. William T. Delaney	Dr. George M. Peavler
Dr. James A. Dickey	Dr. Nathan H. Reeve
Dr. Nat T. Dulaney	Dr. W. K. Vance

Virtually all of these veteran doctors maintained offices in downtown Bristol, mostly within a four-block area. Dr. Butler, Dr. Ensor, and Dr. Carter had the longest terms of service to Bristol, more than 30 years each. Dr. Dickey practiced here for about 25 years, as did Dr. William T. Delaney. In addition to practicing medicine, Dr. Pearson served for some time as Clerk and Master of the local Circuit Court.

The homes of Dr. Bachman (940 Anderson), Dr. Ensor (634 Cherry), Dr. Pearson (423 Pennsylvania), Dr. Peavler (912 Anderson), and Dr. Reeve (518 Sixth) still stand. Dr. Dickey's home (421 Fifth) stood until just after the turn of the 21st century, and Dr. Carter's home (409 Fifth) was demolished in 2004.

Ten more doctors had joined the veterans by 1901. The aged Dr. Butler took as a partner Dr. Joseph H. Delaney, son of Dr. William T. Delaney. Young Dr. Delaney still lived with his parents at 1203 West State Street. Dr. William Copenhaver opened an office at 520 State Street, and Dr. James T. Green, who lived at 1031 Anderson Street, opened an office at 9 Lee Street.

Dr. Hardin W. Reynolds, son of Civil War veteran Maj. A. D. Reynolds, and nephew of tobacco tycoon R. J. Reynolds, had a brief practice with an office at 520 State Street. Unmarried at the time, he lived on the corner of Spruce and Carolina. He did not enjoy the medical field and soon gave it up for business pursuits; he opened Bristol's first Ford automobile dealership and built many buildings here, including the Reynolds Arcade Building, now known as Executive Plaza, on Cumberland. His future brother-in-law, Dr. Thomas F. Staley, had opened an office on the corner of State and Lee, likely the Susong Building that is now being returned to its original grandeur.

Bristol's first female doctor arrived in 1901. Dr. Ethel M. Wood and her husband, Dr. E. Preston Wood, operated as a team (Wood and Wood) with

A Good Place to Live

an office in their home at 24½ Sixth Street. Dr. Michael B. Kinzer and Dr. Carp S. Kinzer, apparently brothers, were then living at 540 Sixth Street. They soon left, however, and I could find nothing further about them. Dr. Charles K. Kernan was just then beginning his practice at 15 Sixth Street. Unmarried at the time, he boarded at the Hamilton House Hotel but by 1910 had a home at 717 Alabama Street.

In 1901 Bristol had one black physician, Dr. Edward O. Woodward. His office was at 16 Fifth Street, and he lived at 220 East State Street. Within a few years Bristol had another black doctor, Dr. James A. Brown, who kept an office at 9 Lee Street.

Dr. Matthew Moore Butler (1838-1913) served as a surgeon during the Civil War. He assisted in the amputation of the arm of Stonewall Jackson. After the war he served the people of Bristol until his death.

By 1905 Bristol had become home to 33 physicians. The city's population was fast increasing at the time, which enticed several new doctors to settle here. Some of them stayed, while others moved on to various locations.

Those who long were well-known in medical circles here included, among others, Dr. Conley M. Cowan, Dr. Landon Haynes Gammon, Dr. N. S. Peters, Dr. William R. Rogers, Dr. Alvin J. Roller, Dr. George E. Wiley, and Dr. William S. Wiley. Dr. Cowan, who helped found St. Lukes Hospital, then lived at 910 Hill Street but later built the brick house that yet stands at 1101 Windsor Avenue. Dr. Gammon lived in the unique house now occupied by the Slaughter Law Firm at 330 Sixth Street. Dr. Peters resided at 901 Georgia Avenue.

Dr. Rogers lived at 502 Lee Street, his father's family home. In 1938 he bought the Hugh Powers mansion at 423 Spruce Street and moved there, paying only $10,000 for what remains as one of the grandest homes in Bristol. Dr. Roller's old home, now called Sycamore Shade (so named by this writer), yet stands at 622 Alabama.

Dr. George Wiley lived with his brother William on the corner of

Moore and Harmling streets. Dr. William S. Wiley later married Susie Brown and moved in with her family at 234 Solar Street, a house now occupied by Mrs. Betty Hunt.

In 1905 Bristol's first osteopath, Dr. Arthur L. Dykes, opened an office at 22½ Sixth Street. At the time, he boarded at the Hamilton House Hotel. By 1913 he also served as president of the Bristol Laundry Company and had relocated his office to 20 Fourth Street, where he may have lived on the upper floor of that old brick building. He married Bessie McCrary, and they long lived at 504 Spruce Street.

The number of Bristol doctors had dropped to 30 by 1908. Although some had left, others arrived. Dr. James A. Dickey had taken in a partner, Dr. Arthur J. Edwards, who lived at 224 Solar Street. Dr. Matthew (Matt) St. John had become associated with Dr. William B. (Will) St. John, and they maintained an office on Sixth Street and both lived at 918 Windsor Avenue.

Dr. H. B. Edmondson, with an office at 110 Moore, had moved into the house at 221 Johnson. He formerly lived in a duplex next door at 223 Johnson, and records indicate that he may have built the still-standing house that is now the Music Apartments. He seems to have not practiced here long.

By 1910 the number of doctors practicing here had reached 34, including one more black doctor, Ulysses S. Tartar, who had an office at 9 Lee Street. Bristol's second osteopath, Dr. Alfred J. Snapp, had opened an office in room 38 of the Interstate Building on Sixth Street and was boarding at 837 Hill Street. Dr. Paul Kernan (I have been unable to determine if he was related to the earlier Dr. Charles K. Kernan) had also opened a practice. He then resided at 700 Georgia Avenue, and three years later he lived at 337 Park Street. Dr. John G. McClellan had built up a large practice. He worked from his home at 544 Alabama Street.

Dr. William T. Delaney was a much respected doctor for many years in the late 19th and early 20th centuries. In addition to his practice, he was a prolific developer of Bristol.

A Good Place to Live

The late Ernest Emmert once shared with me that as a youth he sometimes helped at his grandfather's fruit stand near the corner of Washington and State streets. He recalled that Dr. McClellan came early every morning, riding his horse from his home on Alabama Street. He would remain mounted while he purchased one cigar and two bananas, then he would ride back home, ready for the day.

Doctors on Through the Years

Bristol's second female doctor opened an office in 1913. Dr. Helen G. Bond both lived and practiced at 616 Alabama. Female doctors of that period had a difficult time establishing a profitable practice. Men, for the most part, would not patronize them, and even women seemed to think them inferior to their male counterparts.

But one young man did go to her, with disastrous results. Dad Thomas described him as a "big old goofy boy who often was the victim of pranks." Though goofy, he had a highly exalted sense of morality, always shunning anything that seemed to hint of fleshly lusts. Sometime before the man needed to see a doctor, a worldly brothel patron of the town lured him into Mag Worden's two-stall brothel on James Row, intending to have old Mag demoralize him. He was hardly in her house when she tried to take off his pants. He managed to escape, but with his pants already half off, he was hobbled and fell down her high front steps.

The fellow suffered from hemorrhoids (commonly called piles), and someone told him that Dr. Bond was very good at curing such ailments. Unaware of the examination usually made in cases like his, he hardly had explained his condition to Dr. Bond when she told him to drop his pants and bend over the table. The goofy boy, perhaps thinking he had been tricked into a setup similar to Mag Worden's, jumped up with a yell and tore out the door and ran toward town. He soon spread the word that the so-called woman doctor had tried to rape him. Few believed him, but the gossip became so embarrassing to Dr. Bond that she soon left Bristol for good.

By 1918 Bristol had two more black doctors, Rutherford B. McArthur, who long operated Mercy Hospital, and Barney L. Underwood, who first had an office at 912 State Street.

By 1921 Dr. L. B. Snapp had begun what would be a long practice in Bristol. His home was then at 822 Georgia Avenue, and he later lived at 915 Seventh Avenue. Dr. W. K. (Dick) Vance, Jr. also set up a practice about that time. A son of longtime Bristol physician W. K. Vance, Sr. and a grandson of

Dr. W. Nicholas Vance, a doctor here shortly after the Civil War, he was then living with his parents at 324 Fourth Street. Dr. Nat Dulaney had moved his office to 400 Shelby Street. His book, *Speaking of Accidents*, is still popular among Bristolians today. Dr. McClellan had moved his office to 633 State and was living in the Virginia Hotel, but he still bought two bananas and a cigar every day.

In the mid-1920s Dr. Harry Bachman, son of Dr. Joseph S. Bachman, opened an office at 420 State Street. He and his wife, Agnes, lived at 611 Part Street, and by 1927 he had built the lovely home at 1200 Holston Avenue. The town's third osteopath, Dr. R. McRae Echols, began practicing at 603 State Street. He and his wife, Josephine, then lived at 314 Moore Street.

Dr. Nat Copenhaver, a skilled surgeon, had arrived by 1924 and would long practice in Bristol. For a time he lived at the local YMCA, and his office was at 5½ Fifth Street. He later married Amelia Slack and lived on Holston Avenue. Also in the mid-1920s came Dr. Thaddeus R. Bowers, whose first office was in the Reynolds building at 510 Cumberland Street, and Dr. Elvin Hearst. Both men were still practicing when I arrived in Bristol in 1953.

By 1927 Dr. Joseph S. Bachman had moved to near Thomas Bridge in Sullivan County, Tennessee. However, he continued his Bristol practice for 26 more years.

Dr. W. K. Vance, Sr. had died by 1930, but his widow, Marie Doriot Vance, continued to live at 324 Fourth Street for several more years. His son Doug D. Vance (Dick Vance's brother) had started practicing by 1932 and lived with his mother in the family home. He wrote an interesting little book about his experiences as a Bristol doctor. The title, *Doctor, Is My End In Sight?*, foreshadows much humor that it contains.

Around 1930 came another black physician, Dr. Stephen J. Brown, who had an office at 29½ Fifth Street. He lived at 430 McDowell Street. A black husband-and-wife team, Dr. Alfred W. Thomas and Lelia M. L. Thomas, also practiced here during that period. They lived and had an office at 526 College Avenue.

Dr. Allen K. Turner was here by 1932. He later would operate a much-used maternity hospital in the old Huntsman home yet standing on the northwest corner of Solar and Sycamore. The well-known Dr. Marvin Rock also came during that period, opening an office at 643½ State Street.

Another black doctor was here by 1936. Dr. Julian L. Price, whose office was at 16½ Lee, lived at 716 English Street, but apparently he did not long remain in Bristol.

Bristol had a second-generation doctor by 1938—William Gammon—a son of Dr. Landon H. Gammon, who had been in Bristol since near the beginning of the century. Young Dr. Gammon later made a trip to a foreign country, where he unexpectedly died.

The number of local doctors hovered around 30 for most of the first four decades of the century, despite a population that more than doubled.

Doctors in 1953

Throughout the first half of the 20th century, many doctors came and went, and some stayed in Bristol. Upon my arrival in 1953, the city had 37 physicians, including several whose practice extended back to the early and mid-1920s.

As far as I can determine, only one doctor who carried over from the 1800s still had a practice in 1953. Joseph S. Bachman—whose wife, Hattie Brewer Bachman, was also living at that time—had an office at 6 Sixth Street. After a successful career that lasted 60 or more years, Dr. Bachman's name disappeared from the roll of local doctors around 1954. He may have lived for some time in retirement.

Dr. Arthur J. Edwards, another longtime physician still around in 1953, had an office at 808 Moore. He had begun here about 1905 and continued until about 1960. Also here at that time was Dr. William R. Rogers, whose practice dated from about 1903. He died in May 1954 and is buried in the Mountain View Cemetery.

To the best of my recollection, the first doctor I consulted after coming here was Dr. John O. Marcy, whose office over the Bunting drugstore was within a half block of where I lived. No appointment was necessary; patients merely went and took a seat. In time, the doctor would get to everyone.

Sometime later I had occasion to consult Dr. Walter R. Gaylor, Dr. W. C. Carreras, and Dr. William Graves. Often I yet find myself saying something I learned from Dr. Graves. When a patient faced what would ordinarily be an anxiety-producing situation, he would calmly say, "Well, we'll see what develops." Many are the instances now when, under trying circumstances, I say the same thing.

I soon learned of other doctors through my cousins with whom I later lived on various occasions. They preferred doctors who made house calls. They summoned Dr. Graves once in a while, but their favorites were Dr. W. K. (Dick) Vance and Dr. T. R. Bowers. Dr. Vance once made a late afternoon call at their home, and they gave him a bag of apples they had gathered from a large apple tree in their side yard. A day or two later they read in the

paper that he had died. I remember wondering if he got to eat any of the apples they had given him.

Of the doctors here in 1953, I know of none still practicing. Indeed, I know of only one who is yet alive, though others may be. My friend Dr. B. Young Cowan retired some time ago but continues to live near Bristol.

Fifty-six doctors were practicing in Bristol in 1960. Today the number is hard to ascertain, in that so many are clustered together and listed as practicing groups. Bristol has become something of a noted medical center within recent years, attracting many doctors of varying specialties.

Dr. H.T. Berry, long a prominent physician and civic leader in Bristol

In all periods of which I have written, many doctors remain unlisted who were certainly worthy of note. The number was small in the early days, but now has become too large to give much individual detail in a work such as this. Readers who wish to pursue the matter further should refer to the city directories of the past century.

But whoever the doctors were, and in whatever period they may have served, they did their part to make Bristol a healthier place, and they are each due a measure of appreciation and honor.

PAY FOR THE DOCTORS

Dr. William (Will) Teeter was born and grew up near Wallace, Virginia. After graduating from a medical college in St. Louis, Missouri, he began his practice at Wallace. Later he and his wife, Ella Whitten Teeter, bought the old Col. Samuel E. Goodson homestead (formerly the John Goodson place), about two miles up Beaver Creek from downtown Bristol, and he continued his practice. With money inherited from her father, Mrs. Teeter added to and remodeled the old Goodson home. Long a showplace on the Bristol-Abingdon highway, the house was demolished when Interstate 81 was built in the 1960s.

A Good Place to Live

A few years ago someone gave me one of Dr. Teeter's account books that covered the late fall and early winter of 1922. It shows his total income for the month of October as $413. Many doctors today take in more than that in one half day.

A night visit to Jack Winslow's little girl brought in $2.50. Delivering a baby for Mrs. George Wolf was entered in his book for $9.00. On Christmas Eve, he called on and doctored Noah Hast's entire family for $4.00. The night before, he had gone all the way to Wyndale to doctor Dave Broady's horse—yes, you read it right, a horse—for which he charged $3.50 plus $1.00 for medicine. Also in December he bandaged the legs of a woman with varicose veins for $2.00. Near that time he cut shot out of Jim Little's neck for $1.00. (I wonder how the shot got there!) For a 3:30 A.M. birth he charged $15.00.

He noted that November 1, 1922, was not a good "doctoring day," mainly because he attended the funeral and burial of D. F. Bailey at Walnut Grove. He mentioned that lawyer Bailey was "put away nice."

For his half of a bill for an operation performed with Dr. W. R. Rogers, he received $25.00. He made a visit to see the patient in the hospital at Bristol and charged $2.00.

Early on the morning of December 21, 1922, Ella Mae Wright brought her very sick little girl to Dr. Teeter's office. Realizing that the child needed hospital care, he used his own car to drive the girl and her mother to St. Lukes Hospital in Bristol, where he placed the patient in the care of his close friend Dr. L. B. Snapp. Though he spent the better part of a morning taking care of this neighbor's daughter, he charged only $2.00, including "ambulance service" to Bristol.

His usual charge for a simple office visit seems to be $1.00. He once cut cinders out of the lip of Horace Slagle's daughter and still just charged $1.00. (Folks riding trains in those days commonly got cinders in their eyes, but how cinders got in her lip was not noted.) He charged $5.00 for operating on a man's leg in his office; perhaps the procedure was a bit more involved than removing cinders from a lip.

Of course, he sometimes charged extra for medicine, but not much. He once made a notation that he had sold Dr. William Phillips of Wallace some morphine tablets for $2.00.

Charges written in an account book differed from charges collected, however. Time and again, Dr. Teeter entered notations of "no good," "lost," or "forgotten" by bills that had been recorded. Evidently he made no overt effort to collect those delinquent bills. In one case, a family gave him a calf valued

at $15.00 for a number of bills incurred. Usually, his highest charges were for night deliveries of babies, and these were the bills that seemed most apt to become delinquent. His delivery fee ranged from $10 to $15. Several entries had "forgotten" written by them.

But he did all right. And, if it means anything, he has one of the most impressive monuments in Walnut Grove Cemetery.

Nurses

Over the years many nurses have lived in Bristol and have played a valuable role in the healing arts. At first most of them were termed as home nurses, that is, they went to care for patients' in their homes. Then as hospitals were founded, some of the nurses began working in them, but Bristol had an ever-growing home-nurse force.

Many nurses, but not all, are listed in the old city directories. Only two are listed in 1905, while the number grew to 59 in 1953. By that time, and for several years prior, they were listed in two groupings: practical and registered nurses. Sometime before then, some of them were categorized as school-trained nurses.

An overwhelming number of nurses were unmarried. Some were black. A few were into midwifery, most of them black. One black midwife well remembered by Bristol's old-timers was "Aunt" Eliza (Liza) Pace, who long lived at 224 McDowell Street. Some said her name suited her, for whenever she answered an urgent call, she "went at a pretty good pace." Usually walking to wherever she was needed, she often turned down an offered ride on a horse or in a buggy or, later, in a car, saying, "No thank ye, suh, I'se in a hurry!" She always carried a rather large black bag containing the articles she used in making deliveries. She was so skilled in delivering babies that local doctors occasionally called on her for assistance in difficult cases. The late Dr. William R. Rogers frankly admitted that sometimes Aunt Liza was his last hope for a successful delivery.

One old man, a night worker in the local railroad yards, told me how one morning at about 3:00 A.M. he saw Aunt Liza and a young man rushing across the tracks in a sleet storm. They were taking a shortcut to Maple Street, where the young man and his laboring wife lived. He was several feet ahead of Aunt Liza—a "two-track gain on her" was the way my informant described it—and obviously in a great hurry.

The yard man clearly heard the fast-stepping nurse call out, "Now don't be frettin' so. If that baby done born by the time we get there, it just means there won't be much trouble."

A Good Place to Live

Roxie Jefferson, said to be a direct descendant of President Thomas Jefferson through a slave line, was first a home nurse and later a midwife. She lived at 1008 Shelby Street but later moved to 326 McDowell Street. Alice Thomas, another nurse also skilled in midwifery, long lived at 708 Clinton Avenue.

In many—perhaps most—cases, the nurse moved into the patient's home and stayed until the patient recovered or died. Some of them actually had no homes but just went from place to place living with families they served. Whenever there was a space between patients, they usually lived in local rooming or boarding houses.

One nurse had a particularly good situation. In the early part of the 20th century, the Hamilton House Hotel catered to persons who came to Bristol to be treated by local doctors. Laura B. Keithley became the hotel's house nurse and so served for several years. There were several permanent residents there at the time, most of them older men, and at times she was called upon to look after them when they become ill while staying there. She later lived at 348 Moore Street.

Helen Harper, grandmother of my now-deceased friend Helen Daggs, was a capable home nurse and a favorite of the more elite of the city. One wealthy family hired her as their nurse on a lengthy worldwide trip, and she got a flag from every country they visited. She must have had 15 or 20 of them. Helen Daggs gave them to me when I cleaned out the old Jefferson-Daggs home in the early 1980s, and I later passed them on to a young man I thought would benefit from them more than I would.

Helen Harper was so light skinned that many people often mistook her for a white person, as happened more than once when the compilers of city directories worked here. At that time, the directories included a symbol to designate a black person, but in several instances her name does not bear the symbol.

She first lived at 851 Broad Street but later moved to 332 Fourth Street into a little upstairs apartment above her daughter, India Harper Jefferson, also a home nurse. (Mrs. Jefferson is highly spoken of to this day.) One day Mrs. Harper walked to the back fence of her daughter's yard and engaged in conversation with a neighbor, then suddenly fell dead. She is buried in the Citizens Cemetery.

Several Bristol home nurses married widowers after taking care of the wife. One 24-year-old nurse married her patient's widowed husband, even though he was 62. They must have had a happy marriage, for she stayed with him until he died four children and fifteen years later.

Every now and then, a nurse got more than a husband. Sometimes she got a nice home and a ready-made family of varying sizes. About 1910, James Whitman, a railroad engineer, lived in Bristol with his wife and four young children. When his wife developed a mortal illness, he hired Linda Eversole, a young widow who had just become a home nurse, to care for her. Taking care of Mrs. Whitman was Linda's first and last job. Many home nurses at the time assumed multiple duties, so she not only nursed, she also cooked, cleaned house, did laundry, and looked after the children.

In time the wife died. To keep things on a proper level, James took a room downtown while Linda stayed on to care for the motherless children, until a marriage could take place. Both parties were willing, it seems. James took Linda over to Parson Burroughs, who then lived at 317 Third Street, and there they were married two weeks to the day after the wife's funeral. Because of James's job, the family soon moved to Salem, Virginia, where five more children were added to the family.

Nursing is still a well-paid profession in Bristol today. Of course, the number of nurses is far greater than at the beginning of the past century.

DENTISTS

Around 1860 Dr. John Keys opened a practice of dentistry in Bristol. As far as I can determine, the city has never since been without dental services.

Then, as now, most people dreaded dental work. And, quite frankly, in those early days it was not always so pleasant. Dr. W. T. Wilbar and a Dr. Adkins apparently were aware of the general fear of dentists. In 1875 they advertised in the *Bristol News,* soliciting those who had suffered "fearful experiences" with other dentists. The following story happened about that time, which makes me wonder if they knew of John English's fearful experience.

John English, a grandson of the noted Rev. James King, was about 21 years old when he visited a local dentist. In September 1872 his father, Col. John G. English, wrote a long letter to his oldest son, then living on and operating the family plantation in Monroe County, Mississippi. As was his usual practice, Colonel English wrote a rather vivid account of what must have been a long-remembered tooth pulling.

> Johnny took the toothache on Sunday afternoon. Monday it was worse and much more on Tuesday. He slept none on Tuesday Night. Neither could he eat. Gum was so much swelled—so tender and painful he could barely drink water. On Wednesday early I Send [servant

A Good Place to Live

and former slave] Jabaz for Dr. [A. J.] Dunn but he did not arrive until nearly noon. He got Johnny on the bed and got hold the bad tooth with his pullers, and gave a yank but it hurt so bad that he came up with the pullers, thus to no avail. Then the doctor had me to hold down Johnny's head and put Jabaz on his feet. The Dr. Dunn got upon the bed and straddled him about the waist. He applied the pullers again with Much trouble for Johnny could hardly bear for anything to touch His mouth. The doctor then pulled hard and fast and the tooth Was jerked out. Johnny seemed to swoon a bit and just lay still moaning. But then all of a sudden he yelled and leapt up with such sudden force That we all were knocked loose. Dr. Dunn was knocked backward Over the foot of the bed and sprawled out on his back in the floor. His pullers were thrown from his hand and hit Jabaz in the stomach Which curled him double for a time. Johnny went leaping all round The room yelling continuously. The pain was so great he knew not What was going on? After a time or two around the bedroom he ran Through the kitchen still yelling every breath and blood flying From his mouth. This frightened Tulip [the cook] so bad that She took out of the kitchen and ran clear up into the rose garden [about where Volunteer Parkway now runs] before she came to her self. She left pudding boiling on the stove which was scorched so Badly it was lost. For this I chided her very much. Johnny jumped the back porch banisters and then ran around and around the yard still yelling like an Indian ready for battle. Both dogs got excited and joined the noise, which was so great that it was heard all the way to Perdue's [neighbors who lived perhaps a quarter of a mile away]. This alarmed them very much and they all came running very fast. Oh it was an awful time! When we finally caught Johnny we gave him an extra heavy dose of Dr. Scales Pain Killer [a liquid medicine, said to be over 80 percent alcohol, formulated by Dr. J. H. Scales, another local dentist]. He soon was asleep and is sleeping yet some seven hours later. Tulip is making more pudding which she hopes to give to him when he awakes. Word came back from town late today that Dr. Dunn has a very sore Back and his straddles were injured some by Johnny's leaping up. We paid him one dollar.

A hard-earned dollar, indeed! I would venture to say that neither the patient nor the dentist ever forgot the fearful experience. Poor Johnny did

not have long to remember. He died about two years later, just as he was preparing to enter King College, where he planned to study for the ministry. He is buried in an unmarked grave in East Hill Cemetery.

At the beginning of the 20th century at least two dentists who had been in Bristol since the 1870s were still practicing, Dr. Samuel W. Rhea and Dr. J. M. King. Dr. Rhea's office was then at 418 Main Street (soon to become State Street). He lived at 325 Sixth Street and had recently moved from 514 Fifth Street. Both houses were demolished long ago. Dr. King then had an office at 600 Main, probably in what was known as the Pile Building, and lived at 534 Alabama. When I lived at 518 Alabama, I used to pick pears from a tree in the backyard of his former home.

Four other dentists were practicing here by 1900. Dr. Charles G. Aven had set up at 500 State Street and lived at 500 Chalmers, a street that no longer exists. Dr. William S. Barker had an office at 21 Sixth Street and lived at 725 Maryland Avenue. He later moved to 801 Georgia Avenue. Dr. Hiram F. Henderson had an office at 422 State Street and lived at 1017 Anderson Street. Dr. Edward T. Jones had an office on the corner of State and Lee (likely the Susong Building) and lived at 308 Moore Street. A little later he built the house that yet stands at 238 Solar Street.

By 1905 Dr. T. McIntyre had set up a practice. He was then boarding at 502 Anderson Street but later lived in the house that yet stands at 1100 Holston Avenue.

A dentist with the unusual name of Blessing S. Brown had an office in the Interstate Building on Sixth Street by 1908. At first boarding with Mrs. H. O. Bunn at 126 Seventh Street, he remained in Bristol many years and long lived at 316 Maryland Avenue. Also by 1908, the Southern Dental Parlors had opened in the Cox-Butler building on Sixth Street. Operated by Dr. William G. Long, who then lived at 1019 Anderson Street, the rather pretentious dental parlor closed within two years, and Dr. Long moved his practice to 26½ Sixth Street.

Dr. George D. Smith, the first known black dentist, was also on the scene by 1908 with an office at 23½ Fifth Street. He lived at 421 Scott in a neighborhood that had both black and white residents. By 1913, he was no longer here, but another black dentist, Dr. Alfred W. White, had opened an office in the same location at 23½ Fifth Street. His home was then at 800 College Avenue. He later served a vital role in establishing Mercy Hospital for blacks. He had left the scene by the late 1940s.

A dental partnership known as Union Dentist and located at 414 State

A Good Place to Live

Street was operating in 1913. Consisting of Dr. John F. Givan, who lived at 1100 Holston Avenue, and Dr. John P. Bailey, who lived at 309 Fifth Street, the partnership lasted only a brief time.

The number of Bristol dentists held at about 12 for several years. By 1924 Dr. James King and Dr. Samuel W. Rhea were no longer practicing, after working for over 40 years. Dr. A. W. White remained as the only black dentist in the city. By 1927, he and his wife, Geurna B. White, lived at 827 Alabama Street, and Clarence A. Smythe had entered the local dental field. Bristol Dental Laboratories had opened at 10 Sixth Street by that year. There were still 12 dentists practicing in Bristol at that time, compared to 32 physicians.

In 1929 Bristol had 16 dentists, including Dr. William Whitsitt Hurt, who then had an office in the Union Trust Bank building at 310 State Street and lived at 315 Fifth Street. Folks made a little joke about Dr. Hurt's initials. Some said they meant *we won't hurt*, and others said they meant *we will hurt*.

The Bristol Dental Laboratories were still operating here by 1932, as well as Thompson Laboratories at 310 State Street.

In 1936 the number of Bristol dentists had risen to 17. Dr. John T. McIntyre had been joined by his son, John T. McIntyre, Jr. and they had offices at 11 Sixth Street. When I arrived in Bristol in 1953, about 20 dentists served the city. Dr. Douglas Riddle, a distant cousin of mine, was then located at 6 Sixth Street, and Dr. Vincent S. Tiller, who would later do much work for me, was at 510 Cumberland Street.

Dr. Jack Hyder, whom I never knew, but whose widow and son have been good friends of mine for years, was here in 1953. His widow, Jane Wood Hyder, is a great-niece of Capt. J. H. Wood, who built historic Pleasant Hill, my home in Bristol, Virginia. She told me that Dr. Hyder was the first person to die in an auto accident on the Volunteer Parkway. Their son Jack is well-known as City Attorney of Bristol, Tennessee.

In the latter half of the 20th century, a few dental specialists began to appear. One I have long valued as a friend, Dr. K. Dale McLaughlin, set up an orthodontic practice in the early 1970s at 512 Alabama Street.

By 1975 Bristol had about 30 dentists, a number that remained virtually unchanged to the end of the century. By then most of the names now familiar in dental circles were here.

Certainly there were and are many names in the dental profession worthy of inclusion in this writing, but space does not permit me to name them all. A list of them can be found in the city directories of the 20th century.

A GOOD PLACE TO LIVE

Medicine Makers

DRUG MANUFACTURING IN BRISTOL

Taking into consideration all the early Bristolians who concocted remedies made of herbs, barks, roots, etc., the number of medicine makers at the time would be great. Most of them remain obscure and unknown, but Pocahontas Hale reached such a volume of production and scope of distribution that she may rightfully be called a drug manufacturer.

She claimed that she learned the art of herbal medicines from her Indian grandmother, who reputedly applied her remedies to herself and lived to be 116 years old. Fortunately, Mrs. Hale could find all the raw materials needed for her nearly 100 remedies nearby, though some had to be brought in from far up on Holston Mountain.

At first, when she had a small operation, Mrs. Hale went out and gathered the materials herself. Later, when her volume of sales became great, she hired Jacob Weems, a black man, to collect the ingredients for her, after she first carefully instructed him in how to identify what she needed. Martha Jane Hart, a friend of mine, said that her grandmother often told her of Jacob's trips to her meadows along what is now King College Road, where she allowed him to take bags of queen of the meadow, a plant that supposedly cures many ailments.

Mrs. Hale, also the madam of the notorious Black Shawl, Bristol's largest house of prostitution, was nicknamed Old Pokey. She brewed up her medicines in a large kitchen/dining room area of the brothel, which stood on the lot now occupied by the Cameo Theatre. One of the frequent visitors at the Black Shawl told how the smells of the brewing operations were almost overwhelming as they wafted through the halls and rooms. More than one of Old

Pokey's "girls" left the place because they could no longer stand the constant saturation of fumes.

She often administered her own medicines, and her fame as an herb doctor and drug maker grew so widespread that by 1875 she was making far more money by selling her remedies than by operating the brothel. Folks near and far began calling her the Bristol Medicine Woman.

Word-of-mouth advertising—the only advertising she ever had—increased her sales, so she asked local druggist John G. Pepper to order her a great quantity of bottles, all the same size and style. She also ordered labels that said "Hale's Indian Remedies." At the bottom of each label, she hand printed which ailment the contents of each bottle was supposed to relieve or cure. My friend Virginia Caldwell owned one of these bottles, handed down to her from her grandfather David F. Bailey. She said he "swore by Old Pokey's remedies." The label bore the hand-printed words "stomach settler," and Mrs. Caldwell said her grandfather claimed the remedy was good for everything from heartburn to diarrhea.

One lady living in Bristol in 1953 was well convinced the stomach settler saved her life. When she was a child in the 1870s, many children died of acute dehydration caused by persistent diarrhea, an affliction sometimes called "summer complaint," as it often occurred during summer months. Some of the problem may have been caused by food poisoning. She "had it bad," as she told it, and Dr. M. M. Butler had tried various standard remedies but with no success. Finally, he sent for the stomach settler. It worked; she survived and lived to the age of 99!

Mrs. Hale, a realistic businessperson, well knew that many persons would not come to her brothel to buy her medicines. (I suspect that most women were reluctant to send their husbands there!) Dr. Pepper agreed to carry a line of her products in his drugstore. After his death, W. W. James offered to sell her products from his large store conveniently located on the corner of Main and Front (now State and the Randall Street Expressway).

Some of her customers came to Bristol by train, loaded up on the Indian remedies at James's store, and that same day returned to their distant homes. Mrs. Hale had no agents, but area merchants who heard of her seemingly efficacious remedies came to James's store, bought stock, and became the unofficial distributor for their widely scattered communities. Several doctors, including two from Bristol, did likewise. Knowing that some of their patients would have an aversion to taking medicine made by a madam, they removed her labels and dispensed the remedies without the patient's knowledge as to

who had made it. A few local drugstores also practiced the same "benevolent deception."

One of Mrs. Hale's most famous remedies was for tuberculosis—commonly called consumption at the time—a tragically common ailment in those days. Even local doctors were forced to admit that hers seemed to be the most effective remedy available locally. Many folks would swear that their lives had been saved by her elixer made up in the form of a bittersweet syrup. Another noted remedy of hers was for rheumatism, or "rheumatiz," as locals called it.

And, perhaps to aid her other business, she had what she called a sure-fire cure for impotence, commonly called "male weakness" in those days. Legend says that she kept some of this remedy handy for dosing shy men who came to her establishment. She also had a sure-fire cure for constipation, made from the juice of green apples, that she perhaps a bit facetiously labeled "Green Apple Two Step." I hear that expression yet used in this area to describe urgent trips to the bathroom.

One old fellow living two or three miles northwest of Bristol came to James's store one day and bought a bottle of the famous Green Apple Two Step remedy. James told him how much constituted an effective dose. But the man stated that he was "hard to work," so there in the store he took about a triple dose, then immediately left, walking toward home. Later he told James that though he had left the store about noon, it was dark before he got home, and that he had to "stay nigh the bushes all the way." From that experience he learned to keep within the prescribed dosage.

Mrs. Hale also had a supposed cure for skin cancer, in the form of an ooze, which the patient applied to the affected area. Some folks came from far away for treatment, and she became a familiar sight walking along the street to the Virginia House Hotel to administer the remedy to patients staying there. She claimed that a daily application of her concoction for two weeks would stop the progress of such cancers.

Patients said it burned like fire, and indeed it often disfigured their faces as if they had actually been burned. "Well," she would tell them, "that's better than dying."

Though far from being a religious person, Mrs. Hale would sometimes say, "I believe the good Lord has placed in the kingdom of nature a remedy for every disease of mankind. We have but to find them." She strongly believed that her grandmother had found them.

Whatever her remedies were, she jealously guarded their formulas. They existed only in her head, for she wrote nothing down. Some folks tried to

pry them from her, but their queries were always met with a stony silence. A local doctor or two offered to buy them from her. She would only reply that it would be a sin to sell them and they could only be passed on to someone who met certain requirements. Apparently, she found no one who could qualify.

For reasons of secrecy, she never let anyone help her brew up her remedies, nor would she allow anyone watch her work. When her medicines became well-known and much sought after, she spent all her waking hours to keep production equal to the need. Jacob Weems, who at first worked about one day per week, eventually had to work almost every day to supply the necessary raw materials. He later told Dad Thomas that his pay was free meals at the brothel and 50¢ per day. He also admitted that as a fringe benefit he got a free visit each week with "one of Old Pokey's girls."

Most everyone in the town said that Mrs. Hale "raked in piles of money" from both operations. She required payment in coins and maintained a small bank account, but according to banker John C. Anderson, her balance seldom reached more than 100 dollars.

She kept a big, black, vicious dog tied beside a dry cistern behind her brothel, and no one dared approach him. Some locals believed she had filled the cistern with her coins. But as soon as her business closed, fortune seekers flocked to the then-unguarded supposed treasure hole. When they found the cistern empty, some thought perhaps she had dropped her earnings down an unused chimney, but that proved to be only a rumor. Others thought she had buried the money in the lot back of the Black Shawl. After her death, the owner of that property excavated the lot, but no coins turned up.

Soon after her death, a man who weekly visited her brothel and was said to be her confidant suddenly became wealthy and built the finest home in his community. And he splurged on a lot of other things, such as a grand surrey. Then his neighbors remembered that he had always come to the Black Shawl in a one-horse wagon that stayed parked at the back door during the time he spent inside. Some theorized that in the darkness of the night—the town had no streetlights then—he loaded "bushels of money," which he took to his country place and secreted away. Perhaps Mrs. Hale had an agreement to share it with him, but she became sick and demented before her death. If the pair had made arrangements for a sharing plan, they never carried it out.

She died penniless, and her prized formulas are now dust in the Citizens Cemetery at the end of Piedmont Street. Because of Mrs. Hale's reputation, the governing board of East Hill Cemetery would not allow her to be buried there. Consequently, she was buried in the black Flat Hollow Cemetery at

Buckner and Oakview. Flat Hollow Cemetery was later moved to what is now the Citizens Cemetery. More than 50 years ago, Dad Thomas showed me her purported gravesite. Of course, no enduring headstone marks where Bristol's famous medicine maker now rests.

Dr. Scales Pain Reliever

Dr. J. H. Scales opened his Bristol dental practice in January 1873 in an office over the Bunting and Pepper Drug Store on the Tennessee side of Main (now State) Street. Dr. Scales thought the pain he had to inflict on his patients was distressing, which doubtless became the incentive behind his diligent search for a fast, effective pain reliever.

He rented a residence in the 800 block of Main (State) Street on the Tennessee side. Behind the house, as was common through the South at that time, was an old-fashioned detached kitchen complete with a large fireplace. The house also had an inside kitchen, leaving the outside kitchen an ideal place for his commercial pursuit.

Within a year or two, he was able to offer to the public Dr. Scales Pain Reliever. As had Pocahontas Hale, he asked Dr. J. G. Pepper to order bottles for him. I. C. Fowler of the *Bristol News* printed labels that included a guarantee of fast pain relief from any cause.

Dr. Scales Pain Reliever was very effective—almost too effective in some cases. Often those who took a liberal dose were sound asleep within minutes. Dr. Scales originally had thought he should administer the dose about one half hour before starting a dental procedure, but the first patient upon whom he tried it wound up asleep 15 minutes later, and Dr. Scales had to bring in a man from the street to help hold the patient's mouth open. He then decided to begin within five minutes after giving the pain reliever to the patient. He always sent each patient home with an extra dose or two to use when the effects of the first dose wore off.

Dr. Scales contacted area dentists and medical doctors and gave them free samples to prove the effectiveness of his product. In a short time, sales dramatically increased and he hired a local unemployed drummer (traveling salesman) to canvass the area for him.

No one disputed the effectiveness of Dr. Scales Pain Reliver. Soon folks in Bristol and throughout the area freely offered praises for it. Dr. Scales wrote up some of the testimonials and included them in a brochure, which he sent to prospective dealers and buyers.

At first, he "imported" much of his ingredients from an old fellow living

near the head of Sharp's Creek in the foothills of Holston Mountain. A little later, he reduced his imports to a few choice herbs from local farm suppliers. He supposedly swore a local tinner to Masonic secrecy, then had him build equipment so he could manufacture his own principal ingredient. After Dr. Scales moved his new machinery in, he closed and locked the window shutters and put a heavier lock on the door of his detached kitchen laboratory.

Joseph R. Anderson, Bristol's founder, had a touch of rheumatism, and his doctor instructed him to get a bottle of Dr. Scales Pain Reliever. After about three days of dosing, he felt like a new man. He was so pleased, he bought several bottles to sell in his store. They quickly sold, so he doubled his next purchase. The next time, he bought 100 bottles, which sold within three months.

Perhaps a year after Anderson started carrying Dr. Scales Pain Reliever, he suddenly destroyed all his stock and, with red face, ran an article in the local paper trying desperately to make an explanation and an apology.

On that day, in the 800 block of Main, passersby noticed smoke rolling from under the eaves of the detached kitchen where Dr. Scales had his laboratory. As usual, the first thought was to carry out what furnishings they could before the fire consumed everything. They found the door locked, but they battered it down with an improvised ram and rushed in to do their neighborly duty. One of the group ran uptown to bear the sad news to the good doctor. He came running too, but not before the men had carried a copper still and two barrels of fermenting mesh from the burning building.

The secret was out. Dr. Scales Pain Reliever was almost pure whiskey, and he had found some way to change both the smell and taste. No wonder patients had fallen asleep in his dental chair!

Anderson, a strong temperance advocate, led the anti-liquor forces in Bristol. Indeed, he was a driving force behind the local chapter of the Sons of Temperance. One may imagine his consternation when word reached him that afternoon that for over a year he had been a liquor merchant. He had not only sold it, he had consumed a considerable amount of it himself. In less than an hour, all his stock and been removed, the contents poured on the ground at the back of his store, and the bottles thrown into an old dry well just across the tracks.

Not only was Anderson scandalized, but all over town there were saintly old sisters, and maybe a few brothers, aghast and horrified to learn they had been imbibing the "devil's brew." And many of them had bought it at Anderson's store.

The fire ended the flourishing medicine maker's career. With his credibility ruined, Dr. Scales did not long tarry in Bristol, but the citizens never forgot him. One of Joseph Anderson's granddaughters detailed the story for me, adding that her grandfather had dark brooding spells over the matter for as long as he lived.

HAGAN, WOOD, AND NICKELS

About 1889 Charles F. Hagan and Jonathan Logan Wood founded a drug manufacturing company in Bristol known as Hagan and Wood. The chief product of their small operation, located at 515 Cumberland Street, seems to have been a general strength-building agent called Bloodroot Body Tonic. An old-timer told me an old Indian woman who supposedly got the formula from her ancestors "brewed up" the tonic for Hagan and Wood.

The company did not long exist, and Wood later founded the Wood Drug Company with G. Emmit Nickels. Both men descended from pioneer families of Scott County, Virginia. Wood's ancestors, generally known as the "Big Moccasin set," go back to Jonathan Wood, a Revolutionary War soldier who early settled on Big Moccasin Creek. (Capt. J. H. Wood, who built my house, also descended from Johathan Wood.) Nickels came from the family for whom Nickelsville, Virginia, is named. He and his wife, Myrtle, lived at 49 Taylor Street, and Wood and his wife, Bertie, lived at 717 Maryland Avenue.

By the mid-1890s Wood Drug Company was operating in the same building as did Hagan and Wood at 515 Cumberland Street. Among other medicines, the company produced a general tonic—likely a carryover from Hagan and Wood—guaranteed to build up the system and soothe frayed nerves. Another remedy was called Wood's Female Medicine.

Besides their own products, the company apparently distributed for another drug firm or two. Much of the medicine sold was under the label of a Dr. J. L. Sparks, such as Dr. Sparks Soothing Syrup, Dr. Sparks Nerve and Bone Liniment, Dr. Sparks Tasteless Chill Cure, and Dr. Sparks Eye Water. Wood Drug Company also sold Farrar's Sarsaparilla.

Ernest L. Andrews bought the drug business, and by 1901, Wood had moved to Greeneville, Tennessee, where he founded the Farmer's Protective Union Store in 1895 with his brother-in-law Emmit Nickels.

Wood soon (possibly 1904) returned to Bristol and formed the Wood Food Company with his brother, Patrick H. Wood. The company was more than a food supplier, it also made and sold medicine and possibly handled medicine from other makers. Located at 712-714 Shelby Street, it operated

for perhaps five years. In 1905 J. Logan Wood lived at 820 Moore Street.

Later Wood and his former partner, Nickels, joined together in the Globe Nurseries Company. By 1918, they opened the Wood-Nickels Company, a dry goods store at 506-510 State Street. Not one to give up, J. Logan Wood again entered the patent medicine business in the 1920s, this time with the New Era Company, another short-lived venture.

Wood lived in two different houses in the 700 block of Maryland Avenue, one of which was 719. At the time of his death, February 9, 1942, he resided in Alexandria, North Carolina. According to his obituary, he was born in Scott County, Virginia, on May 22, 1876, a son of Jonathan and Caroline Gray Wood. He married his first wife, Margaret Alberta Childers, on June 14, 1893. Their surviving children were J. Logan Wood, Jr., Mrs. Cecil Davis, John W. Wood (Johnson City), Dr. Hagan E. Wood (Black Mountain, North Carolina), and Mrs. D. Grant Webb (Abingdon).

Wood's near-constant partner, Nickels, founded the Nickels Manufacturing Company and was also a vice president of the Bank of Bristol. About 1915, he built the house that yet stands at 401 Pennsylvania Avenue. Before his death, however, he moved to 719 Seventh Avenue.

Both men did well in Bristol but not in medicine.

THE CIN-CO-LERY CHEMICAL COMPANY

The Cin-Co-Lery Chemical Company was another patent-medicine producer that sprang up here in the mid-1890s. (I have not been able to determine how the company's unusual name came about.) It was established by Charles F. Hagan, whose father, Patrick, among many other notable attainments, founded the Town of Dungannon in Scott County, Virginia, and also was one of the founders of Bank of Bristol in Bristol, Tennessee.

In addition to running his company, Charles Hagan was manager of the U.S. Bureau of Law and Collections in 1896. At that time, he was unmarried and boarding at the Hamilton House Hotel on Front Street.

The company's principal product was the Cin-Co-Lery Compound. Each bottle was contained in a separate box that had a picture of Hagan on the side. A description of the product on each box read, "A tried and true tonic for the brain, nerves, muscles, and blood. Renews vitality. Prepared by Cin-Co-Lery Company—Sole Proprietors—Bristol, Tn./Va.-USA—price $1.00."

Hagan employed agents who canvassed the Southern United States. I have seen some of their correspondence from such places as Six Mile, Alabama; Lock Key, Kentucky; Princeton, West Virginia; Lavonia, Georgia; Whitley,

Milton, and Lawley, Florida; Lodi, Texas; Hobbs, Virginia; Marlinton, Tennessee; Middlesboro, Kentucky; and Goodwater and Jones Mill, Alabama.

The expense account for one of the agents, Chambers Devault, who lived with his wife, Laura, at 498 Rose Street, reflects the low cost of travel and lodging in those days. His first week's expenses amounted to $13.00, the second week totaled $9.35, and the third totaled $8.35. He did mention that the merchants to whom he made sales sometimes offered free lodging.

James Kennedy, another agent, in a letter dated April 5, 1898, on stationery from the Hotel Hull at Beckley, West Virginia, writes of a sale to J. B. Bushkirk amounting to $7.00. Another agent wrote that during the previous week he had made no sales because high water from flooding had kept him from traveling to rural stores. He lamented the fact that even though he had made no sales, he had expenses of $8.75.

The practice seems to have been for the salesmen to take orders and forward them to Hagan in Bristol. He in turn would ship the product on consignment and collect when the merchant sold the medicine. Collections, however, often proved difficult. Many merchants complained of and took credit for breakage in shipment. Records show that Hagan turned some accounts over to collection agencies or lawyers who lived near the defaulting merchants.

The wholesale price for the medicine was $8.00 per dozen. Selling at $1.00 per bottle, the merchant would make $4.00 per dozen. Some merchants complained that they could not sell any of it and shipped it back to Bristol. To say the least, it was not a very profitable business for anyone.

Though the business continued for a few years, Hagan turned to other enterprises for better and more certain income. At the beginning of the 20th century, he was operating a coal yard on Scott Street between Johnson and Moore. Coal came from his father's numerous mines in Wise County, Virginia.

In 1908, Hagan acted as president of the Bank of Bristol in the stead of his father, who was the actual president. About 1911, he became trustee of all his father's numerous land and business holdings.

He married Custis Lee Jett, daughter of John W. Jett, and moved into her home at 213 Solar Street, where he lived the rest of his life. Many of my readers will remember his son Hugh Hagan, who was active in civic affairs.

DR. YI'S CHEMICAL COMPANY

Toward the end of the 19th century in Bristol, Dr. Yi's Chemical Company made a treatment for hogs and fowls called the Great German Hog Cholera Cure. This company was possibly taken over by or became the Ger-

man Manufacturing Company and later became part of Charles F. Hagan's Cin-Co-Lery Company.

I discovered an old bit of correspondence dated 1898 to Hagan from an irate Florida merchant stating that the cure was absolutely worthless and he wanted to be relieved of paying for it. I could find no other records on the purported cholera remedy.

One old-timer remembered that Dr. Yi operated from a small room in the back of the Carter building that yet stands on the northeast corner of State and Moore. Apparently he had no family and slept in the same room and ate in nearby cafes. My informant did not know where he came from nor where he went when he left Bristol.

THE ANDREWS MANUFACTURING COMPANY

Possibly because of the chain of events that brought me to Bristol, I am always fascinated to read of others who came here because of unusual circumstances, such as Ernest Linwood Andrews. He arrived in this area literally fleeing for his life. Born near Smithfield, Virginia, a son of Jack and Emma Glover Andrews, he was orphaned at the age of five. An uncle took him to Memphis, Tennessee, and raised him there. During a widespread yellow fever epidemic in 1878, Andrews came to East Tennessee, where he soon found work in Union (now Bluff City) with the L. Gerstle Company.

Leopold G. Gerstle had come from Chattanooga to Union in 1870 and established a drug manufacturing business. In 1888 he moved back to Chattanooga and founded the Gerstle Medicine Company, makers of St. Joseph aspirin.

Young Andrews continued to work for Gerstle until 1889, then moved to Bristol, where he bought the stock of the Wood Drug Company. He soon established his own thriving drug business, at one point operating from 710 Main (State) Street. By the beginning of the 20th century, he had moved production to 515 Cumberland, the former location of the Wood Drug Company.

When Andrews arrived here he was unmarried and lived for a while in a boarding house at the corner of Sixth and Shelby. On December 21, 1898, he married Lola Mae Steele of Tazewell, Virginia. He met her while visiting in her father's home during a drug-selling trip through Tazewell County. The couple were instantly smitten with each other, and marriage soon followed. By 1901, they had established their home at 536 Sixth Street. About 1906-07 they moved to the house that yet stands at 529 Taylor Street.

The Andrews Manufacturing Company remained at 515 Cumberland

E. L. Andrews, a prominent Bristol drug manufacturer, long lived in this house that yet stands at 529 Taylor Street, Bristol, Tennessee.

until moving to 119-123 Virginia Street about 1909. The business remained there until it closed during the Great Depression. By 1934 Andrews had opened the E. L. Andrews Sales Agency.

Of the several drug-manufacturing companies that operated in Bristol, his appears to be the most successful, with the exception of the S. E. Massengill Company. His products—many of them preceded by the words "St. Andrew's"—included, among others, Black Devil Pills, Rub-on-Oil, Quick Liver Pills, Chill Killer, Nerve Builder, Sarsaparilla, Wine of Life Root, Cold Tea, Sure Shot Vermifuge, and Winolro Medicine for Women.

Andrews served as a town alderman for several years, as well as on the local school board. He was long a steward in the State Street Methodist Church and attained high degrees in the Masonic order. In 1935, as he entered a taxicab in the driveway of his home, he was apparently stricken by a massive stroke or heart attack and suddenly died.

JOHN R. DICKEY—MANUFACTURING DRUGGIST

John R. Dickey, a native of Peach Bottoms in Grayson County, Virginia, came to Bristol in the early 1870s and worked in a drugstore. Dr. J. F. Hicks, a prominent local physician, gave him an original formula for a new type of eyewash and urged him to become a drug manufacturer.

A Good Place to Live

Young Dickey made up a batch of the product, bottled it, and was delighted that it quickly sold to the local trade. His success put a passion in him to produce patent medicines, so beginning in the late 1870s he added more formulas (many from Dr. Hicks) and continued in the drug manufacturing business for as long as he lived.

W. W. James gave Dickey his first big boost. W. W. James's store on the northwest corner of Front and Main (now Randall Street Expressway and State) was a flourishing outlet for patent medicines. Though the establishment was not a drugstore, James carried more medicines than did some of the regular local druggists.

One reason he could turn such a large stock of medicines was because of his location so close to the depot. No through trains ran on the rail lines serving Bristol at the time, and passengers had a long enough stop to shop in nearby stores. Many tired, sleep-weary passengers came to James's store and often bought medicines there.

When James heard of Dickey's Old Reliable Eye Wash for dry, sore, and aching eyes, he invited Dickey to leave a generous supply in his store. It caught on like wildfire as satisfied customers spread the news far and near. Inquires soon came in from an ever-widening area.

Years later, Dickey told of how one of his first inquires came from a backwoods merchant in Hamblin County, Tennessee. The retailer had heard of the remedy through a man who lived in his community and had bought a bottle when traveling through Bristol. The merchant simply addressed his letter to "Eye Wash Man, Bristol, Virginia." Over the years, the storekeeper sold hundreds of bottles of Old Reliable Eye Wash and other Dickey products.

James not only gave Dickey a big boost in starting a successful patent-medicine venture, he also "gave" him a wife. Early in their association, James took the young druggist home with him to talk business while enjoying the noon meal. There Dickey met his host's daughter Sarah. The couple later acknowledged that it was mutual love at first sight, and they married in the James home (then located on James Street) on Tuesday, April 5, 1881. (The bride's sister, Laura Lucretia James Wood, was grand dame of Pleasant Hill, my home in Bristol, Virginia.)

Sarah, a rather talented person, designed most of the labels and bottle inscriptions used on the Dickey products. She also handled most of the correspondence and billing for her husband's drug business, and she continued to do so even after J. S. Livesay became secretary-treasurer of the firm. In the late 1890s the business was located at 10 Front Street.

By the end of the century, Dickey had obtained the former James property at the corner of Front and Main (State). His prosperity had reached the point where he was able to erect a handsome four-story hotel directly on the corner. First known as the Tip Top, and later as the Travelers, it was called the Colonial when I arrived in 1953. The building has been replaced by a parking lot.

He erected another two-story building immediately north of the hotel on Front Street. Rooms upstairs in the building (8½ Front Street) housed the Dickey Drug Company for the next 60 years or so.

After his first wife died, Dickey married Julia Hoffman, a music teacher at Virginia Intermont College. As president of the board of trustees of the Baptist women's college for 29 years, he had helped interview her for the job. (His daughter-in-law told me that even as he interviewed her, he secretly determined that someday he would marry her. In a short time, that determination was realized.)

Around 1890 Dickey built an elegant, late-Victorian-style house at 101 Main (State) Street, directly in front of the First Baptist Church. He resided there until his death on October 12, 1923, from injuries received when he fell off a horse. One of the most prominent Baptist layman in Virginia, he was active in the First Baptist Church, and his funeral took the place of a morning service, an act seldom done for anyone. He and his two wives are buried in East Hill Cemetery.

His death did not end the Dickey Drug Company. Two of his sons, Ernest H. Dickey and John R. Dickey, Jr. ran the company for a few years. Then John left to become president and manager of the Watauga Sand Company, and another brother, Herman, joined Ernest. For a brief period, John B. Baumgardner managed the company for the Dickeys. Then Ernest and Herman took over again and ran it until Ernest became the sole manager and operator sometime around 1963.

Ernest and his wife, Dorothy, lived on Prospect Avenue. John and his wife, Maude, long lived at 815 Moore Street. Herman and his wife, Evelyn, lived at the end of Portsmouth Avenue, where they had a Guernsey dairy operation. He last lived at 100 Front Street in downtown Bristol.

Stella Dickey, one of John R. Dickey's three daughters, married Joseph Connelly, an insurance man who had offices in the Dickey building at 8½ Front Street. Connelly built their home at 516 Spruce Street about 1909. The couple both soon died of tuberculosis. Their son, Henry D., moved around, living with his aunts and a good deal with his grandfather Dickey. When I

came to Bristol, he was running a thriving gas station on the corner of State and Washington. For a few years, possibly 1957 through 1963, he joined his uncles in the Dickey Drug Company.

Another of Dickey's daughters, Florence, married Joseph M. McQueen. Their daughter, Dorothy, married Howard Barger, a highly valued and often used informant of mine.

Dickey had another son, Carl, who lived in Florida, and another daughter (name unknown to me). She married an upstate Virginia gentleman who had a military school.

Besides Old Reliable Eye Wash (renamed Old Reliable Eye Water in 1906 because of changes to the formula required by the Food and Drugs Act), other products made by the Dickey Drug Company included Southern Liver Regulator, Old Reliable Salve, Indian Blood and Liver Pills, Arabian Horse and Cattle Powders, Tasteless Chill Cure, Eureka Vermifuge, Blood Cure, Magic Nervine, Cough Drops, and flavoring extracts. During the Great Depression, several products proved unprofitable and were dropped. The eyewash held on longer than any of the others.

About 1985, Ernest H. Dickey's widow, Dorothy Douglas Dickey, told me she had continued to make and sell the eyewash until shortly before that time, meaning that one of the earliest Dickey products had been made for over 100 years. I am indebted to her for much of the information I have shared here. I have been fortunate to have known so many older citizens who kindly and generously shared information with me. You who read this book are greatly benefited by what they shared.

MYSTIC WINE OF LIFE COMPANY

In 1907, five local businessmen, ecncouraged by the profits being made in the patent medicine business, formed a company with the unusual name of Mystic Wine of Life Company. President of the company, Michael D. Andes, whose old home is now the New Hope Bed and Breakfast at 822 Georgia Avenue, operated the Spot Cash Grocery Store at 20 Lee Street. The vice president of the firm, W. P. Reeves of the Lockett-Reeves Company, then lived at 312 Woodlawn Avenue. Charles M. McAfee, then boarding at 504 Sixth Street, was secretary-treasurer. G. T. Brown, the in-house manager, was then boarding at 504 Sixth. J. M. Scott, a real-estate dealer, served as a member of the board.

Opening on January 1, 1908, at 510 Shelby Street, the company employed seven salesmen to canvass most of the Southern states. Their efforts were

apparently well directed. Within three years, the Mystic Wine of Life Company had sales of around $40,000 per year.

Five years after opening, McAfee had become president and E. P. Scott served as vice president. H. B. Wexler had joined the company as second vice president. At the end of another five years, the company had moved to 720 Shelby and had become totally under the control of the Scott family. John E. Scott, who lived at 616 Alabama Street, served as president at that time. The company's final location was 315 Eighth Street.

Products offered under the Mystic Wine of Life brand included Liver Regulator, Cough Syrup, Worm Confections, Antiseptic Healing Oil, White Camphor Liniment, Blood and Liver Pink Pills, and Neuralgia and Headache Tablets. The company had ceased to exist by 1925.

THE S. E. MASSENGILL COMPANY

Without a doubt, the S. E. Massengill Company (now King Pharmaceuticals) has become the largest of all the many medicine makers that have existed in Bristol. Dr. Samuel Evan Massengill, a native of Sullivan County, Tennessee (Blountville area), and a son of a country physician, started the company in 1897 in a small downtown building at 20 Fourth Street. At first, the firm was a wholesale outlet for the Arthur J. Connor Company of Boston, Massachusetts.

By 1901, Norman Massengill, a brother of the founder, had joined the company and the name had changed to Massengill Brothers. The brothers, who lived together at 1205 Anderson Street, soon bought equipment and began manufacturing their own drugs.

Samuel Massengill, one of those individuals who dared to think big, early sought to enlarge his scope of sales by sending more and more salesmen to an ever-widening area. His effort brought success. Needing larger quarters, the company moved to the old YMCA building at 22-24 Fifth Street, perhaps after briefly locating at 20 Fifth Street.

By 1908, Samuel lived at 913 Hill Street and Norman lived nearby at 900 Hill Street in a small but very ornate late-Victorian house that no longer exists. Within two years, the plant had moved to the old Reynolds Tobacco building at 39 Fourth Street, Samuel had built the imposing house that yet stands at 920 Holston Avenue, and Norman was living at 400 Mary Street. He later moved to 500 Maryland Avenue. At some point, Norman dropped out of the firm, and around 1917, Samuel moved the factory to its final location on the old King College property on Fifth Street.

In 1924, Norman was serving Bristol, Tennessee, as tax collector, as well as the commissioner of finance and collector of water rents. By 1927, he had died. His widow, Eula, still lived at 500 Maryland Avenue when I arrived in Bristol in 1953. Norman and Eula were the grandparents of my good friend David Massengill, noted singer and songwriter of New York City.

In 1953, the S. E. Massengill Company had become a giant in the drug-manufacturing field. The plant employed several hundred people and had been greatly enlarged. Branch outlets had been opened in Kansas City, New York, and San Francisco. It had become a great example of what someone who thinks big can do.

Beecham Laboratories later bought the company and moved it out of the country. In January 1994, the Gregory family bought the building and began operating King Pharmaceuticals.

POWELL BOTANIC COMPANY

The Powell Botanic Company was founded by Joseph Powell. Those who knew him said he was the best judge of medicinal roots, herbs, barks, seeds, and flowers in all the Southern states and that he could tell by sight, smell, or taste over 200 different varieties of crude drugs. His business opened at 25 Fourth Street on February 2, 1902. At that time, he lived on Sycamore near West Street.

Powell spent much time in the fields and woods around Bristol, searching for beneficial plants and such. On the darker side, his visits to the nearby woods caused him to be "used" as evidence in a divorce case. A man living near Bristol charged that his wife was spending long hours in the woods with Powell, ostensibly to learn how to identify plants that were good for certain ailments, but the suspicious husband thought otherwise. The judge denied the divorce, ruling that the husband had not presented concrete evidence.

Powell's business soon folded, and he went to work for David Blustein and Brother. The Jewish firm, located at 13-17 Ninth Street, dealt in junk, hides, wood, etc. Powell never gave up his vision of a flourishing patent medicine business, however, and in 1910 reopened at 19 Fourth. By that time, he had moved to 103 Maryland Avenue. But again, his hopes were crushed. Within a short time, his name disappears from available records.

OTHER MEDICINE MAKERS

Early in the 20th century, Linwood Drug Company, a division of the E. L. Andrews Manufacturing Company, operated in Bristol, but the company

does not appear to have lasted long. Strother Drug Company at 614-616 State Street was a wholesale outlet for a company in Lynchburg.

Turner Drug Company, which in 1908 was located at 627 State Street, was founded by George M. Turner. Near the end of its existence (around 1924), it was located at 643 State. In the early 1920s a division known as the Turner Chemical Company was located at 16 Seventh Street. One well-known product of this company was Turner's Penetrating Balm. Turner and his wife, Mamie, long lived at 802 Windsor Avenue.

The Bristol Drug Manufacturing Company was operating here by 1909 as a part of the Lockett-Reeves Company, Wholesalers. It later became the Bristol Drug and Gum Corporation. The Southwestern Crude Drug Company was situated at the Lockett-Reeves building on the corner of Scott and Moore, with W. J. Craven as its president and treasurer. Around 1922 the Puri-Tone Medicine Company was in business here for a very short time. And around 1923 a medicine company by the name of Nervec was located on Moore Street.

Sometimes proprietors of drugstores concocted medicines of their own—often just one product—such as W. C. Reser's Red Cherry Expectorant. His son, Clyde, told me that the only equipment required to manufacture this medicine was a dishpan and a stirring spoon. He remembered helping his father stir up and bottle this medicine.

Great efforts were made to turn Bristol into a drug-manufacturing center, as evidenced by the number of drug companies listed here—and there are several I have not mentioned. Yet of all those named, only S. E. Massengill Company survives, having descended to King Pharmaceuticals.

And what did the medicine makers do with their money? Of course, they spent it in numerous ways and for many and varied purposes. Around the end of the 19th century and the opening years of the 20th, stories of the pleasant and healthful climate in southern Florida began to flood into Bristol. The information came in printed publications and from those who had visited or were living there.

Several Bristolians, including John R. Dickey, began explorations of the purported tropical paradise. Some of them bought land in interior regions of southern Florida, while others preferred the coast. Dickey went a little further and found an island, Captiva, off the coast near the city of Ft. Meyers, where he bought a long stretch of beach (one report says a quarter of a mile, another says a half) and built a vacation cottage. This little Gulf playground, which served the Dickey family for perhaps 80 years, was where Ernest H. Dickey was fatally stricken with a heart attack on Easter Sunday morning 1968.

Henry D. Connely told me many interesting stories of time spent at his grandfather's place on Captiva Island. He remembered one time when the food supply boat failed to arrive. The Dickey family had a small barrel of grits in the pantry, and they survived on grits and fish until the supply boat finally arrived. Connely was never fond of grits for as long as he lived. "Got burnt out on them at Captiva," he would say.

Drugstores

Medicine makers need distribution for their products, and Bristol has never been without a drugstore since Dr. Richard M. Coleman opened the town's first pharmacy in 1855. He began on the southeast corner of Fifth and Main (State) in a small brick building that belonged to Joseph R. Anderson, founder of the city.

As the population of the city increased, so did the number of drugstores. All available information indicates that most of them were well patronized. Then, as now, folks sought health in a bottle. There is a common misconception among people today that early drugstores dealt only in medicines. This is far from the truth. Old ads show that pharmacies offered far more than medicines. Many of them sold paint and other materials one would normally expect to find in building-supply outlets.

Bristol began the 20th century with several flourishing drugstores, including Bunting & Son at 418-420 State Street. Established in 1869 by Jeremiah Bunting, it was sold in 1909 by Lindsay Bunting (the son) to Joseph W. Jones and J. Ernest Long, but the firm kept the Bunting name through a great part of the century.

Lindsay Bunting lived in 1901 with his widowed mother, Mary, in the family home at 308 Moore Street, a house where Bristol's first druggist, Dr. Richard M. Coleman once lived. The house had been built for Madison Jones by local carpenter G. W. Blackley. Over the years, a persistent myth developed that the house was the Bristol home of Col. John Mosby, but myth it is.

Also in 1901, W. C. Reser was boarding in the Bunting home while clerking in Bunting's drugstore. He had recently arrived from Greene County, Tennessee, and would play an important role in Bristol's drug business for several years. Nearby at 427 Mary Street lived Newton Colbert, another Bunting clerk who later joined Reser in opening a store of their own.

Minor's Drug Store opened in 1888 on the southeast corner of Main and Fifth, the same location as Bristol's first pharmacy. The proprietor, C. C. Minor, lived at 522 Lee Street. The Minor family early settled in the new

Bunting's drugstore became a Bristol institution. It long operated at 422 State Street in Bristol, Tennessee. This interior shot was made in the 1930s.

Town of Bristol, where they prospered. Minor's sister Nanie J. Robertson built the oldest part (south side) of the present Troutdale Restaurant building about 1870. Henrietta, another sister, married George N. Colbert (parents of Bunting's clerk Newton Colbert).

Minor's Drug Store operated for about 101 years. By 1923 it had moved to 600 State Street and was there for many years, until moving to 8 Sixth, its location when it closed. Rives Walker, who had formerly owned his own drugstore, clerked for Minor in 1901. His home still stands at 208 Johnson Street.

Another drugstore here at the beginning of the century was the Fowler Drug Company, owned and operated by Martin L. Fowler at 520 Main Street. There is some indication that the firm had its origin before 1900, possibly around 1898, but it soon closed. In 1905, Fowler became deputy commissioner of revenue and was managing the Harmeling Opera House. After moving from 518 Fifth Street, he lived at 217 Johnson, almost directly across the street from where I now live.

The only pharmacy operating at the beginning of the century that did not bear a person's name was City Drug Store at 537 Main Street. The proprietor, Benjamin C. Cochran, then lived at 625 Highland Avenue. A few years before, he lived at Pleasant Hill, my present home. He did not own it but rented from Capt. J. H. Wood, who had just erected the house at 208 Johnson and was living there with his new bride (second wife). By 1905, Cochran was in the iron business.

Around 1903-04, Newton M. Colbert and W. C. Reser formed the short-lived firm of Colbert and Reser, Druggists. After their partnership dissolved, Colbert opened his own drugstore at the corner of Moore and State (Carter Building). By 1905 Reser had joined with I. B. Cowan in the firm of Reser and Cowan at Sixth and State. At the time, Reser was still boarding in the Bunting home on Moore Street, and Cowan lived at 1003 Anderson Street.

By 1908, Benjamin C. Cochran was back in business at 424 State, Minor's old stand, while Minor had moved to 413 State. George M. Turner, who lived at 300 Eighth, had set up at 627 State. Newton M. Colbert was in Reser and Cowan's old stand on the corner of Sixth and State.

W. C. Reser had formed the Owl Drug Company at 601 State Street with himself as president, Lindsay Bunting as vice president, and Benjamin C. Cochran as secretary. Cochran had moved to 224 Johnson. Reser's son Clyde told me how the firm's strange name came to be. In those days, many downtown businesses stayed open late, but this pharmacy stayed open later than

most. Usually a group of local men came to loaf about the store and perhaps play a game of cards and so on. H. E. Jones, a prominent local businessman, was often among the late-night visitors. When a discussion arose as to what the new store should be called, he suggested that since it kept such late hours, the name *owl* would be fitting. The name stuck.

By 1908, W. C. Reser had married Viola King of Bluff City. When the couple planned marriage, they did not have a suitable location for the ceremony. Viola's cousin E. W. King had a new house (now owned by the Bristol Historical Association) on the corner of Anderson and Seventh, and he offered the use of his grand parlor for the occasion. The couple were married standing before the mantel in that parlor.

They first made their home at 910 Hill Street. There is some indication that the number was later changed to 904 Hill; if so, the house still stands. When I came to Bristol, the local Salvation Army's Maj. Raymond Hoekstra owned the house at 904 Hill, and it was occupied by Capt. and Mrs. Elbert Steadham, commanders of the Salvation Army. Clyde Reser told me that this was the house where his parents first lived and where he was born. W. C. Reser later built the two-story house at 1108 Holston Avenue at a cost of $5,000.

Drugstores were important to health care in Bristol. Shown here is the interior of the Owl Drug Store, long operated by W. C. Reser.

A Good Place to Live

By 1910 Joseph W. Jones, co-owner of Bunting's Drug Store, had joined with Lindsay Bunting to form Jones Pharmacy. Locating at 14 Sixth Street, they apparently hoped to gain some of the trade along rather busy Sixth Street. I could find no indication that the firm long endured.

Three years later, Tom Hammer opened Hammer's Drug Store at 424 State. He then lived at 718 Pennsylvania Avenue. By 1918, Hammer's stand was occupied by the Paramount Drug Store, a corporation formed by Charles F. Cowan (president of the firm), Gordon A. Montgomery (vice president and manager), and Taylor O. Cowan (secretary and treasurer).

The prosperity of the 1920s brought in a few more drugstores. Cowan's, at 533 State, was likely owned by one of Moses Rutledge Cowan's sons. The store seems to have been under the management of E. H. Cohen. About 1922, Smith's Drug Store opened at 724 State Street.

It was also during this period that G. A. Montgomery set up the State Line Drug Company at 409 State Street. He and his wife, Janette, a sister of the Cowan brothers, lived at 317 Ash Street. In later years, she ran a dancing school in her home at 512 Pennsylvania Avenue, which was the former Huling home built by Charles Huling, a partner in the Stone-Huling Lumber Company.

Ellis R. Umberger also opened his drug business during this period. Located at 720-724 State Street, Umberger's Drug Store featured a sandwich bar and soda fountain. He had three daughters by his first marriage, and one or more of them helped run the business. He was not a pharmacist, but he hired one to take care of his prescription business.

Umberger took 35-year-old Irene Stokley as his second wife. She had begun working as bookkeeper for Bunting's drugstore in 1913 and remained there until retiring in 1963 after 50 years of service. For many years, the Umbergers lived at 930 Windsor Avenue. After he died, his widow had a house built at 721 Fifth Street.

Even during the darkest days of the Great Depression, new drugstores opened in Bristol. The Arcade Drug Store, located in the Reynolds Building, 510 Cumberland Street, was here by 1932. It was owned by James A. and Mary L. Crockett, who then lived at 518 Lee Street. Charles A. Greever was in some way associated with this firm. He then lived at 611 Park Street.

Bradley's Drug Store, a long-lasting firm, was also open by 1932, at 533 State. The proprietor, Thomas W. Bradley, may have first lived upstairs over the store. He and his family later lived at 820 Euclid Avenue.

The General Shelby Pharmacy, which also opened during the height of the Great Depression, was located in the General Shelby Hotel at 100 Front

Street. In 1932, it was operated by James M. Rayburn of Glade Spring, Virginia. Another long-lasting firm that opened during that time was People's Service Drug Store, Incorporated, at 643 State. It was managed by Earl C. Caudle, who lived with his wife, Ella, at 1012 Fairmount.

A little later Hawley's Drug Store opened at 22 Sixth Street. Owned by Irvine C. and Kate A. Hawley, who then lived at 400 Carolina Avenue, the firm did not long operate. Hawley then worked for Minor's Drug Store, and his wife had become the home service secretary for the Bristol chapter of the American Red Cross.

By 1934, J. Gaines Thomas, who then lived at 1238 Windsor Avenue, had opened Thomas Drug Store at 1618 West State Street. The business is the first drugstore of which I have record that was located outside of a three- or four-block downtown area.

In 1936, the Bristol Drug Corporation store was flourishing at 633 State Street and even had a food department. Marvin Rock was its president, while Zenas W. Wheeler was vice president. D. Wayne Fuller was secretary and treasurer. Rock then lived at 1723 Windsor Avenue, Wheeler's home was at 618 Locust, and Fuller lived at 502 Sixth.

Several informants have told me of a doctor who had opened his office at 5 Fifth Street by the mid-1930s. He was a drugless physician—that is, he wrote no prescriptions. His methods of treatment used no drugs whatsoever. The drugstores made no profit from him!

The City Drug Corporation was in operation by 1940 on the southeast corner of Piedmont and Cumberland. The company seems to have been of short duration. Sydney G. Vaught, who then, along with his wife, Sallie, lived at 1022 Euclid Avenue, was president. Cecil G. Watson, vice president of the firm, also managed the Colonial Confectionary at Front and State. He and his wife, Mary, lived at 614 Pearl Street.

The makeup of Bristol's drugstores saw little change throughout the 1940s. But one large drugstore, Cole's, did set up by 1948, taking over Minor's stand at 600 State Street. Minor had moved his store to 8 Sixth, where it remained as long as it existed.

The Owl Drug Store, under the management of W. C. Reser's widow and other members of the family, operated to around 1950.

LATER DRUGSTORES

Upon my arrival to Bristol in 1953, I settled into the local YMCA and was told I could buy two hot dogs and a soft drink at Bunting's lunch counter

for 25¢—very good news for a young man whose entire fortune consisted of a little over $30. Soon I found living quarters and learned that Umberger's, People's, Bristol Drug Corporation, Bradley's, Minor's, and Cole's were all within two or three blocks of my new home.

Bunting's had become a Bristol institution and was doing a flourishing drug business along with many offerings in cosmetics and notions. Its lunch counter was heavily patronized. I well recall patrons eating from tables that were actually miniature showcases displaying articles of merchandise right under where their food and drink sat.

Since becoming the city historian, people have often asked me why our early drugstores moved about so much. Clyde Reser explained to me that local landlords felt drugstores made choice tenants, so they offered enticing concessions to firms that would move into their buildings. He recalled that a landlord once gave his father three months free rent in order to get him to move.

Through the 1950s and '60s, a few new names began to appear in the drug field here: Bullock's, Clark and Palin, Dunn's, Todd Armistead, and perhaps others. By the late 1960s and on into the '70s the chain drugstores began opening up retail outlets, and by the early 1980s stores such as SupeRx, White Cross, Eckerd, and Revco, dominated.

Around 1980 Bunting's became the center of a struggle by local preservationists to save the store and its old building in the Anderson block on State Street. In 1881, Joseph R. Anderson, the town's founder, built a store at 410 State (next to his home on the corner) and soon erected more buildings extending to the corner of Fifth Street. Originally, all stores on the block were three stories high. A tornado that struck in early June 1893 so badly damaged the third floors that Anderson's son John tore them away (with the exception of his father's store) and made them into two-story buildings. The old top trim was preserved and replaced atop the restored buildings.

During the struggle to save Bunting's, a couple of myths emerged. The first was that Bunting's had always been at its location on State Street, but it was at two or three other places before moving there. The other myth was that the building was as old as the drugstore, which opened in 1869. However, the building had not been erected until sometime in the 1880s. The local historical association led a valiant but unsuccessful fight to prevent its demolition, and it was destroyed by implosion during church time on a Sunday morning in 1984.

Driving down State Street from East Hill Cemetery that morning, I saw what I thought was a billowing cloud of smoke downtown and quickly

assumed it came from a raging fire. I was wrong. What I saw was dust from the terrific implosion that instantly destroyed the old building that long housed the popular Bunting's Drug Store, which the historical society said was the longest operating drugstore in Tennessee at the time. Though the much lamented building is gone, the name lives on in Bunting's and Northside Drug Center at 1883 Euclid Avenue.

Today the retail drug business in Bristol in almost completely dominated by large corporations, including Wal-Mart and Kmart. We are a far cry from the time when Bristol was served by one little drugstore on the corner of what is now State and Fifth.

A Good Place to Live

Hospitals

In spite of efforts by many in the medical field, Bristol entered the 20th century without a hospital. After Dr. H. Q. A. Boyer's hospital closed in the mid-1870s, the need had often been discussed, and a number of plans had been made, but for various reasons those plans had been scrapped, or at least tabled until they were all but forgotten.

The population greatly increased soon after the turn of the century, making the need for a suitable hospital more apparent. Finally in 1904, Evan Shelby Hospital opened in a large brick residence that yet stands on the northeast corner of Tenth and Shelby. Unfortunately it closed after about a year.

About 1907, a small hospital opened on the second floor of the Butler building on Sixth Street. The hospital, operated by Dr. Joseph S. Bachman, Dr. William R. Rogers, and Dr. James A. Delaney, had only three rooms. Two bedrooms contained two beds each, and a smaller room, used for surgical operations, contained an iron operating table and a copper sterilizer for surgical instruments.

Dr. Bachman's office was at the corner of Sixth and Shelby. Dr. Rogers, who at the time was city physician for Bristol, Virginia, had an office over Bunting's Drug Store at 420 State Street. Dr. James A. Delaney, son of Dr. William T. Delaney, had an office at 24½ Sixth Street and lived at the corner of Eleventh Street and Hill Street. The doctors occasionally called on the assistance of Dr. John J. Ensor and Dr. M. M. Butler, well-seasoned surgeons who had served Bristol since the Civil War era. Dr. Butler had assisted in the amputation of Stonewall Jackson's arm.

Around 1907 or 1908, Dr. William R. Rogers had an experience that

caused him to open another small hospital—actually more of an emergency room—on Bristol's notorious Water Street. The area bounded by Front Street on the east, Lee on the west, Cumberland on the south, and Beaver Creek on the north was then known as Big Hell Bottom. In the midst of it was Water Street, which some called "the center of hell," lined with two- and four-stall brothels. Bootleggers were also numerous in that area, along with two or three gambling dens that usually posed as pool halls.

Strangely, two of the town's best hotels at the time operated on Front Street, just a block away from "the center of hell." A young man staying overnight at one of these hotels, the St. Lawrence, decided to visit one of the brothels. While there he got into a brawl with an intoxicated patron. A hard fight ensued, and the drunk man slashed the young man in several places and he began bleeding profusely. When Dr. Rogers arrived, the young man begged the doctor to save him, admitting that he had a wife and two small children that he wanted so much to see again. The pitiful plea greatly touched the usually stoic doctor, but he didn't have the instruments he needed and had to quickly improvise. Only by heroic efforts was he able to keep the poor fellow from dying right there on the floor of the seamy brothel.

Within a few days, Dr. Rogers rented a small cottage on Water Street, from which two prostitutes had recently been evicted for nonpayment of rent. There, in the middle of Big Hell Bottom, he opened what he called the Emergency Hospital.

The Emergency Hospital proved to be not only beneficial for the victims of the frequent vice-den battles, but it was a boon for the workers in the nearby railroad yards, where accidents occurred with tragic frequency. My informant of long ago told me that another doctor, whose name he could not remember, took over the work when Dr. Rogers moved his hospital practice to another location. I could find no records telling how long the Emergency Hospital operated.

Around 1907-08 the Roman Catholic Church became interested in establishing a hospital in Bristol. Their idea was welcomed by many local citizens but was strongly opposed by a large percentage of the devout Protestants of Bristol who feared that the real purpose was to make Catholic converts. Several local pastors thundered forth from their pulpits against the project, doing much to turn public sentiment in the Protestants' direction. Whether because of this strong opposition or for other reasons, the Catholic Church finally dropped the plan.

A Good Place to Live

ST. LUKES HOSPITAL

Opening in the same building as the short-lived Evan Shelby Hospital, St. Lukes was operating by December 1, 1908. (Indication is that it had newly opened by that date.) This hospital was organized by Drs. William R. Rogers, James A. Delaney, Conley M. Cowan, and William R. Booher. Dr. Cowan then lived at 1022 Anderson Street, and his office was at 26½ Sixth Street. Dr. Booher lived at 822 Florida Avenue, with an office at at 20½ Sixth Street.

During the hospital's planning stages, Dr. Cowan heard his pastor preach an eloquent sermon on Luke, the beloved physician of the Gospels. The pastor had strongly emphasized the fact that healing is a vital part of Christian practice. While intently listening to the sermon, Dr. Cowan conceived the idea of the name for the hospital. He suggested it to his partners and they agreed.

St. Lukes Hospital was for white patients only, and no one with contagious diseases was allowed admittance. The rooms or wards were classed, meaning that fees varied according to which section of the hospital the patient occupied. Miss Nancy Kiplinger, a highly qualified nurse, was superintendent of the new facility.

For several months the hospital served the town well. Not only did Bristol

St. Lukes Hospital operated from about 1908 until 1925 on the northwest corner of Shelby and Tenth streets. The building still stands.

greatly benefit, but many patients from the surrounding area came for treatment. Then, almost without warning, the hospital closed on August 1, 1909. The doctors did not make public the motive for closing, but Dr. Cowan emphatically stated that it was not for financial reasons. The hospital had been altogether a success in that respect.

Of course, the closing of St. Lukes was a bitter disappointment for the citizens of Bristol. But as they nursed their disappointment, events transpired that would provide for them an even better hospital.

Soon after the hospital closed, Dr. C. M. Cowan made a business trip to Louisville, Kentucky. While there his foot slipped from a curb and he turned his ankle. He received medical aid from the Louisville City Hospital, where he met Mrs. N. F. Armstrong, who had served the hospital in a managerial position for some eight years. He could not forget her and her obvious capability.

Not long after returning to Bristol, he met with the other doctors with whom he had been associated in the hospital venture and secured their agreement to contact Mrs. Armstrong about coming to Bristol. He was pleasantly surprised to learn she was considering a change. The doctors paid her way here and lodged her at the Hamilton House Hotel while they negotiated with her.

Their efforts were successful, perhaps more successful than they had hoped for. Not only did Mrs. Armstrong lease the hospital building, she also leased the large brick house immediately north of it. Thomas Hayter, owner of both buildings, readily agreed to connect them with a covered, second-story walkway. He promised to have the work completed by September 1.

On Saturday, August 21, Mrs. Armstrong traveled by rail to Cincinnati, Ohio, to buy equipment for her new hospital. Her purchases were shipped to Bristol in record time. When she returned to Bristol, she was delighted to find that lodging had been found for her at 408 Carolina Avenue. She immediately moved from the Hamilton House Hotel to that location.

Mrs. Armstrong changed the name of St. Lukes to Armstrong Hospital. On Wednesday, September 8, 1909, she received her first patient, Edwin H. Ream from near Baltimore, Maryland. The hospital had not formally opened at that time—indeed only a few rooms on the second floor of the main building were ready for occupancy—yet Ream's case was urgent. Staying in a hotel far from home, he had come down with typhoid and badly needed a place to be cared for. Before the week ended, the hospital had seven more patients.

On Monday night, September 13, Mrs. Armstrong opened the hospital

with a reception and open house. Many medical men of the city and area were present, along with a great cross-section of the local citizenry. After a brief ceremony in which the mayors from both sides of Bristol participated, Mrs. Armstrong invited all those present to tour the facility.

Dr. William R. Rogers, one of the founders of St. Lukes, was among those at the reception. Just before his death (May 1954), he described the new hospital as viewed that night. His first perception of the hospital could be described with one word—*white*. All the rooms and halls were painted white. The window blinds were white. The floors, while not white, were light gray. All the new metal furniture was white. He was especially impressed by the beds. Those used at St. Lukes had been secondhand, bought from here and there, and were the kind commonly used in homes. He said that there were even a couple of old rope, or corded, type beds, and one that had belonged to his grandfather was a high four-poster.

Mrs. Armstrong had not bothered to take time to sell the old furnishings. Rather, she had hired John Farris, a local drayman, to haul everything to a local trash dump at what now is the corner of Euclid Avenue and Morrison Boulevard. (The old Goody's building now occupies the site.) Dr. Rogers did add, with a chuckle, that not all of those old beds reached the dump; many of them were distributed among the drayman's friends and relatives.

Dr. Rogers, a skilled surgeon, was much impressed by Armstrong Hospital's operating room, which he said was one of the finest he had ever seen outside of large cities. The operating table was one of the costliest available, and the room contained many other expensive surgical appliances, including a copper instrument sterilizer. He also told that the operating room had a large skylight, which he declared to be far more effective than artificial lights, especially on a sunny day. (The presence of the skylight would indicate that the operating room was on the third floor.)

The kitchen, at the back of the first floor of the main building, was spotlessly clean and well furnished. It had two large cookstoves and a deep sink where all dishes were submerged in boiling water after each meal. The water heater was the largest Dr. Rogers had ever seen. He estimated that it had a capacity of at least 150 gallons. It was installed by Fred Hayes, an early Bristol plumber, who said it was the largest in the city at the time. All the hospital linen was submerged in boiling water before the final washing.

Dr. Rogers concluded by saying that he and other doctors delighted in seeing what Mrs. Armstrong had done. By combining the two buildings and furnishing them well, she had given Bristol the largest (about 30 beds) and best

equipped hospital that had ever been located within her borders. The local residents were pleased and felt more secure knowing that advanced medical aid was available to them. There was much gratitude to her for what she had done.

Mrs. Armstrong had secured the services of a sufficient number of nurses and orderlies for smooth operation of her hospital. She also had hired a splendid cook, Mrs. Lucy Steward of 15 Powers Alley. The head laundress was Marie James of 626 Quarry Street. The janitor and gardener was Samuel Clark of 417 Scott Street, and he well tended, in season, the garden spots behind both buildings.

It would seem that Mrs. Armstrong, who had more than once said she liked Bristol better than anywhere she had ever lived, was situated for life. This likely would have been the case, had not her first patient been Edwin H. Ream. He lived on a farm near Baltimore that had been in his family for several generations, and he came to Bristol about twice per year to represent a large wholesale building-supply company. James F. McCrary described him as handsome, well-dressed, urbane, and possessing well-defined charisma.

When Dr. J. S. Bachman had moved Ream from the Tip Top Hotel to the yet unopened (at least publicly) Armstrong Hospital, he could not and did not know it would change the life of Mrs. Armstrong and the future of the new hospital.

At the hospital Ream received the best of care under Mrs. Armstrong's personal supervision. His rapid improvement surprised everyone. During his recovery period, Mrs. Armstrong often took time out from her busy schedule to read to him. He was very fond of the classics, so he was delighted to hear her reading them in her clear and well-modulated voice. Finally he was able to travel back to Baltimore.

After his departure, Ream, a widower, and Mrs. Armstrong, a widow, exchanged letters almost daily. (According to Dr. William R. Rogers, the local postmaster once privately apprised him of the situation.) This caused some apprehension among the doctors who had engaged Mrs. Armstrong to take over the hospital, but no one said anything publicly about the matter.

Ream did not wait for his usual time to return here. In late November he arrived in Bristol for his wedding to Nell Armstrong. The hospital cook passed down the story that the bride confessed she had fallen deeply in love with the groom the very day he was put under her care, and she had been in sort of a daze ever since. And apparently cupid's arrow had struck him within a very short time.

A Good Place to Live

The wedding came as a surprise and shock to the city. Immediately citizens grew anxious about the future of the hospital. It was of some comfort when Mrs. Ream assured the public that she would not abandon Armstron Hospital until actions were taken to insure its future.

On Thursday, December 14, 1909, Mrs. Ream sold her interest in the hospital, including all the new equipment, to Drs. N. H. Reeve, James A. Delaney, William R. Rogers, and Joseph S. Bachman. After closing for about a week to rearrange things, the hospital reopened with the same employees.

Though Dr. Conley M. Cowan was no longer connected with the hospital, the group decided to again take up the name St. Lukes. Dr. Reeve emphasized that they wanted to provide one of the area's best hospitals and that all doctors who had patients in need of special care could use the facilty. At the time of its reopening, the claim was made that St. Lukes had the best operating room to be found between Baltimore and Memphis. And that room was much used over the next 16 years.

In time, the doctors recovered the several thousand dollars they had spent on the project. They admitted paupers for a nominal rate and performed the surgical work for these unfortunate people for free, but they asked the governments of both Bristols to contribute to help cover the expenses. St. Lukes Hospital was nonsectarian; all clergyman were welcome to minister there, regardless of denomination.

At about this time, Jen McGoldrick and her sister Lavalette came to Bristol to visit their aged mother, Mrs. Permelia McGoldrick (widow of Thomas). She lived in a house that still stands at 420 Taylor Street and in recent years was beautifully restored by Dr. Dale McLaughlin. Mrs. McGoldrick begged her daughters to stay, and both felt they should. Jen and Lavalette (called Miss Lav) had entered nurses training in Norfolk in 1896. They graduated in 1900, and went to work in a Norfolk hospital at $15 per week.

Dr. N. H. Reeve, speaking for his board of doctors, asked Miss Jen to take over as superintendent of St. Lukes Hospital. She agreed and engaged Miss Lav to assist her. When the sisters left the hospital in Norfolk, their salary had increased to $25 a week. Their income at St. Lukes would prove to be rather uncertain.

Miss Jen and Miss Lav had one assistant nurse, Miss Annie Peters. A little later a sister of the McGoldricks, Mrs. Ida Rhodes, came to assist with the work at St. Lukes. In times of unusual sickness, they had to call in more nurses, some from as far away as Knoxville. A little later Miss Jen started a class for nurses, which helped relieve the nurse shortage at St. Lukes.

Soon after coming to St. Lukes, Miss Jen and her staff took on all the duties of operating the hospital. She honorably dismissed the employees working there at the time and personally saw to it that they all found new jobs. Dr. Rogers, who so loved Lucy Steward's biscuits, employed her as his family cook. In a short time all the other employees had equal or better paying jobs than they had at the hospital.

For three or four years, the four nurses did all the work. Miss Jen took over the cooking and, for as long as the hospital existed, would never let anyone else do it. She finally did hire an assistant to wash the dishes and peel the potatoes and fruit. The young women had constant cleaning to do and even did minor building repairs. Washing was a daily task. The place was heated by coal grates in each room, and each winter it was quite a task to carry full coal hods up long flights of stairs to the second and third floors. In summer the gardens had to be cultivated. The nurses even had to carry the dead down from the upper floors. Occasionally, if a doctor or family members were present, they would help with this task.

There were no eight-hour shifts for the four nurses; they were essentially on duty 24 hours per day. They tried sleeping in shifts, but even so, those sleeping might have to be awakened for special duty. Initially all four young women shared a room on the first floor of the main building. When a third building was brought into the complex, they slept two to a room.

About two years after Miss Jen took over the hospital, the doctors who had started it asked her to become the owner. They were concerned that the other doctors of the town were not sending their patients there and felt that if the hospital was not doctor owned, the situation would change. They were charitable enough to "step out of the way" if it would improve the health care of the local citizenry.

Miss Jen bought St. Lukes, and in a short time virtually every doctor in town began to send patients there. By careful management, she paid it off on time and soon hired two orderlies who each worked a daily 12-hour shift. The shifts were alternating. (Miss Lav thought they alternated weekly.) She hired a black laundry woman and her husband, who did most of the cleaning and much of the garden work.

Miss Lav told that the onerous task of carrying food trays from the first-floor kitchen to the many rooms upstairs required many trips at each meal. She was happy when the orderlies were hired, with the task falling to them.

True, the nurses were somewhat relieved of many previous chores, but they were still subject to being called from rest at any hour. Theirs was a labor

of love. They were dedicated to the care of the sick, which made their work easier, but their pay was small. Satisfaction in a job well done made up for the lack of fitting compensation.

A third building (immediately north of the second building that had been added a few years before) was added to the complex. It too became connected with a second-story covered walkway.

The building that yet stands at 25 Tenth Street and where the nurses were headquartered was the critical care unit, where the most severely ill stayed. The third floor housed the operating and birthing rooms. The next building north was for the less ill, and the third building north was for those patients who had almost recuperated. Student nurses were also housed in the third unit, which by 1921 was listed separately as the Nurses Home.

The McGoldrick sisters continued to operate St. Lukes until about 1920. After they departed, Miss L. E. Cornish managed the hospital. By 1921, Dr. George Wiley had become president of the hospital board, and Dr. N. H. Reeve, one of the original founders, was secretary and treasurer. Dr. Wiley was then the city physician and lived at 512 Harmeling Street with an office at 603 State Street. Dr. Reeve had moved out on the Sulphur Springs Turnpike but maintained an office at 30 Sixth Street (Bachman Building). By 1924 Dr. Wiley was still president, R. T. Marshall had become the manager and treasurer, and Miss Mary Humphrey was superintendent.

St. Lukes continued until November 1925, when Kings Mountain Memorial Hospital opened. The last patient moved from St. Lukes was 14-year-old Harmon L. Pippin, Jr., son of Dr. Harmon L. and Ellen Hayes Pippin of 820 Cumberland Street. Dr. Pippin had closed his practice at Mendota, Virginia, and moved to Abingdon, Virginia, before coming to Bristol in 1924.

Young Harmon was suffering from a ruptured appendix, so he was operated on at St. Lukes. His kind and faithful father hardly left his bedside for several days and nights. The boy had to miss a year of school during his recuperation period, but he made a full recovery. Later he became Lt. Col. Harmon L. Pippin and married Mary Cox (daughter of E. B. Cox). He died at the age of 85 in Bristol on January 15, 1997.

Also in the hospital at that time was Stella Rebecca St. John Moore, wife of Charles B. Moore. She was there for the delivery by Cesarean section of her only child, Charles B. Moore, Jr. Her surgeon was Dr. Joseph S. Bachman. She too was moved to Kings Mountain, and her son became the first baby in the nursery of that new hospital. He yet lives in Bristol, Tennessee, and is a highly valued friend of mine.

St. Lukes had served long and well, and would be long and fondly remembered by those who had benefited from it. After it closed, the building served various purposes, sometimes as apartments, other times as a boardinghouse. More than once it was more or less a brothel, though posing as a boardinghouse. A man who lived there in 1944-45 told me that it was then part apartments and part boardinghouse. All residents had to share one bathroom. The second-story walkways had been removed by the mid-1940s. The two northern units of the hospital were demolished around 1955, or perhaps a little later, but they were gone by 1960.

When I came to Bristol in 1953, the old house was occupied by Siota Page, who may have had boarders. Several years later, a couple divided the building into several small apartments and sleeping rooms. It was during that period that a distraught young man hanged himself in what had been the hospital operating room. My friend Jim Kinnamon later bought the place and did extensive remodeling. He finally sold the the noted, historic landmark to Scott Plaster, the present owner and occupant.

And what of the McGoldrick sisters, who had labored long and faithfully to make St. Lukes so beneficial to the city of Bristol? Miss Jen moved to 11 Tenth Street, next door to the third unit of the hospital. A little later she moved one door north to 9 Tenth Street. She remained there until about 1956 and continued to do nursing (mostly private) until her death. Miss Lav went back to live with her mother at 420 Taylor Street. For years she did nursing in Kings Mountain Memorial Hospital. She died about 1960 after around 60 years in the nursing profession. Bristol was made better because these two dedicated nurses decided to live here.

COST AT ST. LUKES

Information concerning cost at St. Lukes is scarce. The earliest bill from which I could gain such information is dated 1910 for a patient who stayed 10 days. Her total bill, including five doctor visits, ran to $25. At that time, charges for room, board, and nursing care ran to $1.50 per day. Doctor's charges were extra and usually amounted to $2.00 per visit.

Hugh Hagan, who was born at St. Lukes in 1915, told me that the bill for his birth (he still had it 80 years later) ran to $31.50 for a nine-day stay in the hospital, delivery fee, and doctor's visits.

According to Miss Lav McGoldrick, the daily charge had risen to $2.00 per day by the time she left St. Lukes about 1920. She said the birth delivery fee was up to $12, including use of the delivery room. She remembered when

there was much concern among local citizens when the appendectomy fee was upped from $50 to $60.

Maj. A. D. Reynolds was charged only $112 in 1925 for a surgery far more involved and serious than an appendectomy. Though his surgery seemed successful, he died soon after returning home. Apparently he had a heart attack, which may have been brought on by the stress of his sickness and operation.

Mitch Newland came to St. Luke's in 1925 with a likely broken neck and was there two or three days before he died. His son kept a record of expenses incurred, noting that he paid A. S. McNeil and Son $15 for ambulance service to the hospital from the Newland home in the Arcadia community. The son spent $1.50 for a night's stay in the Virginia Hotel. After his father died, he paid the hospital $24, which included the hearse fee for hauling the body from the hospital to McNeil's Funeral Home, then located at 532 State Street.

A local man spent a week in St. Lukes just before it closed. His bill, dated October 26, 1925, totaled $31.50, including room, board, laboratory work, medicine, and laundry. The bill was not completely paid until three months after the hospital closed. (All outstanding bills had been transferred to Kings Mountain Memorial Hospital.)

Doubtless the hospital costs seemed high to the patients of those days, but they are virtually nothing when compared to present-day medical costs.

Of course, there was no retirement plan for the nurses and other employees of St. Lukes, and Social Security would not be available for 10 more years. Though her earnings were small, Miss Jen McGoldrick saved enough to invest in a gold-mining operation in Canada, hoping to have something upon which to live in her later years. Alas, that mining operation failed, blasting her hopes for a secure old age.

Stories of St. Lukes Hospital

There is no way that one could know all the happenings that occurred at St. Lukes, nor can one comprehend the great range of human emotions experienced there. But thanks to a few old-timers, especially Miss Lav McGoldrick, we do have a sampling that may show a faint picture of life in St. Lukes.

Not a Merry Christmas

One of the first patients Miss Lav treated in St. Lukes was 18-year-old Simpson Leonard from Phillips, Virginia, who suffered serious internal injuries and profuse bleeding from a gunshot wound. Dan Bays, his close friend, accidentally shot him on the night of December 24, 1908. The shot also

injured Bays' hand. The two were hurried to Bristol through a dark rainy night, followed by several friends and relatives. Around midnight, Drs. Joseph S. Bachman and William R. Rogers preformed surgery on Leonard. The boy was weak from heavy loss of blood, and for a while it did not appear that he would survive the operation.

What Miss Lav so clearly remembered was the agony and loyalty of the friend. For days, Bays would hardly leave Leonard's bedside. He did not sleep any for the first two nights, and he took no food or drink for the same period. Often he would break out in loud bouts of bitter weeping, blurting out that he could not live if his friend died.

Well, reader, how would you feel if you thought you had fatally shot a close friend? Bays finally returned home briefly, when it appeared that Leonard was improving. Those who knew Bays told that it scarred him emotionally for life.

Needle Makes a Doctor

Not long after Miss Lav came to work at St. Lukes, an 8-year-old boy came under her care. The lad had been playing with his younger sister, while their rather feeble grandmother sat sewing in her rocking chair. To make things handy for herself, she hung her pincushion low on the wall near her chair. As the children played around their grandmother's chair, he ran backward into the pincushion, driving a large needle into his back, where it broke off near the eye.

He was rushed to St. Lukes, where Dr. J. A. Delaney, aided by X-rays, operated on his back and removed the needle. Infection set in, requiring the little boy to stay in the hospital for several days. The doctors and nurses became heroes to him. Before he left the hospital, he boldly told Miss Jen that when he grew up he would become a doctor.

He held to that determination until he was grown, often telling of his noble ambition. When Dr. Rogers and Dr. Delaney learned of the boy's unwavering intention, together they made it possible for him to attend college and medical school. Indeed he did become a doctor, and when Miss Lav told me this story in 1958, she said he was enjoying a good practice as a surgeon in North Carolina. A lifetime of medical service was brought about by a broken needle.

Blizzard Baby

Stories of personal service, sacrifice, and unfeigned charity are often told

of St. Lukes. The following story illustrates that true benevolence is not prejudiced, nor does it know any bounds.

The night of January 18, 1916, was bitterly cold with near-blizzard conditions. The temperature hovered at six below zero. About 9:00 P.M., an unmarried, pregnant 16-year-old from the notorious slum on Second High Street showed up at the hospital. A neighbor had brought her in a buggy because he couldn't get his car started due to the bitter cold. The poor girl wore no coat but had wrapped up in a quilt that was so ragged it hardly acted as an effective shield from the extreme cold. She was in an advanced stage of labor and apparently having extreme difficulties.

Of course, Jen McGoldrick, head of the hospital, knew the hospital would never receive a dime in payment for services rendered. But without hesitation, she had the girl brought into the hospital and taken to the delivery room. She then sent an orderly running for Dr. Joseph S. Bachman, who lived a little over two blocks away.

The baby boy, at least a month premature, was born about midnight but was not healthy. Miss Jen, who aided in the delivery, knew he would have to be kept warm. She had the coal grate filled to the brim, and she sat up the rest of the night holding him close to the fire. The baby lived and grew up in Bristol, finally settling in McMinn County, Tennessee, where he became rather prosperous. He came back here on a visit in 1952, and the first person he wanted to see was Miss Jen. His mother had often told him of the dedicated and kind nurse who had saved his life.

Not a Restful Night

Sleep was never certain for the nurses and other employees at St. Lukes. Miss Lav told how one night a couple of "shady ladys" from Bristol's Little Hell had engaged in a battle, using sharps knives or razors. Awakened from a deep sleep, Miss Lav helped patch them up and put them in rooms on different floors. She went back to bed and about an hour later was awakened by screams, knocking, and cursing coming from the floor above her.

One of the injured women had arisen from bed and gone looking for her adversary. She thought she had found her, but actually she had attacked another patient. But that woman wasn't taking it lying down. Before the hospital staff succeeded in separating the two, the patient had broken the chamber pot, spilling its contents "over the harlot's head," as Miss Lav expressed it. To say the least, her scheduled night for sleep was not very restful.

Medical Knowledge Saves His Life

Young Victor Keebler, son of A. C. Keebler of 1112 Anderson Street, worked for Bristol's streetcar system during his summer breaks from medical school. On one of the runs out Windsor Avenue, a large horsefly flew into the coach and annoyed the passengers by buzzing about. Victor saw the fly alight on one of the windows, so he made a slap at the pest, lost his balance, and ran his hand through the breaking glass. He suffered a deep gash, severing an artery in his wrist. The blood spurted, but he used a bit of knowledge he had obtained as a medical student. With nothing else available, he quickly used one of his shoestrings to tightly bind his arm. He then ran to St. Lukes, where the chief nurse tied the artery and bound up the wound. He survived his injury and the following summer was made conductor on one of the cars. You may be certain he never again used his hand to swat a horsefly!

The Suicidal Surprise

Annie Peters, long a nurse at St. Lukes, once told of how she had gone to bed about eleven o'clock one night, expecting and badly needing a good night's rest. But that was not to be. About an hour later she received an urgent wake-up call from Miss Jen to help with a man on the third floor who "had lost it" and had tried to jump from a window. It took two orderlies and a couple of nurses to hold him until Dr. Bachman, who lived nearby, came and sedated him. When the man was finally sleeping soundly, the orderlies and nurses carried him down to the first floor and put him to bed in the front room on the Tenth Street side. Sometime during the wee morning hours, he came out of his stupor long enough to succeed in jumping from the window. He was found sprawled out in the yard and sound asleep again, for the window was about 30 inches from the ground.

Generous Surprise

Nursing at St. Lukes was more or less a thankless job. But once in a while there was an unusual and surprising show of gratitude.

Perhaps one of the best known Bristolians treated in St. Lukes was Maj. A. D. Reynolds. He became ill in 1925 while away from town but was brought back and admitted to St. Lukes. After a successful operation, he remained in the hospital for several days, receiving especially good care from two of the nurses.

Soon after he was dismissed, he sent his right-hand man, James Morrison, Sr. to the hospital with a sealed envelope for each of the nurses. Each enve-

lope contained a note of thanks along with a $100 bill, far more than a nurse received in a month working in the hospital. One of those nurses told me she immediately went to the H.P. King store and bought herself a new Sunday outfit and still had a good portion of the money left.

Midnight Surprise

In 1916 a lady and her newborn baby were sleeping soundly in a room on the second floor at St. Lukes. She had intended to have a home delivery, but her doctor, fearing she might have complications, had advised her to go to the hospital. About midnight she awoke to the sound of her room window being jerked up, followed by three or four men jumping into the room, excitedly talking as they threw something under her bed. In the hall, nurses and orderlies ran back and forth rousing the patients, some of whom were loudly screaming.

The young mother froze in horror, clutching her baby to her breast. The men then threw open the door, and she saw that they were firemen dragging a large hose that they had passed under her bed. A small fire had broken out in a room directly across the hall from her, and it so happened that the nearest way to it for the firemen was through the mother's room. Luckily they extinguished the fire before any great harm was done.

The baby who was in her mother's bed that night is still living and has become a good friend of mine, Mrs. Harriett Barringer of Bristol, Tennessee.

The fire had broken out in the room of an older man who was deathly sick with pneumonia, and his much younger wife was standing by his bed when the fireman rushed in. She fainted in the ensuing excitement, and one of the firemen picked her up and carried her into a vacant room nearby. He placed her on a bed, and nurses came in to revive her. The woman's husband died within a day or two. A little less than three months later, she married the fireman who had carried her out of her husband's room.

Romance in the Critical Care Unit

A railroad worker had fallen from a train. His feet slid under the wheels, causing one foot and one lower leg to be severed. He was brought into the hospital in a bad way. The bleeding was so profuse that it soaked completely through a mattress. Though it looked at first as if he wouldn't survive, his nurse, a young widow, fell madly in love with him. He did survive, and they married and had 11 children. One of their daughters is a good friend of mine.

Sad Times at St. Lukes

Not all happenings at St. Lukes had a happy ending. Many people came for treatment and never returned home. According to Miss Lav, several people had died in every patient room. Often she helped carry the dead down the long stairways to be placed in a back room on the first-floor, called the cooling room by the hospital employees, to wait for the undertaker. In some cases, relatives claimed the bodies and hauled them to remote areas for burial.

The only time I ever saw a tear roll down the cheek of Miss Lav, a well-seasoned nurse, was when she told me of the death of Alice, an eight-year-old girl who had been bitten by a rattlesnake in a berry patch near her home. The child lingered for a few days and greatly endeared herself to the hospital staff. Finally she lost her heroic fight for life. Miss Lav told how the girl's father backed a battered old Model T truck to the back door. The open bed of the truck was covered with fresh straw. He placed little Alice's body on the straw for the long journey to near Hiltons, Virginia. Miss Lav, seeing that he had nothing with which to cover the child, took a quilt from her own room and, as she put it, "tucked her in" for the final trip home.

A death that greatly shocked the city was that of Dr. George W. Overstreet, D.D.S., who long lived at 310 Park Street. One day he complained to a friend that he felt weak and achy all over, yet he planned to finish the day. As he worked on his last patient of the day, he suddenly collapsed, leaving her with three unfilled holes that he had just drilled for fillings. He was rushed to St. Lukes, where doctors diagnosed his malady as typhoid. At that time, the city had several cases of typhoid, much of it caused by a polluted water supply. Dr. Overstreet lingered a while before his untimely death. The poor patient left behind was Mrs. Nannie Zimmerman Carter, wife of Dr. A. M. Carter. Her husband took her to Dr. S. W. Rhea, who finished the job.

Well-meaning advice led to the unfortunate death of Joseph Mitchell (Mitch) Newland of the Arcadia community in Sullivan County, Tennessee. Mitch, a son of Rebecca Anderson Newland and a nephew of Joseph Anderson, founder of Bristol, lived on a portion of the large spread of land that his father had owned. In 1900 Mitch built the huge frame house that yet stands and is now the home of his grandson Charles Newland. Mitch was always on the lookout for ways to make his farm more productive. A cousin of his, a commercial apple grower in Wythe County, Virginia, told him that dried-up apples that remained on trees would hinder production in the following growing season. After the leaves had fallen from one of the apple trees in his yard, Mitch noticed a few dried-up apples near its top. He climbed high in

the tree to pull and throw them down, but he slipped and fell to the ground. He likely broke his neck and was rushed to St. Lukes in Bristol, where he lingered for two or three days and then died.

The Trying Time of 1918-19

When the great flu epidemic of 1918-19 more or less swept the world, Bristol was not spared. The plague started here with 40 cases that developed almost simultaneously, then spread like wildfire all over the city. Hardly was there a home without one or more cases of it; often entire families were sick at the same time.

The flu brought many deaths, often including several members of the same family. Ernest Emmert told me that he remembered seeing four caskets in the living room of a home at one time. There used to be a homemade monument in East Hill Cemetery—it has now crumbled—that contained the names of a mother and four children who died the same week.

The disease was rampant in the Army and all other branches of war service. Many young military men died—including a son of Dr. Joseph S. Bachman, who long practiced at St. Lukes—and were sent back to Bristol for burial. One old-timer remembered seeing twelve caskets lined up along the depot platform at one time, having been removed from the baggage car of an arriving passenger train.

Often entire families were so sick, they could not wait upon one another. There would be no one to cook and serve food, nor supply water for the fevered victims. The local service canteen at the Bristol depot began cooking and sending beef broth and rice to these families. Margaret English wrote in her diary that her sister, Sally Farris, helped cook and serve 400 families in one day.

The town's doctors were badly overworked, going night and day to minister to the sick. Occasionally one of them came down with the malady and thus was put out of service for weeks. Dr. W. R. Rogers told that there was a period when he did not remove his shoes for three days and nights. Sometimes doctors had a chance to catch a short nap while visiting a sick patent. Drugstores were hard put to keep enough medicine to supply the needs of the sick. Most of them kept their stores open day and night. A young man clerking in Minor's Drug Store later told how he was called from his bed one night to take a passenger train trip to Knoxville to secure and bring back some drugs. He returned about noon the next day to find the line of folks waiting in the store for his coming.

Hospitals

The undertakers were often far behind, and funerals sometimes had to be delayed for a week or more. The gravediggers knew no rest for days at a time. And to contribute to the problem, the bitter cold weather had frozen the ground so deeply that it was difficult to dig the graves. Many burials took place without ceremony of any kind. Some burials were done without family members present because all others were ill at home. An old man living here in 1954 told me that the hardest moment of his life came when he, from his sickbed, saw his little boy carried from the home by strangers for a lonely burial in the snow-blanketed East Hill Cemetery. One old lady told me how she became concerned about a neighbor's family after not seeing any of them out for three or four days. She went to check on them and found the widowed mother deathly sick, unable to raise her head from her pillow. Two of her children, also near death, were in the same room. In a little side room, two more children lay dead in bed. No one had been able to give food or drink for at least four days.

Some escaped the plague by taking desperate measures. One lady told that neither she nor her children went beyond their front door for three months. She had food brought from the grocery store and left at her back door. Even then she did not so much as see the grocery boy; she counted out the money and laid it out for him.

Robert Anderson of Valdosta, Georgia, the last living grandchild of Bristol's founder, told me that he was sent from his home in a section of the town where the flu was raging to stay with an aunt on Solar Street, an area considered much safer. The aunt, Mrs. Mary Wood, then lived at 124 Solar Street. Sycamore Street gently sloped down from this location to Beaver Creek Valley below. The street was often covered in ice that winter, presenting a strong temptation for young Robert to go sledding. This he did without mishap for a while, but then came the time when his sled gained speed and he could not stop in time to keep from plunging into the icy waters of Beaver Creek. He climbed out, shivering and shaking, and ran up the hill to his aunt's home. When he arrived, he was almost too numbed and fatigued to travel. It took a considerable effort to "thaw him out." His aunt Mary, greatly alarmed, feared he would take pneumonia. Thankfully her fears were not realized. He lived to a ripe old age, dying about 1991.

According to the three nurses that I interviewed concerning their experiences at St. Lukes, the great flu epidemic was the most trying time they could remember. The hospital was taxed far beyond its capacity, both in space and services needed. Rooms that had been set up for two patients usually had six

or more crowded in them. More patients lay on the floors than in the beds. The hospital borrowed feather beds and mattresses from all over Bristol and placed them on the floors to make the overflow patients more comfortable. The nurses and orderlies got little sleep. Several—indeed, most—of the town's doctors were in and out at all hours of the day and night.

At the same time, the city experienced a coal shortage. Miss Jen put out an appeal for the town residents to share fuel with the hospital, and the kind citizens responded. One old lady who lived on Broad Street walked four blocks in deep snow and numbing cold, carrying a bucket of coal in each hand. If that were not enough, she insisted on taking the buckets to the second floor, where she helped replenish the fireplace grates.

One patient, an older man, had been brought to the hospital with a bad case of the flu. After several days he was no better and seemed to be getting worse. About two o'clock one morning, he suddenly began calling frantically for a nurse. When she arrived, he told her he had just had a dream in which he had seen his own death occurring at nine the next morning. He must get a will made, he told her, and would she please send someone for a lawyer. She tried to put him off until daylight, but he would not hear of it—he must have a lawyer without delay.

She dispatched an orderly to bring A. B. (Bo) Whitaker, who lived two blocks away, to the hospital, but she had little hope that he would come. To her surprise, the rather sleepy lawyer appeared at the door in a short time. He knew the patient and was aware that he had much property to dispose of. Whitaker immediately drew up the will, which the man signed with a trembling hand. Two of the nurses served as witnesses. The sick man immediately began to grow worse, and as he had dreamed, he died at exactly nine o'clock that morning.

Annie Peters, who nursed at St. Lukes during that dreadful time, said the hospital usually had at least one death per day. She remembered one day when three died before noon and another time when five bodies lay in the cooling room awaiting the undertakers. Oftentimes death occurred in a room where six or more suffered from the flu, which, of course, unnerved the other patients.

But even in the midst of it all, Miss Jen took time to be an angel of mercy to many outside the hospital who were in real need. Just a half block away, in a poverty-stricken area known as Crumley's Alley, was a destitute family all down with the flu except an 8-year-old boy. Near dark, Miss Jen went through a deep snow to see about the family. She found that they had not a bite of food in the house. She told the little boy to wait up, that she would return with food as soon as she could.

Things were critical at the hospital, and long hours dragged on before she was able to fulfill her promise. The night became bitterly cold as the temperature fell to near zero.

At 3:00 a.m., Annie Peters looked from a second-floor window toward Crumley's Alley. In the bright moonlight she saw Miss Jen heading toward the destitute home, carrying a big pot of hot soup.

Miss Jen later told that the little boy had placed a chair near the front door to await her coming. He had apparently dropped off to sleep, but he easily awoke when she called at the door. She poured him a bowl of the hot soup, and he was ready for a refill before she was through checking on the family.

Years later, grown up and in much better circumstances, he served as a pallbearer at Miss Jen's funeral.

My Last Visit With a St. Lukes Nurse

Dr. W. K. (Dick) Vance's widow lived alone for several years in a pleasant little house on Spruce Street in Bristol, Tennessee. She had been one of the first students in Miss Jen McGoldrick's nursing school and later had worked under her at St. Lukes Hospital. One late summer day I was strolling along Spruce Street when I saw her trying to start a lawnmower, but she was having difficulty with the well-aged machine. I stopped and, after chatting briefly, managed to get the mower started and then mowed a round or two for her.

Then she stopped me, saying, "No, no, let me do it. This helps keep me young." She was then over 90 years old! I suppose all those nurses at St. Lukes had to be of a hardy lot.

Kings Mountain Memorial Hospital

Everything has a root origin—an actual point of beginning. How unfortunate it is that in writing history, the start often has to be made at a point far from the beginning. In writing of Kings Mountain Memorial Hospital, I am fortunate to be able to go back to the sowing of the seed that led to the full flowering of a fine hospital for Bristol.

Then, as now, the local chapters of the Daughters of the American Revolution (DAR) often had guest speakers at their meetings. Sometime around 1905, the Sycamore Shoals Chapter of the DAR invited as their speaker Dr. Matthew Moore Butler, who first began practicing in Bristol in 1860. After leaving to serve as a surgeon in the Civil War, he resumed his practice here and became one of the most respected doctors in the city.

No one could then know what far-reaching consequences his speech would

A Good Place to Live

Kings Mountain Memorial Hospital, erected in 1924-25, served Bristol until early 1953. This picture was made soon after it opened. The building still stands but is badly in need of some TLC.

have on the medical future of Bristol. In that speech Dr. Butler dwelled long on the inadequacy of medical services during the Revolutionary War and the Civil War. He made the statement that if adequate hospital facilities had then been available, hundreds—perhaps thousands—of lives could have been saved. Dr. Butler had long lamented the lack of hospital services in Bristol and didn't miss the opportunity to speak of the matter that day.

In the audience was Mrs. J. H. McCue, who long served as the regent of the Sycamore Shoals Chapter. Her husband, a high official of the Virginia and Southwestern Railroad, was a prominent citizen of Bristol. The family long lived at 311 Fifth Street but later resided at 713 Euclid Avenue. When Dr. Butler finished his discourse, she arose and addressed the chapter, suggesting that they begin and head a move to build a suitable hospital for Bristol. She further urged that the hospital be a memorial to the patriots who won a crucial victory over the British on October 7, 1780, in the Battle of Kings Mountain, considered to be the turning point of the Revolutionary War. The names of the American soldiers killed during the battle would be placed on a bronze plaque in the new hospital.

The suggestion was well received, and the movement to build Kings Mountain Memorial Hospital began that day. But the envisioned hospital would be a long time in coming.

Hospitals

At about the same time, the *Bristol Herald* made an appeal for a Bristol hospital. Citing the growth of the city, the paper bemoaned the fact that those who needed surgery had to go to distant cities for such services. The newspaper's publicity of the need for a hospital greatly helped the Sycamore Shoals Chapter in their effort to raise funds.

In 1906 a prominent and wealthy citizen of Bristol offered a choice lot, 100 by 100 feet, for the location of a hospital, provided both cities would contribute $5,000 each toward erection costs, but apparently nothing came of it. Then in 1908 St. Lukes Hospital opened. Hope sprang anew that the small hospital might inspire the building of a larger one. The owners of St. Lukes even offered to turn all furnishings and equipment over to the Kings Mountain promoters if a larger hospital was built. But hope was all it amounted to at the time.

Shortly the ladies of the DAR redoubled their efforts for the hospital. One fund-raising project, called "tag day," brought in about $1,600. On that day, members of the organization and other volunteers solicited every business and professional person in the city, along with anyone they perchanced to meet on the streets. When someone donated, he or she was tagged, which gave that person immunity from being solicited again on that day.

In spite of the intensive efforts of the DAR ladies to raise money for a fine city hospital, the group was able to raise only a few thousand dollars, and it would be nearly 20 years before the dream would be realized. During that time, Mrs. McCue, instigator and heavy promoter of the project, died, but others carried on the work.

In 1921 a city-wide committee was formed for the purpose of raising the needed funds. Pioneer merchant E. W. King, who had become a prominent civic and church leader of the city, was chosen to head this committee. Pledges were sought not only from all residents of Bristol, but from those in the surrounding area who would also benefit from hospital.

And the pledges were made—all the way from 50¢ to several thousand dollars. Middle class business persons often pledged $500. Many citizens made real sacrifices to provide the needed funds. The great flu epidemic of 1918 had emphasized the need for a larger hospital. Churches designated certain Sunday offerings to the cause; some businessmen gave the first dollar made in a day, along with their regular pledge. One man said he even gave up drinking coffee so he could give what he usually spent for that popular beverage to the Kings Mountain fund. James King Brewer, another citizen, was forgetful and often misplaced things. In order to try to break himself of the habit, he fined

himself a quarter every time he lost something. Some days his fine amounted to more than a dollar, but he cheerfully gave it to the hospital fund.

All these pledges and donations added up. Within a year or two, the committee contracted with C. B. Kearfott, a prominent local architect, to design the building. As usual, he came up with a superb design for a fitting and beautiful building.

Drawings of the proposed building were placed in prominent places over the town, including both courthouses, the depot, several large business houses, and even some of the city churches. The drawings inspired a surge of pledges and brought several large donations.

As usually happens in such fund-raising campaigns, several of the pledges were not promptly paid. After construction started in 1924, a special appeal went out for pledgers to pay up. I have a letter sent by E. W. King to a local, rather wealthy businessman, imploring him to pay his pledge of $500, in that $50,000 had to be raised within a short time to pay outstanding bills.

Construction of the hospital was by Kingsolver and Huddle, general building contractors and suppliers. This firm was composed of David M. Kingsolver of 5 Elm Street and J. D. Huddle and Jefferson D. Huddle of 513 Park Street. The company office was located in the Interstate Building at 10 Sixth Street, Bristol, Tennessee. The Holston Construction Company was also involved in this construction project. Materials were furnished by Bristol Brick Company, Virginia Woodworking, Stone Lumber Company, Twin City Boiler Works, Gemmell Brothers Electric, and Fred Hayes Plumbing and Heating.

The four-story building had terrazzo and hardwood floors, a roof garden, a solarium, steam vacuum heat, a cold room where ice was made, an X-ray department, an emergency room, a laboratory, and a nose and throat clinic. The hospital also had operating rooms, delivery rooms, and necessary service units such as a kitchen and laundry. There were private, semiprivate, and ward rooms on the first and second floors. The third floor had delivery rooms and nurseries, along with rooms for obstetrical patients. The fourth floor was given over to the surgical department.

A number of private rooms were furnished by individuals who usually dedicated them to the memory of someone with a bronze plate on the door. Containing not only a bed, but also a cot for a nurse, the rooms had telephone connections, curtains, and rugs.

On Wednesday, November 11, 1925, Dr. Malcolm Fuller, pastor of First Baptist Church, led the ceremony that dedicated the building "to the glory of

God and to the service of humanity." Representatives of the American Legion unveiled a plaque honoring Bristol's casualties of World War I.

Dr. Butler, whose speech had inspired Mrs. McCue to start the movement to build the hospital, had died August 12, 1913. However, in the crowd was his 2-year-old great-granddaughter, Betsey Butler Fleming, a sixth generation descendant of Kings Mountain patriots. Mrs. McCue had also died, but her husband was present.

The hospital opened for patients a few days later, first receiving the two remaining patients from St. Lukes. Agnes Lynch was the first superintendent of the new hospital. Several former employees of St. Lukes served under her.

At last, through the dedicated and untiring efforts of many local citizens, and by much generous and often sacrificial giving, Bristol had a hospital of which she could be proud. It served long and well. Many were born there, many died there, but many more were made well because this institution existed with its capable and dedicated staff.

In time, it was necessary to add additional beds. A nurses home was soon erected immediately east of the main building.

By 1927, Julian P. Moorman was the manager and Mrs. George H. Harmeling was superintendent. Mr. Moorman and his wife, Minnie, then lived at 824 Fairmount Avenue. Mrs. Harmeling lived at 713 Cumberland Street. The hospital phone number was 1142, and the manager's office phone was 892.

Kings Mountain Memorial Hospital went through stressful times during the Great Depression, as did most institutions and businesses. There were always those who could not, or would not, pay their bills, and that number greatly increased during that tragic period. It was difficult to meet the payroll and pay the bills. Employees were laid off, many of whom never returned. The hospital incurred heavy debts. The patient population also greatly decreased because many of the sick refused hospital treatment, knowing that their bills could not be paid. One patient who did enter the hospital during that trying time once told how the place was not well heated, and the food was meager and not well prepared. But the hospital pulled through as best it could, ever endeavoring to meet the needs of the city.

By 1934, Dr. David Townsend had become the superintendent. Dr. Townsend and his wife, Frances, lived at 1308 Windsor Avenue. By 1938, Carolyn E. Davis was superintendent. She then lived in a house that still stands at 203 Solar Street, built by Dr. William Whitten in 1871. By 1940, Dorothy A. Matthews headed the hospital. She lived in the hospital property, and was still there in 1944.

All the while, the city was growing, which caused the hospital to become overcrowded. The facility was barely 20 years old when crowding became rather acute, but its location could not accommodate further expansion. By the time World War II ended, there was strong sentiment for a new and much larger hospital.

Ernest J. Maden was then superintendent. He and his wife, Margie, lived at 437 Maple Street. He was followed by John C. Gilbert, Jr., who served through the remaining years of the 1940s. Several prominent local men served on the hospital board through the last decade of its existence. Robert C. Boswell and Roy C. McClure served as presidents of that board. Others who served with them were William Stone, Leslie R. Driver, Earl Francisco, Jack Stone, Roland Galliher, and Frank DeFriece.

Kings Mountain Memorial Hospital entered the 1950s still serving Bristol and the surrounding area. But the end was in sight. The last full year for this hospital was 1952. By then a new and much larger hospital was under construction, and when it opened in January 1953, Kings Mountain closed.

The hospital association sold the State Street properties two years later. The Dan Graham Bible Institute was interested in purchasing the old hospital building to house the school, which had organized in 1951. I attended a meeting held to consider this possibility in the Institute building at 15 Fifth Street (now demolished). Rev. Dan Graham had invited Arthur W. King to speak on the feasibility of moving the school. I remember speaking briefly in favor of the plan during that meeting.

For a time it appeared that all was going well toward the school's acquisition of property. Then it was discovered that Virginia had far more stringent requirements for the granting of degrees than did Tennessee. It was felt that the school could not at that time meet the requirements. Thus the plan was dropped, much to the disappointment of many Graham supporters.

A service station was soon built upon a portion of the southwest corner of the property, but it no longer stands. For a few years in the 1950s, the main building was used as a nursing home, but it moved into the smaller nurses quarters.

Today both buildings have been vacant for several years. They have been vandalized and are in a sad state of repair. From time to time, hopes have been raised that some beneficial use could be made of the buildings, but sadly those hopes have not been realized. Even in their present condition, they stand as a monument to the resoluteness of many Bristol citizens of years past who were determined that the city should have a fine hospital.

Bristol Memorial Hospital

When I arrived in Bristol in August 1953, the city was being served by a new hospital known as Bristol Memorial. It had been built because of sheer necessity. Kings Mountain had served the city for 28 years but just could not meet the needs of a growing population. In 1947, the hospital board, with the general approval and support of the medical community, decided that something must be done. In May 1948, a site and building committee was appointed, and on December 3, the board voted to purchase a site on Midway Street in west Bristol for the proposed hospital.

Bristol Memorial Hospital, named in honor of all war veterans, opened its $2 million, 132-bed facility on January 18, 1953, with Harvie Perkins as president of the hospital board. John C. Gilbert, who had served as superintendent of Kings Mountain, became administrator of the new hospital. Part of the new hospital complex was a doctor's office building that also housed a drugstore.

Ten years after the hospital opened, an addition brought the number of beds to 215, plus an additional 36 bassinets for newborns, along with a new physical therapy department. By early 1968, the hospital had expanded to 269 beds, and Memorial Hall had been added for extended-care services. Many of my readers may remember the underground tunnel connecting the two facilities, and somewhere in that tunnel the state line was crossed.

Bristol Memorial Hospital (now demolished) was opened in early 1953.

The region's first comprehensive cancer center opened in Bristol Memorial in 1977. In the early 1980s, two patient wings—Four South and Five South—were added, bringing the total bed capacity to 422. Through the years, many services were added, including an advanced cardiac care unit in 1988. Medical education and training was also a vital part of the hospital's overall programs.

In 1989 the name changed to Bristol Regional Medical Center in order to reflect the hospital's expanded range of services. But even as Bristol Regional Medical Center expanded its services and programs, plans were already afoot for an even larger hospital and comprehensive medical center.

BRISTOL REGIONAL MEDICAL CENTER

In September 1990, steps were taken for a much larger medical facility. Application was made to the Tennessee Health Facilities Commission for a Certificate of Need. The certificate was granted, and a site for the facility was purchased near the intersection of 11-W and Interstate 81 in Bristol, Tennessee. On May 20, 1991, a ground-breaking ceremony was held. To prepare the 120-acre site, the top of a large hill had to be removed and the area more or less leveled.

In January 1994, the $112 million, 377-bed hospital opened. Several related medical facilities have been erected near the hospital, giving Bristol a true medical center.

Bristol Regional Medical Center is part of Wellmont Health System, which also operates Holston Valley Medical Center in Kingsport and Lonesome Pine Hospital in Big Stone Gap. The state-of-the-art hospital, with its spacious and well-landscaped grounds is something of which Bristol may be justly proud.

MERCY HOSPITAL

As far as I can determine, the first and only black hospital to operate in Bristol was founded about 1919 by Dr. Rutherford B. McArthur, M.D., and Dr. Alfred White, a dentist. Dr. McArthur then lived at 433 Clinton Avenue in Bristol, Virginia, while his office was at 29½ Fifth in Bristol, Tennessee. Dr. White then lived at 825 Alabama in Bristol, Tennessee, and had his office at the same address as Dr. McArthur. Mercy Hospital, located on Garland Avenue, filled a need that had been evident for a long time.

St. Lukes, the only hospital in Bristol at that time, was strictly for whites—no exceptions—like most area institutions. The whites-only policy was very

grievous to Miss Jen McGoldrick, head of St. Lukes at the time, but there was little she could do. Seriously ill or injured blacks had to be treated in their homes, which had led to many untimely deaths. On rare occasions, some were taken long distances to larger cities that had hospital facilities for blacks.

There was a small settlement of blacks on Broad Street a short distance from St. Lukes Hospital. During a snowy spell, a young boy, about 10 years old, came down with pneumonia. Late one afternoon, he had walked home through a cold, blowing snowstorm from his school some distance away on McDowell Street. That night he came down with chills, followed by a high fever. His condition quickly worsened into a full-blown case of pneumonia, a serious and usually fatal condition in those days.

He was an only child, and his parents became almost frantic with apprehensive fear. They well knew they could not take him to St. Lukes, but in desperation and on the advice of Dr. McArthur, they sent word to Miss Jen asking her if she could help. Dr. McArthur was well acquainted with the skilled nurse and knew of her impartial kindness to the sick.

Her sister, Miss Lav McGoldrick, long told that as soon as word came to Jen, she put together what she considered essential supplies and medicines. She then quickly threw on her boots and heavy coat and took off as a severely cold dusk settled over the city. Before leaving, she instructed that nourishing hot food be sent to the family from the hospital kitchen.

It was three days before she returned to the hospital. If the sick boy could not be brought to the hospital, she would take the hospital to him, which she virtually did. Even after she returned to St. Lukes, she made twice-daily trips to continue her medical ministrations. The boy slowly recovered.

During the time she was staying with the boy's family, she did much talking with Dr. McArthur concerning the establishment of a hospital for the blacks of Bristol. Both had long felt that such a facility was desperately needed. Together they worked out the details. Time and again during the course of those long conversations, she used the expression "mercy should know no color."

In the following spring, she secured the use of a large, old unoccupied residence at 417 Garland Avenue at the corner of Sixth. Dr. McArthur and his friend Dr. White then set about the somewhat daunting task of opening Bristol's first black hospital. St. Lukes donated some unused furniture and equipment to the new institution.

Then came time for a name. Dr. McArthur, along with many others in the city, regarded Miss Jen as an angel of mercy. And he remembered her oft-used

A Good Place to Live

expression that mercy should know no color. Later he told that the word *mercy* stood uppermost in his mind as he thought on a name, thus came the name Mercy Hospital. And merciful it proved to be as it served the blacks in Bristol.

The first known superintendent of Mercy Hospital was Bessie Norment, who apparently resided in the hospital. There may have been one or two superintendents before her. By 1927, Vera Mosley had become superintendent. She was shortly followed by Ada M. Walker.

Dr. McArthur left Bristol about 1925. Later Dr. Alfred W. Thomas and his wife, Dr. Lelia M. L. Thomas, were at Mercy Hospital. Dr. Dudley G. Riggs, who had an office at 19½ Lee Street, also practiced at this hospital. He and his wife, Georgia, lived at 716 English Street.

In 1938, William M. Brown, who then operated Brown's Funeral Home at 310 Lee Street, was president of Mercy Hospital, W. A. White was secretary, and Eugene Brown was treasurer. Two years later, Dr. White, the dentist who had helped found the hospital, was serving as secretary and manager. Ada M. Guthrie (Mrs. Ernest A. Guthrie) still served as superintendent.

Though Mercy Hospital operated for blacks using a black medical staff, there were times when white doctors were called in to do specialized work. Ruby Harrington told me that about 1924, when she was 18, she was operated on in the Mercy Hospital for appendicitis. Dr. Nat Copenhaver and Dr. William R. Rogers, both white surgeons, did the operation.

Mercy Hospital ceased to exist about 1941, after many years of service to the black community of Bristol. The building no longer stands.

But the memories linger on. Mrs. Jewel Bell, a friend of mine who had operated the King College switchboard for over 50 years, told me an interesting story. As a child, she lived on Fifth Street Extension. Near her on Blackley Road lived her aunt Mrs. Nora Howard. One afternoon, Jewel was walking along Fifth Street on her way home from school. A cab from Carter's Taxi Service, a black cab company, came along, drew up to the curb, and stopped right by the puzzled little girl. Her aunt got out of the cab, embraced and kissed Jewel, then told her she was going to Mercy Hospital for an operation and wouldn't be back. She went on to tell Jewel that though she would be dead, she would still be around watching over her and protecting her from danger. This was meant to be comforting, but to a young child, the thought of dead person being around was very frightening. Jewel managed to say, "I love you," and then quickly fled toward home. Her aunt's premonition was correct. She did die at Mercy Hospital and is buried in the Tennessee Colored Cemetery off Weaver Pike.

Another black friend of mine told me that he was delivered by Dr. McArthur in Mercy Hospital. This was nothing unusual, but when it came time for his mother to take him home, she had no way to travel and no money to hire a taxi. Dr. McArthur called a cab, promising to pay the fare. The doctor had an intense distrust of taxi drivers, so he rode with the new baby and his mother to their home on McDowell Street. After seeing that the two were safely home, he had the taxi take him back to the hospital.

Trigg's Hospital • St. Ann's Infirmary

A small hospital operated here from about 1932 through 1939. At first known as Trigg's Hospital, it was located at 631 Euclid Avenue and was managed by Dr. Daniel Trigg and his wife, Mary, who lived at the same location. A prominent lawyer of the same name long practiced in Abingdon, Virginia, but I have been unable to determine if there was a connection between the men.

By 1934 the hospital had moved to 16 King Street, in Bristol, Virginia, and had become known as St. Ann's Infirmary. It was still operated by Dr. Trigg and his wife. The hospital seems to have closed about 1939, and apparently Dr. Trigg left Bristol about that time.

Years ago an informant told me that the hospital existed primarily for the care of the local Catholic families but that it also treated non-Catholics. I have no proof of the claim.

Staley's Hospital

Dr. Thomas F. Staley operated what some called a hospital at 26 Fourth Street. He was a son-in-law of Maj. Abram D. Reynolds. Dr. Staley was a practicing physician in Bristol by 1905, when he maintained an office at 418 State Street in the same building as Bunting's drugstore. At that time he and his wife, Sue, lived near the corner of Carolina Avenue and Taylor Street in a house that still stands, though it has been much remodeled. By 1913, he had moved to 510 Anderson Street. By 1918, he was living at 315 Woodlawn Avenue, where he lived the remainder of his residency in Bristol.

Early in his career, by 1910, he became a specialist in treating diseases of the eyes, ears, nose, and throat. Around 1920, he opened what is sometimes called an infirmary, at other times a hospital, at 26 Fourth Street for the treatment of such diseases. This hospital or infirmary operated in a rather plain but solidly built two-story brick house that had been a former residence of a Hammer family.

By 1924, Dr. Staley had taken Dr. Arthur Hooks as a partner. Dr. Hooks then lived at 115 Fifth Street, just a little over a city block from the hospital. By 1927 Dr. Arthur B. English was also connected to the hospital. He then lived at 501 Spruce, the former Major Reynolds mansion. By 1932 Dr. Hooks had moved to 1177 Holston Avenue.

Dr. Staley's wife, Sue, died in 1933 in a Richmond, Virginia, hospital from complications following an operation. Later Dr. Staley married Alda Carr Daniels, widow of Harry Daniels. She was an accomplished musician and at one time organist of the State Street Methodist Church.

Dr. Staley had retired by 1938 and was still living at 315 Woodlawn Avenue with his second wife. By that time, his former medical facility had become the Hooks and English Infirmary and was being operated by his former associates, Dr. Arthur Hooks and Dr. A. B. English. These two doctors were still practicing at that location when I arrived in Bristol in 1953 and for a few years afterward. However, I do not believe they were keeping live-in patients at that time.

It appears that Dr. Staley came out of retirement in 1942 and opened an office for private practice at 412½ State Street. I have been told that he finally went to live with his son in Detroit, Michigan, but died soon after going there. He was first buried beside his first wife in East Hill Cemetery. Later they both, along with the other members of Major Reynolds's family that were buried there, were moved to the Shelby Hills Cemetery.

When I arrived in Bristol, what I call the Staley monument was still standing. In the mid-1920s, Dr. Staley bought the former Joseph R. Anderson garden that bordered on Franklin Street—the street no longer exists—which ran along the north side of Anderson Park between Woodlawn Avenue and Fifth. On the lot he built a brick apartment complex in the then popular English Tudor style. It may have been designed by Reginald V. Arnold, a prominent local architect, who with his wife, Betty, long lived in the complex, first in apartment 4, then 6, and finally 12. The complex was finally set up as a home for retired missionaries and thus became a monument to the kind generosity of Dr. Thomas F. and Sue Reynolds Staley. Unfortunately it was demolished many years ago.

FLEENOR'S PRIVATE HOSPTIAL

Fleenor's Private Hospital was founded in 1926 by Dr. Charles Warren Fleenor and Dr. Jim Delaney in the former John R. Dickey home at 101 State Street in Bristol, Virginia. The house was demolished long ago, and the area is now used as a parking lot by First Baptist Church.

Hospitals

Dr. Fleenor was born on a farm near Benhams, Washington County, Virginia, on September 15, 1870. One day while working in a hayfield, he suddenly threw down his hayfork and exclaimed, "Boys, there's got to be a better way to make a living!" There was, and he found it.

His next step was to enter school at Holston Institute in Sullivan County. Upon finishing there, he enrolled in the Louisville Medical School and received his M.D. degree in 1893.

Not long after his graduation, he moved to the Holston Valley community in Sullivan County and began his practice of medicine, first on horseback and by buggy, and later in a Model T Ford. For the first six years in the Valley, he boarded in the home of Mr. and Mrs. Theophalus Thomas. In 1890, he built a two-story house on a farm he had purchased. Much of the labor building the house was done by those who owed him for medical services. The house is now occupied by his daughter-in-law, Mary Lou Fleenor.

In 1906, he married Josephine St. John of Chilhowie, Virginia. Two children were born to them, Carita Whitlock and Charles Warren Fleenor, Jr.

Dr. Fleenor had an office near his home for several years. About 1923,

Pictured on the right circa 1929 is Dr. Charles Warren Fleenor, who long operated Fleenor's Private Hospital on Main Street in Bristol, Virginia. Pictured with him are three of his neighbors, left to right, David O. Painter, a Mr. Stone, and Philip Painter.

he opened a small infirmary and office in the Dr. Nat Delaney Building on Shelby Street in Bristol, Tennessee. In 1926, he and Dr. Jim Delaney rented the former Dickey home and opened a small, private hospital there. Dr. Delaney soon withdrew from the organization, but Dr. Fleenor continued to operate the hospital until his death in 1936.

His hospital managed to operate through the worst part of the Depression, when many patients could not pay. And, of course, there were always those who were unwilling to pay. It was the opinion of his son that Dr. Fleenor subsidized the hospital from the proceeds of his medical practice along with food from the farm.

Given incentive by the fact that so many of his patients died from diabetes, Fleenor went to New York City and took a course in the control of the disease by strict diet. He was the first Bristol doctor to learn and practice this method of treating diabetics. Patients came from distant places to be treated by him for the dreaded disease.

It is fortunate that Dr. Fleenor's account books yet exist. From them one can gain an insight into the medical costs of that time. In 1934, a local man spent seven days in Fleenor's hospital. His bill, including medical treatment, amounted to $24.50. In 1933, one night in the hospital totaled $5.00. Room-and-board costs leveled off to $3.00 per day for adults and about $2.00 per day for children. Cost for the use of Fleenor's operating room was $10. Administering anesthetic (usually done by Dr. Dick Vance) also ran to $10. In 1935 Dr. Jim Delaney was performing operations at the hospital. He charged $45 for most types of surgery.

Dr. Fleenor was charging $1.00 to $2.00 for office visits. On July 22, 1934, the little daughter of Mrs. Betty Stewart of Harr, Tennessee, was bitten by a snake and brought to Dr. Fleenor for treatment. The charge was $2.00.

Dr. Fleenor is buried in the Cold Springs Presbyterian Church Cemetery.

GRACE MEMORIAL HOSPITAL

Founded by Dr. Albert J. Kimmons in 1926, Grace Memorial Hospital was located at 214 Eighth Street (corner of Anderson) in Bristol, Tennessee. He named the hospital for a daughter by his first wife, Mary Cowan Kimmons of Bedford County, Tennessee. He was assisted in the operation by his second wife, Mrs. Nannie Salts Kimmons, and her sister Eulalie Salts, daughters of J. M. and Susan Kern Salts. Mrs. Kimmons served as vice president of the organization, and Eulalie Salts served as secretary-treasurer. Other nurses helped with the work. A nurses home was maintained at 806 Broad Street.

Dr. Kimmons was born at Shelbyville, Tennessee—date unknown, for he would never tell his age—a son of J. D. and Grace Henderson Kimmons. He was of Irish decent and served in the U.S. Army during the Spanish-American War. He received his medical degree from Vanderbilt University School of Medicine and began his practice in Shelbyville. Later he transferred to San Francisco, California. He served for a time on the United States warship *Siberia*.

Dr. Kimmons came to Bristol in 1909 and established his medical practice here, at first in the Interstate Building on Sixth Street. A few years later he moved to room 210 in the Mahoney Building. In 1922 he was located at 600 State, room 210. Shortly he moved his office to 26 Sixth Street. In 1926 he moved his office into his new hospital at 214 Eighth Street.

He purchased land in the knobs overlooking the city of Bristol (Clifton Heights) in 1912 and there built his home, named Twin Peaks. Dr. Kimmons also owned and maintained a 500-acre estate at Shelbyville, known as Pleasant Grove, which he converted into a hunting preserve and game refuge. On this estate he had the only herd of buffalo in Tennessee. He also kept deer, elk, black-faced sheep, belted hogs, choice saddle horses, purebred Hereford cattle, and a collection of rare fowls.

During a part of World War I, he served as surgeon in the Charleston, South Carolina, Navy Yard. After his return to Bristol he married Nannie Salts on April 18, 1919.

As soon as Dr. Kimmons set up his Bristol practice, he advertised that his specialty was the private diseases of men and women, which was understood to mean any malady of a sexual nature—venereal diseases, malfunctions of the sexual organs, etc. But he went a step further than did most physicians who treated such conditions; he offered special treatments for female frigidity and male impotence, an area of medical practice then shunned by most physicians. Of course, he did not openly advertise treatments for those conditions, but he saw to it that the word of mouth publicized his special fields of treatment.

It was soon commonly known in the city that he also preformed special operations for women who did not wish to carry through with a pregnancy. Gaining a wide (though discreet) reputation, he was soon receiving patients from all over Southwest Virginia and East Tennessee.

At first his treatments were given in a sanatorium (actually his home) in the Clifton Heights section of town. After opening Grace Memorial Hospital, he continued there for the rest of his life.

For men who suffered from impotence, he had a theory that 99% of male impotence was caused by a psychological block. And, as he often expressed it, under the right "pressure" of an attractive female, the mental block could be "leaped over." So he engaged attractive young prostitutes to give his special form of treatment. At least one time, according to the disposition of a noted divorce case, he engaged a local housewife to aid one of his patients. He had known the woman for a long time and had noted that she had "special charms" along this line. It was not revealed how he knew of those special charms.

Dr. Kimmons also theorized that there was no naturally frigid woman; that the real trouble was with unskilled and overly eager men. Therefore, he concluded that with the right kind of "attention" from a man, any woman could overcome what seemed to be naturally frigidity. He considered himself to be an expert in helping women "to leap over the block," the same term he used for successful treatment of male impotence.

The reader may easily determine whom he chose to administer his treatment for female frigidity. In one case still openly talked of 50 years ago, his treatment of a local, shy housewife was too successful. A short time after she "leaped over the block," she left her husband and became a notorious prostitute. Indeed, she eventually opened her own three-stall house of ill fame.

For the relief of male impotence or female frigidity, Dr. Kimmons at first charged $300. But he gave a "grace period" to see if the cure was complete and permanent, and if the treatment failed there was no charge. One old man, yet living here in 1954, told me that it took him four years to pay off a loan he had obtained for what he called his "very successful jumping the block."

For the "canceling out of pregnancies," as he termed it, his charges varied, often according to the ability to pay. If a prosperous man got a girl in trouble, the charge for her relief might be $1,000, but the usual rate was $500. Many men about impoverished themselves paying for their moment of indiscretion, and some women did likewise. Dr. Kimmons did do some charity work. The pastor of a little storefront church here became overly friendly with a divorced woman in his church. She became pregnant and threatened to expose him if he didn't get her free from her condition. The poor man barely existed financially. In panic he poured out his tale of woe to Dr. Kimmons. The doctor, realizing that the erring minister was about to be ruined, kindly did the operation free of charge. The minister, who later left his calling, was the driver of the first taxi that I ever hired in Bristol.

Dr. Kimmons became rather wealthy, but he was very generous. His larger

gifts were nearly always anonymous. He is said to have given heavily toward the construction of the Anderson Street Methodist Church. And he anonymously gave $2,000 for the building of a fence around a then struggling local golf course.

Though many people frowned upon the unusual medical practices of Dr. Kimmons, in time, and against heavy odds, he became socially accepted in Bristol. Some of the most elite and prominent of the city became his close friends.

A while before Christmas 1940, Dr. Kimmons suffered a severe heart attack. He lingered for a few weeks and then died at his home at 2:30 A.M. January 5 (some say January 6), 1941. His funeral was held at the First Presbyterian Church at 3:00 P.M., January 7, after his body had lain in state at Grace Memorial Hospital until near that hour. Dr. H. H. Thompson, pastor, and Rev. Kyle Creggar conducted the service, assisted by members of the King Masonic Lodge of Bristol and the Masonic lodge in Shelbyville, Tennessee. Dr. Kimmons had long been a member of the latter lodge before moving to Bristol.

Active pallbearers were Dr. E. H. Hearst, George M. Warren, Frank W. DeFriece, R. J. Mottern, Joseph A. Caldwell, Henry Hayner, Carl A. Jones, and Dr. Nat Copenhaver. The list of honorary pallbearers is rather impressive and includes a long-time pastor of the First Baptist Church and many other leading citizens. Probably the best known were C. J. Harkrader, who later wrote the much read book on Bristol, *Witness to an Epoch,* and Dr. S. E. Massengill.

Dr. Kimmons had a strong aversion to being embalmed and buried in the ground, so he had bought an above-ground vault. After his casket was placed in the vault, a granite lid was placed on top, but it failed to tightly seal. All was well for the rest of the winter. Then came a warmer weather, and an offensive odor began to seep from the vault and was carried on spring breezes for as much as a mile away. The problem was solved when the lid was pried up and the vault was flooded with embalming fluid before being resealed.

Grace Memorial Hospital closed on February 28, following the death of Dr. Kimmons. At the time, it was stated that the hospital might reopen at a later date, or it might be sold, or Mrs. Kimmons might make it her home. The hospital did not reopen, and Mrs. Kimmons died later that year on July 15 or 16, 1941.

The building was demolished when Anderson Street was widened to four lanes.

A Good Place to Live

The antique Victorian bed that belonged to Dr. Kimmons came into the hands of a friend of mine. She made me a loan of it, and I used it for several years in my home at Pleasant Hill.

Dr. Kimmons has now been gone for over 60 years, but because of his unusual works, he is not forgotten.

Fort Shelby Hospital and Grigsby's Hospital

When I arrived in Bristol in 1953, two small hospitals were operating here and are still often spoken of by many local residents. Both were open by 1946, and both had closed by 1970 (likely a few years before that time).

Dr. Allan K. Turner operated the Fort Shelby Hospital for maternity patients at 200 Solar Street in Bristol, Virginia, in the former John N. Huntsmen home built in 1910. Shelby Manor, a rest home owned by Eddie and Laverne Canter, now occupies the grand old Bristol landmark. Often yet, someone will tell me that she or he was born there. A few years ago a lady came back to Bristol from Alabama and asked me to direct her to where her son was born some 35 years earlier. She was pleased to see the place again.

In the early 1940s, before he opened the hospital, Dr. Turner operated a children's clinic at 213 Seventh Avenue in Bristol, Tennessee. He and his wife, Pearl, long lived at 1001 Prospect Avenue in Bristol, Virginia.

Dr. Bernard C. Grigsby operated a hospital at 308 Moore Street in Bristol, Virginia. The original part of the building was the old Madison Jones home, built about 1860 by pioneer Bristol settler George W. Blackley. Jones left Bristol shortly after the Civil War began, and R. T. Lancaster bought the house. He then sold it to Dr. Richard M. Coleman, and after Dr. Coleman's death in 1870, druggist Jeremiah Bunting lived in the house for many years.

A myth developed that the building was once the home of Col. John S. Mosby. Even though the claim has been cast in metal and displayed on a state historical marker (the marker no longer stands), it is still a myth.

In later years a large addition was built on the back of the original house and the whole turned into apartments. Then Dr. Grigsby made a hospital of it. It was largely a maternity hospital but did take in other type cases. Often I hear folks tell of being born there.

After the hospital closed, the old building quickly deteriorated and was finally demolished. Later a modern office complex was erected on the site.

Dr. Grigsby later maintained offices in the Professional Building on Edgemont Avenue in Bristol, Tennessee. He and his wife long lived in a house called Owl's Nest on Arlington Avenue in Bristol, Virginia.

Hospitals

Yopp's Sanitarium

Around 1913 Bristol had an institution for the treatment of people addicted to liquor and drugs. Known as Yopp's Sanitarium, it was located on the corner of Lee and Mary Streets. Its letterhead does not specify which corner, but it was likely in the old brick house that still stands on the southeast corner of that junction. The house on the opposite corner was then occupied by C. C. Minor.

An old bill for services rendered at Yopp's Sanitarium lists A. J. Yopp as president, Frank G. Dawson as manager and treasurer, and Dr. Harvey Robinson as the resident physician. The mailing address was P.O. Box 575 in Bristol, Virginia. There were two telephone companies in Bristol at the time, and the institution was connected to both with numbers 560 and 583. According to the letterhead, the sanitarium also had a location in Norfolk.

The bill was for $100 plus 50¢ for the pressing of clothes. The length of the patient's stay is not given but was likely for one month. Alas, other correspondence found with the bill indicates that the treatment was not successful.

From what I can determine, Yopp's Sanitarium did not long operate here.

Adair's Hospital for Animals

As far as I can determine, the first animal hospital in Bristol was opened by Dr. Hugh H. Adair at 111 Water Street. Known as Adair's Hospital for Animals, it was operating by about 1917 and had ceased to operate by 1923.

Dr. Adair was practicing his veterinary skills here by 1912 and was first located at 107 Water Street. At that time he was meat and milk inspector for Bristol, Virginia. In 1918 he was rooming at 818 Cumberland Street, in the home of Clarence P. Moore. By 1921 he had moved to 310 Park Street.

Even after he opened his animal hospital, he continued his position as city meat and milk inspector. As late as 1932, Dr. Adair was still city meat and milk inspector, with an office in room 5 at what we now refer to as the old city hall.

By 1936 he had joined forces with Dr. F. A. Jones in the firm of Adair and Jones at 107 Water Street. Records of the U.S. Postal Service show that he was appointed acting postmaster of Bristol, Virginia, June 22, 1933, and as postmaster on May 28, 1934. He served in this position until June 1938.

By the early 1950s, Dr. Adair had died, but his widow, Crate, was still living in the family home on Arlington Avenue.

A Good Place to Live

Bristol on Wheels

What would the world be like without wheels? Bringing it closer to home, what would Bristol be without wheels? Indeed, Bristol exists because of wheels. The coming of the trains caused the founding of the city, and the city continues largely because of wheels.

The fastest travel on wheels in Bristol at the beginning of the 20th century was by railway or streetcar—and streetcars did not move at great speed. All other means of transportation available at that time can be described with one word: *slow*. Bristolians traveled much as had their forefathers before them— on foot, by horseback, or with vehicles drawn by horses, mules, or oxen.

About every business day, and especially on Saturdays, downtown Bristol was clogged with horsemen and animal-drawn vehicles of about every description imaginable, ranging from fine manufactured wagons, buggies, and surreys to crude makeshift means of conveyance. Among the latter was a two-wheeled, handmade cart that appeared in town just about as regularly as the coming of Saturday.

Carts at that time were not uncommon, but what made this one unique was its solid wheels, made of about eight-inch-wide cuts from a round log. Rough trip it must have been. The donut-style cuts from the log were not perfectly round, and the out-of-round portions had not been matched to the cart. Thus one side lurched upward while the other went down, and the cart steadily rocked back and forth along the rugged road.

The heavily bearded old driver, known to everyone as Uncle Jeems, lived on Holston Mountain, somewhere near the head of Sharp's Creek. Every Saturday morning he left his home by rooster-crowing time and began the long journey into Bristol in his cart, pulled by a team of oxen named Buck and

Before the era of the automobile, many Bristolians traveled in the manner shown here. Dr. A. M. Carter and his wife, Nannie Zimmerman Carter, occupy the seat of this buggy, circa 1890.

Ball (perhaps Bawl). Everyone knew their names because every few feet Uncle Jeems cracked the whip over their backs and yelled out, "Get along, Buck. Get along, Ball."

Ostensibly, Uncle Jeems came into Bristol to peddle produce. His cart might hold apples, green beans, roasting ear corn, watermelons, and such. Later in the season, he might have large pumpkins, dried fruit, cured meat, and heavy bundles of hay. But likely the most profitable product in his "rock-a-by cart," as Old Dad Thomas called it, was not visible. A box covered by a loose board in the bottom of his cart always contained high-powered, quick-acting moonshine, which he discreetly sold to select customers.

Today cars line the streets and fill parking areas that in the early days were filled with wagons, buggies, and carts, along with whatever draft animals might have been used to pull them. The latter were tied to hitching rails or staked down, or if more than one person had ridden into town on the vehicle, someone might have been left to hold the animals in place. Most merchants provided hitching rails in front of their stores for the benefit of their customers, for not offering such a rail was an almost certain road to business failure.

Sometimes folks would use the hitching rail in front of one store then go to another popular store nearby where the rail might be full, which galled the shunned but used merchant. Heated verbal confrontations often ensued, and hard fights occasionally erupted between a shunned merchant and roving

A Good Place to Live

shopper. Old Dad Thomas told me that he saw E. H. Seneker, whose store was on the northwest corner of Main (State) and Lee, throw a man back in his wagon during a spirited fight over this situation.

During the earliest years of Bristol's existence, traffic was uncontrolled, often resulting in confusion and chaos. Certainly, there were no stoplights for wagon traffic or other animal-drawn vehicles. Nor did a mounted horseman ride up to an intersection and have to wait for side traffic to clear. Some folks all but raced horses through town, and speeding animal-drawn vehicles were a daily hazard. To add to the danger, Main Street was often beset with great clouds of billowing, blinding dust; the low visibility created dangers for man and beast.

The hazards of uncontrolled street traffic finally caused the passage of ordinances designed to create safer conditions in downtown Bristol. In the 1870s, laws were passed governing the speed of horses ridden along the clogged streets. Another law was passed at about the same time forbidding the feeding of horses or mules "parked" at the curbs.

No laws were passed concerning the direction of traffic flow. The town had no one-way streets; all were "any-way" streets, that is, just any way the driver or rider wished to go. Thus, a trip along those streets required a constant

This was the manner of moving freight before motorized vehicles came into use. This picture of a wagon and its very young driver was made on Cumberland Street about 1900.

weaving back and forth in an effort to dodge those coming and going in other directions. All the while, mounted riders tried to avoid collisions with vehicular traffic. Indeed, Bristol had some exasperating traffic jams in those days.

In rainy or thawing seasons, wagons, especially those bearing heavy freight, bogged down in deep mud, frequently blocking traffic for long periods of time. In dry times, clouds of fine, blinding dust billowed upward from the streets, making it difficult for drivers or riders to weave in a safe path along their hazardous course. Collisions were common and often led to injuries to people or animals, as well as property damage.

Sometimes there were other "complications." Minnie Faidley Bridgeman, one of my informants of long ago, used to say, "When them wagons run together, the drivers would often fight a while before moving on." The earliest traffic fatality of which I have record occurred in 1871 when a freight wagon rolling through a blinding dust cloud knocked down and ran over a man who was attempting to cross Main Street at what is now Lee and State. The man, apparently a stranger in town, was never identified and was buried in East Hill Cemetery.

The hazards to all forms of traffic were ever present, with pedestrians especially vulnerable. During dusty times, there was always the possibility of a wagon or buggy suddenly bearing down upon someone, greatly endangering life and limb. An old newspaper clipping of about 1905 tells of such a happening on Lee Street near State. An old lady crossing the street was run down by a buggy driven by Mrs. Ellen Carmack Hart, who then lived at what is now 2004 King College Road. Mrs. Hart had driven into town to sell or trade a two-week collection of eggs. Fortunately, the accident victim was not seriously hurt.

Yes, women did drive horse-drawn vehicles on the streets of Bristol in those days, and some of them were branded as "speedsters." Mary Preston Gray told of her friend Mrs. Herb Peters, who used to drive all over town, sometimes a little too fast. Miss Gray delighted to tell how her friend would stop her "extra fine buggy" on Lee Street just under her husband's second-story law office window and call up to him, "Herb! Oh, Herb, throw down a silver dollar, I'm going shopping." Mr. Peters would toss down a dollar, never missing the buggy. She could buy several articles for a dollar in those days, with perhaps a little change left over.

Many people living in or near Bristol walked downtown in order to avoid the congestion and hazards of heavy traffic. But walking could be more dangerous than driving a vehicle, especially in dusty times. Nat Henderson, long

A Good Place to Live

a familiar figure on the streets of Bristol, tried to make his passage through the dusty streets a bit safer. He carried a ram's horn, which he would about constantly blow when walking through dust clouds. Sometimes others followed close with him, hoping his safety device would prevent injuries. Alas, the sounding of his horn sometimes created just the opposite of the desired effect, when nearby teams became frightened by the unfamiliar sound and ran away, creating a greater danger for all concerned.

The possibility of danger and congestion was not the only thing that caused many Bristolians to walk to town in those days. Then as now, space was a real problem. Some of the local residents who possessed fine horses and buggies left them at home and walked into the downtown section of Bristol. Even some of the larger churches did not have adequate parking room for horse-drawn vehicles. Thus, many locals walked long distances to church.

In the late 1800s, a streetcar system was set up in Bristol and was much used by those who did not want the hassle of downtown congestion and parking woes. On Sundays, many rode the streetcars into the center of town, where most of the larger churches were located. As valuable as the streetcars were to the city, they too often posed a hazard. The track ran down the center of Main (State) Street, and on either side were stretches of unpaved road. During dusty times, streetcar operators moved very slowly and just about constantly sounded the horn, warning of their approach. Even so, accidents did occur.

In the middle of one blinding dust cloud, a streetcar hit a wagon loaded with chickens when the wagoner attempted to make a hasty crossing of Main from Sixth (on the Tennessee side) to Moore (on the Virginia side). The wagon was demolished, breaking open several chicken crates. Dozens of chickens scattered all over that area of town. It was a hot summer day, thus many merchants had their doors open. Chickens ran into some of the stores, flying and jumping about and, in some cases, damaging merchandise. Not a few were grabbed by persons on the street who did not seem prone to return them to the owner. The reader may reasonably assume that fried chicken or chicken and dumplings were served on many a Bristol table that night.

A similar accident happened when a wagon hauling watermelons pulled into the path of an approaching streetcar near the State Street Methodist Church (State at James). Alas, the melons were so crushed that few were salvageable. Watermelon laced with street dust did not make an appetizing morsel.

Bristol did not have many real carriages in those pre-automobile days. When the word *carriage* is used in early writings, it often refers to a fine

buggy or surrey. A real, enclosed carriage was somewhat of a status symbol, implying wealth and prominence. Rev. James King owned a real carriage in which he rode about over the new town. Much later, his daughter, Melinda King Anderson, owned one that is said to have been finer than that owned by her father.

Capt. J. H. Wood, who lived in my present home, owned a fine carriage made by Brown Brothers, formerly of Rogersville, Tennessee, but later of Bristol, Virginia. In his backyard was a carriage house and stable with doors opening onto King's Alley (formerly the stage road). His coachman was Peter Jefferson, a former slave, who was also Captain Wood's gardener and yardman.

The carriage, painted dark blue and trimmed in gold, was used to transport Jefferson Davis about town when he visited Bristol in the early 1870s. Davis was entertained in Wood's home at the time and occupied the bedroom over the north parlor.

When Captain Wood left Bristol about 1901, he sold the carriage to Maj. Henry Clinton Wood, his unmarried brother, who lived at 616 Anderson. (Clintwood, Virginia, was named for this brother.) The house was occupied by the Weaver Funeral Home when I came to Bristol in 1953, and the Haven of Rest Mission now occupies the site. Juliet and Sally Wood, maiden sisters who lived in the major's home, delighted to ride about town in his grand carriage. After he died in 1909, the sisters used the carriage for a few years, then sold it to someone in Abingdon, Virginia.

There were perhaps two other fine carriages in Bristol at the turn of the 20th century. One was owned by Maj. A. D. Reynolds, who preferred to ride his great white horse, but his wife and family often used the carriage. The other belonged to Col. J. M. Barker, who supposedly sold it to an out-of-town party soon after building his home on Spruce Street in 1903.

Many Bristol homes had horse stables in the backyards, often connected to the buggy shed. Of course, feed had to be bought from nearby farmers or from feed dealers in town. V. Keebler, an early pioneer settler of Bristol, was a principal supplier of stock feed.

Some horse owners rented pasturage near town. The Susong meadows (in the vicinity of present Euclid, Highland, and Fairmount avenues and Park Street) were much used for this purpose. Many town horses were also kept in highland meadows on Big Buck Ridge along what is now Massachusetts and Rhode Island avenues. Of course, horse owners found it inconvenient to go so far to get their horses when needed.

A Good Place to Live

Fathers often sent grown, or near grown, sons for the horses or mules when needed. Ed Faidley used to tell of how one family (named Collins) lost an 18-year-old son. The young man, evidently discontented with his family and home, seems to have read of distant and exotic places. A little after noon one day, his father sent him to Big Buck Ridge to bring a horse home. Hours passed but he never returned. Greatly alarmed, his father went looking for him, but neither the boy or the horse could be found. It was a quarter of a century, after both his parents had died, before he was heard from again. (It was said that the mother died of sorrow two or three years after he disappeared.)

He returned to Bristol in 1924 to visit his one remaining sister. While here, he told that on the day of his disappearance, he had hidden in a grove of trees near the present King Memorial Church (in the King Town area) until well after dark. At suppertime, he became hungry and almost relented and went home. But his determination to find a new life reasserted itself, and he began a long journey southwestward. At first, he hid out in the daytime and traveled at night. After he reached Fayetteville, Tennessee, he began riding days. He virtually lived on what produce he could find on wayside farms. He told that he made it fine until he reached the arid sections of south Texas and then almost perished making the last 100 miles. His journey finally ended near Harlingen, Cameron County, Texas, some 1,400 miles from Bristol. He first worked for others but finally went on his own and enjoyed abundant prosperity as a prominent fruit grower in the fertile Rio Grande Valley.

Several local men made good money by keeping mules with which they plowed gardens and truck patches for local residents. Road grading and other construction work at the turn of the century also used horse and mule power. It is amazing but true that the railroad, all the way from Lynchburg to Bristol, was graded by the use of such power.

Today, travelers using public transportation often find themselves in distant places where they often depend upon rental cars. There were wheels for rent in early Bristol, along with the necessary power to turn them. Livery barns offered buggies and horses for rent to those who needed them. As rental companies now have rules and regulations for the use of their cars, so the livery barns had rules for their horses and buggies. I once had, and may yet have, a printed card of rules and regulations handed to each customer by Moore and Hart, livery operators in Bristol, Virginia. The rules stipulated that buggies were not to be overloaded and were to be returned in clean and operable condition. They were not to be taken through dangerously flooded streams nor raced on rough roads. They were not to be kept in barns or sheds

at night, but were to be parked at least 100 feet from such structures, due to possible fire hazard.

Rules for renting horses were similar. A horse was not to be ridden or driven over 25 miles in one day. (I wonder how the livery operators checked the mileage!) No horses were to be raced. They were to be watered and fed when needed. They were not to be driven or ridden into flooding streams, and were to be kept in open pastures at night, safely away from barns and other structures. Again, fire hazard was the concern. Moore and Hart even thought to add a stipulation that the cost of treating snakebites would be the obligation of the renter.

The firm of Moore and Hart began (by 1896) as Clarence P. Moore & Company at 208 Moore Street and by 1902 had moved to 19 Lee Street. By 1905, Moore had partnered with his wife's brother, Joseph C. Hart, and the business had moved to 111 Water Street. At the time, Hart was rooming on Taylor Street, likely in the home of Moore, who lived at 52 Taylor. The firm later moved to 113-115 Water Street.

About 1915, the partners yielded to the times and changed over to the automobile business. Hart lived at 409 Lee, and Moore lived at 818 Cumberland Street. Moore's widow, Bessie G. Hart Moore, died sometime in the 1980s at the age of about 108. She last lived at 804 Park Street in Bristol, Virginia.

During the first quarter of the 20th century, several persons tried operating livery stables or barns in Bristol. For a while, W. H. Fleenor worked as a liveryman with Clarence P. Moore & Company. By 1901, James M. Thompson had opened stables at 117 Seventh Street, not far from his home at 100 Seventh. Around 1900, Charles L. Worley, of the pioneer Worley family of this area, had a livery operation on Lee near Cumberland Street. A little later Herman D. Gibson set up stables on Cumberland. He then lived at 55 Third Street, one of the best residential sections of Bristol. Edward Scott came on the scene with an operation at 17 Lee Street. He lived at 60 Pennsylvania Avenue. Another liveryman was R. M. Hunt, whose place of business was at 116 Lee Street. He lived at 221 Oak Street, a rather elite section at the time.

By 1910, S. L. Millard of 4 Mary Street had a livery at 511 Sycamore Street. He came from one of the oldest pioneer families in the Bristol area. One of the last of the livery operators here, he remained in the business until about 1925.

Oscar L. Cross, a liveryman of this period with a large operation at 513-515 Sycamore, lived at 511 Scott Street. By 1913, John F. Holt and James Snapp had taken over the R. M. Hunt business at 116 Lee and renamed the

company Holt and Snapp. Both men roomed at the local YMCA. Carter R. Chalmers operated briefly at 122 Lee Street.

By 1918, W. B. Kilgore and Son had opened stables at the corner of Shelby and Eighth Street. Kilgore and his wife, Laura, long lived at 1225 Spencer Street. The business continued until about 1930, outlasting all other livery stable operators. In its final years, the company was operated by N. T. Bray and finally by Bert Music.

Livery stables did not operate solely for the purpose of renting out vehicles and horses. They also boarded horses for varying lengths of time, and more than one had campground space that they rented out to wagoners who came into town and needed to stay one or more nights.

The era finally ended but the livery stables did much to keep Bristol on wheels. With the gradual increase of the automobile age in Bristol, horses and horse-drawn vehicles began to decrease. But even into the 1920s, horses, wagons, and buggies could occasionally be seen in downtown Bristol. A few people yet live who can remember a slight resurgence of such traffic during the worst of the Great Depression, when many people—mostly farmers from the surrounding area—lost their trucks and cars or could no longer afford to fuel them. But in the city, most who fell into that category walked wherever they needed to go. At least one local doctor was so affected by the Depression that he walked when making house calls. He also walked from his home to his office each day, a distance of a little more than a mile. He later said that he never felt better than when he was forced to walk almost everywhere he went.

Before she died, Edith Davis, a friend of mine, told that when the Depression gripped the land, her parents had to decide between a cook and a car. Her mother, from an aristocratic Philadelphia family, had always been used to the services of a cook, so they decided the family would park the car in order to keep paying a cook.

THE ERA OF THE AUTOMOBILE BEGINS

The era of the automobile began in Bristol in 1903 with the purchase of a new Locomobile Steamer by James King James. And you who live here today well know what "a great oak from this little acorn has grown."

James King James, commonly known as King James, was a son of the second marriage of pioneer Bristol merchant W. W. James, formerly of Blountville, Tennessee. W. W. James had first married Mary E. Davis, who was the mother of his first family, which included Laura Lucretia, wife of Capt.

J. H. Wood. James's second marriage, in 1858, was to Mary Jones of Lee County, Virginia. By her, he fathered four or five sons, all of whom died young (one by suicide) except James King James, who was named after Rev. James King of early Bristol fame. With the unusual name of James King James, he usually signed as J. King James.

By the time of his death in 1901, the father, W. W. James, had become rather wealthy. Doubtless, it was some of that inherited wealth that figured in the acquisition of Bristol's first automobile. At the time of the purchase, King James lived at 57 Scranton Street in Bristol, Virginia. I say *his purchase*, but it was only partly that. Information later given by his widow, Julia Kendrick James, informs us that it was partly won on a bet. King James had a friend living in Knoxville, Tennessee—Mrs. James thought his name was Whitson—of marked financial means. On April 7, 1903, James went to Knoxville on what his wife called a "minor business matter." That trip had the unexpected result of introducing a big business in Bristol. While there, he called on Whitson, who was delighted to see him and invited James to a nearby saloon. Although James had been raised as a bone-dry Methodist, he had become a moderate drinker, and he accepted the invitation.

James King James ushered in the automobile era in Bristol when he bought a Locomobile Steamer in 1903. In a short time he opened the first automobile agency in the city.

Both men became a little tipsy, and Whitson told of his recent purchase of a new Locomobile Steamer. After another round of drinks, he offered to bet James the car for a payment of only $50.00 and a correct guess as to its color. In later years, James often told this story and said he almost said black, which was the usual color of cars in those days. Then the thought came to him that such a guess was too easy. So the next color that "popped in his mind" was red. He won the bet. He had only 20 or so dollars in his pocket, but his friend offered to take payments. So Bristol's first car was bought on the easy-payment plan. Sound familiar? How many times have easy-payment

A Good Place to Live

Bristol's first automobile moves slowly along State Street, near the corner of State and Moore. By present standards this car is on the wrong side of the street, but it didn't matter then.

plans been set up in Bristol during the past century? The receipt for the final payment is dated June 4, 1903.

In the years that followed, King James became a compulsive gambler and drinker, which caused him to lose the ample fortune he had received from his father. According to his own statement, his gambling habit began with that first and successful bet in Knoxville. Heavy losses caused him to turn more and more to the solace of a strong drink. So the foundation of his local fame became the cause of his downfall.

The fact that King James started Bristol's automobile era in 1903 is beyond dispute. Later that year he opened the city's first automobile dealership. His dealership was not as we know them today; he had no showroom or lot on which to display a number of cars. His Locomobile Agency was a one-room office in the Spurgeon building where he kept well-illustrated brochures and a catalog describing available vehicles. Try as he would, though, he did not make his first sale until more than a year later, when Dr. N. H. Reeve bought a car in October 1904. But it was not Bristol's second car. By that time, James King Brewer had purchased a gas-powered Ford. The house were Brewer then lived still stands next door to me at 220 Johnson Street.

King James did not drive his first car from Knoxville to Bristol, because such a trip would have been difficult due to the condition of the roads at that time. He wanted that car home and wanted it fast. In those days, Railway Express sometimes made special arrangements for items too large for the express car by attaching a flat freight car to the rear of a regular passenger train. And that is the way Bristol's first auto was delivered to town. The transportation of the vehicle to Bristol cost more than the amount of the purchase.

When James learned which train would be delivering his much prized car, he passed word around, inviting all to come to the depot to watch the car arrive on April 11, 1903. Most Bristolians had never seen one, and many had not the faintest idea what the contraption would look like. The word spread quickly, so not only the city folks, but also those in the surrounding area knew about the upcoming, exciting event.

According to Old Dad Thomas, who was there, the day dawned clear and warm. Well before sunrise, folks began to gather at the depot, some of them from far into the countryside. Among the latter was Philip Painter, who lived in the Holston Valley and would in a short time own the first car in that prosperous section of Sullivan County. He passed some of the details of events that morning to his daughter, Carrie Painter. An anxious and expectant crowd waited, all wanting to see what most of them considered more of a novelty than a dependable means of transportation. By the time the first faint wail of the whistle was heard from the rapidly approaching train, the crowd had covered the platform and had lined up by the track far into Tennessee. Others had assembled at the freight depot across the tracks to the east.

According to Philip Painter, the train ground to a halt at the Bristol depot at 8:23 A.M. The flatcar bearing the Locomobile Steamer barely cleared the State Street crossing. And there Bristolians and their country neighbors got their first look at Bristol's first automobile. An era had begun that continues to flourish to more than a hundred years later.

Before the automobile could be unloaded, the flatcar had to be detached, pulled back into Tennessee, and put on a sidetrack by the switch engine. The Locomobile was then rolled down heavy planks into the lot formerly occupied by the Tennessee depot on the corner of Third and State. Symbolically, the coming of the automobile signaled the end of rail passenger service for the city, though it would be 68 years in coming.

Several old-timers gave me a description of the Locomobile Steamer. It was dark red with black accent stripes its full length and had no top. Clearly, it was meant to be kept in a shelter. The seats were well upholstered with

leather that had been dyed black. The cover of the dashboard matched the seats. A ten-gallon boiler, constructed to withstand 160 pounds of pressure, provided the steam power. (One hopes it had a safety valve!) It had a rear seat that would hold two persons if they were not too large and didn't mind being tightly wedged together. The wheels were of heavy wire with solid rubber tires. The ride would be rather rough, especially over uneven or rocky roads.

Once the vehicle was unloaded, the proud owner proceeded to "fire up," preparing for its first Bristol run. At that point, much of the crowd quickly dispersed; some in the number actually ran. Talk had circulated that "the thing" might explode. As one old lady was heard to say in her hasty retreat, "Why, that thing might blow up and plumb destroy this end of town," presumably with her in it.

In October 1953, Old Dad Thomas stood at what he thought was the exact spot where the car was unloaded, and told me "the rest of the story."

> Now, sir, when young King got that thing steamed up rat good, he asked who wanted to be first to take a ride. The first one to step up was old Parson Burroughs—you know, that marryin' man. He got rat in the thing lack it was a buggy and sot down, jist grinnin' like a kid playin'. But you know, sir, when that thing started to move off toward State Street, he plumb lost his nerve, I guess. He riz up and jumped out of that thing like a scared hen off of her nest. He took up Third Street in sort of a lively trot. Later he told that he got to thinkin' that thing might not could be stopped, and no telling where it would take a body. Maybe plumb to Narth Caroliney. But some others did ride that day, and they held their seats when the thing rolled out. As I recollect, Ed Faidley was the next one to get in.

Ed Faidley's daughter, Minnie Faidley Bridgeman, later gave me much information about Bristol. King James did spend several days taking his friends for rides about. Once the local folks learned the automobile could be stopped and wasn't going to blow up, they just about took all the owner's time riding in the "kerosene buggy," as some called it. Rides must have continued for some time. Maggie English wrote in her diary of taking a ride in the car on November 29, 1905. One hopes the day was mild, as the vehicle offered no protection from the elements.

Although the Locomobile was the first car to be owned and kept in Bristol, and the first one that most of the residents saw, it was not the first

to pass through. A short time before James bought his Locomobile, a man from Georgia (perhaps Atlanta) drove a car of some type into Bristol. He was promptly arrested and fined for speeding (going faster than a buggy) on Bristol's State Street. He might have been moving 15 miles per hour—likely less. Once fined and released, he immediately drove out of town, presumably at a safe speed!

At first, King James kept his car in a cowshed back of his home on Scranton Street. About three years later, in 1906, he erected a house at 53 James Street on the southeast corner of James and Cumberland. In the basement, doors opened on Cumberland Street, and there he had Bristol's first in-house car garage.

And what became of Bristol's first automobile? Fred Sheen, a local insurance man, came into possession of it. Some say he won it on a bet, while others say he bought it. He used it for a few years and housed it in a shed behind his home that yet stands on the southwest corner of Moore and Quarry Streets. James later got it back, likely when someone traded it in on a new vehicle at his car agency. By that time, he had some idea of its historical value, and he vowed he would keep it for the benefit of posterity. He kept it under wraps in his home garage, parking his current car on the street. But the best intentions of men often go astray, a situation especially true of men who cannot resist a good bet.

By the mid-1920s, James had become a compulsive gambler, sometimes winning but more often losing. He became good friends with a traveling salesman from Baltimore who frequently had business in Bristol, and evidently, they also became gambling partners.

Around 1925, in the salesman's room at the Hotel Bristol, James bet that his friend could not guess the purchase price of the car. If he could, James would give him the car. (I have no record of what James would have won.) According to his widow, Julia, he was sure the man would rely on the original selling price of some three or four hundred dollars, whereas the car had only cost $50 plus the winning of a lucky bet. It is likely that James had told his friend of this but had forgotten that he had.

The friend won the bet, and Bristol's first car left the same way it had come, by rail. This time it went by regular freight rather than by flatcar express. Mrs. James told that the salesman then began collecting old cars and eventually had one of the largest collections in the United States. I could find nothing further about Bristol's first automobile. Since it was part of a noted collection, the possibility is strong that perhaps somewhere it may yet exist.

A Good Place to Live

When King James Brewer became owner of the second automobile in Bristol, he had a problem—there were no gas stations in the city or even in the area. Consequently, he had to order fuel by the barrel from Knoxville or Richmond, which created another problem. The railroads would not carry barrels of gasoline in the same car as other freight. Shipments of gasoline, in whatever amount, required an entire car or flat for whatever the railroad considered a safe manner of conveyance, which made for a heavy freight charge, much more than the cost of the fuel itself.

And Brewer had another problem. His wife, Olive Carlock Brewer, would not allow him to store the gasoline anywhere near their home at 220 Johnson Street. Someone had told her that if it should explode, "there wouldn't be a thing left on Solar Hill." Brewer, a rental agent, luckily had a small, vacant house on Wood Street (now Piedmont), so he stored his gasoline there.

By 1907, gas was available in Bristol, but only in meager amounts. Even then, the city had no service stations. The few car owners in town at that time came together and ordered a few barrels to be delivered in one rail car, which saved a great deal on freight charges. The first gas pumps (hand operated) were put in by car dealerships, feeling that gas must be available if cars were to be sold. The first bulk gasoline dealers in Bristol were R. H. Devault, Hoge Brewer, and George H. Clyce. Sinclair was one of the first major oil companies represented here.

Early service station operators did not at first pump gasoline through a hose into cars; they poured it from a can into tanks that were usually under the driver's seat. Later, gasoline pumps were installed at curbside, usually in front of an automobile agency.

Soon after Brewer bought his new car, he had a stone wall built in front of his new house. At the same time, he built a narrow cement driveway up to a parking place for his car. It had rather high curbs at the entry point, and his daughter, Louise Brewer Moore, told how he backed the car into one of the curbs, making a considerable dent in his new vehicle. She told that he brooded for days over the incident. But he should not have brooded, for he had thereby won a place in Bristol history—he was involved in the town's first one-car accident!

None of the early drivers had any previous experience. Once they bought a car, they were on their own. After all, who was there to teach them to drive? Old-timers told that many who were not afraid of King James's car were afraid of his driving and would not ride with him. One, who saw the first trip on the day his car arrived, said James made a weaving path down State Street,

almost running into buildings now and then. For a while, many people left the streets and ran into buildings when they saw him coming.

The automobile was slow in catching on in Bristol. In spite of many shortcomings, the horse-and-buggy era prevailed for several years after the coming of the first automobile. But all the while, automobiles were becoming more and more popular with local citizens. By 1909, there were 32 automobiles in Bristol. Among the owners were Dr. Joseph S. Bachman, Dr. N. H. Reeve, Dr. William R. Rogers, C. W. Umholtz, Ellis Wilkinson, E. G. Goodell, James Gannon, M. A. Stull, Clarence G. King, Dr. N. S. Peters, Carl A. Jones, G. Arthur Schieren, and Dr. George E. Wiley. As the number of Bristol car owners increased with each passing year, the city found a need for additional car dealerships.

In 1909, Ellis Wilkinson, who then lived at 429 Taylor Street, proved that a car could be used for more than just short trips about town. He drove his car to Roanoke, Virginia, in eight hours. Wilkinson, a clerk in the J. A. Wilkinson Company (a dealer in wholesale building products), left his home on Taylor Street at 6:00 A.M. and arrived in Roanoke at 2:00 P.M. He had to travel over whatever roads existed at the time—he did not have Interstate 81 or even US-11—and for the most part, those roads left much to be desired. They were unpaved, filled with mudholes, and at places were rough and rocky. There were no bypasses. In most cases, the principal roads went right through the main street of cities and towns. But one thing was in his favor—there were no stoplights, nor even stop signs to slow him down.

The trip was not without mishap. At one point somewhere near Wytheville, he became stuck in a mudhole. Luckily, the driver of a nearby wagon and team pulled him out, with little time being lost. Another slight delay was at the New River ferry near Radford. The operator, refusing to carry him over with horses and horse-drawn vehicles on board, made a special trip to carry the car only. Considering all the setbacks, Wilkinson made pretty good time. He later told that he was longer in returning to Bristol because he wasn't "pushing as hard." Wilkinson later moved to Kingsport, Tennessee, where he was treasurer of the Kingsport Lumber Company.

Someone who participated in an auto parade from Bristol to Blountville around 1909 said 20 or more cars lined up at James Park (near where the Blountville highway now leaves US-11W) about a mile west of downtown Bristol to make the run, which supported the move for better roads. So many cars passing at once created quite a stir along the way. Many persons living along the Blountville road had no idea there were that many cars in all of East Tennessee.

One accident did occur along the way, possibly the first of its kind in the area. The plan called for cars to maintain a distance of 50 or so feet between them, a wise precaution considering the braking systems on those early cars. To add to the hazards of the trip, rolling, boiling dust clouds greatly reduced visibility along the dirt road. Willie Stoots had been placed at the back of the parade because, as my informant told me, "Willie was a greenhorn driver." Near the present County Home Road, young Willie, perhaps blinded by heavy dust, rear-ended a car driven by Clarence G. King. The drivers ahead, apparently unaware of the accident, continued on and made it into downtown Blountville 30 minutes after leaving Bristol.

Now, J. King James would not be bested in anything when it came to the automobile age. The following day he drove his new car to Blountville in 22 minutes. (This was not the first car he bought; by 1909, he had his third car.) Not satisfied, he turned around and "pushed it a little harder" on the return trip. Cutting two minutes from the record, he made it from downtown Blountville to James Park in 20 minutes flat.

Travel between Bristol and Blountville was heavy in those days, largely consisting of horse-drawn vehicles or riders on horseback. As the use of automobiles increased, there was much complaint by their owners that wagon or buggy drivers would not yield the right of way. Some complained that they had to drag for miles before they could find a passing place, causing their cars to overheat. The road was rather narrow at the time and, for the most part, was lined by fencing. The farmers along the way, who often used the roads for their wagons and farm machinery, deeply resented the car traffic and had little inclination to show any courtesy in the matter.

An early liability suit tells of a car-buggy accident near what is now Mt. Tucker near Blountville. A farmer and his rather large wife were on their way by buggy to the county seat to attend a funeral. In the suit, the woman swore that she had on the only "Sunday clothes" she then owned. They met an automobile driven by a Bristol businessman. The farmer's buggy horse likely had never seen such a thing as then confronted him in the road, and he bolted sideways, rearing through a rail fence. The woman, in great fear, jumped from the buggy and landed astride the fence. She later swore that not only was she injured in such a manner as to be unable to sit comfortably for a month or more, but that her good dress was split asunder so completely that it was very embarrassing to her when other travelers stopped to assist, including the driver of the car involved. In that she wore no underwear, she swore that she was indecently exposed until a lady passenger lent her a shawl with which to cover herself.

While the woman coped with her, shall we say, personal injuries and indecent exposure, her husband was having problems of his own. The horse tore into a thriving cornfield and did considerable damage. The man lost the reins and was thrown from the buggy, landing on his neck and shoulders in the muddy field. The horse continued to tear about over the field, damaging at least three acres of fine corn, according to later claims in the suit.

The suit sought $500 in damages but was later settled (without trial) for $300. I assume the unfortunate couple missed the funeral in Blountville.

In 1912, Carl Jones, Sam Sparger, and C. J. Harkrader made a trip from Bristol to Washington, D.C., in an Overland car. They had to carry extra gasoline since there were no filling stations along the way. They also took along extra axles, because when pulling through deep mudholes, axles often snapped. On arrival, the *Washington Star* carried a story of the 400-mile trip, along with a picture of the Overland car. About a year later, Harkrader and Joe Fleming drove two Apperson Jackrabbit cars to Washington in support of the good-roads movement. Others made the trip at the same time, but I have been unable to identify them.

All these trips helped boost local car sales. Once people saw that automobiles were durable vehicles capable of long trips, their interest was aroused in purchasing them. King James reported that he made several sales after Ellis H. Wilkinson's run to Roanoke.

Even as late as 1918, folks continued to be amazed at long car trips. On April 18 that year, Maggie English excitedly wrote in her diary that John H. Caldwell had arrived in Bristol, having driven his car all the way from Labelle, Florida, a distance of around 800 miles. He had 18 flats along the way, but such was expected by car owners in those days. Miss English wrote on June 1, 1916, that Dr. Roller and his wife had given her a ride in his elegant new car. (Dr. Alvin J. Roller then lived at 622 Alabama Street.)

Virtually all those early cars were open topped, offering little or no protection from the weather. Later, some models came out with leather or cloth tops that had to be bolted on. At first bumpers were not standard equipment and cost about $25 extra for the set. There was no gauge to show when the motor was overheating. A register that screwed into the radiator could be bought for about $15 to $20.

None of the early models had heaters, windshield wipers, or sun visors. And it was way "down the line" before car radios became available. A well-filled toolbox was a near must for successful travel in those early days. Indeed, as far as automobiles are concerned, we have come a long way.

Automobile Dealerships

As before noted, J. King James opened Bristol's first car agency in 1903. It was located in the Spurgeon building, which stood on the site of the first home erected in Bristol, Virginia—the Dr. B. F. Zimmerman home, built in 1853-54 in the 400 block of State Street and much later numbered 419½ State. (The site, now a parking lot near the corner of Randall Street Expressway and State, is immediately east of the former Blue Ridge Bank Building.) Two years later, James had moved to 19 Lee Street and was still the only agency in town. By 1910 he had brought in several cars to sell directly from his place of business, and customers no longer needed to order from a catalog. His widow still had the catalog in 1960, but its whereabouts today are unknown. (The couple had no children, and after her death, the furnishings of the home were sold.)

Bristol's second automobile dealership, Shelby Automobile Company, opened in 1910. It was the Ford agency set up by Dr. Hardin Reynolds at 234 Shelby Street. A son of Maj. A. D. Reynolds and a nephew of tobacco magnate R. J. Reynolds, he had been trained as a physician but did not enjoy practicing his profession. He set up a medical office in Bristol for a short time but soon abandoned his practice in order to more fully enter into the business world. But he did gain something from his brief practice; close friends and associates gave him the nickname "Docky." He had been dead several years when I came to Bristol in 1953, but several who had known him well still referred to him as Docky.

By 1913, Dr. Reynolds had moved his agency to 518 Shelby Street. And by that time, Cecil Davis and Sam Sparger had opened Davis and Sparger Auto Company at 718-724 Shelby. Dr. Reynolds later sold his agency to James D. Tate, who took on Q. E. Eller as a partner. Still later, Walter C. Adams bought the agency, with Ken Boyle as his partner.

Soon after Dr. Reynolds opened the Ford agency, he brought in his wife as partner, and by 1913, she was secretary-treasurer. As far as I can determine, Mrs. Ethel Romph Reynolds was the first woman in Bristol associated with the automobile business. In later years, I knew this grand lady, though at the time I did not know of her important place in local history.

The automobile was flourishing in the city by 1918, when Bristol had at least eight dealerships. One of them, the Cowan-Sams Company located in room 6 of the First National Bank building, operated as had J. King James at first, making sales from an illustrated catalog. W. T. Sams, W. E. Sams, and J. R. Delaney were associated with this company.

Dr. Hardin Reynolds (left), had the first Ford agency in Bristol. Pictured with him is his wife, Ethel Romph Reynolds, who assisted him in the operation of this early agency. On the right is James Morrison, Sr., who worked with Dr. Reynolds's father for many years.

Kite-Barker Motor Company, a firm composed of Joe S. Kite and James M. Barker, Jr., had opened on Cumberland, corner of Lee, offering Hudson, Hupmobile, Oakland, Buick, and Dodge. Kite lived at 330 Park Street, and Barker still lived with his parents in the grand Barker mansion that still stands at 322 Spruce Street in Bristol, Tennessee. E. K. Crymble of 225 Solar Street is said to be the first person in Bristol to purchase a Dodge car, and it came from this firm.

Liberty Motor Company, composed of J. D. Baumgardner, J. M. Dickson, and C. A. Dickson, was then located at 613 Shelby. I have been unable to determine which brand of automobiles the company sold. Baumgardner lived in Strong Town and was superintendent at the Bristol, Tennessee, post office. J. M. Dickson, who then lived at 1237 Windsor Avenue, was a clerk in the post office. C. A. Dickson lived at the same address.

The popular Overland car had come to town, offered by Moorman Motor Company at 19 Lee Street in the same location formerly used by both J. King James and Clarence P. Moore & Company. The company, operated by Julian P. Moorman, who then lived at 824 Fairmount Avenue, also sold Willys-Knight cars. There was also the Virginia-Tennessee Motor Company at 25 Seventh Street, owned by G. S. Barger of Kingsport, Tennessee.

Also by 1918, related businesses had opened in Bristol. Charles J. Harkrader at 505 Cumberland offered automobile accessories and supplies. His home was then at 115 Solar, in the house now occupied by Holbrook Surveyors. Interstate Hardware and Supply Company of 200-210 State also offered automobile supplies, as did Moore and Hart.

Where there are automobiles, there is a need for mechanics. Moore and Hart employed a mechanic, and Standard Motor Company, owned by the

A Good Place to Live

same men who owned Liberty Motor Company, also offered repair services at 418-420 Cumberland.

Kilgore and Graham at 503 Cumberland offered car repairs. Frank Kilgore, who then lived at 958 State, years later had a thriving service station and repair shop. He also was president of the City Service Oil Company, at Piedmont and Sycamore, and vice president of Thrift Auto Supply. He built the house at 901 Euclid Avenue.

Harvey Henderson was the first black man in Bristol to own an automobile. It is shown here in this circa-1922 photo.

Some early auto mechanics in Bristol were Sam Sparger, Cecil Davis, Louis Keesling, Frank I. Kilgore, Robert Ferguson (known as Red), Elmer and John Ager, W. I. and Abe Bolling, Val and Ed Marion, Arthur Elliott, and Felix Walker.

By 1921, the automobile industry was going full blast in Bristol, with 16 car dealerships operating. A Nash, considered a luxury car at the time, could be bought from Bristol Nash Motor Company at 113-117 Water Street. Buicks were offered by Cartwright Motor Company at 806 West State Street. A Chevrolet could be bought from W. W. Fain Motor Company at 304-306 State. Franklin cars were available from Holston Garage at 417-419 Cumberland. Joe S. Kite, a man long associated with car sales in Bristol, was then dealing in Dodge cars on Cumberland at the corner of Lee Street. Baker-Fickle at 526-528 Cumberland offered both the popular Overland and the sturdy Studebaker.

At that time, 10 automobile repair places were open in Bristol. Most of the dealerships also offered such services. Five places sold tires, including Charles J. Harkrader at 505 Cumberland, who many years later wrote a delightful book, *Witness to an Epic*.

The first truck available for sale in Bristol was an International Harvester, with high, wooden-spoke wheels and solid-rubber tires, but it did not work out too well. The Reo and Federal trucks were then tried and proved to be more satisfactory. At least three brands of trucks—Sampson, Defiance, and White—were available in 1921 at three regular automobile dealerships.

The next two or three years brought other well-known brands to the local trade. Essex, a long-time favorite, and Hudson, an early luxury car, became the specialty of H. E. Smith at 516-518 Shelby Street. By 1923, the Virginia-Tennessee Motor Corporation at 524 Cumberland was offering Cadillacs and Reos along with Federal trucks. This company was made up of Frank Goodpasture, J. D. Faust, and C. G. Cruikshank. (The Goodpasture name continues today in the Bristol automobile world.) The company still offered solid and pneumatic tires at the time. The number of tire dealers had increased to eight by 1924.

Car usage had become common by the early 1920s, and 14 taxi services were operating in Bristol by 1921. Gasoline, so hard to come by at the beginning of the auto era, was plentiful, and most dealerships had gas pumps. The city had several "filling stations," including one at the corner of Eighth and Shelby; another was at the corner of State and Goodson (on the little lot directly behind First Baptist Church). There was also one at the corner of Moore and Sycamore. Reputedly, one of the busiest was at the junction of Weaver Pike and the Bluff City Highway (near present Stone Castle).

Many cars came topless in those days; consequently, there was need for a local top maker. By 1921, F. C. Swan, at 510 Shelby, could make a top for you. Didn't like the upholstery in your 1921 Ford? No problem. It could be

The second Dodge in Bristol was owned by E. K. Crymble. It is shown here parked in front of his home at 225 Solar Street, Bristol, Virginia.

changed for you by Quailes Brothers at 701 Wood Street. If you didn't like the paint on a new car, or if the old paint needed renewing, Uneeda Carriage Company at the corner of Shelby and Ninth could solve your problem. Nearly all trucks at the time came without beds (then called bodies). Interstate Body Company at 15 Ninth would finish up your truck for you. And, yes, by 1924 Bristol had a car wash, called the S. S. Car Laundry, located at 11 Eighth Street.

On through the "Roaring Twenties," the automobile business continued to flourish and expand in Bristol. By 1927, another car wash, the Bristol Auto Laundry, had opened, managed by Pierce Rutherford, at 625 Shelby.

The city had 20 car dealerships. Chrysler had become available at the Virginia-Tennessee Motor Corporation at 520-524 Cumberland, and Lincoln was offered by States Motor Company at 720-722 Shelby Street. Packard, a long-time favorite among the more elite of Bristol, was available at Joe Barker Motor Company at 802-804 State.

Cumberland Street seems to have been a favorite location for automobile dealerships in those days. The Whippet was available at the Overland Company at 513-515 Cumberland. Chandler, a sturdy car, was offered by Bolling Chandler at 210 Moore Street. "Buck" Hayes, a merchant of the Hickory Tree Community near Bristol, bought one, and I saw it perhaps 15 years ago. Dave Hayes owned it at the time and stored it in the Rutherford Transfer and Storage Company building in Bristol, Tennessee.

Star cars were sold by Davis-Bedwell at 26 Seventh. A cousin of mine owned a Star roadster when I was a child. It had one main seat in front and a rumble seat, or "mother-in-law seat," behind that I rode in one time. A lid raised up where the trunk should have been, revealing the seat with an upholstered back on the underside of the lid.

By 1927, car rentals, called auto liveries, were available. Fields Rent-a-Ford, one of the first to open, was located at 501 Cumberland and owned by R. E. Fields of Johnson City, Tennessee. There was another Rent-a-Ford company at 417 Cumberland. In addition, Odell and Poore at 12 Fourth Street offered cars for rent. The company was operated by Joseph D. Odell, who lived at 1117 Florida Avenue, and Arthur J. Poore of 700 Alabama Street.

Five businesses offered automobile storage space in 1927. There were several reasons for the strange—at least it so seems to us now—practice. Many cars did not have tops, and the owners did not have sheds or garages for them. Most cars had to be drained on freezing winter nights or if they sat long unused. The storage places were heated, and most of them offered complete

maintenance programs. Whenever the owner needed his car, he walked or took a taxi to the storage place.

Several older Bristolians have told me of this now unusual practice. One old gentleman showed me a letter he received from his mother while he was away in college. She wrote, "Your father left about half an hour ago to bring the car up from Koty's storage place [111-117 Water Street]. He should be here soon and we will then start to Abingdon." Few car owners today would be that patient.

Graham Brothers trucks had come to Bristol by 1927, sold by John I. Pritchett from his location at 840 State Street. Pritchett and his wife, Margaret, then lived at 1200 Seventh Avenue. Davis-Bedwell at 26 Seventh Street sold Mack Trucks.

The automobile business remained at about the same level for the next couple of years. One new offering in 1929 was the Graham-Paige luxury car. The dealer was H. E. Smith, located in the 800 block of State Street.

Frank Drugan had appeared on the scene by 1929. President of the Bristol Motor Company, the Buick agency at 516 Cumberland Street, he resided in the General Shelby Hotel. Long after I arrived in Bristol in 1953, he was still head of the business and still lived in the General Shelby Hotel.

By the late 1920s, competition between dealerships became very keen.

Blacksmith shops continued to operate in Bristol long after the era of the automobile began. The shop pictured here was located in the 800 block of Shelby Street. This scene was captured on film about 1920.

Greater efforts had to be made to sell a profitable number of a particular brand of car, so some dealers took advantage of the growing interest in car ownership in the rural areas around Bristol. They would take a car and demonstrate it to persons who had expressed an interest. Dealers who felt sure of a country sale usually had a second car and driver standing by for the return trip into town. If a sale was made, the dealer would often give the buyer a crash course in driving. The lesson usually took place in a meadow or pasture, where there was little danger of running into something.

Frank Drugan told me of making a sale to an older man who owned a small farm far on Holston Mountain. His meadow field, bordered on one side by the mountain and on the other by a moderately high bluff, had a rail fence atop the bluff. The buyer allowed his older son to take the driving lesson. When the son and Drugan were about to launch out, the father cautioned the son, "Now, Herman, you drive on the mountain side of the meadow and don't go nigh the bluff side." Drugan said he too tried to make sure the new driver didn't go "nigh" the bluff side!

In another case, Joe Kite sold a car to a farmer in the Cold Springs community of Sullivan County, Tennessee. He made the sale, gave the new owner a driving lesson, and then returned to town. The wife of the new car owner was a rather daring lady. The first time her husband left home for a few hours, she decided she could drive the car. She managed to get it started and headed out through their big meadow. She soon got into a panic and forgot how to stop the vehicle, if indeed she ever knew. When her husband came home, he found her driving in circles all over the meadow. She remembered that in time, the gas would run out and then the car would stop, so she drove on until the motor finally sputtered out. Her husband said he wasn't about to try to run her down and tell her how to stop the thing. At least she got a good lesson in steering.

Another farmer in the same area was used to having his horses stop when he yelled "whoa" at them. He bought a car and received the usual crash course in driving. A day or two later, he took the car out to practice driving again. All went well until he attempted to park it in a side shed of his barn. The back of the shed had a loose plank wall, and the man drove the car through the wall, yelling, "Whoa, whoa!" at the top of his voice.

Car Insurance

Today, adequate car insurance is virtually a must, but it was more or less optional in Bristol's early automobile era. But even then, many local car owners did carry insurance.

As far back as 1913, seven insurance companies offered automobile insurance in the city, and two of them seemed to specialize in car insurance. The American Automobile Company of St. Louis had an office on the second floor of the Mahoney Building (formerly Pyle Building) at 600 State Street on the southwest corner of Sixth. The Maryland Motor Company of Baltimore was located in the heart of the car district at 516 Cumberland Street. By 1918, nine Bristol insurance companies specifically offered automobile coverage.

A Depressed Business

Along with virtually all other types of businesses, Bristol's car dealerships were greatly affected by the Great Depression. However, in 1932—one of the low years of that dreadful era—13 dealerships still held on, along with numerous related businesses. Arthur Poore managed to keep his car rental service going, but he always got cash in advance before letting a car go. Even two car washes were somehow surviving. One would think that car owners would have done their own washing during that penny-squeezing time.

Sales of new cars fell sharply. There was a glut in the secondhand department, even though a good used car could be bought at a low price. One fellow told me how he bought a good three-year-old Ford for $75. He also bought his son a 1923 Chevrolet for $20.

Numerous "easy credit plan" buyers defaulted on payments. Their cars were repossessed, but efforts to resell them were often futile. One man bought a Hudson on credit, then unwisely, and possibly illegally, sold it to a man living in Coeburn, Virginia. Unfortunately, the second buyer lost his job and thus become the second defaulter. By then, the local dealer was clamping down on the original buyer. In desperation he sent a letter telling the man that if he could not make payment to please return the car at once. Further information revealed that defaulter number two wrote back that he was in such financial straits that he could not buy gas to drive the car back to Bristol. (At this point gas was selling for about 17¢ per gallon). Defaulter number one then quickly took the train to Coeburn to bring the car home.

The original buyer was then in charge of property valued at more than a million dollars. Apparently, though, he was not able to scrape up enough cash to make a payment (likely less that $25) on the Hudson. Such were conditions during the Great Depression. The Hudson was considered a luxury car, so perhaps the man's pride was greater than the contents of his pocketbook. Such sometimes happens today, doesn't it?

Though the practice followed by many dealers in taking cars to the nearby

A Good Place to Live

By the 1930s automobiles were very common in Bristol. This picture was made in the 800 block of Euclid Avenue when that street was paved with brick.

countryside to demonstrate to prospective buyers had lagged, it was in desperation revived to a considerable degree during the Great Depression. P. A. Goodwyn, who owned Goodwyn Motor Company at 840 State Street, used to tell of one instance that he truly thought came near killing him. He had taken in an older model Chandler on trade and needed to sell it. He heard of a gentleman farmer in the Weaver Community who appeared to be a good prospect, so one day he drove the Chandler out to the man's farm.

The demonstration and driving lesson took place in a large meadow on the prospect's farm. Seemingly, the farmer was a quick learner, and as he headed back toward the farmhouse, a large deer jumped a nearby fence and began a graceful lope across the field. The farmer was an avid deer hunter, and his resulting excitement caused him to lose control of the car. No, he didn't collide with the deer, but he did run the car into a deep ditch that traversed his meadow. The front wheels dropped and slammed against the opposite bank with an impact so great that the back of the car bucked high in the air.

The car had no top, and the impact threw both occupants high over the front of the car, in what Goodwyn described as somersault fashion. The driver landed in deep grass and rolled over and over for some distance. Goldwyn landed on his shoulders in the deep grass. He believed that had he landed on his head, he would have broken his neck.

The accident helped clinch the deal. The farmer, greatly impressed that the sturdy Chandler had not been damaged by the hard impact, gladly paid the $40 asking price.

There was yet a problem. Goodwyn had not engaged anyone to take him back into town. Consequently, he asked the buyer to aid in the matter. Goodwyn drove the car and the new owner to a point at the top of Hog Town Hill (near present Stine Street), where he turned the car around. Not wanting the greenhorn driver going further into the city, he turned the wheel over, hoping the man would make the return journey without mishap.

In spite of being a bit "stove up," Goodwyn walked to his business on State Street. And the proud new car owner did make it home, and he drove his sturdy Chandler through the rest of the 1930s.

Those fortunate few who did have money found a buyers' market during the Depression years. New cars were offered far below usual retail, and used cars could be bought "for a song." Farmers were among the most likely customers, since many of them had not bothered with banks, as had many city dwellers, and they hadn't lost their life savings. Walter C. Adams, long the manager of States Motor Company, said that he learned about the relative prosperity of country folks on Christmas Eve in 1932.

The day was cloudy and a bit cold. Adams had sat around his agency all morning without the least indication of making a sale. Because it was Saturday, as well as Christmas Eve, he had sent the garage help home and was alone except for his assistant in the sales department. He was on the verge of closing up for the holidays when a rough old wagon, pulled by a badly mismatched pair of mules, drew up before his main door. In it sat a tall, lanky old man who apparently had not seen a razor for a good two weeks. Beside him sat a short, rather plump woman.

Adams soon learned they were from near the foot of Holston Mountain in what is now known as the Ryder Church community. The old man informed Adams that he and his "wife woman," as he called her, had been thinking of getting themselves a little better something to ride in, and said, "We aim to give ourselves a pretty good Christmas present." The old lady said nothing, but she clearly was impressed by the shiny, new cars around her.

Adams tried to steer the couple toward the cheapest Ford on the floor, but the old man, having none of it, was drawn toward a big, shiny, well-ornamented Lincoln. After he looked it over good, he asked his wife if it suited her, adding that he thought they ought to have the best, in that they had waited so long. She allowed it would do, adding that she bet it would ride a sight better than the old mule-drawn wagon.

The old man then told Adams that he reckoned they'd take it if the car dealer would deliver it "out to the place." Adams then asked him politely and

as gently as he could if he felt he could borrow enough money to pay for it.

"Tarnation, no," he snapped back, "I ain't never borrowed a dollar in my life, and I don't aim to start it now." He then turned to the old lady and asked her, "Maw, reckon you've got enough change on you to take care of this deal?"

She allowed she did but sheepishly added that she would have to get behind something to get it. Adams showed her to a private back room. In moments she stuck her head back out the door and said she guessed she needed a pair of scissors to get to it. No scissors were in the office, but the old man quickly handed her his pocketknife, and she retrieved the money that had been sewn up in her underclothes. In a short time, she reentered the room with a roll of bills in her hand—more than enough to pay for the desired new Lincoln.

On Monday, Adams, followed by his assistant, delivered the new Lincoln to the rather humble hill-country home. To reach the place, they drove over a road so rocky that Adams feared for the low-hanging parts of the car. Once there, he gave his usual crash-course driving lesson and parked the car in the only shelter, a hay shed at the side of a rickety old barn. Before leaving, he heard the old man say to his beaming wife, "Won't we make a stir when we drive up to the meetin' house next Sunday!"

From that time on, Adams was a bit more prompt and courteous when confronted by one who appeared to be an unlikely prospect. He suspected that the apparently poor farmer was selling his corn crop in liquid form.

Most of the major dealerships survived the Depression years in Bristol. The automobile business was just beginning to flourish again when World War II began. In a short time, new cars became unavailable, as the factories that made them were converted into war production. As the war progressed, gasoline rationing began.

I well remember the day before rationing took effect. I was attending the Ft. Douglas one-room school in rural Johnson County, Arkansas. The teacher, Frank Phillips, used his car as a bus to transport students in the area to and from school, a distance of about five miles. When we started home that afternoon, he stopped at the general store operated by our cousin, Richard Phillips, and filled his car to the brim. I recall seeing Cousin Richard hand pumping the gas up into a glass reservoir and then allowing it to flow by gravity into the car's tank. Doubtless, cars all over Bristol were filled to the brim that same day.

Tire rationing also began at about the same time. Many a car owner learned anew to patch inner tubes and to boot tires, using them until they were bald. I have seen tires used until not a trace of the tread could be seen.

The unavailability of new vehicles caused the used car business to flourish. Prices skyrocketed; old cars that had sold for as little as $50 (some less) quickly zoomed to well up into the hundreds. One man told of paying $700 for a 1934 Chevrolet that would have sold the year before for only $75.

Auto repair shops actually profited by the war. Most of Bristol's car dealerships were able to survive because of their thriving repair shops. Old cars were patched up by the hundreds, and, as one fellow expressed it, kept running "as long as they would hang together." A former car dealer told me that income from his repair shop more than doubled during the war years, which kept him from closing his doors.

Carpooling became a necessity as more and more older cars got beyond repair. The gas shortage and rationing also contributed to the need to share rides. Public transportation boomed during those years. Buses and passenger trains were loaded far beyond comfortable capacity, often with standing room only. One lady told me that in 1944 she stood in the aisles of passenger trains for two days and nights when she returned from a trip west. She went to sleep several times while standing, but falling down always awoke her. Another person told of about the same experience on a cross-country bus trip. But in

Inside a crowded bus during World War II. The only identified person in this picture is Bishop (Bish) Osborne, front row, left side in aisle seat. Filled to the brim, buses and trains were the norm during this period.

that case, he said the people standing in the aisles were so packed together that one could hardly fall, though sound asleep. Even a year or two after the war, I personally remember making a bus trip when just about the same situation existed.

One great benefit that did result from the war era was that people learned to walk again. Some locals who ordinarily took the car if going just a block or two away began to walk long distances. Some of the city's most elite and sedentary were walking miles to reach their desired destinations.

One lady whose family lived far out on Georgia Avenue told how on Sunday mornings the family was roused up earlier than usual so they could walk the long distance to the First Presbyterian Church and be there by 10:00 A.M. for the opening of Sunday school. Sometimes they made the trip in cold and rainy weather; at times they waded through snow in order to get there. She said the children loved such times, even though overshoes were hard to get.

Many walked even farther to do business in downtown Bristol. One person told me that when funerals were held, most of the crowd walked to the place of service. He remembered an instance when the funeral of a prominent citizen was held in the First Baptist Church. The body was hauled up to the East Hill Cemetery, where the undertaker and mourners patiently and politely waited for the main crowd to walk the three blocks or so, much of it uphill, to attend the graveside services.

One couple told me they used to walk the four miles from their home in

Service stations came early in the era of the automobile in this city. Pictured here is one that operated on Front Street near downtown Bristol. Photo circa 1946.

Walnut Grove (near Interstate 81 exit 7) to downtown Bristol every Saturday, rain or shine, to do grocery shopping. But it wasn't all a business trip; they always made sure they had enough time in town to see a movie at the Cameo Theatre.

After the war ended, the automobile business in Bristol made a steady recovery, but a couple of years passed before things returned to normal. Used car prices held up during that time.

Walking and public transportation were still much utilized. A down-and-outer often seen on Loafer's Glory in Bristol once told me that he became a hobo in 1945 because he didn't like fighting for space on trains or buses. He learned the art of hopping on freight trains whenever he needed long-distance transportation. Even in 1953, he sometimes would become bored with life on Loafer's Glory and would merely slip into the rail yards and jump a train for a trip to Roanoke or Knoxville—no ticket needed.

By late 1947 and early 1948, happy days were here again, car wise. If someone wanted a new car, all the person needed to do was go to any of a number of agencies and make the selection—and the selection was great. Consequently, better used cars began to show up at numerous outlets. Bristol was on wheels again!

BRISTOL ON WHEELS MID CENTURY

When I came to Bristol on August 20, 1953, I arrived on wheels by bus from Hazard, Kentucky, with a change at Jenkins near the Virginia border. At that time, the automobile business was flourishing here, with several big-name dealerships going full blast. Used car lots were numerous, so much so that one did not have to go far to find one. The city had many outlets for automobile accessories and parts, along with a large choice of repair shops.

West State Street was a popular location for new-car dealerships and used car outlets, so much so that it could have well been called Bristol's golden car strip. Several other car lots were scattered over the city. Bristol Motor Company, a long-time Ford dealer, was at 720-724 Shelby Street. Southern Motors offered the popular Pontiac on the corner of Piedmont and Sycamore. Victor Motors, the Nash dealer, was located at 35-37 Fourth. Virginia Motors—located ironically in Tennessee at Seventh and Shelby—sold the soon-to-vanish DeSoto.

One used car lot stands out in my memory—however, I do not recall its name or who operated it—on the southeast corner of State Street and Pennsylvania Avenue, just beyond the end of Loafer's Glory. (The business was on

A Good Place to Live

Repair shops were necessary to keep Bristol on wheels. Koty's long operated on Water Street in Bristol, Virginia.

the lot where once stood a service station that blew up in a gas explosion soon after World War II, resulting in a few deaths and much property damage.) I had no vehicle at that time, and whenever my work took me into that area, I would sometimes stroll over the lot and sort of drool over the many cars displayed there. I vividly remember a dark blue or black Packard, perhaps a 1947 model. I also remember one or two Nash cars on the lot, which seems to have specialized in used luxury cars.

From near the beginning of the car business in Bristol, credit had been available, but it was not easy to come by. Buyers just about had to "go through the third degree" to obtain it. This situation may have eased a little by mid century, but it still was not as simple as it is now. Signs proclaiming "no credit, bad credit, no problem" were unthinkable in mid-century Bristol. If someone defaulted on payment or went so far as to have a car repossessed, his credit might be ruined for years.

Taxis and Drivers

Hardly had the car era gotten underway in Bristol when taxi service began to be offered. Very early, someone rightly conceived the idea that those people who did not own cars would pay those who did to drive them to desired destinations. Too, some early car owners, especially those that could hardly

afford them, decided that a good way to recover their money would be to offer their cars for hire. Taxi service was available in Bristol by 1912, possibly a year earlier.

One of the first taxi services was the Bristol Transfer Company, with headquarters in the baggage room at the railroad depot. This company was of great benefit to incoming passengers who needed further transportation. By 1921, the city had 14 taxi businesses, one of them operated by a woman.

Thirty-Eight Taxi Company, located at 506 Cumberland, was owned and operated by W. W. Cass, who then lived at 905 Maryland Avenue in Bristol, Tennessee. Cass, a former merchant of Stoney Creek, Carter County, Tennessee, named his taxi service for his business telephone number.

Moore Street Taxi Company was owned by B. J. Cox. Some other taxi drivers at the time were William Barker, A. L. Crawford, H. D. Crawford, W. E. Ager, A. P. Royston, Freeman Rowe, J. R. Fillison, Dudley Noe, D. S. Emmert, W. M. Glover, W. F. Barr, C. N. Moore, J. J. Wilburn, B. F. Sublet, and C.J. Foran.

The field must have become overcrowded, for the number had dropped to nine by 1924. Two were operated by blacks. Charles E. Roberts was at 203 Water Street. Two Hundred and Two Taxi Station, likely named for the telephone number, was operated by Nathaniel Smith at 511½ Sycamore.

Taxis greatly contributed to the demise, slow though it was, of streetcar service in Bristol. At first, taxi service was limited to the city and nearby areas. Then it began to extend to more distant points, chiefly to those areas not served by passenger trains. Trains ran so frequently at the time, there was little demand for car service to Abingdon, Bluff City, or Johnson City. Blountville, without rail service, was frequently served by Bristol taxis. Then as Kingsport developed, it too became a common destination for long-distance taxis from Bristol. And Kingsport taxis often came to Bristol. In 1918, a local taxicab company served notice that it would have to increase its fare to Kingsport because gasoline had gone from 16¢ to 18¢ per gallon.

Later, as train service decreased, taxi service became frequently used for trips to Abingdon, Johnson City, Jonesborough, Elizabethton, or Mountain City. At that time, the run to Mountain City was made by way of Damascus because the high mountains of the direct route were too much for early model cars.

During the earliest years of the taxi era, drivers charged 5¢ per mile for long-distance taxi service. Rates for in-town travel were very reasonable. Jim McCrary remembered that a ride from downtown Bristol to the Holston Valley railway station near the end of Georgia Avenue cost 10¢.

A Good Place to Live

Driving a taxi may have been easier than many occupations of the time, but it was not always the most pleasant or safest of jobs. Drivers often had to contend with uncivil and querulous persons. Drunken passengers were near-daily customers, many of whom could not pay the fare at the end of the trip. Collection of those unpaid fares was near impossible.

A veteran driver told me that he once hauled a drunken man from a "rough" café to his home on Spencer Street. The trip had hardly gotten underway when the passenger leaned over the back of the front seat to tell the driver something. But the poor driver got more than words. His shirt collar stood out from his neck, making a perfect receptacle when the passenger vomited profusely, filling the shirt full clear down to the belt line. The driver needed a bath and clean clothes before he could resume his duties. He also lost the fare for the trip. After the vomiting started, he stopped the cab. The drunk man, realizing what he had done, jumped from the cab and staggered into a nearby yard, where he disappeared in the dark.

Another former driver told me that he once picked up a man and his wife at the corner of Front and Cumberland. They entered his cab quarreling, and by the time he reached Piedmont, the spat had turned into a violent fight. As the couple rolled and tumbled in the backseat, one of them kicked a window out. Then the husband opened a back door of the taxi, shoved his wife out, and jumped into the street, where the fight continued. The driver quickly left the scene, as the enraged couple rolled in the street, fighting like mad cats. He lost his fare but was greatly relieved to be rid of them.

Sometimes taxi drivers had frightful experiences. A driver once picked up an old lady on Spencer Street, who appeared a little dazed. But she clearly told him she wanted to go to the local depot, a common destination of taxi users in those days. All went well until they neared the depot parking lot. The women suddenly seized him from behind, threw her hands around his throat, and began choking him. In a frantic effort to escape her attack, he lost control of his car and crashed into the Travelers Hotel (later known as the Colonial). He later learned that the woman had just been dismissed from the mental hospital at Marion, Virginia. Apparently, she needed to go back!

B. J. Cox—his name was actually Abijah Jerome Cox—certainly had an interesting career as a taxi driver. He was born in the Cherokee section of Sullivan County, Tennessee, a son of a minister and coffin maker. He married Victoria Smith from Mendota, Virginia, and moved to the Spring Creek section, where he farmed for a few years. Deciding he could make more money as a taxi driver instead of a farmer, he sold his livestock and farm machinery,

then invested the proceeds in three new Buicks and opened the Moore Street Taxi Company at 9 Moore Street. He later operated as the Sixty-Four Cab Company at 504 Cumberland.

Cox would never forget the passenger he took on his trip to eternity. Cox was called at noon one day to a rooming house on Fifth Street, where he picked up a well-dressed, dignified appearing man who asked to be taken to Sterchi Brothers Company, a furniture store and funeral home at 636-642 State Street. All along the way, the man conversed in a cheerful manner. His speech indicated he was well-educated, and there was much evidence he was refined and well-mannered.

Cox supposed the man was likely a minister on his way to conduct a service in the funeral parlor. When they reached the destination, the man calmly paid the bill and included a $1.00 tip, far more than double the charge for the fare. He thanked Cox for his promptness and courtesy, then stepped to the door of the funeral parlor. Before Cox had pulled away from the curb, the man took a pistol from his coat pocket, shot himself through the heart, and fell against the funeral parlor door.

As Cox often said, a taxi driver never knew what a new day would bring forth. Not long after the suicide, a baby was born in the backseat of his cab as he raced toward St. Lukes Hospital. He and the expectant father had to preside until Dr. Bachman arrived. Cox had yelled for a man standing in a nearby doorway to summon the doctor.

B. J. Cox operated a fleet of taxicabs in the early years of the automobile era in Bristol.

A Good Place to Live

On Sunday, March 13, 1921, he had the most memorable experience of his career. At about 8:30 P.M., he received a call to pick up three passengers near the Tennessee High School, which was then on Alabama Street. Awaiting him were three men, including Neal Guthrie. They asked to be taken to a point about four miles out on Weaver Pike. The men did not seem to want to talk, so Cox did not try to carry on a conversation with them. At their destination, they got out of the taxi but asked him to turn out the lights and wait a few minutes. At that point, he became suspicious and pulled his pistol from his coat pocket and placed it on the seat within easy reach.

Apparently, a woman was supposed to have met them in a nearby lane, but she did not appear. They finally came back to the cab and asked to be brought back to Bristol. Cox had not driven but about a quarter of a mile when one of the men asked him to pull over. Before he could bring the taxi to a stop, he was hit over the head by what he thought was a blackjack. As more blows followed, he grabbed his pistol and began firing into the backseat in spray fashion, hoping to hit them all. He was convinced that the passengers intended to murder and rob him. The passengers all jumped from the careening car, which soon ran into a ditch and wrecked against a telephone pole.

C. A. Hatcher, who lived near the scene, heard the shots and wreck and came to see what was going on. He saw two of the men running down the road. He then saw the other one stagger and fall against a fence, where he died from a gunshot through his chest. The man clutched a .32-caliber pistol in his hand. Hatcher and others had heard nine shots, probably six from Cox and three from Guthrie, the slain man. Hatcher found Cox weak from loss of blood but still conscious. The two others escaped into the night.

Guthrie, who had once been a chauffeur for Senator J. Parks Worley in Bluff City and Dr. Thomas F. Staley in Bristol, had a record of several prior arrests. A black mask was found in his pocket, indication that he was prepared to do robberies.

Cox continued to operate a taxi here for several more years, but he saw that word got around that he was always heavily armed, so he suffered no further attacks. This old veteran of early Bristol taxi service is buried in the Cleveland Presbyterian Church Cemetery in Holston Valley. His granddaughter, Miss Carrie Painter, who yet lives near Bristol, told me that her grandfather deeply regretted killing Guthrie, even though the local authorities and citizens regarded it as a clear case of self-defense.

Another taxi driver was not so lucky. A year or two ago, a lady wrote me

from Florida telling me of her grandfather, who in the mid-1930s was a Bristol taxi driver operating from a stand on Piedmont. His little boy (the lady's father) was at the stand with him one night. A man and woman came to the stand and asked the driver to take them out near Paperville. The little boy stayed with the dispatcher while his father made the trip. The father told his son to wait there and he would be back soon, then they would go home, because his shift would be over. The trip was his last ever. The boy waited, but hours passed and his father did not return. About daylight, the man's body was found, lying close to the cab, near the Rutherford place on Sinking (or Paperville) Creek, a short distance from the village of Paperville. He apparently was robbed and murdered. I do not know further details of this sad case.

On rare occasions, passengers had reason to fear the drivers. Most drivers were law-abiding citizens who would do no harm to anyone in their care. But occasionally there was an exception, especially during the World War II years when good drivers were hard to find.

During that time, a young woman was living alone in an apartment on James Street while her husband served in the Army. One day she needed to go to her family home near Camp Ground Methodist Church, so she sent for a taxi. The driver, a young man who had been rejected for military service, was working his first day for the taxi company. In a wooded area not far from the destination, he suddenly turned the car onto an old logging road leading into dense woods. He raped the terrorized woman, then pushed her from the cab and fled. In a day or two, the cab was found near Greeneville, Tennessee. Apparently, he had used all the gas in the tank and then fled on foot. He was never captured.

I well knew one lady here who frequently used taxi service. Before leaving home on such a trip, she made sure her pistol was in her large purse. Fortunately, she never had occasion to use it. We who knew her had no doubt but that she would have used it in case it was needed. Her close friends privately called her "Pistol Packing Mabel."

In 1946, many war veterans had returned to Bristol, seeking jobs. It soon became apparent that there were not enough jobs to fill the need. One man, who had been a carpenter before his induction into service, finally landed a job as driver for a local taxi company. All went well for a few weeks. Then one Sunday morning, a call came in from a woman who lived in Ruth Perry's apartments at the corner of Fifth Street and Franklin. The driver went over and found two women, who asked to be taken to the First Baptist Church. One of the women had recently arrived from the hills of Eastern Kentucky,

A Good Place to Live

the other was local. The one from Kentucky told me of her unforgettable taxi ride that morning:

> Me and Hazel got in the cab and had an ordinary ride until we got to the rail crossing on State Street. I did notice that our driver, though pleasant and courteous enough, seemed to be a bit nervous. As we got over the crossing, we met an old rattletrap of a truck that was coming down State. When it got near us, it backfired the loudest I ever heard. Went for the world like a big gun firing. That driver just stiffened and yelled out, and then split into the big lot right by the tracks [old Tennessee depot lot], and just tore around over that lot a-screaming and yelling to high Heaven.
>
> I reckon his leg stiffened on the gas, for the car was just flying and going round and round. I'd be looking right up the tracks one moment and right down the next.
>
> Hazel was beating him over the head and yelling, "Stop this thing! You stop it quick!" But he wasn't paying her any mind. He finally tore across Third Street and right into a building over there. But he had mind enough to throw that thing in reverse and shot back nearly plumb to the tracks. Then he tore out and ran split across State Street, and there were trucks and cars coming at us from both sides, and he clipped the front of one and sideswiped another one that was parked on the far side of State. All the time, he was yelling and jerking about.
>
> I just knowed he had gone plumb slap-dab crazy, and I was scared stiff. I just knowed our time had come.
>
> He slammed into the porch of the freight depot, but then whirled and tore across the tracks toward the big depot. And here we went, just bumping, and it threw me and Hazel all over the backseat. But then that car hung up on the main track and jerked hard. The back end of that car bounced up a time or two and threw us both right up against the top.
>
> As soon as it settled, I jumped out one door, and Hazel sailed out of the other. I didn't have much mind left, but I recollect taking off toward home. I sort of come to, over by the Low Dollar Store. I could still hear that man a-screaming and yelling like the pure devil had hold of him.
>
> I reckon Hazel was more out of her head than I was, because instead of taking toward home, she took right up the railroad in the other direction. Oh, it were an awful time.

Poor fellow seems to have had a case of shell-shock, and when something reminded him of the battlefields—such as when the old truck backfired—he went completely berserk. I knew this woman rather well, so being a bit facetious one day, I asked her why, when free from the danger of the berserk cab driver, she did not walk a block or so on up to the First Baptist Church. She sort of shyly replied that she was in no condition to go to the church. I later learned through her friend Hazel that the woman from Kentucky had good reason not to go on to church. During the extreme fright in the cab, she had soiled her clothes! Both women said that a year or two passed before either of them got up nerve to again ride in a taxicab.

Though most owners of taxi companies forbade it, some drivers earned extra money by pimping for prostitutes. One man admitted to me that he made more by that practice than he did in regular salary.

One driver, who did this as a profitable sideline, suddenly quit it one day. A married man from a nearby town—Kingsport, I think—came to Bristol regularly to conduct business, and he soon had the driver procuring prostitutes while he was in town. One day the driver delivered the man and his female companion for the day to a local café, where they were going to eat before proceeding to a cheap hotel. The cab was hardly parked until the visiting man's wife drove up behind them. She jumped out, ran up to the cab, drew a pistol, and shot her erring husband dead.

I once talked to a man who witnessed the shooting. I asked him what reaction the lewd woman had to the frightening development. He said she froze, sat deathly still, and stared ahead as the man died at her side. The driver jumped from his seat and took shelter by "hunkerin' down behind the cab."

The incident cured the driver of pimping. Years later, he became a deacon in a local church.

I well remember Robert Fleenor, who drove a taxi in spite of the fact that he had only one hand. He roomed for some time at 518 Alabama, where I too lived at the time, and made a pleasant fellow roomer.

In 1927, eight taxicab companies operated in Bristol. B. J. Cox had moved to 504 Cumberland and had changed the name of his company to Sixty-Four Cab Company, in line with a going fad at that time of naming one's company by the telephone number. The Yellow Cab Corporation had also set up by that time.

Two years later, only six companies offered cab services in the city. Three of them had taken telephone numbers for their names: the Fifty-Three Cab Company operated by E. C. Stockton and C. V. Adams, Fourteen Hundred

Taxi Service at 141-146 Cumberland operated by W. E. Phipps and J. H. Frye, and Thirty-Eight Taxi Company operated by Landon S. Carroll, who then lived at 700 Pennsylvania Avenue. His father, Louis Carroll, built the first home I owned in Bristol—and in my life—that yet stands at 123 East State Street.

During the Great Depression, the city saw a decrease in taxi service. By 1932, few people had money to spend on taxi rides. One fellow, J. Sullivan Leonard, named his company Cut Rate Taxi Service. Indeed, he had cut the rates to get the business. Landon Carroll managed to hold on through 1932, but he later said that there were times when he only cleared three or four dollars per week.

Earl Penley, who later distinguished himself in transportation circles, had opened the Red Top Taxi Company in the midst of the Depression. In 1932, it was located at 308 State and advertised that it never closed. The company promised to respond as quickly at midnight as at midday and offered special out-of-town rates. Red Top had a substation at 31 Fifth Street.

Another company that opened during the Depression was Red Bird Taxi Service. First located at 112 State Street, it was in business by 1934. One of the partners was Bryant Offield, who was still driving a cab in Bristol well over 40 years later. I knew him well and remember that he was noted for the slowness by which he drove his cab over town. He always seemed calm under all circumstances, and saw no need to dart about, endangering life and limb. His first partner was Charles N. Moore.

There was not much competition in 1934; taxi companies had dwindled to four. Only one had been added to that number by 1936. At that time, Bryant Offield had taken over Red Top and it had moved to 120 State Street. Blue Bird was then under Aaron W. Dempsey and had grown to the point that he was using 20 cabs.

Late in the 1930s there was little increase in the taxi trade. Six were operating in 1938. Earl Penley and Anne J. Barkley then had the Yellow Cab Company with its three locations. Times had gotten better by 1940; the number of taxi companies had grown to eight.

The war years (1941-45) were actually good for Bristol's taxi businesses. With gas rationing and good cars hard to find, many persons who owned cars often took taxis in order to conserve what gas they could buy. There was plenty of rail and bus travel in and out of Bristol, creating much business for the taxis.

In 1942, eight taxi services operated in the city. Yellow Cabs had added local bus service, called Yellow Coach. The company's substations were still

Small bus lines operated to and from Bristol for several years. The Fuller Bus Line Company served Bristol for many years.

operating, one of them at the Greyhound bus station at 41 Piedmont. Times had greatly improved, making more money available for the necessity or luxury of a taxi ride.

As the war progressed, some local taxi operators turned to more profitable pursuits, and the number of taxi companies dropped to five by 1944. Most of the companies were what one might term as "big-timers."

By the end of the 1940s, the taxi business had made a notable comeback, with 12 companies going strong in 1948. By that time, H. M. Knight and H. H. Morris had taken over the large and prospering Yellow Cab Company and were doing business from 39 Moore Street. Earl Penley, former owner of Yellow Cab, had turned his attention to the Yellow Coach Company.

When I arrived in Bristol, the number of cab companies had dropped to eight, but all of them were doing a flourishing business. Checker Cabs and Yellow Cabs operated together from 41 Moore Street. Both were owned by Forest M. Phillipi and Henry H. Morris.

Even though automobiles were owned in abundance at that time, many people relied upon taxis for transportation. And that was the case on through the 1950s and beyond. In the mid-1960s, six taxi companies still operated in Bristol. Bryant Offield, the old veteran cab driver, continued to operate the Blue Bird taxi stand at 112 State Street. He and his wife, Nina, then lived at 400 Taylor Street.

City Cab Company long operated in Bristol.

The number of cabstands had dwindled to four at the beginning of the seventh decade of the 20th century. The Yellow and Checker cab companies, had had become Bristol Radio Cab Company and offered a great improvement in taxi service. Since drivers did not have to return to the cabstand to receive further orders, they could be dispatched to pick up customers while still out on their runs.

At the beginning of the 1980s, the number of cab companies had dropped to only three but, by 1985, had risen again to four. About 1986, Bryant Offield ceased operating his Blue Bird taxi service. He had driven taxis in Bristol for more than 52 years, which I strongly suspect is a record for the city, and close to a record nationwide. Juanita Offield Goforth, a professor at East Tennessee State University and wife of Rev. Bill Goforth, is a daughter of the veteran taxi driver.

The marked decline of taxicab companies that began in the 1980s has dropped to only two at the time of this printing. Individual car ownership has all but eliminated what was once a valuable service.

A Good Place to Live

Weather

Bristol has what I call a moderate climate, usually free from extremes of any season. Ordinarily there is no heavy snowfall, nor does fallen snow lay very long. Rainfall is usually ample, maintaining a green summer and assuring abundant crops. Too, the city does not usually suffer from temperature extremes. Ninety degrees would be unusually hot in the summer, and winter temperatures seldom dip below zero. Hail may fall during an occasional thunderstorm, but rarely does it do much harm. Damaging windstorms do not often happen.

However, the area is subject to frequent and sometimes sudden changes. A saying often heard states that if you don't like the current weather, just wait a little while and it will change. Often that is true. I have known days to start with temperatures below freezing and by midafternoon be as balmy as a spring day. Likewise, I have known days to dawn unusually mild and be frigid before noon.

Those who forecast the weather tell us that the Bristol area is one of the most difficult in America for which an accurate forecast can be issued. A forecast of two or three inches of snow may end up being ten inches or more. A forecast of heavy rain may actually turn into a light shower—if it rains at all. Or no rain in sight may soon be a near cloudburst.

Bristol definitely does have four distinct seasons, and they usually blend smoothly into one another as time dictates. Each season most often brings the type of weather expected, but not always. Since weather patterns are often repeated, let us look at what has happened weather wise in the area. Notes made before 1800 on Bristol's weather conditions are very scarce, but a few do exist.

An old lady living in Blountville, Tennessee, in 1852, who was reared on the North Fork of the Holston River near present Mendota, Virginia, wrote of what must have been a very cold winter:

> In the winter of 1798 it got so cold that some of the trees in the woods near our cabin froze inside and split open. It sounded like muskets firing when they did. Toward daylight the sounds were more oft heard. It was a dreadful sound. The river was covered with ice so thick that papa could take the oxen and cart over on it. Some of the mountain branches froze solid to the bottom and ice piled up high at the place where they started. There was not much spring until the middle of May.

At the other extreme must have been the summer five years earlier. A man who spent his last years in the new Town of Bristol wrote of the hot summer of 1793:

> I was then ten years old and we lived on Big Spring Creek [early name for what is now Sinking, or Paperville, Creek]. It got so hot that we could not sleep in the house. Instead we piled up brush and leaves out in the yard and slept out there under the stars. I recollect that it would feel as hot in the near midnight hours as it did at noon time. Even out in the yard we soaked in sweat.

An old member of the pioneer Susong family wrote of better times: "We came here from far up in Virginia in December, 1794. I recall that the next year was extra ideal. The weather remained mild and there was plenty of rain, so that we made a very fine crop. Had everything in great abundance. But there came an awful drought a few years later, which about starved us out."

The drought that he remembered may have been that of which Rev. James King wrote in response to his son-in-law, Col. John English, who had written of a severe drought he was experiencing Monroe County, Mississippi:

> I have often heard my father tell, and though a child I recollect much of that awful dry and hot summer of 1799. The branches dried up and Beaver Creek got as low as I have ever seen it, before or since [he was writing in 1859]. Many wells went dry. Most of the settlers had built near springs, and a lot of those springs went dry. The bold

spring [abundant flow] at Holly Bend [his childhood home on Beaver Creek] became as low as it ever was in my time; so weak that we became greatly alarmed. And the rattlesnakes and other fearsome serpents [likely copperheads] came down out of the knobs seeking water until it was dangerous to step out. One morning when the door was opened at daylight, a huge rattler was on the doorsteps. There was much scarcity all around, and more so when came the winter. That is what caused father [Col. James King] to ever after store up enough corn for two or three years needs.

It seems that droughty weather was not always the cause of food scarcity for man and beast. Sometimes just the opposite was true. Col. Samuel E. Goodson, who figured prominently in early Bristol history, wrote of what must have been the very wet summer of 1810:

When I was seventeen there was the wettest summer ever known here. I lie not when I say it rained very near every day from late March right on into early fall. Beaver Creek, that usually flowed so gently back of our home [old West Point, which stood about two miles upstream from what became downtown Bristol] was very near the constant flood. Indeed, some of the more simple thinkers of our neighborhood really believed that another Noah-like flood would soon come upon the land. We planted the big Blue Spring Field in corn but the seed rotted in the ground. It was water logged and rotted on the trees, and little fruit could be had.

No one living in the Bristol area in 1816 would ever forget that year. Old-timers called it the year without a summer. And they were almost right. Such was the case over a large section of the United States, when it seemed spring would never come. Winter-like weather just continued on and on. You may have heard of June frost; here we have June snow! Rev. James King, writing of that time, stated: "At the burial of my grandmother Goodson [mid-June 1816 in present Ordway Cemetery] we had to wear heavy clothing to bear the cold weather, just the same clothes we usually wore in mid-winter. And the tops of the Beaver Knobs were white with fresh snow."

Only July and August that year had no snow or frost. There was frost in June, and snow was falling by late September. Very little food was raised that year. Men working in the fields had to wear overcoats and gloves. No fruit or

berries could be had. The game population of the area was almost reduced to nothing, as desperate men sought to have food for their starving families. Many a young man, and even children, shivered on the banks of Beaver Creek as they tried to catch a fish for lunch. There was a great loss of livestock due to the lack of grass or grain.

Reverend King wrote that his father sent wagons far into the South to seek provisions but to little avail. Fortunately by then, Colonel King had long had the practice of storing up a two- or three-year supply of grain ahead of time, so his family fared better than did most of their neighbors.

But that long winter passed, and 1817 brought normal weather patterns again. Most climatologists agree that the April 1815 eruption of Mt. Tambora, a volcano just east of Java, part of the islands of Indonesia, caused the year without a summer, as the dust in the air filtered out the sun's rays.

The winter of 1839-40 was also unusually cold but did not last as long as in 1816. Rev. James King, writing to a friend in Jonesborough, Tennessee, ended his letter with these revealing words: "I will have to cease writing. The ink is freezing in the bottle, and yet it is set close to a good fire."

The summer of 1852 was unusually long and hot. Joseph R. Anderson, who founded the Town of Bristol, long told that there was no frost after late February that year and there was no more until the second week in December. Midsummer was so hot that little could be done outside. He told that his surveyors, who laid out the Town of Bristol in an open field, were drenched with sweat as they worked. He further told how those surveyors would go at the close of day to nearby Beaver Creek, strip to the skin, and spend a great length of time reclining in the cooling waters. He also remembered that the next year was mild and had ample rainfall, ideal conditions for growing. Indeed when his house (the first building in Bristol) was erected, there were great fields of grain growing near it, and the meadows were lush.

The winter of 1856 was severely cold in Bristol. James King III, oldest son of Rev. James King, wrote to his sister who then lived near Egypt, Mississippi, that the ground became covered with snow in November and was still so in mid-February. There had been a full week when the temperature had not risen higher than ten degrees above zero and usually fell to ten below at night. The mill wheels had been frozen solid for over two months. Consequently, the new town was running short of breadstuffs because no grinding could be done.

It seemed almost providential that the spring of 1865 came early. The prolonged Civil War had caused a severe scarcity of food. Most of the residents

Several times in its long history, Bristol has been damaged by the flooding of Beaver Creek. This picture shows the great flood of 1917.

of Bristol were actually starving, and the early spring was of great benefit to the hungry. In many instances, the unfortunate folks lived on the early green shoots of various plants that popped up far ahead of their usual schedule. The remainder of that year was also very favorable to the production of much needed food for long-bare tables.

Alternation between hot and dry, wet and mild, cold and snowy periods dominated the 1870s. Old newspaper files of the period carry statements such as "This prolonged drought is truly alarming," or "This is one of the greatest crop years ever known in the vicinity of Bristol." Then comes a chilly notice from editor I. C. Fowler: "I hung a thermometer eighteen inches above the ground from a limb of my apple tree last night. This morning at daybreak it showed eighteen below zero." Another time, he wrote, "There was the greatest and most damaging flood on the South Fork of the Holston three days ago."

At first the mountains, hills, and valleys were covered with a junglelike growth of trees and vegetation, which held heavy rain back to the point that heavy flooding of the rivers and small streams seldom occurred. Some of the early settlers built their homes too near the watercourses—many of them well into floodplains—leading to disastrous situations. Homes were destroyed or badly damaged or moved when raging floods unexpectedly bore down upon them. Sometimes there was loss of life.

Beaver Creek has from time to time flooded downtown Bristol, most recently

on October 1, 1977, causing thousands of dollars worth of damage. At times, boats could float down State Street and its adjoining thoroughfares.

Over the years, there have been some unusually heavy snowfalls in the Bristol area. William Henry Harrison Gaines, who lived in a homestead about five miles east of Kingsport, kept a daily journal in which he made several notations on the severe and snowy winter of 1878-79. Temperatures remained low throughout the long winter, and snow after snow piled up on the ground. In January 1879, he wrote that 27 inches of snow covered the ground. He added that it was so cold that the family had to bring the cooking inside the house. He did not mean that they had been cooking in the open; he meant that the outside kitchen (called yard kitchens by some) had become so cold that they had to move the cooking to the big fireplace in the main house.

Under the date December 4, 1886, Jesse H. Miller, who lived near Bristol, wrote in his diary, "snow began to fall at night." Two days later he wrote, "the snow that began on the 4th is now three feet deep and still coming down."

A picture exists showing Main (State) Street during that time, and the big snow was long talked about by area residents. About all activity ground to a standstill. Some roofs collapsed, and many snow-laden limbs split from the trees. A local livery stable roof collapsed, killing six horses. Many local residents had to dig their way out of their homes because drifting snow had blocked the doorways. And some homeowners spent hours in the bone-chilling cold trying to push and shovel snow from their overloaded, and near collapsing, roofs.

The severe winter of 1894-95 was also long remembered. Ice and snow covered the ground for months, and the temperature never reached above freezing through the entire month of January. On the night of January 15th, a record may have been set for a low temperature. Col. J. B. Peters then lived in what was known locally as the furnace bottom, a now-vacant area south of Euclid Avenue immediately across the railroad tracks. That night he hung a thermometer on the front porch of the Palace Hotel (later St. Lawrence). It read eight above zero at 6:00 P.M., and by 8:00 P.M. it was at zero. By 5:00 the next morning, the temperature had fallen to 21 degrees below zero.

In early February that winter, with thick ice covering the ground, a man skated from Abingdon to Bristol in three hours. Then came spring, and folks thought the bad weather was over. By May 19th, the apples were big as marbles, and gardens had received their first hoeing. In the late afternoon that day, the weather suddenly turned very cold. Heavy snow fell during the night,

and the next morning, Bristol awoke in a winter wonderland. Ten days later, a light snow fell.

Three years later, on May 22, 1898, another spring snow fell in Bristol. The trees had leafed out, and the accumulation of snow resulted in many limbs breaking off and piling up under the trees. Some trees were split asunder by the heavy weight of the snow.

The following year, the morning of May 26, 1899, dawned bright and mild. Around noon, a cool wind blew in from the north and, by midafternoon, became very cold. It stilled about sunset. The next morning, there was heavy frost and below-freezing temperatures.

The summerless year of 1816 contrasts with the near-winterless 1896. According to old-timers who were living at that time, the mild winter was preceded by a harsh winter in 1895, just like the old proverb "One extreme follows another." The last freeze occurred in late February, and the last frost was in mid-March. By mid-April the weather was hot as June is usually expected to be. The summer months were extremely hot. Dad Thomas, who then lived near the present Mumpower Park, told me that he moved his bed to the back porch of his home in late April and did not have to take it back inside until early November. Even then he slept on top of the covers for another month or so. There was no frost of consequence until four or five days before Christmas, and there was no snow at all until late January of the following year, and then only a light dusting. That winter was similar to 1852, another warm year. What makes Bristol's almost-winterless year so strange is that, as best as I can determine, barely a hundred miles away in any direction the weather was about as usual. Bristol seems to have been in a strange warm pocket.

The year 1900 was hot and dry in Bristol and the surrounding area, as well as much of the South. Rain became scarce in early spring, and even more so as the year passed. Crop failures were common, creating a scarcity of food. Many wells dried up, as did springs, many of which were thought to be everlasting. Dust clouds were easily made by vehicles traveling along streets and roads. This droughty year was one of the hottest ever experienced in Bristol. But it passed, and 1901 was normal, weather wise.

On August 24, 1909, the temperature was hot in Bristol, yet there was frost in nearby Shady Valley. Almost two months later, on the morning of October 16, two inches of snow covered the ground in Shady Valley. Snow showers in October are not all that uncommon, but a "laying snow," even for Shady Valley, is rare in early autumn.

Perhaps that snowy morning in mid-October so near Bristol foretold the

harsh winter to come. The previous winter also had been severe. Heavy snows had fallen, covering the ground for the greater part of January and February. More snow in March lay on until early April. Temperatures had remained frigid through most of that winter. Then in November that year, heavy snows started again, and the winter of 1909-1910 proved to be severe.

Dad Thomas, who usually walked to downtown Bristol about every day, told me that he was housed in without his daily trip for about two months. "I just couldn't get on enough clothes to keep me from freezing," he said.

A Tornado Hits

Fortunately, Bristol seldom has severe storms or tornadoes. Though occasional tornado watches are broadcast, they rarely develop. But they can and do sometimes strike in the area. Few people now living know that the heart of downtown Bristol was once hit by what locals called a cyclone. June 5, 1893, was an unusually hot, humid day. From early morning, the skies were overcast, and by that afternoon, dark, low-hanging clouds had rolled in from the southwest. Nightfall did not bring relief from the oppressive heat. The air was very still, without the least semblance of a cooling breeze. After the evening meal, many Bristolians sat on porches, fanning themselves, before retiring for the night.

Most local residents were sound asleep in their beds as eleven o'clock neared. This was the case in the J. P. Rader house that stood on Shelby Street, directly across from where the former Tennessee post office building stands. At the time of the tornado, the lot was occupied by the brand new, $15,000 farmers market. The Raders, like most of their neighbors that night, left their windows open in a vain attempt to catch a cooling breeze.

Just before eleven, thunder began to roll and lightning began to shimmer over the knobs back of Windsor Avenue. Mrs. Rader awoke her soundly sleeping husband and asked him to close the windows, as she thought "it was coming up a thunder shower." Some shower it was!

Rader arose, shut the windows, and then started across the central hall to the east room. By then, a loud roar, sounding like continuous thunder, was swooping down from the knobs and into the town. And it was becoming much louder by the second. There was a dash of rain followed by a heavy peppering of hail. Rader opened the front door to see what was going on. The door was wrested from his hand and thrown back against the wall.

At that moment, the large market across the street disintegrated with an explosive sound. Bricks, timbers, windows, doors, beams, and planking flew

everywhere. Pieces of lumber began flying around Rader's home. A splintered piece flew through the front door and hit him on the knee, knocking him to the floor. Within a few seconds, the front hall was filled with split and broken lumber, along with large shards of glass. Downtown Bristol's only known tornado had struck.

All along that portion of Shelby and on Broad, one block away, men and women jumped from their beds, grabbed sleeping children, and ran. Some went to inner hallways as broken glass sailed around them; some dove under beds. One man said he "leapt down the cellar stairs, right behind my screaming wife."

Maj. Henry Clinton Wood then lived on Broad Street. He was trying to get to an inner hall when shards of glass hit him from a breaking window. He was seriously hurt but recovered.

One fellow was soundly sleeping in the upper story of a house that then stood on the corner of Seventh and Shelby (later site of the E. W. King Wholesale Building). His roof was torn clean off while he slept on, and he did not awaken until he heard screaming and excited voices in the street.

The tornado followed the usual course of such severe storms, from southwest to northeast. It seems to have bounced over most of Sixth Street and touched down again near the intersection of that street with Main (State), where it badly damaged the large windows of the Judge M. B. Wood Building that stood on the corner of Sixth and Main. The plate-glass windows were shattered into small particles, and one of the metal frames was twisted from its position.

Across Sixth Street south of the Wood Building, the Pyle Building was badly damaged. Water flooded the office of the *Courier*, which was located in the building.

The tornado then took right up Main Street, bursting out windows and ripping off roofs. Telephone lines lay tangled in the street. Sometimes the flying roofs knocked portions of cornices from the building into the street. The 500 block of Main was practically blocked by debris. Heavy rain poured into the buildings, ruining much of the furnishings and stock. Some stock was sucked from the buildings and thrown into the street.

The central telephone office and switchboard were located on the second floor of the Barker Building, which stood just off Main Street on Lee. Joe Anderson was the lone operator on duty that night. Before he knew what was happening, the roof was swept from the building. The switchboard for a time was a solid blaze as wires spewed and glowed with heat. The frightened

operator made a lunge for the stairway but in the darkness stumbled and fell headlong down it. Apparently the fall did him no harm, for instantly he jumped up and ran into the street. He remembered what a thunderous roar the storm made as it swept on up toward Front Street.

The 400 block of Main was hard hit. The Anderson block stretching along the south side of the street suffered much injury. Some three-story buildings were so badly damaged that they had to be cut down to only two floors. Although Anderson's store building also suffered much damage, it was repaired and continued with three stories until it burned in 1945.

The 40-year-old Anderson home, the first building erected in Bristol, stood hard against the store building. The upper portion of the east chimney toppled, and some windows were broken. The historic house might well have received more damage had it not been somewhat shielded by the larger store building.

On the third floor of the Anderson building, the St. Omer Commandery Hall, which had just been remodeled and refurnished at a cost of about $3,000, was flooded and filled with debris, badly damaging the furnishings and plush carpets. Curtain and Haynes, a law firm on the second story, saw much water damage to their law library. (In 1927, the now-famous first country music recordings would be made on the same floor where the law offices were located.)

The tornado veered up Front Street, damaging the Dickey Building (old W. W. James property) as it passed. The three-and-a-half-story St. Lawrence Hotel (formerly called the Palace Hotel), standing tall and proud on the northwest corner of Front and Cumberland (where the General Shelby Hotel was later built) seems to have been in the direct path of the fearsome twister. The roof was torn off, and the upper story was almost a total wreck. Windows shattered as the building shook. The chimneys toppled, filling the street and some of the upper rooms with bricks. Some of the furniture was crushed flat to the floor by piles of debris. Fine carpeting was ruined as heavy rain poured into the upper floor.

Only one guest was on the upper floor. David J. Hart, who became a Bristol merchant and later operated Hartfield Dairy on King College Road, had taken the northwest corner room the afternoon before the tornado struck. His room was away from the falling debris, which probably saved his life. He long told how he had a time rushing—at least trying to rush—down a dark and debris-covered stairway to the lower floors, all the while being soaked by the wind-driven rain. His only aid in his escape effort was the near constant flashes of lightning.

Fifty-eight years later, he chuckled as he told how he was in the hotel lobby before he realized he was wearing only a meager night shirt and had not bothered to slip on any shoes. "My only thought was to get out of there," he explained. Luckily he found a man in the street who owned a clothing store a block or so away on Cumberland Street. Hart persuaded him to open his store—it had not been damaged—and sell him enough clothes to "tide him over," as he expressed it.

The Hamilton House Hotel, just beyond the St. Lawrence, did not escape the wrath of the storm. The brick structure was shaken from top to bottom, its third floor wrecked and furnishings ruined. Guests rushed down the stairways, dressed or undressed as they were in their beds. Several lovely, large, old maple trees had stood in front of the hotel, and most of them were twisted off near the ground and scattered across the street and on the railroad tracks near the depot.

The storm evidently missed the depot by a few feet, but two or three empty freight cars parked near it were blown over. A row of several parked passenger coaches was struck by the tornado and immediately started down through the yard, rapidly gaining speed. Car inspector Frank White, who was standing near the cars when the sudden sweep of wind came, jumped on the end car and put on two brakes with all the strength he could muster. Once the cars stopped, he grabbed a flag and raced down the track to stop Number 3, whose distant whistle he had already heard. He knew the tracks near the depot were covered with debris from the two hotels across the street and might wreck the incoming passenger train. He managed to flag the train to a stop near the present Ash Street Bridge.

The tornado crossed the railroad and headed directly toward a heavily populated residential area. But it apparently lifted high in the air, because there was no evidence that it touched down again in the rural area beyond downtown.

There was little sleep in the town during the remainder of the night. Messengers rushed to the residential areas of Bristol to apprise downtown property owners of the terrible destruction. Word quickly spread from house to house. By 1:00 A.M. the business section of Bristol was crowded with hundreds of local residents, including many women and children. But most of the crowd quickly dispersed when another heavy thunderstorm rolled in from the west at about 3:00. The storm did not carry strong winds, but the torrential downpour of rain greatly added to the existing damage.

The tornado was much talked of through the following years. More than

half a century later, several old-timers described to me that never-to-be-forgotten storm. Those who lived through the event are all gone now, so I have recorded this as an admonition to the present and future generations. Can what has happened before weather wise happen again? Beware and take precaution when conditions are right for such storms to develop.

My good friend Tommy Knoll told me of a violent windstorm that struck Bristol March 15, 1933, on the same day—indeed, at the same hour—he was born. His mother was in the delivery room on the east side of Kings Mountain Hospital, while the west side was receiving damage from the violent winds. The storm blew out the windows in a room where several World War I veterans were receiving care, and according to Knoll, flying glass killed two or three of them. The same storm did much damage in Bristol, as well as throughout East Tennessee.

AUNT MAGGIE'S DIARY

Old diaries and journals often provide information that would be difficult or impossible to obtain otherwise. I am fortunate to have been allowed to read and copy portions of a diary that provides a glimpse of the weather in Bristol during the first quarter of the 20th century. Margaret (Maggie) Rhoda English long lived in a house that yet stands at 640 Alabama Street in Bristol, Tennessee. She was born May 14, 1849, in Monroe County, Mississippi, but she spent most of her life in Bristol, Tennessee. She died in Bristol July 7, 1942, and is buried in East Hill Cemetery.

She was a granddaughter of Rev. James King of local fame. Her father, John Goodson English, began keeping a diary in the mid-1850s. After he died in 1887, Maggie took up where he left off and continued until the mid-1920s. Her writings include bits of information concerning Bristol weather:

April 19, 1904	There is ice here in Bristol and nine inches of snow covers mountains near here.
April 18, 1905	Ice froze inch thick last night
August 15, 1905	There was a cloudburst near the head of Beaver which caused the worst flooding ever known in Bristol.
August 31, 1905	Severe wind and electrical storm today. Lightning struck the steeple of the Negro Baptist Church and caused the bell to ring.
September 3, 1906	Very hard storm. Lightning struck the steeple of the First Presbyterian Church. Also struck Tip Top Hotel

Weather

and a house in Fairmont. Burned a house in west end of town. Storm raged continuously from nine to eleven in the morning. [Carter Crymble told me that he well remembered this storm. He had just taken hold of a metal gate at his step-grandmother's home on Fifth Street when the steeple of the church was struck. Even at that distance (about three blocks) he received quite a shock from the strike.]

January 7, 1907	The temperatures have been ranging from 50 to 70 degrees for over a week.
January 27, 1907	Snow has been falling every day for the past week.
August 17, 1908	The steeple at First Presbyterian was struck by lightning today. Was struck once before. [After the second strike, the steeple was removed. The lower section of the tower remained on the church as long as it was in use.]
May 15, 1910	There was a killing frost on this morning.
June 1, 1910	Frost and very cold. There is a high wind.
June 3, 1910	Bad storm today. Electricity goes off.
January 19, 1912	It was 80 degrees today
May 15, 1915	There was a killing frost today.
January 18, 1916	It is six below zero and near blizzard is raging outside. [Maggie's niece Robel Baumgardner was born that night and still lives in Bristol, Virginia. Another niece, Sarah Baumgardner, became the wife of Dr. Lewis Cosby the next day. The family called it the time of the three B's—blizzard, baby, bride.]
June 1, 1917	I still have on my winter flannels.
June 14, 1917	Big flood on Beaver Creek. It is all over downtown.
August 25, 1917	It rained every day here from August 4 to August 24.

A Very Cold Winter

In her diary, Maggie English writes that the winter of 1918 was the "longest, coldest winter that any of the oldest resident of this city can remember." Indeed it was, so much so that it deserves a special write-up. That winter brought unusually cold weather to much of the eastern half of the nation.

If a winter is going to be bad, there usually will be some rather cold weather by mid-October. Such was the case in October 1917. Frost came early, and the last ten days of the month brought three or four hard freezes.

A Good Place to Live

One old-timer of the city read the signs and openly predicted a severe winter ahead. He was right. The happenings in October did constitute the prelude to one of the worst winters ever experienced in the area.

November saw unseasonably cold temperatures and much snow. December came in with a blizzard, and conditions worsened as the month progressed. Indeed, Bristol had a white Christmas that year—very white—and many rooflines were decorated with giant icicles. January found the city in the grip of the worst winter since 1895. And it would remain the worst until 1977. But Bristol did not suffer alone. A severe winter gripped the entire eastern section of the nation. Blizzards swept much of the country mid-January, causing many deaths and untold suffering.

To add to Bristol's woes, the city, and much of the country, had a coal shortage. Indeed, in some places in the East and Northeast, mobs of desperate and freezing people raided the railroad yards, forcibly taking coal from parked freight cars. One Eastern newspaper reported that some of its city's most elite and law-abiding citizens were involved in the mob action. While no such actions were recorded in Bristol, many citizens were slipping into the railroad yards at night and taking away as much coal as they could carry. When several cars of coal finally became available to the city, another problem developed. Moisture remaining from the mines froze the coal into a solid mass that could hardly be separated into easily transportable quantities.

Before the severe weather began, some families had put up a good supply of coal, some far in excess of their actual needs. While those who were without suffered and froze in their homes, J. H. Faucette, local fuel administrator, ordered the haves to share with the have-nots. He threatened to confiscate the abundant supplies of the people who did not react favorably to his plea; in a few cases, he carried out his threat.

Faucette ordered restaurants, movie houses, and stores to close no later than 10:00 P.M. He further ordered other types of businesses to close even earlier. Many planned activities had to be cancelled. Merchandising was greatly curtailed, since not many people ventured out in the severe weather.

Temperatures stayed below freezing for weeks at a time, sometimes reaching far below zero at night. Water pipes froze solid in nearly every home in the city. One old-timer told me that an exposed water pipe in his kitchen froze solid in spite of a roaring fire kept going day and night in the cookstove. A retired plumber told me that those of his trade stayed busy day and night. He spoke of one time when he went 48 hours without sleep. Plumbers at the time charged 50¢ per hour during the day and 75¢ at night.

Weather

On January 12, 1918, heavy snow came in with strong winds near nightfall. By midnight, the thermometer read eight below zero, and the snow, as one old-timer expressed it, was "falling sideways." Visibility was low, causing one man to become lost between his coal shed and his home. He wound up at the back door of the house next door. Fearful that he might become hopelessly lost again, he spent the remainder of the night with his neighbor. Luckily the telephone wires were still up, so he could notify his family what had happened.

A switchman in the local rail yards nearly froze to death that night waiting for the passing of passenger train number 13, but another switchman found him and took him to St. Lukes Hospital for treatment. Another switchman also nearly froze to death as he waited at Glade Spring for passenger train 42 to pass. He was taken to a hospital at Roanoke on that train.

The next day, Maggie English wrote in her diary, "Fearful time last night. Awful blizzard. Was twelve below zero at five this morning. Ten inches of snow on the ground. Sun was bright today, but the high came around two this afternoon—only sixteen above. It is zero at nine tonight."

During mid-January—my informant thought it was on the 18th—a cruel hoax was wrought on the city. Someone started a rumor that an awful blizzard was approaching Bristol and would strike about nightfall. It would, the prankster declared, be far worse than the one of the previous week on January 12th. There would be likely two feet of blowing snow and temperatures down to thirty below zero. The city went into a panic, making all kinds of preparations, including the housing of livestock insofar as was possible. One old lady who didn't like dogs in the house even allowed her pets to come in and sleep by the fireside. Water was drawn up in anticipation of freezing and bursting pipes. Some folks sought shelter in warmer homes of friends or relatives. Virtually all businesses in the city closed by 4:00 p.m. so the owners and workers could go home and brace for the coming super blizzard.

The temperature, which had hovered around freezing all day, actually moved upward near dark, and that night proved to be the mildest of the month, barely reaching the freezing point just before daylight the next morning. The culprit who started the hoax was finally identified. Local citizens made it so hot for him that he finally decided it would be best to leave without delay. He did and, as far as is known, never returned.

But that one mild night did not signal the end of severe weather. In a day or two, conditions were as bad or worse than ever. Virtually all new building construction closed down before that long month was over, and most of it did not resume until spring.

A Good Place to Live

The coldest temperatures came at the end of January, including a reading of 23 below zero in Bristol. Nearby Marion, Virginia, registered 30 below, and at the Southwestern State Hospital on a hill above the town it was 28 below. The staff at the hospital was hard put to keep the buildings at 50 degrees, far below the comfort zone.

That night in Bristol, nearly all homeowners kept water running in their kitchens and bathrooms, which caused the water pressure to drop to a low point. However, the mayor later stated that the constant moving of water probably kept the main lines from freezing.

The coal shortage became so acute that town officials set up a community wood pile. They hired men to cut up wood and bring it to a central distribution lot near the corner of Third and State on the site of the old Tennessee depot. By charging a small fee for the wood, the city just about broke even.

Finally, officials made an appeal for old junk wood, lumber of all descriptions, and unused fenceposts to be brought in and added to the pile. Many barns and sheds were then cleaned out. The old plank fence that had long surrounded the large East Hill Cemetery was torn down at this time and served the charitable purpose of keeping the living warm, rather than protecting the dead. A new wire fence was erected in the spring.

There were many times when pedestrians could hardly stand up on the streets. One old man told me that he fell five times within a city block, and each attempt to stand up resulted in more slipping and sliding. Old sleighs that had not been used in years were brought out and once again used to traverse the slippery streets. The tinkling of the bells on these horse-drawn vehicles was a pleasant sound on dreary days. Of course, the horses had difficulty in standing up also. A local blacksmith stayed busy making special slip-resistant shoes for horses.

A few people living in unheated, or near unheated, houses died of hypothermia, and several others died from flu and pneumonia. Burials for those who died of whatever cause during that dreadful time were difficult, due to the depth of the hard-frozen ground. Men built bonfires over burial spaces, trying to soften the earth a bit.

In early March, the city enjoyed several days of sunny, mild weather, accompanied by much thawing. Will Palmer noted in his diary that the temperature reached 55 degrees on March 10, adding, "This has put folks to thinking of gardening."

Alas, a week or so later, there was a heavy snowstorm with the temperature

dropping to 10 degrees. Wintry conditions set in again, and there was little relief until mid-April. Frosts continued until mid-May.

The winter of 1940-41 was rather severe, but Bristol did not have a winter that came near to matching 1918 until 1977—and even it did not have as heavy snow, nor as low temperatures, as that earlier winter. Will it ever happen again? No one knows, but the "chilling" reality exists that, weather wise, what has happened before can happen again.

Weather Extremes

In 1934, the U.S. Weather Bureau began keeping records on the Bristol area, and daily information is available for the years since. The hottest day from 1934 through 2004 was July 29, 1952, when the temperature reached 102 degrees. The coldest day, January 21, 1985, saw 21 degrees below zero at dawn. The wettest month was August 2003, when more than 11 inches of rain fell. The wettest year was 2003, with 65.5 inches of rainfall. The coldest month, January 1977, averaged 22.1 degrees, and the hottest month, July 1993, averaged 79.6 degrees. The driest month of the period was October 2000 with only .02 inches of rain. The most snowfall in one month was 16.2 inches in November 1952. The most snow in one winter occurred in 1959-60 with 51 inches.

While much of the country suffered severe droughts through the early 1930s, Bristol had a touch of dryness, but not as intense as some places in the West. Several older Bristol citizens may remember the "brown sky" days that occurred for a brief period during one of those droughty summers. (Some of my informants thought 1931; others thought it was more likely 1933 or 1934. All agreed it was during the Great Depression.)

In midsummer, with day after day of dry, extremely hot weather, folks began to notice that the unusually brilliant sunlight was obscured by haze. At the same time, housewives began to find an exceptional amount of fine, brown dust on their furniture. Porch floors, swings, and chairs also became covered with dust. Gradually, the skies developed a brownish color. The distant mountains became blurred in a brownish haze. Those with breathing problems found their symptoms growing worse. Some of the more superstitious of the city thought the end of the world was near. Even some of the most learned of the town struggled to find a plausible explanation. Then the haze slowly began to vanish.

Several Bristol citizens had radios at that time, and through that medium the mystery was finally solved. Someone at the local radio station WOPI

A Good Place to Live

Weather in the Bristol area can be severe. Pictured here is the aftermath of the great four-day snowstorm of 1993.

picked up news from the West and broadcast the explanation of the mystery to the city. The dust bowl era was at its height. Great clouds of dust had been drawn upward, and strong winds had driven those clouds eastward (some for more than a thousand miles), causing the brown-sky scare in Bristol and elsewhere.

Many of my readers will remember with me the harsh winter of 1977. Snow fell heavy around Christmastime of 1976, and there was not much thawing until early March. Meanwhile, the city shivered through cold days and cold, long winter nights. Water pipes froze all over the city, and plumbers stayed busy trying to restore water service to many homes. My own water supply was out because of frozen water lines from about January 28 through the first week of March. The following winter was also cold but not quite as bad as 1977.

At about 5:00 p.m. on October 1, 1977, Bristol was hit by a severe storm following an unusual afternoon of continuous, rumbling thunder. The clouds thickened in late afternoon, and the violent storm struck with high winds and a downpour just as many folks sat down to supper. The heart of Bristol was fortunate, but a few miles down Highway 11-E, near the Bristol Motor Speedway, a tornado crossed the valley, doing much damage. Fallen trees on the hillsides still mark the path of the twister, which set down again in the Vance Tank section and did more damage. That night Beaver Creek flooded downtown Bristol, the city's last major flood to date.

Christmas morning of 1983 registered 10 degrees below zero. The sun shined brightly all through the day, but the temperature remained frigid. That was the coldest temperature I personally experienced in Bristol; fortunately for me, I was in Florida when it reached 21 below in January 1985.

A snow in March 1993 reached a depth of about 17 inches, all but paralyzing the city. I remember that no mail service ran for two or three days. The day before the snow started was as pleasant as one could want. Although the forecast called for heavy snow, few believed it would come. But it started that night and snow fell for about three days.

In January 1996, a heavy, wet snow caused power outages for much of the city and surrounding area. Some residents had no power for several days. I remember how strange it was to see downtown Bristol in darkness, and of course the stoplights did not work. For those of us who depend upon electric power for heat, this outage was keenly—or should I say coldly—felt. My power on Solar Hill went out about ten o'clock Tuesday night and did not come back on until midmorning on Thursday. I was fortunate; many in the area were without power for a much longer period. The water failed in some parts of the city. Several residents moved in with friends or relatives, or stayed in motels, until service was restored.

A Good Place to Live

Food for Bristol

Wherever there are people, there has to be food. The human body requires a constant source of fuel, whether grown, bought, received as a gift, or even gathered in the wild.

Groceries have been available in Bristol since December 24, 1853, when Joseph R. Anderson opened a store in one room of his new brick house. The location was on the southwest corner of what was then Fourth and Main, now Edgemont and State. The store offered food supplies but was a far cry from the large supermarkets of today. The offerings were limited, even when compared to the larger store Anderson would later operate and two other stores that soon opened in town.

Most Bristolians today depend wholly on grocery stores for their food, but in the early days of the town, most people grew what they ate, having an occasional need for staples such as sugar, salt, pepper, coffee, etc. Many early residents came from a farm background and had been reared virtually living off the land. In a somewhat limited manner, they continued to do so after moving into the new town. Even on small lots, efforts were made to produce as much food as possible. Some still owned farms nearby, and others went into the country around Bristol and rented small plots for food-growing purposes. Thus, in the first 25 years or so of the town's existence, few residents depended solely upon local grocery stores for all their food.

Even Joseph R. Anderson, founder of the town and her first merchant, had gardens and truck patches that covered most of the block now surrounded by State, Edgemont, Shelby, and Fifth. He also kept two or three milk cows, along with fattening hogs and a flock of chickens. He also had a sprinkling of fruit trees on his place. One time, when selling a lot on

Fifth Street, he bemoaned the fact that it took his best apple tree. He also had a long grape arbor and a row of beehives along the Shelby Street side of his lot.

His son, John C. Anderson, used to tell that those beehives were sometimes the center of a rather risky game he and other neighborhood boys played. When he was about 10 years old (1860), he and the boys would slip around behind the hives. They would then dare one another to ease up to one of the hives with a stick in hand and give it a slap or two. The boy who could stand the longest after he stirred up the bees won the game. Most boys quickly forgot about the glory of winning and fled. Anderson used to say that is where he found that discretion was the better part of valor!

He recalled one time when an older son of Joseph R. Anderson (doubtless, this was James King Anderson) heard the commotion and came running out to see what was going on. Finding himself in the midst of swarming, angry bees, he quickly fled and took refuge in the nearby chicken house. Alas, some of the bees "took refuge" with him. In moments, he was out and running toward the main house.

Dr. B. F. Zimmerman, Bristol's first doctor, lived across the street from the Anderson home. He had a large garden on the northeast corner of what is now Lee and State streets, where now stands the building that formerly housed the Blue Ridge Bank. At the back of his garden was a strawberry patch. Needless to say, there were many boys in town who found the ripe strawberries more of a temptation than they could resist. Much of the crop disappeared in the night. As was the case with his neighbor, Joseph R. Anderson, the Zimmerman garden was tended by slave labor.

Not only did about every early settler have a flourishing garden, most of them had fruit trees on their lots. An early visitor to the town wrote of how he stood at the depot and viewed an otherwise drab town made beautiful with what he called a sea of fruit trees in full bloom. He further mentioned that even most of the stores had fruit trees on their back lots.

A guest at the first hotel in Bristol (the Columbia) told of being awakened by a chorus of roosters crowing in the backyards of nearby homes. This too was a sign of the self-sufficiency of early Bristol residents. He also mentioned that he saw a wagonload of farm produce being hauled into town. He learned it came from a nearby farm belonging to a Bristol merchant. The farm was tended by slaves and a tenant farmer.

One thing in favor of those who grew food in early Bristol was the richness and depth of the soil of the Beaver Creek bottoms, upon which most of the

town was situated. According to old-timers here, the soil was so rich it would grow almost anything.

Most of the early stores were of the general type and carried a limited variety of groceries. In the first years of Bristol's existence, all goods were hauled to town in freight wagons. Some early residents maintained a fleet of wagons, foreshadowing the trucking companies that would come much later. Some wagoners hauled from such distant points as Baltimore and Philadelphia. Major Z. L. Burson laid the foundation of his fortune in this manner.

Of course, fresh fruits and vegetables available in local stores had to be in season. Refrigerated freight cars and trucks were far in the future. Early merchants took much produce in barter trade. They lived in hope that they could sell it before it withered or decayed. Often their hopes were in vain. They preferred good keepers such as apples, potatoes, pears, and such. Nevertheless, they took in an abundance of such perishables as cabbage, grapes, berries, plums, cherries, and peaches.

Tomatoes were usually planted only for ornamental purposes because many people thought they were poisonous. As strange as it may seem, some people shunned them because of another dark reason—they thought tomatoes really were passion fruit, as they were often called.

A good example of this centers on a bachelor in Holston Valley. He had a strict upbringing and was taught not to even think of the "sins of the flesh," lest thoughts lead to action, and action to eternal damnation. Someone had told him tomatoes were to be strictly avoided if he wanted to remain morally pure, saying that eating them would bring on a fit of uncontrollable dark passions that would surely lead to seeking the sins of the flesh. If somebody served soup that contained tomatoes, he would starve before eating it. He remained a bachelor until he was 69 years old, then he married a 15-year-old girl. His neighbors couldn't help but wonder if he had at last eaten some tomatoes!

Bristol merchants took in large quantities of dried fruits and berries to sell to the public. Such would add a bit of sparkle to an otherwise unappetizing and monotonous winter diet. But some of the fruit may have had a little "meat" with it. One retired old merchant said he had sold much dried fruit that had probably come from two years or more back and oftentimes was worm infested.

Milk, butter, and eggs were available throughout the year, though the supply lessened somewhat during winter. All three items were a major part of the barter trade. Milk was not sold in bottles or other small containers at that time, but was measured out in the purchaser's own vessels from large contain-

Food for Bristol

Much of the milk for Bristolians in the early part of the 20th century came from local farms. This cow, owned by David J. Hart, became the oldest producing Jersey cow in America. She was named Bonnie Belle Primrose.

ers (often a barrel) brought to town in farmers' wagons. Sometimes if another wagon or horseman passed by while milk was being poured, the customer might get a generous helping of dust along with the milk.

Eggs were not always fresh. There were instances where some had been under a setting hen for a week when that hen decided to quit the job. One lady admitted that she had killed a blacksnake in her chicken house after it swallowed six or seven eggs. She ripped the snake open, retrieved the eggs, and bartered them on her next trip into town.

E. H. Seneker, an early Bristol merchant, often delighted to tell how he turned the tables on a lady who tried to pass off some inferior butter. Along with eggs and other items, she brought a pound of butter to his store and said she wanted to trade it for another pound of butter. After a bit of inquiry as to why she wanted to trade butter for butter, she blurted out, "Well, now, I seed Grandma a-drooling snuff juice into it when she was taking it out of the churn."

The quick-thinking merchant never batted an eye and replied, "Why, sure I'll make a trade. I always want to keep my customers happy." He took it into the back room, softened it up a bit, then put it into his special mold that impressed his initials on the top. Coming out, he handed the butter to her, snuff juice and all. She went away happy, thinking she had made a good trade.

A Good Place to Live

Street peddlers have sold their goods in Bristol from near the beginning, even after large grocery stores opened in the city, and the practice continues to a lesser degree today. Within the past year, I have had a tomato peddler at my door, and a few years back, a man came by with a small truckload of farm produce for sale.

About anything grown on a farm was often brought into Bristol to peddle. Many early peddlers drove their wagons into town, parked them in a convenient place, and waited for customers to come to them. Others, who perhaps were a bit more aggressive, went from door to door and often were more successful than those waiting by their wagons. Older children would occasionally be sent from parked wagons to go door to door.

I. C. Fowler, editor of the *Bristol News*, once complained that he could hardly get his writing done because of having to look up and tell some youth that no, he did not need any apples, potatoes, beans, or whatever might be offered. One time, a bit on the facetious side, he wrote of a local man who had bought some well-aged butter from a youth on the street. He commented that the youth was better on the sell than the man was on the smell!

Along with fresh produce, eggs, butter, and milk, there was often cured, or even fresh, meat for sale. And always someone was coming in with a load of live chickens.

An informant of long ago told me of one farmer coming in with a load

Most early Bristol grocers made home deliveries. This is the delivery wagon of Smith and Satterwhite.

of chickens and several of his near-grown "young'uns" when a slow-moving switch engine hit them at the Main (State) Street railroad crossing. Fortunately, no one was hurt, even though the wagon turned over on its side and spilled all aboard onto the tracks. The well-filled chicken coops broke open, and the greatly frightened fowls scattered in every direction, most of them going right down Main Street.

My informant, who was standing in front of the Nickel House Hotel nearby, remembered that the old man jumped up and called out to his boys, "You'ns catch them chickens quick. Your maw's done worked too hard raising them critters to lose 'em now." He so commanded, and the race was on.

My friend said, "The boys ran the chickens all down through town, some going up Front Street plumb to Circus Bottom [site of the present Bristol, Virginia, jail]. Some folks helped them, and I thank they got them all except one. They's a man playing pool over at Jamison's place, and afore he knowed what was happenin', a big chicken jumped rat up on the table. He jist grabbed it and wrung its neck. Then he laid it under the table and went on with the game. He tuck it home, he told me later on, and Betty Jane [apparently his wife] made dumplin's outen' it."

Old Dad Thomas also told of an unusual peddler:

> I recollect one spring they's an old man—thank his name was Dowdy—that lived out here in them hills just t'other side of Paperville. He come in here one day about dinnertime with a wagonload of frush picked poke sallet. He parked over here at Seneker's Corner [northwest corner of Lee and State], and he'd stand there by that wagon plumb full of poke sallet.
>
> And once in a while, he'd yell out, "All ye folks that needs a good cleanin' out, come up here and get a arm load of this sallet. Ye know that poke sallet is one of the best things around to get you doing the back-door trots [urgent trips to the outhouse]." And you know, sir, afore night, that wagon was plumb empty, and that man had a pocketful of money.

According to old-timers, some of the peddlers even brought in wild game—squirrels, raccoons, groundhogs, rabbits, and opossums. Occasionally a whole deer might be in a peddler's wagon. One old-timer told me that he always bought a squirrel for his wife's dumpling pot. He also told how he loved that good squirrel gravy she sometimes made. One peddler later admit-

ted that what he had sold to Bristol housewives as chunked rabbit meat was actually cuts from a giant rattlesnake. He often laughed at how a local housewife begged him to bring some more of "that fine chunked rabbit," calling it the best she ever tasted.

Not infrequently, moonshine whiskey was stashed away in the peddler's wagon and sold to select customers known to be "safe." One of those "safe" customers was the town sergeant of Bristol, Virginia.

Feathers made great articles of trade during the days when there were far more feather beds than foam mattresses. An early Bristol widow made a comfortable living by operating a "factory" making feather beds and pillows on the third floor of Col. J. M. Barker's Main Street store. It was a one-person operation, and she was always busy. Often she took pay in more feathers, which she made into bedding and sold to the local trade.

Farmers saved up feathers for a year or two before bringing them to market. (It took a great quantity of them to even weigh a pound.) Many of the merchants had long feather bags (six to seven feet long) to lend out to farmers who supplied them with this valuable article of trade. Feathers were light but bulky. Wagons loaded with bags of feathers did not mire down in the muddy streets of Bristol, as did those loaded with heavier articles of produce.

Most of the stores had feather holes beneath the floor. When a sack of feathers came in, the merchant raised up the door over the hole and dumped them in. Getting them out was a little more difficult. (The only surviving feather hole I know of in the area is in the old Deery Inn in Blountville.) Once the feathers were weighed—before they were dumped in the hole, of course—the farmer was given a credit slip that he could take out in trade at the store. Occasionally he might take the value in cash. Feathers for food was quite common in early Bristol.

Long ago, I heard from several old-timers about the "great feather storm" that occurred in Bristol about 1879. An industrious farmer who lived in the Holston Valley had borrowed four or five feather bags from J. J. Childress, a merchant who had a large store on the southwest corner of Fifth and Main (State), where the old First National Bank building now stands. One windy day in late March, the farmer brought the well-filled bags to the store and placed them on the sidewalk. Then he went inside to arrange for the weighing and emptying of the bags.

A few days before, Childress had hired Hugo Patton, a teenager, as a stocker and loader. The lad was more brawn than brain, but that suited him for the required heavy-duty work. High-tempered and self-willed, he had

extreme difficulty in obeying orders. Thus, it had become evident to Childress that he was not going to be an easy employee to manage.

It so happened that just about the time the farmer unloaded his feathers, Childress and the employee were having a discussion. Words grew hot, and Hugo was fired and told to leave at once. Just as the farmer walked into the store, Hugo angrily stalked out, "cussing a blue streak."

On the sidewalk, the teenager saw a chance for parting mischief. He jerked out his pocketknife and ripped open the feather sacks. Then lifting them one by one, he emptied the well-filled sacks into the March wind. In moments, great clouds of feathers were swirling down Main Street.

Inside the store, Childress and the farmer were engaged in hearty greetings, not aware of what was going on outside. Suddenly, a woman who was shopping in the store screeched out, "Lord have mercy, hit's a-snowin', and the sun's a-shinin' plumb bright!"

Childress and the farmer ran to the front door and quickly discovered, much to their chagrin, that it wasn't snowing. And through the flying, swirling feathers, they glimpsed Hugo fleeing down Main Street. The old farmer tore out after him, yelling out curses as he went. But that yelling was his undoing. A few paces down the street, a wad of feathers flew into his open mouth. Naturally, that diverted his attention for a while. By the time he renewed the chase—mouth wisely closed—Hugo had disappeared down Davis Lane, an alley now known as Bank Street.

Feathers flew into open store doors and windows. One man who was yet living when I arrived here told me how his mother-in-law, wearing a "stovepipe" bonnet, was walking along the sidewalk when feathers clustered in front of her bonnet and blinded her. She had to tear the hat from her head in order to see how to dash into a nearby store.

Upstairs on the corner of Sixth and Main was a photography studio. Dr. A. M. Carter, a young physician, had been carefully posed for a picture, and the photographer, bulb in hand, squeezed it just as a wad of feathers blew through an open window and splattered all over Dr. Carter's jet black suit. Of course, the suit was carefully brushed and another shot made, but as a novelty, the feather-spotted plate was developed and long kept by the man's descendants. He was much kidded about being photographed when "tarred and feathered."

For months, even years later, wads of feathers could be found in the most unlikely places—on rooftops, down chimneys, in wells and cisterns, inside open cracker barrels, and among dry goods in stores. Many feathers were

found in the louvered tower of the Main Street Methodist Church (now State Street Methodist) when that old building was demolished to make way for the grand new edifice that arose in its place. Certainly, many Bristolians were then living who remembered the incident and could explain what otherwise might have remained a great mystery.

Sometimes a bartering merchant received added benefits. Toward the end of the 19th century, David Jenkins Hart, a native of Carter County, Tennessee, came to Bristol as a young man with the ambition of making good in the fast-growing town. At first, he got a job as a newsboy on trains running between Bristol and Appalachia, Virginia. After a few months at his new home, he came down with typhoid fever and had to return to Carter County for a while.

But that fever did not burn out his ambition for success in Bristol. He returned and soon landed a job in a large grocery store, where he learned the ways of a successful grocer. A little while later, he and Hugh T. Hicks opened a grocery store of their own at 513 Main Street in Bristol, Virginia. Hart was then a bachelor, boarding at the Hamilton House Hotel on Front Street.

Jacob Susong Carmack, a valued customer of Hart and Hicks, lived on a prosperous thousand-acre farm on what is now King College Road. His only daughter, Martha Ellen (Ella) Carmack, was beautiful, charming, refined, and well-educated (a former Sullins College student).

During the summer of 1897, she sold produce from the farm to Hart and Hicks and often mentioned to them that she was saving funds to purchase the most beautiful wedding gown she could find, for she was to be married the following spring.

Hart fell for her, engaged or not. After one of her trips to the store, he remarked to Hicks that Ella might marry in the spring, but it would be to him and not the man to whom she was engaged. No one seemed to know just how, but Hart managed to win the beautiful young woman away from the other fellow. They married in 1898 and soon set up housekeeping at 328 Moore Street in a house that still stands.

By 1901, Hart had become sole owner of the business and had moved his store to 541 State Street. Much of the groceries he offered came from area farmers. He soon sold out and built a huge two-story house on the Carmack farm. He moved there in 1902 and switched roles; instead of being the grocery merchant, he became the producer of groceries, selling and bartering in Bristol. He set up Hartfield Dairy and long provided milk for the city. At first, he brought it into town in metal cans and dispensed any amount that a housewife might want. In later years, he sold it in bottles.

This picture was made inside the Hart and Hicks store at 513 Main (State) Street in Bristol, Virginia, about 1897-98. David J. Hart is on the left, and Hugh T. Hicks is on the right (foreground).

The Harts had three children, none of whom married. They were good stewards over their ample inheritance. They donated money from the Hart estate for the building of the grand entrance to King College. I have long served on the Board of Visitors for King College, and I recommended to the siblings that they leave the bulk of their estate to that institution. The two youngest opposed it, and when they left the room, Martha Jane, the eldest of the three, said to me, "Well, just wait. I'll outlive them all and do what I want to with it." And so she did!

Bristol's grocery merchants greatly appreciated farmers who bartered with them; much of the early food for the town came in this manner. What they didn't like was farmers who peddled their produce from door to door or who set up their wagons on the streets and sold to the public. Almost always, the farmers' prices were cheaper, which diverted a lot of trade from the established storekeepers. A few merchants tried to solve the problem by buying up the produce as soon as the street peddler made his stand, but the heavy overstocking led to a consequent loss, so they soon ceased the practice.

The town tried to solve the problem by erecting a farmers market and requiring all vendors to rent booths there. Located at 620 Shelby Street, on the lot where now stands the former Tennessee post office, the market was

A Good Place to Live

Old Grocers Row on Moore Street in downtown Bristol, Virginia

hardly open when it was destroyed by the 1893 tornado. The peddlers then hit the streets again, and continued to do so for many years.

When I arrived in Bristol in 1953, three of my cousins—two maiden ladies and one married—ran a boardinghouse at 518 Alabama Street. They were from Letcher County, Kentucky, and still loved country food, which they prepared in the old manner of cooking. A local store had a standing order for their homemade butter. My cousins also delighted in receiving country milk brought in by Miss Carrie Painter from Holston Valley. Miss Painter long worked in the First National Bank during the 1960s and '70s, but even then she arose early and milked three or four cows.

The Johnny Barr family, who lived near Miss Painter, supplied fresh pork for my cousins. And Paul Thomas, a gentleman farmer living in the Cold Spring community, regularly brought them eggs. I can yet hear Cousin Liza calling to him as he left, "Now, Mr. Thomas, bring us some more of those brown eggs—they're healthier."

In the late 1800s stores began to operate in Bristol that were wholly given to the sale of groceries. At that time, it appears that Bristolians seemed to have been more thirsty than hungry. The town had 22 saloons and 12 grocery stores! But the ratio soon changed. The earliest known city directory (1896-97) lists 33 grocery stores, all of them west of the railroad except Griffin and Holdway at 112 East Main (State) Street. The store may have been in a part

of Holdway's house. (The front section of the house—which still stands—was built in 1888; the back ell is older.) Many of the general-merchandise establishments also offered limited lines of groceries.

Twenty-one grocery stores were on Main Street, and neighborhood stores were common. B. H. Butler had a store at 523 Rose Street, and Nathaniel Carrier's store was out on Lakeview Street. Stephen J. Cornett, a distant cousin of mine, had a thriving store at 351 Mary. Delaney and King were then operating in Kingtown. David A. Wheeler, who had been severely injured in a gun battle when serving as a local officer of the law, was then doing a good grocery business at 700 Railroad Street. (Railroad Street was later known as Spencer and is now Randall Street Expressway.) Though Wheeler was confined to a wheelchair, he was able to conduct a successful business. He had a ramp built from his store to his home next door, allowing him to travel between the buildings. Blaine Wade, present Chief of Police of Bristol, Tennessee, is a great-grandson of Wheeler, who is buried in East Hill Cemetery.

Another grocer at the time was G. W. Hammitt, who in 1892 built the brick house that yet stands at 234 Solar. His store was located at 500 Cumberland Street on the southwest corner of Cumberland and Lee. The Janie Hammitt Children's Home was named for his daughter.

Lynn-Kaylor, a grocery store that operated for many years—indeed, until far up into the 20th century—was then located at 533 Main Street. Also, Isaac Sharett operated a small store at 235 Johnson near the corner of Johnson and Scott.

Bristol had two wholesale grocers at the time, including Huntsman Brothers at 11-15 Fifth Street. (The school that caused me to come to Bristol was located on the southernmost portion of the old Huntsman site at 15 Fifth.) W. B. Lockett and Company was then located at 511-513 Cumberland Street, directly west of what is now the Executive Plaza (formerly Reynolds) building. The company later occupied the building on the southeast corner of Scott and Moore that is to be made into a fire museum.

Forty-five grocery stores were operating in 1901. By that time, a flourishing black grocery store, the Bristol Enterprise Trading Company, had opened at 200 Water Street. It continued well into the new century. Two grocery stores were operated by women. Mrs. Mary C. Carroll, widow of George Carroll, had a store at 501 Chalmers Street. Mrs. Martha Shelton was doing business at 800 State Street. She lived at 625 Rose Street, where Eugene Shelton (likely her husband or son) also had a grocery store.

Samuel P. Clyce of Anderson Street and Hugh M. Hill of 303 Fifth were

operating a grocery store at 400 State, in the same building where merchandising had begun in Bristol nearly 50 years earlier.

The wholesale grocers open in 1896-97 were still operating in 1901, with the addition of Jacob L. Crumley's business at 614 State Street. He lived at 805 Fifth Street. An old-timer living in town in 1953 told me how, as a child, he would sometimes be awakened before daylight by the sound of Crumley's buggy rolling by as the wholesaler went to work. Before daylight to after dark was a common schedule for most Bristol merchants in those days.

John N. Huntsman, of Huntsman Brothers Wholesale Grocers, was living at the corner of Shelby and Tenth in 1901, and his brother Joel H. Huntsman lived at 57 Taylor Street. W. B. Lockett, one of Bristol's first wholesalers, resided in Knoxville, Tennessee.

In 1905, the population of Bristol was rapidly increasing. The number of grocery stores had risen to 48. Mrs. Shelton and Mrs. Carroll, the lady grocers, had dropped out of the business, but at least four more ladies had opened grocery stores at scattered neighborhood locations. Mrs. B. H. Butler was at 528 Chalmers, Mrs. S. A. Leonard was at 351 Mary Street, Mrs. Ferby Roberts and Company was out on Fifth Street Extension, and Mrs. Mary J. Swan sold groceries at 17 Scranton Street.

Of the 48 grocery stores, only 14 were on State Street, with four more on nearby downtown streets. Clearly, the preponderance of such stores had shifted to the residential sections of town. Neighborhood grocery stores flourished because of the lack of easy transportation into the downtown section. Certainly, the streetcars were operating at that time, but they did by no means reach into all areas of the city, and people found it inconvenient to carry a large load of groceries on the cars or from the stops to their homes.

J. D. Faucette and Company at 509-511 Cumberland Street had joined the wholesale grocers. The location included the lot where now stands the Executive Plaza, formerly the Reynolds Arcade building. Faucette later turned to dry goods, a field in which he found tremendous success. His business existed until well into the 1970s. His house, which he bought new, still stands at 1101 Windsor.

By 1905, W. B. Lockett and Company had become the Lockett-Reeves Company and was located at 43 Fourth Street. Its president, Walton W. Lockett, resided at 407 Sixth Street. W. P. Reeves, secretary of the company, lived at 117 Ash Street.

Clyce and Hill had vacated the building at 400 State, but Robert L. Knott had opened his grocery business there. He later opened Knott's Bakery there

and may have lived in the non-business part of the building at that time. By 1910, he was living at 404 Taylor Street.

Some of the local grocers sold animal feed along with their other offerings. Among the notables was Smith and Waskey, which long operated at 472 Cumberland in downtown Bristol. An old advertisement for the firm states that a complete line of animal feed was offered, including hay. The firm was composed of Joseph Lindsey Coleman Smith and Robert P. Waskey. Smith and family long lived at 15 Virginia Street, and Waskey lived at 371 Washington Street.

Smith, long active in business and civic affairs, came to Bristol as an engineer on the railroad and, as did many railroad men of the period, decided to stay. He was married to Martha Alice Hagey of Abingdon, daughter of James A. Hagey, who manufactured wagons in that town. Smith became the second city treasurer for Bristol, Virginia. He died in 1919 and is buried in East Hill Cemetery. His great-grandson Tim Buchanan has written a chapter for this book.

J. L. C. Smith was an early grocer in Bristol, Virginia. Along with Robert P. Waskey, he long operated a flourishing grocery store at 472 Cumberland. The firm was known as Smith and Waskey.

In 1908, the number of grocery stores had climbed to 58. The Bristol Enterprise Trading Company had become incorporated and had greatly enlarged its operation. Another black grocer, Jerry Brown, had opened at 712 Myrtle Street, and a Delapp and Sons was doing business at 700 Edmond Street. The number of women grocers had grown by one, with Mrs. Zera Daab opening at 19 Fourth. Her husband, Henry, was selling dry goods at at that location at the same time.

Once more, a large percentage of the grocers were operating in the residential areas of the city. Only 15 were on State Street, and six or so were on nearby business streets. The rest were widely scattered.

Fifty-eight grocery stores for a city the size of Bristol may seem to be a lot

for that time, but the zenith had not been reached. By 1910, the number had zoomed to 69. There was a little dropping back through the following years, but with the exception of 1918, the number remained over 50. By 1929, the number had reached 87, and 103 grocers were doing business in 1938. At mid century, the number stood around 125.

Many of the stores that opened in the first half of the 20th century did not long continue to do business. A few remained for several years. One of the most enduring home-owned stores was Lynn-Kaylor, which was in business in 1896 and continued to operate for some time after I arrived in 1953. It was known briefly as Hammer-Lynn-Kaylor around 1913 but soon reverted back to its original name.

Another long-time operator was Hugh M. Cawood, who first sold groceries at 35 Sixth Street but later moved his operation to 1208 Anderson Street. He was in business for around 40 years. His daughter, Marian Cawood, was the first person in Bristol with whom I became acquainted after moving here. The Cawoods long lived at 1030 Hill Street.

Blacks and women continued to operate grocery stores, mostly of the neighborhood type. In 1913 two blacks, James Jefferson and Frederick Rawley, opened a store in a rather unusual location. What we now know as Bank Street was then Bank Lane (originally Davis Alley). The two men opened a small grocery near the Shelby Street end of the narrow thoroughfare. Jefferson then lived at 1008 Shelby, while Rawley resided at 1100 Russell Street. Some have made the claim that Jefferson was a direct descendant of our third president though the line of a slave girl.

Virtually all Bristol's early grocery stores operated on the barter-credit system, gladly taking cash when it was offered. Such a system did create a very pleasant or profitable way to do business. Finally, some store owners became brave enough to require full cash with every purchase. Sometimes the firm name conveyed the message. Spot Cash opened at 20 Lee Street in 1913. In 1922, Cash and Carry opened at 22 Moore and was owned and operated by Roscoe F. Harrison, formerly of Wallace, Virginia. He married Margaret, the youngest of the H. P. King family. She became a friend of mine in her later years and shared much local history with me.

All merchants know that most of their customers seek bargains, and a few grocers included the promise of such in their names. There was the Cut Rate Store at 800 State Street, doing business in 1918 and owned by R. M. McCroskey and William M. Williamson.

McCroskey's son, Ray McCroskey, Jr. later operated a chain of stores in

Bristol known as Thrifty Markets. He last had a small grocery store on the northwest corner of State and King in downtown Bristol.

The Economy Store at 20 Sixth Street also promised cheap groceries. In 1922, it was operated by Robert H. Martin, who then lived at 400 Pennsylvania Avenue. One grocery simply called itself Cheap Store. It was located at 1617 State Street and was there by 1927. J. E. Bouton was the manager. Then there were the Penny Stores at 321 Mary, 22 Moore, 507 Woodlawn, and on State at the corner of 17th Street. Easy Way Grocery at 110 State claimed to make food buying easy on the purse. It was owned by Aubrey L. Morrison.

Another situational condition that was behind the naming of a few early grocery stores was the fact that some of those in operation were not clean, nor was all the food pure. According to old-timers, some stores badly needed a janitor. Beyond question, some of the food offered for sale was not desirable, to say the least.

I once was well acquainted with a lady who had operated a neighborhood store for some 40 years before I met her. She talked freely and with no apparent shame of some of the food she had sold. For example, I asked her how long she kept bartered unsold eggs before discarding them. "Why, I never discarded any of them," she replied. "I kept them until they were sold, no matter how long it took!"

At mid-20th century, grocery stores, such as the one pictured above, were numerous in downtown Bristol.

She also told of selling meat that was "well aged," as she put it. She explained how she rubbed some of it with red food coloring to make it look fresh. And she went on to tell how mice might get into her bulk-meal barrel, adding, "I've sifted mouse dropping out of a lot of it."

The Purity Grocery at 110 State Street, operating by 1927, was owned by a local company made up of Robert F. Wagner, president; W. D. Wilford, secretary; and Douglas W. (Doug) Wagner, treasurer. The partners hoped that the sound of the name might draw customers who had found some other stores "impure." J. M. McCroskey of Wallace, Virginia, owned the Pure Food Grocery at 851 State Street.

In 1936, the Sanitary Market was going strong at 122 State Street. Owned by Kelley W. Barker and Lee P. Patrick, the business was operating and well patronized under the name of Barker's Supermarket when I came to Bristol.

Some stores had unusual names, such as the Milk Depot at 110 State Street and the Women's Exchange on Moore Street. Later came U-Tote-Em, also on Moore. The store hired no bag boys or carryout boys. You "toted 'em" and supposedly saved.

The life of a grocer, whether in a big or little store, was not easy. The store had to be open by daybreak or often before; and closing, in many cases, was near bedtime. There was always something to do, so owners had little time to rest and they usually had to eat on the run. Competition was keen, not only with other markets, but also with the ever-present street peddlers. Summer was usually slack, because most Bristolians raised a great deal of their food. And in some cases, milk and butter came from a cow kept in the back lot of homeplaces.

Few of the smaller operations could hire help. Most of them were the mom-and-pop type of stores. Often one person, the owner-operator, did it all. Most stores closed on Sunday so a little rest might be had. Profits were small. Very few grocers, even in the larger operations, made much big money.

Years ago I came into possession of the business papers of Joseph Gray, a small grocer who had a business at 507 Woodlawn Avenue. He had a large dairy in the country but moved to town so his children could be near high school and college. His papers show that for the year 1927 he had a net income of $600. Seems little, but $50 per month was then considered a good income.

Quite often, profits were about canceled out by debtors who could not or would not pay their bills. Many Bristol grocery stores closed with hundreds of dollars in uncollected bills still on their account books. Firsthand information

of such a situation came to me through both a daughter and grandson of Volley White, who operated a neighborhood grocery store at 410 Goodson Street. He was always liberal with credit extension. His generosity was stretched to the limit during the Great Depression. All around him were numerous unemployed men, and most of them had hungry families. The kind grocer did his best to help them by supplying food, his pay secured only by due notes. In many cases, he well knew that there was little chance of such notes ever being "picked up" (fully paid). David Shumaker, his grandson, told me that when the store finally closed, "there were baskets of due bills that could never be collected." I am sure that this was the case with many local grocers.

The demise of the once-prolific neighborhood grocery store in Bristol may be attributed to two or three major causes. First was the ever-increasing ownership of automobiles by more and more people. When most local residents did not have this mode of transportation, they found it convenient to walk short distances to a neighborhood store. At the high point of such stores, nearly everyone in Bristol lived in walking distance of one or more of them. The lack of transportation was the major reason that the neighborhood stores were established and why they flourished. As the century passed, the downtown and near downtown stores began to enlarge and offer a greater variety of food products, often at prices the smaller stores could not meet.

Intense advertising of grocery specials did not begin before the 1920s. Such may exist, but I have never located an ad placed in the local newspaper by the early neighborhood grocery stores. The earliest ad I have found for any seller of groceries comes from a 1918 newspaper, and it is rather small and plainly presented. The store placing the ad was one of the larger downtown establishments.

The larger stores soon began the practice of baiting, or come-ons, that is so common now. Sometimes they offered items at below cost to entice customers to their stores. They relied on the fact that a person thus drawn into a place of business is likely to offset the loss of such come-ons by buying several other items while shopping there. Seldom was a merchant wrong in his assumption, and this form of baiting drew customers away from smaller stores.

More and more, the larger stores required cash for transactions, while those scattered in various neighborhoods continued to extend credit. It became a matter of intense vexation to some of these indulgent merchants for many of their former patrons to buy downtown as long as they had cash, then come back to them when credit was needed. This became a rather frequent occurrence during the Great Depression. The Depression actually caused an

increase in business for the small grocer, as long as he could extend credit, but this over-indulgence of the needy closed many of the stores.

Perhaps the greatest factor in the demise of most of the neighborhood food outlets was the coming of the big chain stores. They were slow in taking hold in Bristol, but early they came. Eventually they would not only smother out most of the small stores, but they would also cause the closing of the large downtown establishments.

Piggly Wiggly seems to have led the way. By 1923, the store was operating at 17-19 Moore Street. By 1924, another store of this chain had opened at 718 State Street. By 1929, the first store had moved a short distance north to 44 Moore. It was headed by James J. Moneyhun, who lived at 704 Fairmount Avenue. Walter Patrick, who lived at 911 Piedmont, was also an official of the local organization.

The Great Atlantic & Pacific Tea Company (A&P) was here by 1929, located on what was long called "Grocers Row," the first block of Moore Street (21 Moore Street). When Kroger came a little later—it was here by 1932—it located at 15 Moore.

Early on, the big chain grocers had established a beachhead in Bristol. In time, the grocery business in the city would be dominated by similar chain stores.

Grocery Stores at Mid Century

Many grocery stores were located in and near downtown Bristol in the 1950s; today there are none. All of those in the downtown area back then were within fairly easy walking distance for a healthy person, possibly one mile between the extreme points.

Beginning at J. J. Smith's Grocery at 1 East State, and going westward through the 1000 block of West State, there were 13 thriving grocery stores located along this main business thoroughfare of Bristol in 1953. Barker's Supermarket at 106-110 State was one of them. The building and contents were destroyed in a fire the night of December 19, 1973. Kelly Barker, the owner, later built a new store far back from the corner of State and Pennsylvania. The store is now within the walls of the YMCA building.

On the lot numbered 300 State, between the railroad and Citizens Bank, was Loving's Market, where I bought my first groceries in Bristol. There were three stores in the 700 block of State: Thrifty Market at 709, Lovings's Food Market at 717, and Godsey's Market at 722. On the southwest corner of Eighth and State stood a rather fancy old building that housed Poe's

Godsey's Market long occupied this rather ornate building on the southwest corner of State and Seventh streets in Bristol, Tennessee.

Market. Further down the block at 826 was Loving's Super Market, and then Mick or Mack number 3 at 849. In between was a grocery wholesaler, Bristol Grocery Company, at 829-833. Across what is now the Volunteer Parkway (it was then Ninth Street) was Furrow's Market at 900-904 State. Miller Brothers had a store at 1003 State, and beyond it was Hamilton's Grocery at 1005.

In the first block off State on Lee Street was Guy L. McCroskey's Market (24 Lee). If you turned up Moore Street, three stores could be found in the first block: Kroger at 12, Mick or Mack at 22, and Lynn-Kaylor at 42.

Piedmont Avenue had three grocery stores just off State Street. Piedmont Market was at 48½, U-Tote-Em was at 54, and Piggly Wiggly was at 111. Farther down on Commonwealth was the Three Way Market at 33 and Jessee's at 57.

Stop and Shop was just a block away from State at 526 Cumberland. A block off State in another direction was Bristol Produce Market at 823 Shelby, and just a block farther on Broad was another grocery store, the name of which I have now forgotten.

My first job here required me to shop once per week at Slagle's Supermarket, less than a block from State at 14-16 Pennsylvania Avenue. The store was

owned and operated by Fred and Lucy S. Slagle, who lived in the Pennsylvania Court Apartments at 134 Pennsylvania Avenue (Apartment B-1). Just above Slagle's was Morton's Market at 112 Pennsylvania, and a little farther on was the White Star Market.

In all the area outlined above, not one grocery store operates today. The last one closed sometime in 2004. It was owned by Ray McCroskey and located on the northeast corner of State and King.

Several neighborhood stores were operating mid century. One that I well remember was the King Rogers Grocery at 900 Fifth Street. The popular store offered free delivery. It ceased to operate several years ago.

What a difference 50 and more years have made in the food outlets for this city! There are many places where limited food supplies may be had today, including a few service stations. But by far, the greater part of the food consumed in Bristol is supplied by a few large supermarkets in widely scattered locations. For most local citizens, some type of transportation is required to reach them. Long gone are the days when just about any Bristol resident could easily walk to a food outlet.

Of the two wholesale grocers operating in 1896, only one was still in existence in 1953—Huntsman Brothers by then had located at 612 Shelby Street. The firm was then headed by B. Lee Huntsman, who long lived at 221 Oak Street but later lived at 520 Lawrence Avenue. The business continued until around 1960. Doubtless, it was the longest operating wholesale business to ever exist in Bristol. W. B. Lockett and Company, Bristol's other wholesale grocer in 1896, had long since ceased to exist.

By 1913 the early wholesalers had been joined by the Gibson-Helms Company. William H. Gibson, who resided at 316 Taylor Street, was president of this firm, and G. F. Helms lived at 313 Ash Street. William F. Roberson of Abingdon, Virginia, also had an interest in the company. Gibson later owned the Gibson Candy Company in Bristol and moved his residence to 437 Taylor Street. By 1918, Helms had become president of the Bristol Grocery Company and Jobber's Candy Company.

Also by 1918, the Bristol Grocery Company (wholesalers) had come into existence. H. H. Andrews, who lived at 919 Highland Avenue, was an officer in the firm, as was W. P. Reeves, who then lived at 312 Woodland Avenue. The company was still operating in 1953 at 829 State.

The Swadley-Galloway Company had joined the wholesale grocers by 1921. The firm was composed of R. A. Swadley of 705 Mary Street, Hunter H. Galloway of 49 King Street, and Jake Bewely of 501 Moore Street. Eas-

ley Grocery Company, wholesaler, opened around 1927 at 32 Moore Street. George H. Easley of 917 Anderson Street was president.

E. B. Cox, a distant cousin of mine, had opened for wholesale grocery business in 1929 at the former Easley location, 32 Moore Street. He was then a resident of Kingsport, Tennessee. (His Bristol home still stands at 505 Lindsey Street.) He lived to be around 100 years old, and at the time of his death, he was living in the Appalachian Christian Village, a retirement center in Johnson City, Tennessee.

During the Great Depression, Cash and Haul Company, Incorporated opened at 901 State Street. Mr. and Mrs. William (Della) Mumpower of 1540 Elm Street and Donald T. Stant, a local lawyer who had offices at 510 Cumberland, owned the wholesale company.

W. L. Morley, whose home still stands at 126 Johnson Street, was a wholesale dealer in produce at 36 Moore Street. C. D. Kenny had a wholesale coffee outlet at 16-18 Commonwealth Avenue. J. Henry Kegley, a friend of mine, made a great deal of money operating the Tenneva Frozen Foods Company at 950 Fairview Avenue. Kegley, a native of Wythe County, Virginia, was a pioneer in the distribution of frozen foods in the area. Jones Wholesale also operated for several years.

Most of the groceries consumed by Bristolians today come from the giant distribution centers of the chain grocery companies.

The companies mentioned in this chapter are only a few of those that operated in Bristol throughout the 20th century. For a more complete listing, refer to the Bristol City Directories in the local library.

A GOOD PLACE TO LIVE

The Fourth Estate
TRACING THE HISTORY OF THE *HERALD COURIER*
BY JOE TENNIS, CONTRIBUTING WRITER

"Editors, reporters, publishers, and all the others who put their lives into newspapers are only transients. But newspapers, themselves, live on. . . ."
—*Bristol Herald Courier*, May 25, 1969

Newspapers have come and gone in Bristol since the 1850s. But the main story of printing daily news always comes back to the longest-running publication in town, the *Bristol Herald Courier*, a newspaper that can be traced back to as early as 1865, when John Slack put his wife and his belongings in a small railroad car in Jonesborough, Tennessee, hitched a mule to the front end, and headed north for Bristol.

A native of McMinn County, Tennessee, Slack walked across several mountains to Independence in Grayson County, Virginia, and bought a hand-turned printing press. Then he hauled the press by wagon to his new home in Bristol and began publishing a weekly newspaper called the *Bristol News*. The name was not new; another newspaper by the same—or similar—name had been published in Bristol in the late 1850s, with A. K. Moore serving as the first editor in 1857. Also, the *Bristol News* was not the only newspaper in town. Other newspapers circulating in Bristol during the late 19th century included the *Southern Democrat* (1862); the *Goodson Gazette* (1867); the *Bristol Banner* (1873); the *Bristol Reporter* (1879); the *Daily Argus* (1880); and the *Goodson Democrat* (1885).

In 1866, Slack leased his newspaper to David F. Bailey. In 1868, Slack sold the *Bristol News* to brothers I. C. and Elbert Fowler, and Slack became the edi-

tor of the *Union*, President Andrew Johnson's personal newspaper. In 1869, Slack was elected to the Tennessee State Legislature. Still, he never left his love for Bristol's newspaper scene. On September 8, 1870, he established a new weekly newspaper, the *Bristol Courier*. "Politically," Slack wrote, "we intend that the '*Courier*' shall be in accord with the opposition to radicalism."

With four pages published each Thursday, the *Bristol Courier* became a competitor to the *Bristol News*. Slack sold the *Bristol Courier* to W. M. Burrow in 1876, though he remained the editor. And, by the end of 1877, Slack was once again the owner.

Daily Operations

In April of 1880, Slack briefly tried turning his operation into a daily publication. But he stopped after just six editions, saying that Bristol would not yet support a daily newspaper.

The competing *Bristol News*, in its May 4 edition, noted the move: "We should have been very glad to see the daily *Courier* a success. But our people perhaps fail to realize that they already have a tri-weekly newspaper service. The *News* is issued on Tuesday, the *Courier* on Thursday and the *Reporter* on Saturday. These make a tri-weekly. With these, Bristol can be very well satisfied for a while."

A new era dawned on September 15, 1888, when the *Bristol Courier* became the *Daily Courier* with Charles H. Slack, John's son, steering the operation. This was Bristol's first permanent daily newspaper, but far from its last.

Various newspapers came on the Bristol scene in the late 1890s, including the *Daily Times* (1896), which bought the *Daily Courier* in 1898 and became the *Times-Courier*. That same year, a newspaper called the *Daily Tribune* was launched by James A. Stone and John W. Price; it was used to promote the political campaign of William F. Rhea for Virginia's 9th district House of Representatives seat.

Herschel Dove served as the editor of the *Daily Tribune* and later wrote newspaper editorials for the *Herald Courier*, until retiring in 1950. Dove, incidentally, began his newspaper career as a teenager, serving as an apprentice at John Slack's *Bristol Courier* in 1884.

In December 1898, the *Times-Courier* acquired the *Daily Tribune*. Then, for two years, the merged operation was published as the *Daily Tribune and Times-Courier*. The newspaper was sold, again, in 1900 and returned to a simpler name, the *Bristol (Daily) Courier*. That same year also marked the death of John Slack.

HERALD COURIER DELIVERED

Carroll County native George L. Carter came on the Bristol newspaper scene in 1903. An industrialist credited with opening up Southwest Virginia's coal and railroad industries, Carter began publishing a new newspaper, the *Daily Herald,* with the leadership of two Richmond-area newspapermen, Charles O. Hearon and Alexander Forward. Their office was over Mort's Gun Store at 517 State Street, and their operation instantly thrived. In 1905, the newspaper's front-page flag boasted of having the "largest daily circulation between Roanoke, Va., and Knoxville, Tenn."

Leaving State Street, the *Daily Herald* moved to 18 Lee Street and was published by the Bristol Publishing Corporation. In 1907, the *Daily Herald* purchased the *Bristol Courier* for $10,000, and the new newspaper became the *Herald Courier* on February 9, 1907.

The *Bristol News,* meanwhile, continued to survive. By 1890, it had become the *Daily News.* Then, in 1908, it turned into the *Evening News.*

The *Herald Courier* bought the *Evening News* in 1910, publishing the semi-weekly *Bristol News and Herald Courier* from 1911 to 1919.

In 1919, Carter sold the chain of newspapers to Munsey Slack and C. J. Harkrader. Munsey was a son of John Slack, and he had worked with a couple of other regional newspapers, including the *Abingdon Virginian* and the *Johnson City Staff.* Harkrader, meanwhile, had worked at the *Daily Herald* as a copy boy in 1903 and went on to become managing editor of the newspaper, but he was fired in 1914 by Carter, because Harkrader refused to editorially support John I. Cox's bid for the Tennessee State Senate.

Munsey Slack began operating another newspaper, the *Bristol Evening News,* in 1925. In 1926, Slack and Harkrader acquired an upstart competitor, the *Bristol Evening Bulletin.* These afternoon entities were combined to form the *Bristol News-Bulletin,* which was published through 1950, sometimes jointly with the *Herald Courier.*

BEYOND BRISTOL

Largely during the 20th century, the *Herald Courier* circulated in the rural counties surrounding Bristol, Virginia, and Bristol, Tennessee, including Sullivan, Washington, and Johnson counties in Tennessee plus Washington, Scott, Lee, Smyth, Wythe, Russell, Wise, Tazewell, Dickenson, and Buchanan counties in Virginia. In the early 1900s, as Bristol still supported itself as a major railroad destination, the newspaper went farther and featured the homey, who-visited-whom news of places like Christiansburg in South-

The offices of the modern Bristol Herald Courier

west Virginia; of Sturgill in northwestern North Carolina; and to places in Hawkins, Greene, and Carter counties in Tennessee.

In the 1930s, when the *Herald Courier* circulated in areas of Letcher County, Kentucky, you could also catch up on happenings in the coalfields of Eastern Kentucky.

In 1938, the front-page flag boasted a slogan saying, "The Newspaper That Serves Southwestern Virginia, Eastern Tennessee and Eastern Kentucky." Editions in the early 1930s claimed to be "The paper that serves Southwest Virginia and East Tennessee." In 1942, the slogan said, "Bristol—Shopping Center of the Appalachians Since 1858."

A year later, during World War II, the front-page slogan read: "Prosperity Can Only Be for the Free. Freedom Is the Sure Possession of Those Alone Who Have the Courage to Defend It. Pericles, 485 B.C."

By 1948, the newspaper returned to a front-page statement similar to earlier times, saying, "The Newspaper That Covers Southwest Virginia and East Tennessee."

Upstart Competition

In 1949, the *Herald Courier* faced competition from an upstart operation that, in time, mustered so much success that its founder would eventually acquire the older enterprise. This new newspaper, the *Virginia-Tennessean*, was the brainchild of T. Eugene "Gene" Worrell, a Bristol businessman who

A Good Place to Live

claimed his afternoon daily, on its front-page flag, to be "an independent newspaper for all the people."

The 20th-anniversary edition of the *Bristol Virginia-Tennessean* states, "It has been said that Gene's newspaper career grew out of political frustration and disgust, and this may be partly true. He felt that the *Bristol Herald Courier* was not completely fair in reporting his campaign for congress in 1948, and set out to give his hometown a better community voice."

The *Virginia-Tennessean* premiered on October 16, 1949, arriving a day later than planned. In the newspaper's 20th-anniversary edition, Frank Robinson wrote, "The illegitimate brat, weak at birth, had no foundation for growth and most everyone predicted that it was doomed to die in its infancy. A few more months passed and death seemed inevitable. The infant was red from its daily financial spankings and choking from lack of monetary oxygen."

This statue of a paperboy stands outside the offices of the *Bristol Herald Courier*.

Robinson, the writer, was one of the early leaders in the enterprise. He sold ads for the first edition of the newspaper, while Herman Giles, a native of Big Stone Gap, Virginia, served as the first editor and later the newspaper's publisher. In later years, Robinson became the publisher of the *Elizabethton Star* in his hometown of Elizabethton, Tennessee.

Jack Kestner, a reporter for the first edition of the *Virginia-Tennessean*, wrote for the newspaper until the early 1950s. He then worked for various other newspapers, including nearly two decades as a military reporter for the *Ledger-Star* of Norfolk, Virginia. In the 1980s, Kestner's name reappeared in Bristol when he wrote "A View From the Mountain," a column published mostly on Mondays, later on Sundays, in the *Herald Courier*. Until his death in March 2005, Kestner enlightened readers not only about his many dogs, but also about the arrival of hummingbirds near his ancestral home at Hayter's Gap, Virginia. Kestner also liked to venture into politics, often voicing strikingly strong opinions.

Another Merger

The *Herald Courier* was sold in 1950 to U.S. Representative Carroll Reece of Johnson City, Tennessee. That year, Reece entered an agreement with the *Virginia-Tennessean* to stop producing copies of the *Bristol News-Bulletin*, the competing afternoon newspaper. Reece also agreed to combine the two newspapers into a single Sunday edition. The *Herald Courier* and the *Virginia-Tennessean* also decided to use the same circulation, advertising, and mechanical facilities. A year later, this intriguing arrangement remained, even after Reece sold the *Herald Courier* to Carmage Walls of Alabama.

By the early 1960s, Gene Worrell and his associates had acquired ownership of the *Herald Courier*. In 1968, Worrell alone acquired all of the newspaper stock.

The "Worrell Years" of the Bristol newspaper, from 1949 to 1998, were marked by vast changes in the newspaper industry. Typewriters eventually gave way to word processors and computers. Color photos became more commonplace. And the newspaper offices relocated to a modern-day $1.25 million plant. In doing so, the *Herald Courier* ended the use of hot-type, letter-press printing.

By 1924, the *Herald Courier* was being published at 23-25 Moore Street. In May 1969, the entire operation moved to its present location on what was then called Pierce Street (now 320 Bob Morrison Boulevard) in Bristol, Virginia. Noting the location change in the newspaper's May 25, 1969, edition, the newspaper editorial remarked on "A Sad Silence," saying:

> For more than 40 years, this narrow, bustling little part of Bristol's heart has been home for the *Herald Courier* and, for nearly 20 years, for the *Virginia-Tennessean*.
>
> Now, the great press which rumbled and roared and, in more recent years, creaked and clanked, is stilled forever.
>
> The wire room is empty, the steady click of machines is gone, the bells no longer clang the sound of urgency. The news no longer flows from capitals of the world onto downtown Moore Street.
>
> Gone, too, are those familiar noises, always heard but never noticed, which told of men and their machines at work to put it all together into type—comforting noises which seemed to let us know that all was well. . . .
>
> The heritage of Lee Street moved to Moore Street. And now the heritage of Moore Street moves to Pierce Street, and all of the best

that men and women have poured into these papers will not be left behind.

Editors, reporters, publishers, and all the others who put their lives into newspapers are only transients. But newspapers, themselves, live on—as the *Herald Courier* has done for nearly 100 years and, hopefully, will do for another hundred.

A New Beginning

Shortly before the end of 1997, an aging Gene Worrell visited the *Herald Courier* newsroom and announced that the newspaper had been sold, this time to Media General, Inc., a multimedia company with holdings including the *Richmond Times-Dispatch*, the *Winston-Salem Journal*, and the *Tampa Tribune*. The sale became effective in January 1998.

By this time, Worrell had been absent from day-to-day newspaper operations in Bristol, and his upstart newspaper, the *Virginia-Tennessean*, had been discontinued in 1985. During the 1990s, Worrell, then living in Charlottesville, had delegated running the *Herald Courier* to Publisher Art Powers.

A few months after the acquisition by Media General, Bill Hall was named publisher. James H. "Jim" Hyatt, Jr., later took the role.

Reporters and editors, like Mark Hyler and Stephen Phelps, came and went.

But, day to day, the news—and the newspaper—remained.

About the Author

Joe Tennis is the author of 2004's *Southwest Virginia Crossroads: An Almanac of Place Names and Places to See*, published by the Overmountain Press. A graduate of Radford University, Tennis has written articles for several daily newspapers, including the *Virginian-Pilot*, the *Roanoke Times*, the *Kingsport Times-News*, and the *Bristol Herald Courier*.

A Good Place to Live
The Public Library

LITERACY IN EARLY BRISTOL

Some readers may be surprised to know that a large percentage of early Bristolians could neither read nor write. By some estimates, at least one third of the town's citizens were totally illiterate. Old documents of the period reveal that many Bristolians found it necessary to sign with an X.

The town had no public schools during the early decades of its existence, and the cost of tuition at private schools was more than many families could afford. Sometimes one member of a family was chosen to receive an education, and that member usually soon left the family foal with no time or inclination to share information with his or her siblings.

Many early residents came from rural areas that had even fewer opportunities for education. And some folks just found it easier to rely on brawn more than brain.

Because of the common illiteracy, many early business firms in Bristol were identified by the color of the buildings. The yellow house store was located about where WCYB-TV now stands. There was also the green store on Main (State) Street and the blue store on Cumberland. Also on Cumberland was I. B. Dunn's famous red store—a very bright red, at that—and if that was not enough, Dunn always displayed a bright red flag out front.

I have seen old advertising that urged prospective buyers to come to the green store, red store or whatever color the advertised store might have been. After all the colors had been used, one enterprising merchant on Fourth Street had the spotted store! He painted his building white, then spotted it with colors.

Some businesses catered to the illiterate by painting easily recognized sym-

bols on the front of their buildings. One early druggist had a brass eagle hanging over the street in front of his building. (I have never been able to determine the connection between an eagle and medicine.) G. W. Frost, a boot maker, had a huge wooden boot hanging out front. A tailor displayed giant wooden scissors on his front door. Jewelers usually used the symbol of a clock or watch. Even Pocahontas Hale, operator of the town's largest brothel, did not forget potential patrons of her establishment. She had the image of a woman dressed in deep red standing on the street in front of her building, smiling, winking, and pointing the way to the front door.

The simple system of colors and symbols worked well. Business owners just told prospective customers to come to the blue store, red store, or where the woman in red pointed the way!

William Terry, an early Bristol merchant, could not read or write. However, he had learned to do a little figuring. He worked out a system of marks and dashes to represent various denominations of money. A short dash stood for a penny; a little longer was a nickel; longer still, a dime; and so on up to a dollar. If an item had four dime marks, then it was 40¢. In spite of his handicap, he became wealthy.

Today, the illiterate can watch TV or listen to a radio to learn things, but there were no such sources 150 years ago. Instead, they visited and talked with their neighbors. Ironically, many of the town's illiterate were the most likely to attend public lectures, even though some, perhaps most, of those speakers talked in a manner that one would have thought too learned for the unlearned.

The town crier, whose principal duty was to cry out legal notices—especially decrees of chancery sales—also sometimes interspersed the dull announcements with bits of news. Some of the criers used large handbells to announce their coming.

Rosetta Bachelor, who long served as the town crier, somewhere secured a trumpet, and she did indeed sound this trumpet before her as she strutted along the streets of Bristol. She instituted the system of accepting paid advertising to be cried out. The practice was frowned upon by the town fathers, but no one dared cross her.

There were some among the illiterate who sought others to read for them. Reading aloud to someone is now an almost lost art, and certainly the need for such has lessened. But such was quite common in Bristol, even into the 20th century.

For a long period during the early years of Bristol, Melinda King Anderson

did regular readings to groups of illiterate women who gathered in her home at Main and Fourth (now State and Edgemont). The Andersons subscribed to several periodicals, and many of those women were eager to hear readings from them. Her husband also read the weekly Sunday school lesson to the ladies.

Across the street, John Keys did the same for illiterate men. His group was always smaller than the women's, even though he read in the evenings so working men could come.

Isaac A. Nickels, a Bristol saloonkeeper, used to read the local paper to men assembled in his establishment. He always had attentive listeners, but the ones who sipped while he read soon became so tipsy, they didn't get a clear comprehension of what they heard.

I. B. Dunn seems to have been the most popular reader in town. The two long benches in front of his red store on Cumberland Street were nearly always full when the latest edition of the *Bristol News* came off the press. Dunn was good at reading tedious legal notices and was able to explain the meaning of the otherwise often ambiguous writings to his listeners. Of course, it was the duty of the town criers to make such legal matters known, but many of the men were off the streets when such was done.

Strangely, some of the illiterate faithfully subscribed to the local newspaper, relying on friends or neighbors to read it for them. An old letter mentions that Robert Bibb, a settler in Bristol, had gone next door to read the newspaper to a family, none of whom could read.

Local churches were frequented by many of the town's illiterate. What they couldn't read they could hear. Thus, their religious beliefs were largely in harmony with whatever came forth from the pulpits of the churches they chose to attend.

Reading Materials in Early Bristol

Abundant reading materials were not common in early Bristol homes. Oftentimes such materials included the Bible, the newspaper, and perhaps a book or two. There were poorer homes in Bristol that had not one printed word in them. If a family was able to send a son or daughter to private school, a few schoolbooks accumulated in the home and sometimes were kept and read by two or three generations.

Most of the town's affluent had a variety of reading materials in their homes, but few actually had what could be called libraries. Rev. James King likely had Bristol's largest home library at the time. His collection contained a few volumes that had been passed from his father, Col. James King.

A Good Place to Live

Dr. B. F. Zimmerman, the town's first physician, had a small library, as did Joseph R. Anderson, founder of Bristol. I. C. Fowler, editor of the *Bristol News*, was an avid book collector. Rev. George A. Caldwell, long the pastor of First Presbyterian Church, had one of the larger libraries in town.

There were others who had respectable collections. In virtually all cases, what I am calling *respectable collections* would have numbered no more than 150 volumes. Indeed, a home that had over 25 volumes was rare.

Early bookstores survived largely by selling schoolbooks. Traveling book salesmen occasionally visited the town with minimal success. Citizens who answered the knock at the door often said something like, "Why, I can't read. I don't need no books."

The people who did have books often read them repeatedly, virtually memorizing them. James King III, writing to a sister who lived in Monroe County, Mississippi, stated, "I have read all my books again this winter, and have added two, which makes me an even dozen. I have just about memorized the old ones, especially my favorite, that one about daily life in New York." Doubtless, other Bristolians could have reported similar situations.

A Move for a Public Library

No one knows just when there was first talk of the need for a Bristol public library. Doubtless, there were those of the more literate and progressive slant who very early thought of such a thing. The first recorded mention I have found concerning the need for a library is in a mid-1870s edition of the *Bristol News*.

Isaac C. Fowler, the newspaper's progressive and outspoken editor, wrote an editorial on the matter. He had observed that Jonesborough, a considerably smaller town than Bristol, already had a public reading room. He then went on to lament that Bristol did not have the least semblance of such a thing. He urged the civic leaders of the town to work toward the establishment of a reading room and to not be satisfied with less than 500 volumes. He also asked that area newspapers be included, as well as a few from larger cities. He further suggested that several magazines be offered for the enjoyment and enlightenment of the public.

Doubtless, his plea was well received and agreed with by many citizens, but nothing was then done toward setting up a public library. Many locals felt that a library or reading room would be useless because so many in the town could not read.

Several years later, but well before 1900, a small reading room was set up

in the YMCA. Its offerings were rather limited, consisting mostly of donated books from local folks. Many of the books were old and of limited interest to the general public, and the reading room was little used outside the organization's membership.

The local colleges maintained small libraries at the time, but their use was largely confined to faculty and students.

The coming of a new period of time—whether it be a week, month, or year—usually brings renewed determination to accomplish new or long-delayed goals. Thus, the dawning of the 20th century in Bristol brought a renewed and much invigorated move for a public library.

THE FOUNDING OF THE BRISTOL LIBRARY

One never knows what will happen when several intelligent and progressive ladies get together and engage in stimulating conservation. Something did come out of such a situation on November 24, 1899, and that something is still of great benefit to Bristol more than a century later.

First, let us review the setting. During the first week of July 1875, Dr. James Franklin Hicks moved to Bristol. On the previous June 15th, he had made a brief visit to the town and bought from Joseph R. Anderson a choice lot (number 16) fronting on Fourth Street. The next year, he built a two-story, brick, Italian-style house on the lot. Designed by a Knoxville architect, the house was one of the finest homes in Bristol at the time; indeed, some citizens declared it the finest.

In the grand front parlor of the house was a large, wood-burning fireplace that Dr. Hicks had instructed his architect to include. He had been reared in a home with a massive fireplace and wanted a similar one in his new home. For many years, the elegant house was the showplace of downtown Bristol until its demolition about 1925 to make way for the Central Fire Station.

A few years after the house was built, Dr. Hicks's wife died. A little later, he married Mary McCormick. She was born and reared at Dover House, the family estate near Middleburg in northern Virginia. After receiving a good education, she began teaching at the Virginia Institute in Glade Spring, Virginia. The school soon moved to Bristol and, in time, became Virginia Intermont College. Miss McCormick moved with it and continued her effective teaching career.

Soon after the school moved to Bristol, Dr. Hicks opened his home for a reception for the teachers, and there he first saw his future bride. He later told that he instantly determined that the beautiful young teacher would soon be

the lady of his home. She did indeed become the lady of his home, for shortly after the first meeting, they married.

Soon a few ladies of the town, including Mrs. Hicks, began to have regular get-togethers. At first, they simply met weekly at the various homes of the group. They would sew, knit, and crochet, while enjoying an afternoon of visiting and exchanging news and thoughts.

A meeting of the group was set for the afternoon of Friday, November 24, 1899, at the home of Mrs. Hicks. That day dawned upon a cold, white world, with more snow falling. Around noon, she asked her handyman to build a roaring fire in the big fireplace in the front parlor. Ladies were not easily deterred by cold, snowy weather in those days, so she knew they would be there. They would not come in well-heated automobiles—Bristol had none at the time—but would arrive in carriages and buggies. Some nearby walked, and a few rode the streetcar. But come they did, and they delighted to thaw out by the heat from the cheerful, blazing fireplace.

Let us call the roll of those ladies who did so much to give us one of the most valuable institutions in the city: hostess Mrs. Hicks, Mrs. Alexander B. Harris, Mrs. Albert Parlett, Mrs. Robert (Elizabeth) Gray, Mrs. W. K. (Mary) Vance, Mrs. C. C. (Juanita) English, Mrs. Edward (Kate J.) Lockett, Mrs. W. H. Patton, Mrs. H. E. (Patsy) Graves, Mrs. Edward Keith, and Mrs. G. P. Fairfax.

I will here share with the reader bits of knowledge of some of these women who did so much for Bristol by heading the move to establish a library in the city. Mrs. Harris's husband, Alexander B. Harris, was a civil engineer. The couple lived in the house that yet stands at 700 Pennsylvania Avenue. She was one of the ladies who came to the meeting by streetcar on that cold November day. So did Mrs. Parlett, who lived in what was then the fine new home that yet stands at 728 Georgia Avenue.

Elizabeth Gray, née Preston, was born and reared in a grand brick mansion that yet stands at Seven Mile Ford, Virginia. She was well-educated and intelligent and, in later years, wrote a rather detailed history of the Preston family. At the time of the meeting, she lived at 419 Spencer (now renumbered 417) in what today is considered the oldest complete structure in Bristol. I. C. Fowler had built the house, which now is the center of a move to restore the building and use it as a historic picture gallery. Robert Gray was a civil engineer serving as surveyor of Bristol, Virginia, for many years. In 1900, the Grays moved to 814 Moore Street. Many of my readers will remember their daughter Mary Preston Gray.

Mary Vance was a daughter of Victor Doriot, an early settler of Bristol.

The Public Library

Her husband was a local doctor, and the couple lived at 222 Fourth Street. She had walked through the snow to the meeting that day. Juanita English was a daughter of early Bristol lawyer N. M. Taylor, for whom Taylor Street is named. Her husband and his sisters laid out and developed the elite Holston Avenue in Bristol, Tennessee. C. C. and Juanita English lived for many years at 640 Alabama Street.

Kate Lockett was memorialized when her son turned her former home at 321 Spruce Street into a retirement facility for ladies. The facility was known as the Kate J. Lockett Home.

Mrs. Patton's husband was a printer for the *Bristol Herald*. They lived in the 700 block of Shelby, which was largely residential at the time. She likely walked through the snow to the memorable meeting.

Patsy Graves's husband, H. E., served as a city councilman in the 1880s. The couple had a mansion on Euclid called the Towers. It burned to the ground, but the servants quarters still remain.

Unfortunately, I know nothing of Mrs. Keith or Mrs. Fairfax.

As the ladies sat by the fireside, Mrs. Hicks suddenly arose and made a proposal that they organize a literary club. They all agreed and followed Mrs. Gray's suggestion to call it the 1900 Club. Mrs. Hicks went on to suggest that the club's primary goal should be the establishment of a local library, and to start that move, she would give over half of her books to the initial collection. The ladies agreed, thus the foundation was laid for the library we know today. Doubtless, that cold, snowy, dreary day was made brighter by the shining goal those dear ladies embraced.

The members of the 1900 Club—the first of its kind in Bristol—immediately began to collect books and to lay their project before the public. At first, Mrs. Hicks stored the books in her large home; a little later, other members of the club began to do likewise.

At some point in the first decade of the new century, they were able to interest the editor of a local newspaper in the project. He not only editorialized for the project, he contacted Andrew Carnegie about building a fine library in Bristol. Carnegie's secretary wrote back explaining the conditions the city would need to meet in order for him to make the investment.

One of the conditions was that the city provide a suitable lot for the building. A prominent businessman, who did not want his identity revealed at the time, offered a downtown lot as a gift to the city for the library. For a time it seemed that all was going well. But for some reason, the other conditions were not met, and the project died aborning, an unfortunate failure for the city.

A Good Place to Live

Undaunted, the ladies pressed on. Shortly after the First National Bank building was completed at Fifth and State, John C. Anderson, son of the founder of Bristol, offered the ladies space on the third floor to set up a reading room. The space was not large enough to hold all the books the ladies had collected, however, and they spent several days selecting about 400 titles to place in the reading room. Though called a reading room, there was not much chance to read there. Open on Monday and Friday afternoons, the room had only one small table, and it was used for a checkout. Volunteers served as librarians, and people could check out books for one month, with a short grace period if the due date fell on a day the reading room was closed. It was a feeble beginning but served the purpose until improvement could be made.

During the same period, at least two other reading rooms operated in Bristol. One had long been kept up by the local YMCA and was enlarged in 1908 when the new building for that organization was erected on the corner of Fifth and Shelby. Central Christian Church also had a public reading room. An old city directory lists the rooms as libraries. For a while, the Hill Directory Company maintained a library made up of numerous city directories from over America, first in a room on Shelby, later on Cumberland Street.

In April 1909, a library association was formed and a charter obtained for the Bristol Public Library. All through those early years, a near continuous campaign had been carried on for the purpose of obtaining more books, and the campaign had been successful to a marked degree. The library needed larger quarters to house the growing collection of books and, by 1910, had moved to 109 Sixth Street. (One source calls this the King block, a name for which I have found no justification.)

At first, the new library was open only three afternoons per week, but there was a paid director, meager as the pay was said to have been. The first director was Miss Victoria Eaton, whose home was at 519 Lee.

The library operated at the Sixth Street location for several years, supported by donations and the work of many volunteers. All the while, the number of books continued to increase. Unfortunately, another move had to be made, this time to smaller quarters at 10½ Fifth Street. (I have been told this was on the second floor of what was long known as the King Building, which still stands directly behind First National Bank.) Again, the clubwomen had to spend days deciding which books to take with them, and hundreds of remaining books had to be stored.

After operating in the cramped quarters for a few years, the library closed.

The Public Library

The books, some 3,500 in number, were scattered. Some went to the local YMCA, some to Virginia Intermont College, and some to local high schools. According to Mary Preston Gray, whose mother had named the 1900 Club, the books were placed with the understanding that they would be reclaimed when the library found suitable facilities. And apparently most of them were reclaimed several years later.

In 1919, a City Federation of Women's Clubs was formed in Bristol, and the 1900 Club joined the group. In 1921, the Federation began raising funds for a library. Mrs. Frank W. DeFriece, née Pauline Massengill, became chairman of the library committee and worked tirelessly to raise funds for the project. The 1900 Club pledged $1,000, and the Women's History Club pledged $500. The Gibbons History Club also pledged $1,000 and was the first to fully pay its pledge, using money raised by the presentation of a musical fashion pageant staged March 22, 1922. The federation placed all funds in an interest-bearing account at a local bank. In 1924, the Junior 1900 Club was formed and joined the federation.

A big boost to the effort came in 1928 with the probation of the last will and testament of Mrs. J. F. (Mary) Hicks. She had remained a strong advocate of the library since that cold, snowy day in 1899 when she proposed the project for the newly formed 1900 Club. In her will, she provided $5,000 for the library, wisely including the stipulation that it must open within five years in order for the bequest to be valid. She knew that this condition would speed up the plan.

Though the campaign did gain speed, there still was opposition. Radio had made a feeble entrance. Throughout the prosperous 1920s, many homes had accumulated their own libraries, small though they were. Most homes subscribed to the local newspapers, and national magazines had become standard reading in many, perhaps most, Bristol households. The college and public schools in the city had enlarged their libraries, adding to the feeling that a public library was not needed.

Nevertheless, many determined ladies went forward with their plan. In March 1928, they asked the respective governments of the two Bristols for a building, but their request did not meet with much favor. However, the rejection did not deter the ladies, who had become almost militant in their campaign to reach their goal. They rallied much public support for their efforts.

A leader in the movement to raise funds for the project at that time was Mrs. John Bell Redford, president of the City Federation of Women's Clubs. She served in this office from sometime in 1928 until May 1930. Her husband,

the advertising manager for H. P. King Company, gave her much valuable assistance in promoting fund-raisers, which she and her club members planned and scheduled. The fund-raisers greatly varied, ranging from fashion shows, bridge parties, dances, and talent shows to the sale of a rat exterminator.

The group also had a tag day, the same plan that had successfully raised funds for the building of Kings Mountain Hospital. The ladies canvassed the businesses of the town and also people on the street, asking for donations. When a gift was received, the person was tagged.

They held book luncheons, which had a double benefit—pay was received for the lunch, and each person attending was required to bring a good library book for the collection. Those books were stored—mostly in the homes of club members—until a library could be opened.

The ladies finally came to the conclusion that they must have something definite to present to the governing bodies of the two Bristols, so they began to look for available property. Naturally, the question arose as the location of the library—would it be on the Virginia or Tennessee side of town? The question was settled more easily than expected, for all the suitable properties were found in Tennessee.

Consideration was given to the former W. W. Davis house at 515 Shelby, the Joseph W. Jones house at 530 Anderson, and the former Elks property on Anderson (I have been unable to determine its street number). The three locations were laid before a joint meeting of the city councils in July 1929. The city fathers favored the Elks property, as did the library committee, but gave the City Federation of Women's Clubs the right to make the final choice.

Because the Jones property could be occupied within thirty days and would cost less to remodel in a manner suitable for library use, the decision was made to go there. The house—its design was similar to the Dr. J. F. Hicks home on Fourth Street, where the move for the library started in 1899—had been built in the late 1870s by Joseph L. King. A grandson of Rev. James King, he had founded the long operating King Printing Company.

In what became the first instance of joint ownership by the twin cities, the house was purchased for $20,000 on August 3, 1929. Each city paid half, plus an allocation of $100 per month for maintenance, again halved. Both Tennessee and Virginia state governments had to grant special charters before the deal of joint ownership could be legalized. At the time the property was purchased, Fred Vance was Mayor of Bristol, Tennessee, and James Gannon was Mayor of Bristol, Virginia.

Nearly a year passed before a contract was let in July 1930 to remodel the

The Public Library

The old Joseph L. King house at 530 Anderson Street. This house, erected in 1878, served as the Bristol Public Library from the early 1930s until 1964.

Jones home. Actually, very little had to be done. The large downstairs rooms were to be used for the library, while the upstairs rooms were to be painted and decorated for use by the ladies clubs. The remodeling did not take long, possibly about one month.

Around the first of September, books were reclaimed and moved into the facility, along with many others that had been collected through the 1920s. The new library opened with about 4,000 volumes.

The library came under a board of directors—one from each city governing body, one man and one woman from each city, and one woman from either side of the city who would be agreed upon by both city councils. The first board consisted of Mrs. W. Riley Stone, Miss Margaret McFarland, Thomas J. Burrow, Albert Parlett Sr., Walter H. Robertson, Mrs. W. H. Rouse, and Thomas W. Preston. My informant of long ago thought the library opened on September 15, 1930.

Strangely, I can tell you the name of the first patron of that new library. Indeed, she still lives at the age of 88. Soon after my partner I and took over the management of her business and personal affairs, she told me the story. She was about 13 years old and, from early childhood, had been an avid reader. (Her father had taught her to read by age three.) She was in town

the day before the library opened, and she wandered into the wide-open old house, where many sweating volunteers labored to get everything in order for the next day. From a stack of books on the floor of the old main parlor, she found a title that intensely interested her. Albert Parlett, who was working that day, recognized the girl—he often went to her home in Holston Valley to hunt with her father—and came over to talk to her. She explained that she could not be there when the library opened but would so much like to read the book she had in hand. Parlett knew the reliability of the family, so after a brief consultation with another board member or two present, he allowed her to take the book. He included with it a note asking her father to see that the book was returned within a certain time. Thus, the first book was lent to Miss Carrie Painter, who yet lives near Bristol.

Library Directors

One informant told me that Miss Victoria Eaton, who served for several years as director of the library operated by the 1900 Club, was the daughter of H. H. Eaton, a salesman for the Mitchell-Powers Hardware Company. Another informant thought she was a daughter of Albert Eaton. She was likely a sister of Ethel J. Eaton, who taught at Central School and later was a stenographer in the First National Bank of Bristol. Another likely sister, Bertie Eaton, taught at Washington Street School. In any case, they all lived at 519 Lee, which was one of the earliest duplex houses erected in Bristol (the building still stands). I personally am convinced she was the daughter of Albert (often named as Albert B.), whose widow, Anna J. Eaton, was living at 519 Lee in the late 1920s. There may have also been a sister named Sarah.

The first director of the new library at 530 Anderson Street was Mrs. Lillian L. Fain, the widow of James Rhea Fain, an architect employed by the federal government to design public buildings. His work took him to Nebraska, and while there, he met and married Miss Lillian Lukehart of a German family. They returned to Bristol and lived at 510 Anderson. He was 17 years older than his bride and had died by the time the library opened in 1930. The couple had one child, Marjorie, who married John Lucy and lived for some time at the family home and later at 631 Cherry Street.

Mrs. Fain is well remembered by many who live today. Recently a man told me that, as a child, he and others were terrorized by her. She was large, always wore black, and was very stern, not tolerating the least infraction of library rules. In the reading areas, she maintained a quiet atmosphere; noth-

The Public Library

ing above a low whisper was allowed. Talking at the checkout desk had to be very low, almost in whispers. Adults, while perhaps not terrorized, held her in respect, resentful though they may have been. Mrs. Fain remained until about 1945. At the very last, she took on an assistant librarian, Mrs. Douglas P. Widner, who lived at 915 Highland Avenue.

By 1946, Mrs. Widner had become the director. She was assisted by Mrs. Eufaula Bickley McKee of 1719 Windsor Avenue and Mrs. Julia Kendrick James, widow of James King James, of 206 Johnson Street. By 1957, Mrs. James had been replaced by Mrs. Virginia Droke of 637 Alabama Street.

Four years later, Mrs. Winnie F. Coalson had become director. Her husband, E. Coalson, was the deputy superintendent of Virginia City Utilities. The couple lived at 730 Chester Street. She was assisted by Mrs. Eufaula McKee, Mrs. Eileen Peavler, and Mrs. Margaret Piper. Eileen Peavler, widow of Rutledge Peavler, then lived at 701 Park Street.

Mrs. Piper, widow of Harry M. Piper, lived at 703 Reynolds. She was a daughter of noted banker and long-time mayor John C. Anderson and a granddaughter of the founder of Bristol. She was a friend of mine and gave me much valuable history on the city.

In the mid-1960s, W. D. Carty became the director. Mrs. Peavler and Mrs. Piper continued to assist. Mr. Carty was replaced by Lucille Carmack, who was in office by 1968. Her assistant was Jessie Palmer, who then lived at 501 Pearl Street.

Then came Osceola A. Thraxton, Jr. He was director by 1971, and his wife was his assistant. The couple lived at 224 Wildwood. It was likely after him that the library briefly had Ann Clark for director. She soon met and married Byron Muldoon from Australia and went there to live. I have been told that she later returned to America and may now live in Abingdon.

At some point, Judy Chestnut, who long worked at the library, served as interim director.

Willie Nelms was director in 1977. He and his wife, Charlotte, lived first at 715 Euclid Avenue. Later they moved to a development near the Old Airport Road. He was followed by Doris Stephens, who lived on Route 1, Bristol, Tennessee. She was in the position as late as 1984, and possibly later.

Helen DeWitt Whittaker served a short term as director around 1986-87. She soon became director at Kingsport, Tennessee. I have been told that she hails originally from Darlington, South Carolina. Jean Miller, who was reference librarian, served as interim director after Mrs. Whittaker left and until William (Bill) Muller came into the office. A Georgia native, he took office in

March 1988 and served about 12 years. Bill and his wife, Pamela, lived most of their time in Bristol in a house they bought at 706 Piedmont.

Sue Francisco Whitt served as interim director for a while. Then Christine Maxim Shafer, who had been director at Forest City, Arkansas, took the position and served about ten months. Sue Whitt again became interim director and served until Jud Barry, former director at Kingsport, took over. He lives in Kingsport and commutes to his work in Bristol.

THE LIBRARY MOVES TO VIRGINIA

That the old house at 530 Anderson Street was inadequate to meet the needs of a fast-growing library soon became evident. From near the beginning, contrary to what many local people had thought, there was a need for a city library, and the people did use it. Within a short time after it opened, well over a thousand patron cards were issued, and the number was rapidly soaring upward.

The book collection also rapidly grew, eventually reaching 14,000 volumes, most of them donated. At first, the library charged 5¢ per week for the use of a book; for those who donated five books, the week's use was free. Many a local home was virtually emptied of long unused books, and very few books were actually bought by the library. About 1955, I donated a book and was surprised to find it still in the collection fifty years later.

As the years passed, there was much talk of finding or constructing a larger facility. About 1960, the library board appointed a building committee, chaired by Mrs. Waldo Miles. The committee considered more than 50 locations, finally selecting a site between James Street and King Street, fronting on Goode Street. (The library was numbered 710 Goode Street.) The firm of Jones and Kerfott was selected to plan the proposed building. One story in height and ultra modern in design, it was erected at a cost of $250,000 and opened July 27, 1965. In place of dedication ceremonies, an open house was held on October 24, 1965.

Mrs. Winnie F. Coalson served as director when the new library was built. It opened with about 16,000 volumes and had about 3,500 registered patrons.

Hardly had the new facility opened, when officials noticed that it was too small and the parking space was not able to meet the needs of those who desired to use it. On July 9, 1974, a new addition was approved. It was built to the back of the original structure at a cost of $42,000 and opened in 1975.

The new addition helped the cramped situation, but not for long. By

The Public Library

This building housed the Bristol Public Library from 1964 until the new building replaced it in 2006.

1979, the collection had grown to about 65,000 volumes, and the number of registered patrons kept soaring higher. By that time, there was much talk of the need for another expansion or a completely new and larger building. Plans were prepared for an expansion in 1979 and submitted to the councils of the twin cities. But the expansion never came about. For the next several years, need for such became more and more evident—indeed, soon became rather acute.

Those of us who were privileged to see nonpublic working areas in the back knew just how acute the problem was. And throughout all those years, there was never a dearth of talk and plans for improvement. And there were times when it appeared that something was about to be done, but hope was met with disappointment.

Through most of the 1980s, there was much agitation for a new facility. Hopes sprang anew when a business directly in front of the library and facing State Street was bought, along with the parking lot immediately to the east of it. The plan was that in time a new facility could be erected there. Bill Muller, who was the director at the time, envisioned buying the remainder of the block, which would have made a very ample site for the needed building and parking areas. Eventually, the ground floor of that building was rented to a high-class secondhand clothing store. The upper rooms were used for storage

of excess library property. However, the years dragged on without reaching the hoped-for goal.

It was a great day when finally both governing bodies of the twin cities approved a new building for the library. There quickly arose the question as to where the library should be located, and 18 sites were considered.

One was a slight modification of the earlier plan to build on State Street in front of the old building, but to include the remainder of the block eastward to the corner of Piedmont Street. The main building would have been on that corner, as I remember. The area was to extend backward up Piedmont some distance, which would have required the demolition of three or four buildings, including the historic Cameo Theatre. Somewhat of a furor erupted over the proposed destruction of the latter building. There was some talk at the time of clearing out buildings across the street and down Seventh for a huge parking lot. Soon the entire plan was dropped, mostly because of the uproar over the Cameo Theatre building, along with the perceived danger of crossing the street in front of the site.

Another plan included the site that was finally approved, except the lot would have stretched up Piedmont a greater distance than it finally did. One site that seemed to have been officially approved was the Hassinger property north of Cumberland Square Park between Lee and Moore streets. The library was to have faced southward toward the park. Many felt that this was the ideal location, but the plan lost favor.

Food City offered to donate a two-acre tract on a level area on Morrison Boulevard across Euclid Avenue from that company's store. Some people felt the land was not of sufficient size for the planned facility, and they balked at the cost of buying adjoining land. However, a great many preferred this location, as we shall shortly see.

Meanwhile, some existing buildings were suggested, including the old Kings Mountain Memorial Hospital building on West State Street, the former post office on Piedmont Avenue, an old factory building on Morrison Boulevard, and even the old train station. I don't recall that the local governing bodies nor the library board gave much serious consideration to these proposals, but each had supporters.

During the year of the site selection in 2001, ballots were distributed, asking local residents to vote a preference for a site. Of the 450 people who marked ballots, 355 preferred the Morrison Boulevard site. The result was quite a surprise for most of those concerned with the matter.

Finally, the long awaited decision was made, but the announcement was

The Public Library

The grand new Bristol Public Library was nearing completion when this photo was taken in early 2006.

delayed. However, secrets have a way of leaking out. Wise old Ben Franklin once said that three may keep a secret, if two of them are dead. I have found that he was usually right. My first real clue came when I was asked if a service station had ever been located on the northwest corner of Piedmont and Goode, and strangely some core drillings were being done near that corner. All through that suspenseful waiting period, rumors were flying high that this would be the location. It was really no surprise to me and many others when the official announcement came that the new library would be built on that corner and reach back to join the old structure.

The new building was designed by McCarty Holsaple McCarty of Knoxville, Tennessee. I have been told that the actual plan was drawn by Jeff Johnson. The approximate cost was to be near $12 million. The twin cities supplied most of the money. However, unexpected costs made it necessary to raise additional funds. A campaign was thus organized to solicit funds from individuals and businesses, and the goal was met.

Reckoning that the completion of the new facility would be speeded up by around six months if the old library became vacant, a decision was soon made to close the old facility. Several sites were considered for the temporary location. Finally, Food City offered the use of the vacant Goody's department store building near the corner of Euclid Avenue and Morrison Boulevard.

The offer was accepted, and the old library closed on September 19, 2004. Several days were consumed in moving the collection and equipment. The library again opened on October 4, 2004. The temporary location and building proved to be suitable.

The library, now in its new building, has over 135,000 items to offer to the public. There are nearly 13,000 registered patrons, not including the Avoca Branch. Indeed, we have come a long way from that humble beginning to the grand facility and collection we now have.

The Avoca branch library opened in April 1964 as part of the Watauga Regional Library. It came about due to the efforts of the Home Demonstration Club in that area. It opened with 500 books and was operated by volunteers who kept it open only 15 hours per week. In 1966, it became part of the Sullivan County Library. Today it has close to 2,000 registered patrons. Mrs. Alma Blankenship served for many years as the director of this branch library. It is now under the direction of Rebecca Berry.

A GOOD PLACE TO LIVE

Back Where It All Began
A Musical History of Bristol
By Joe Tennis, Contributing Writer

"In no section of the south have the pre-war melodies and old mountaineer songs been better preserved than in the mountains of East Tennessee and Southwest Virginia, experts declare, and it was primarily for this reason that the Victrola company chose Bristol as its operating base."
—*Bristol Herald Courier,* July 24, 1927

Musical roots are strong and deep along State Street, where old-time Appalachian sounds, country music, and bluegrass are mainstays by bands playing at the Birthplace of Country Music Mural or even in impromptu gatherings. Country music's first stars—Jimmie Rodgers and the Carter Family—recorded in Bristol in 1927. But, wait, you say. How come Bristol isn't Nashville? Where is the big recording industry here?

Well, to follow that story, the answers start with the promise that maybe Bristol could have been Music City.

The story begins with Ralph Peer, a record producer from New York City and a pioneer of recording black blues and folk singers. Peer arrived in Bristol in 1927 with a goal to advance the fledgling "hillbilly" records scene, initiated in the mid-1920s with releases by performers such as Fiddlin' John Carson, of Fannin County, Georgia, and Eck Robertson, of Delaney, Arkansas. Back then, nobody called it "country music." Still, by 1927, recording engineers for a handful of labels were scrambling to record "hillbilly music," often conducting field-recording sessions in spots like Atlanta. Peer, while working for the Victor Talking Machine Company (a forerunner of RCA Victor), made an

announcement that he would record local talent in July and August of 1927 in Bristol.

On July 24 of that year, the *Bristol Herald Courier* announced Peer's arrival. The announcement included this quote, pointing to the reasons why Peer came to Bristol: "In no section of the south have the pre-war melodies and old mountaineer songs been better preserved than in the mountains of East Tennessee and Southwest Virginia, experts declare, and it was primarily for this reason that the Victrola company chose Bristol as its operating base."

The idea to choose Bristol came from a tip by one of Peer's established recording artists, Ernest V. (Pop) Stoneman, a former carpenter who grew up in a log cabin in the Virginia mountains near Galax, about 65 miles from Bristol. For Peer, the important part of making this trip was to find more talent like Stoneman's. But, as it turned out, Peer would do more than that. Here, he would discover country music's first two star acts, Jimmie Rodgers and the Carter Family. Both were unknown when they wandered, separately, into Bristol that summer.

Recording locally for an engineer like Peer, instead of saving for a train trip to a New York City studio, was an "unheard-of venture," remembered Janette Carter, the youngest of the three children of A. P. and Sara Carter, two-thirds of the Carter Family trio.

In later days, Bristol would spawn more stars: as the hometown of Tennessee Ernie Ford; as the place where pop singer and country music songwriter Dave Loggins learned to write songs; and where one of today's new-country stars, Kenny Chesney, first used a recording studio with a musician who would later join the Grammy-winning bluegrass group Alison Krauss and Union Station. Still, despite the seeds planted, Bristol shares little, if any, of the country music glory belonging to Music City in Nashville, and, much less, much of a country music industry.

"If the Carter Family had done some work here in Bristol that, in its time, had achieved success like Alison Krauss and Tennessee Ernie Ford, you may have had a blossoming musical metropolis," guessed Dave Loggins, who grew up in Bristol but later moved near Nashville. "If that had been the case," he said in 1997, "I could still be here."

THE DELIVERY

Picture Peer as the delivery doctor at what Bristol now calls itself—"The Birthplace of Country Music." Before Peer discovered the Carters and Rodgers in Bristol, "hillbilly music" recordings—the sounds of fiddle players and

string-band music—existed in what you might simply call country music in embryonic form.

It was Rodgers, a wild-living former railroad worker from Meridian, Mississippi, who gave country its honky-tonk edge. And it was the Carters, a simple, home-oriented family from rural Maces Spring, Virginia, who provided country music with the roots of carefully crafted compositions, a sense of harmony, and guitarist Maybelle Carter's widely imitated "chicken-scratch" guitar-playing style.

Peer set up microphones at a vacant hat warehouse at the long-gone Taylor-Christian building on the Tennessee side of State Street. He recorded a long list of musicians over a two-week period, including the Bull Mountain Moonshiners, Blind Alfred Reed, Uncle Eck Dunford, and Henry Whitter.

On August 1, 1927, the first day the Carters recorded with Peer, the trio of musicians barely made it to Bristol. Borrowing Maybelle's husband Eck's car, they had a flat tire on the way. Still, while in Bristol, the Carters recorded several songs, including "Bury Me Under the Weeping Willow," "Little Log Cabin by the Sea," "The Poor Orphan Child," "Single Girl, Married Girl," and "The Storms Are on the Ocean."

Alvin Pleasant Delaney (A. P.) Carter, a drifter with all sorts of occupations, guided the Carter Family trio, consisting of himself on vocals, his wife Sara playing Autoharp, and his sister-in-law Maybelle (also Sara's cousin) playing guitar. The Carter Family, with their renditions of hymns, old-time Appalachian music, and, eventually, their original songs, became a popular local act, performing at schools and churches as early as 1926. In later years, even as the group scored big hits like 1928's million-selling "Wildwood Flower," the Carters never ventured far from their Clinch Mountain homes to make appearances. Always dignified in publicity shots, wearing their Sunday best and holding instruments, this First Family of Country Music remained intact until 1943, surviving A. P. and Sara's divorce in 1936 and a temporary move to Del Rio, Texas, to star on a radio show in 1938.

Jimmie Rodgers arrived from Asheville, North Carolina, on August 4, near the end of the sessions. During a 1953 interview with reporter Grant Turner in Meridian, Mississippi, Peer said that Rodgers "didn't have much material ready that was suitable for recording, so we could only make two selections at that time." One song, called "The Soldier's Sweetheart," was an original ballad written in reference to World War I. The second, "Sleep, Baby, Sleep," which Rodgers didn't write, featured the singer's trademark yodel.

Remembering Rodgers's recordings, Peer said they were "rather outstanding.

A Good Place to Live

Jimmie Rodgers arrived in Bristol at this train station.

I thought it would take, so we put it on the market right away. The owners then told us that we made a good guess because that was the top record for some time to come."

On the road since running away to join a medicine show at age 13, Rodgers, then 29, left Bristol kicking and screaming—as much as the tuberculosis eating his frail body would allow. Eventually regarded as the father of country music, he yodeled his way into America's living rooms on radio and with million-selling records like "Blue Yodel No.1" (originally "T for Texas") and "Brakeman's Blues," until his early death in 1933.

THE LEGACY

The discovery of Rodgers and the Carter Family prompted Peer's return to Bristol for more field sessions in 1928. But no recording industry grew here. In 2005, only one studio, Classic Recording Studio, stood in downtown Bristol. Located at 13 Moore Street, Classic is about two blocks from the site where Peer first recorded the Carter Family. And, perhaps ironically, the owners have included relatives of the Carter Family, such as Harold (Bugs) Cornett, a great-nephew of A. P. Carter.

Harold Cornett and his brother, Michael, came to Classic Recording Studio to record their own CD in 1994. A year later, the brothers bought the studio. In the 1990s, their business included recording local blues, bluegrass, and country

acts. But projects have also included recording the late Helen and Anita Carter, daughters of Maybelle Carter. The Cornetts have also recorded the music of guitarist Jerry Hensley, a cousin on the Carter side of their family and one who made a living playing in backup bands for the Statler Brothers and Johnny Cash, who was married to June Carter, another of Maybelle's daughters.

"I hate the Carters never really made any money with their own legacy," Michael Cornett said in a 1997 interview, about six months before his death in a sailing accident off the South Carolina coast in early 1998.

Classic Recording Studio is the place where Kenny Chesney, a chart-topping country music singer from Luttrell, Tennessee, first recorded music in 1990 "with a bluegrass flavor," remembered former studio owner Bandy Brownlee.

Born on March 26, 1968, Chesney arrived at East Tennessee State University in nearby Johnson City, Tennessee, in the late 1980s. He made his first record at Classic Recording Studio with guitarist Tim Stafford, who later won a Grammy for his work with Alison Krauss and Union Station. Chesney sold 1,000 copies of his nine-song cassette at Johnson City-area nightclubs such as Chuckey's and Quarterbacks with "just me and my guitar," Chesney remembered during a 1999 interview. "I feel fortunate to have gotten started in country music where country music began," he said.

In Middle Tennessee, where Chesney and other country stars of his generation now regularly make records, the success of the live radio show "The Grand Ole Opry," on the air since 1925, eventually lured the country music recording industry to Nashville, not Bristol. Beginning in 1937, however, one Bristol radio station would launch the career of another star, this one destined to become Bristol's brightest. His name was Ernest

Country music star Kenny Chesney made his first recordings at Classic Recording Studio.

Jennings Ford, and he grew up attending Bristol's Anderson Street Methodist Church and playing trombone in the Bristol Tennessee High School Band.

At 1223 Anderson Street, Ford's humble birthplace stands in a working class neighborhood two blocks from the car lots, restaurants, and shops of Bristol's busy State Street. Ford lived at the simple white house until age six. While still a teenager, Ford became an announcer at WOPI-AM's State Street studios. Later leaving Bristol for California after a stint in the U.S. Army Air Corps during World War II, Ford's radio career on the CBS and ABC radio networks eventually led to a singing career spanning country, rockabilly, gospel, and pop records.

Ford signed a recording contract with Capitol Records in 1949 and soon scored hits with "Mule Train" and "Shotgun Boogie." Then known as Tennessee Ernie Ford, his 1955 hit "Sixteen Tons" would eventually sell 20 million copies and help Ford land his own TV show and lifelong status as an internationally-known celebrity with a penchant for homespun humor.

All along, Ford saluted Bristol as his hometown. In 1961, he returned home to record a gospel album at Anderson Street Methodist Church. Eight years later, Ford came to Bristol to break ground for his first roadside quick-order restaurant at the three-way intersection of Blountville Highway, Euclid Avenue, and Gate City Highway.

"That was a big deal—that he was from Bristol," said Dave Loggins. "If anything, Tennessee Ernie Ford would make somebody like me feel like it was possible."

THE IRONY

Born in nearby Mountain City, Tennessee, on November 10, 1947, Dave Loggins moved to Bristol at age eight. By the 1950s, while Ford made headlines, little mention was then made of the Carters, Loggins remembered.

Janette Carter conceded: "Their music, a time or two, just about died out. Then, when Daddy died, that's when they realized what it was, what it was about."

That was 1960, about the time folk music began careening into pop culture. Musicians noted the Carter sound as not only a cornerstone of country music but also the roots of bluegrass and an influence in folk. In those years, the folk sounds of Bob Dylan and Donovan began influencing the teen-aged Loggins, a 1965 graduate of Bristol Virginia High School. Loggins strummed a guitar he bought at a shop on Bristol's State Street and studied how songs were written. But he didn't consider music a career option. For a while, Log-

gins worked as a drafter while attending East Tennessee State University.

Quitting college, Loggins took off for Nashville to live with his brother. One of the first songs he wrote, "Pieces of April," became his career breakthrough when later recorded by the band Three Dog Night. Yet, still wanting to make a name for himself as a performer, Loggins turned his music career in another direction. In 1972, he toured with the Nitty Gritty Dirt Band, including stops at clubs in Boston, Denver, and Los Angeles. Loggins combined that road experience into "Please Come to Boston," a folksy song he recorded for Epic Records. A huge pop hit in 1974, it told the story of a "rambling boy" who wouldn't settle down, and it earned Loggins a Grammy nomination.

Bristol's Country Music Monument

After a series of albums on the Vanguard and Epic record labels in the 1970s, Loggins turned back to songwriting and hit pay dirt in the 1980s when songs he wrote or co-wrote, including "Roll On, 18 Wheeler," "She and I," and "40 Hour Week," became standards for country superstars Alabama. As a performer, Loggins and singer Anne Murray won the Country Music Association's Vocal Duo of the Year Award in 1985 for "Nobody Loves Me Like You Do." Loggins also wrote songs for Reba McEntire ("One Promise Too Late"), Don Williams ("Heartbeat in the Darkness"), Restless Heart ("Fast Moving Train"), and Sawyer Brown ("Wantin' and Havin' It All").

Still, while Loggins does not trace his own influences directly to the Carters, a latter-day version of the Carter Family did record one of his songs, "My Father's Fiddle."

"That's the only connection we have," Loggins said. "That might be a little ironic, that they liked my song."

A Good Place to Live

The old Lark Amusement building hosts this mural, painted by Tim White, signifying Bristol's contribution to American music.

THE LANDMARKS

In 1986 at the center of Bristol, artist Tim White painted a billboard-size mural interpreting the 1927 recording sessions on the side of the old Lark Amusements building on State Street. Boldly, the mural proclaims "Bristol, Tenn-Va/Birthplace/Country Music" and depicts the faces of Peer, the Carter Family, and the Stonemans, plus Jimmie Rodgers giving a double thumbs-up salute. Tuesday nights in the summertime, groups gather there to play free shows, performing old-time bluegrass and Appalachian tunes.

On the outskirts of the city lies another monument: the Grand Guitar. Standing 35 feet tall and stretching 70 feet long, the guitar-shaped building is only for looks; the Grand Guitar cannot actually be strummed. Two sets of six ropes span nearly the entire length of both sides of the beige-colored building near the Tennessee-Virginia state line, and each rope is a different size, just like a real set of guitar strings. This unforgettable landmark was built in 1983, with a cinder block foundation, off Interstate 81. It's been used as a museum and stands as a proud symbol of Bristol's country music heritage.

Back on State Street, country music and bluegrass performers often grace the stage at the Paramount Center for the Arts, a 756-seat theater built as a

The Grand Guitar as seen from Interstate 81

movie house in 1931 by the Paramount Pictures Company. Closed in the 1970s, the Paramount was restored and reopened in 1991 with a gala celebration featuring Tennessee Ernie Ford performing a hometown show just a few months before his death in Reston, Virginia, that same year. Ford is remembered with a granite star on the sidewalk in front of the Paramount. The Carters, the Stonemans, and Rodgers are remembered, too.

The Paramount is often used for concerts sponsored by the Birthplace of Country Music Alliance, a group dedicated to toasting Bristol's place in music history. A 1997 show celebrating the 70th anniversary of Peer's Bristol sessions starred descendants of the Carter and Stoneman families. A year later, in 1998, the U.S. Congress passed a resolution recognizing Bristol as the birthplace of country music.

Outside, on State Street, the lights of the Paramount marquee flash about a block away from Bristol's man-size Country Music Monument at the corner of State Street and Edgemont Avenue. For Bristol, and the modern country music world, that monument marks the spot where it all began, long ago, in that temporary recording studio, when a man named Ralph Peer came to this city looking for music.

A Good Place to Live

Originally built as a movie house, the Paramount Center for the Arts now holds concerts and other events enjoyed by those in Bristol and the surrounding area.

About the Author

Joe Tennis is the author of 2004's *Southwest Virginia Crossroads: An Almanac of Place Names and Places to See,* published by the Overmountain Press. Portions of this chapter originally appeared in an article by the author, entitled "How The Birthplace of Country Music Lost Out to Nashville," published in *Blue Ridge Country* magazine's July/August 2000 edition.

A Good Place to Live

An Invitation To the Faithful
Bristol's Great Evangelistic Campaigns
By Tim Buchanan, Contributing Writer

One of the most intriguing memories to many Bristol citizens pertained to their participation in tent and tabernacle meetings. This memory is now a generation removed from modern America, but for most of Bristol's history, listening to itinerate revivalists, attending lengthy evangelistic meetings, and walking the "sawdust trail" were common and touching experiences for most families. These services were held in temporary locations that could accommodate hundreds, or even thousands, of people for an extended period of time. The tabernacle, which invoked stories from the Old Testament of where God came down and spoke to His people, continued to be a place of separation unto God. Many still remember a conversion experience while attending one of these meetings. The smell of sawdust and burning coals provoked a memory that would remain through their lives.

The mainline denominations—Methodist, Presbyterian, Baptist, and others—all have these revivals as a part of their history. What qualified as an evangelistic revival varied with each denomination, but four-, five-, or six-week revivals were a common practice for protestant churches in Bristol. This chapter gives the stories of some of the largest and most memorable revival campaigns in Bristol in the 20th century. By no means are these the only important revivals that people might remember. When one revival closed, others appeared on the landscape, espousing their own denominational viewpoint.

For the most part, the following meetings took place in canvas tents or wooden tabernacles, and, supported by the Bristol Ministerial Association,

bridged denominational boundaries. A few of these meetings or evangelists were especially important to the story of the religious history of Bristol.

Billy Sunday • 1920

The news that Reverend William A. "Billy" Sunday, a Presbyterian evangelist, wanted to have a meeting in Bristol circulated throughout the community for months before final arrangements for his visit were made in January of 1920. The excitement it generated rivaled the discussion of a presidential visit or attending a World Series baseball game. For many Bristolians, it was to be the event of their lifetimes. For Billy Sunday, Bristol was a marked change from evangelistic meetings in large metropolitan cities, and the revival was a noted historical shift in the direction of his ministry.

Billy Sunday's advance agent, Fred W. Rapp, arrived in Bristol on Sunday, January 27, 1920. He spent the next day in conference with the Bristol Ministerial Association and the local Sunday Executive Committee. J. D. Faucette, a Bristol merchant, was the chairman of the campaign committee. This organizational meeting solidified plans for the upcoming revival, inspecting a potential site at a recently built tobacco warehouse and visiting local colleges, schools, and factories throughout the city.

The tobacco warehouse on Commonwealth Avenue was found to be more than adequate to serve as a tabernacle, with noted modifications. This location would be adapted to seat 4,500 people and hold a choir loft and platform to accommodate 500. Prior to Mr. Rapp leaving Bristol, he stated, "This is just the type and size community to get the greatest blessing from a series of Sunday meetings." March 21 was set as the beginning of the five-week revival.

Highly promoted in the *Bristol Herald Courier* as the "Biggest event in the religious and social history of the city," the Sunday revival was definitely one of the most organized. The ministerial association immediately made plans for a religious census, identifying citizens not affiliated with a local church. Rev. C. B. Livesay served as the census supervisor. The local committee was actively involved with preparing the tabernacle and nursery and making the city ready for the thousands of visitors expected to arrive in Bristol for the meetings.

A housing committee chaired by C. W. Roberts of the Bristol Chamber of Commerce was directed to find 1,000 available rooms, and A. E. Fuller of the parking committee made plans for the expected onslaught of cars. Harry Piper, the music chairman, was slated to coordinate local vocalists and musi-

cians and prepare a 500-voice choir representing all Bristol churches. This was a big event for a city of nearly 15,000 people.

The tabernacle materialized in accordance with the specifications furnished by the Sunday team, with a hospital, restrooms, office quarters, a book room, and a restroom and private bath for Billy Sunday. The local Billy Sunday organization set up an office in the Bristol YMCA on Shelby Street.

As the time drew near for the beginning of the revival, the city was preparing in a fever pitch. Daily newspapers throughout the region brought the latest details of the big event. Both cities encouraged businesses and residences to spruce up the community to bring the right impression of the up-and-coming emergence of Bristol in the world. Bristol was in the midst of an economic revival as the impact of the Gilded Age began to make its way into the Appalachian region. Merchants packed their businesses with Billy Sunday biographies and materials, furniture stores were stocked full of cots and padding for the influx of out-of-town guests, and the latest fashions were sold at H. P. King's and many other specialty-clothing shops.

Noted evangelist Billy Sunday conducted a long-remembered revival in Bristol during the spring of 1920.

The famous Sunday sounding board arrived just prior to the meeting, and a thick padding topped with wood shavings covered the floor to deaden the sounds in the audience and make ideal aural conditions. The seating process was a remarkable system used in all of Sunday's meetings, whereby the front seats in the house were filled first, and then the rest were filled in order as attendees entered the building. In the choir loft, the chairs were numbered, and each choir member was assigned a particular seat. A reserved section was set aside for special guests of the evangelist, with another section reserved for the 300 secretaries who kept records of every aspect of the campaign. Seats

throughout the sanctuary were saved for the 250 ushers used for each service. These ushers represented each participating church in Bristol. Directly across from the tabernacle were ladies' restrooms and a building, referred to as the green cottage, which would serve as a nursery that could accommodate over 100 children up to six years old.

On Saturday evening, March 20, Billy Sunday made his arrival at the Bristol Union train station on the "Memphis Special." He was seven hours late but still had a large crowd of onlookers. The Reverend and his wife—known as Ma Sunday—along with numerous members of the ministry team pressed their way through the crowd and were escorted to Hotel Bristol.

Homer Rodeheaver served as Sunday's choir director; for some years he had been regarded as "the most famous choir director in America." He was an important factor in the great success of the Billy Sunday campaigns. Robert Matthews, who served as the evangelist's personal secretary, was an accomplished pianist who played for Mr. Rodeheaver during the meetings in Bristol.

The next day, the wooden tobacco warehouse, sanctified as a house of worship, was filled hours before the opening-day services, which were held at 11:00 A.M., 2:30 P.M., and 7:30 P.M.

Sunday's delivery of his sermons, in which he used entertaining illustrations, kept the crowd's attention. The crowds packed the evening services to capacity with special delegations nightly from civic clubs, local industry, and large parties from cities throughout the region. On Friday the 26th, over 200 visitors from Saltville sat in the reserved section in the tabernacle, over 100 from Chattanooga sat together on the next Sunday morning, and 200 citizens of Johnson City came together on Sunday evening. This pattern was maintained for the five weeks of the revival. The Rotary, Elk, and Kiwanis civic clubs, various Masonic orders, and students and professors from Sullins, Virginia Intermont, and King colleges were some of delegations that met *en masse* during the first week of Sunday's arrival. Many commented that the audience was swayed from tears to laughter and back again during the sermons. Nobody could tell a story and make it more memorable than Billy Sunday.

Entertainment was a tool of Sunday's sermons, but not the goal. He would thrill audiences with comic gestures and comments, use personal incidents and vivid illustrations, and then drive home that "no man committed sin and got away with it." He would convince an overwhelming number of people that it "did not pay to meddle with the world and yield to its temptations." His appeal was to the return to old-fashioned Christianity and become unspotted

by the world. During one sermon, he told the record-breaking crowd, "If you would wash your own windows, your neighbor's house would look better."

Attendance records were continually broken as the revival progressed. On Easter Sunday, over 15,000 people attended three services, which was considered the largest single Easter attendance in Bristol's history.

Sunday's meetings also resulted in an unprecedented number of people making "decisions" (coming forward to the altar to affirm or reaffirm a belief in Jesus). The first decisions in the meetings were directed to recommitment, then shortly thereafter hundreds walked the sawdust trail (so-called because the aisle was covered in wood shavings) for conversion. On April 17, following the Saturday evening sermon, 792 decisions were made; nearly 400 were made by a delegation of Odd Fellows attending the meeting.

Most afternoon services, except Mondays, were dedicated to select groups of people—the black community, children, women, mothers, cottage prayer members, men, and others. These services resulted in a huge outpouring of people walking to be counseled by Sunday and local pastors.

Bristol had never experienced the overwhelming number of people that crowded the city streets, including those that met for meals in city establishments and guests of hotels and tourist homes. One survey indicated that slightly over 700 automobiles were parked the full length of State Street, over 200 guests registered at the Hotel Bristol, and more than 1,000 meals were prepared at one business, Everett's Café, at lunch between 11 A.M. and 2:00 P.M. On one day, around 800 people lined up outside the Chamber of Commerce Grill. Visitors from as far as New York drove to have the opportunity to hear the famous evangelist.

On Sunday, April 26, the last day of the revival, Billy Sunday preached four sermons in the tabernacle to capacity crowds totaling over 20,000 people. Local chairman J. D. Faucette presented Sunday a check for $17,093.16 for contributions during the meetings, and then the crowds enjoyed further speeches by prominent men from throughout the region, including at least one former governor.

The Sunday evangelistic campaign resulted in approximately 16,000 conversions and an overwhelming resolution of endorsement from the ministers of the city. On the Sunday following the meeting, 467 people were received into thirteen Bristol churches. State Street United Methodist Church saw 90 new members, and First Baptist Church took on 60. The Bristol Ministerial Association reported that by the following week, nearly 900 new additions were recorded.

Throughout the revival, individuals and organizations alike gave numerous personal gifts to Sunday. After most meetings there were bouquets of roses taken to the rostrum for Sunday and Rodeheaver. If that wasn't admiration enough, many unique gifts were received from Bristolians, including: a silver loving cup from employees of the Dixie Tannery; a leather sermon case from Tennessee High School; a purse with $206 from the Columbia Paper Mill; a 1,000-mile railroad voucher from employees of Norfolk & Western Railroad; a purse filled with gold coins from the Weaver Pike Delegation; and a roll of money from the Shriners.

Several of the most unique gifts given to Sunday and his party were recorded. Eighty-three-year-old Jane Carmack of Bristol, Tennessee, gave enough pre-Civil War handwoven linen to make a full suit of clothes for Sunday and a pair of trousers for Rodeheaver. Mr. and Mrs. D. J. Hart gave two Jersey cows. This writer has the letter of appreciation sent to the Harts following the meeting.

The citizens of Bristol were overwhelmed, and in the words of some of the attendees, forever changed. There were many redeemable results of the Sunday meetings. During the entire revival, there were neighborhood and denominational cottage prayer meetings and Bible studies supporting Sunday's efforts. Many of these prayer groups continued to meet for numerous years afterward. One Presbyterian ladies' Bible study eventually evolved into the Blue Stocking Club, which is still an active member of the Bristol community.

LEAMAN-RAMSEY • 1928

Billed as the "greatest religious campaign ever staged in Bristol," Rev. Mel Leaman brought the "Big Tent" to the city in 1928. Leaman was a 33-year veteran of the pulpit and pastor of Lonsdale Baptist Church in Knoxville. William Ramsey, one of America's most noted music directors, assisted Leaman. Ramsey, having served intermittently with Leaman for ten years, previously directed music for evangelists Sam Jones and George Stuart. He also served with Dr. Mordecai Ham, a relationship that would last for over 30 years.

On Sunday, March 4, 1928, the much-publicized revival began in the auditorium of Calvary Baptist Church on Shelby Street, because the enormous tent was late to arrive at the vacant lot within a short distance of the church. This six-week campaign brought in the support of the churches of west Bristol, namely, Calvary Baptist, Anderson Street United Methodist, and Windsor Avenue Presbyterian. By Thursday the 8th, the 2,000-seat tent was

erected on the corner of Shelby and Twelfth streets and was crowded that evening with people from throughout the region. Meetings were held every evening of the week, with noon meetings at area factories. Sunday services were held at 11:00 A.M., 3:00 P.M., and 7:30 P.M. each Sunday. Within days, the evening services were packed to overflowing, with many people being turned away due to the lack of seats.

Downpours of rain and snow showers did not seem to detour a standing-room-only crowd and heated sermons by the evangelist. "Signs of the Times," "Crossing the Deadline," and "The Perils of Postponement" were some of the sermons that glued people to their seats, and by the end of the revival drew over 600 conversions and rededications. Many accepted the call to the ministry and to mission work.

During one especially memorable service, Rev. Leaman referred to the "houses of sin" in Bristol by stating, "many of you are so close to hell tonight that the person beside you can smell the fumes."

A Bristol newspaper reported that following the revival, on April 22, Calvary Baptist baptized 70 of 100 new converts in the Holston River, and area churches of all denominations received new members.

Bristol resident Laura Beaver, whose father built the benches to seat the attendees, was converted as a young girl at one of the Leaman meetings. The revival was etched in her memory; to this day, she remembers the smell of sawdust and the burning coals inside the metal drums placed strategically throughout the tent on cold days.

Within weeks of this revival, preparation for a new church was begun across the state line in Virginia, which resulted in the founding of Euclid Avenue Baptist Church.

MORDECAI F. HAM • 1931

One of the most anticipated revivals held in Bristol was one held by Dr. Mordecai Fowler Ham in 1931. Known nationally as the "Ham-Ram Campaign," Ham was one of America's leading revivalists, known widely for attracting overflow crowds from all denominations, with a remarkable number of decisions. Without any obligation to the local churches, financially or otherwise, the revivalist brought one of the most skilled organizations into large and small communities throughout America. Ham brought along veteran music director William Ramsey, who had served with him since 1912. Many Bristolians remembered Ramsey's association with the Mel Leaman tent revival held three years earlier. Ramsey had also directed the music for

George Stuart, who conducted a similar revival in the old Winston warehouse in the late 1890s. Earl S. Rogers served as chorister for the party, and Rawley Tredway as pianist and secretary.

Within the view of the entire community, Ham, under the direction of Mr. Ramsey, constructed a pine frame tabernacle off Commonwealth Avenue, the current site of the Tokyo Japanese Steakhouse. The tabernacle was partially open on four sides with a raised center to light the massive 3,500-seat interior. It was quickly constructed by a team of contractors including C. F. Beaver, who oversaw the construction of many such tabernacles throughout East Tennessee. The choir platform was built to seat 250, and a raised center pulpit could be seen from the hundreds of handmade wooden benches.

Dr. Mordecai F. Ham, a nationally known evangelist, was well received in Bristol.

Following a similar meeting in Johnson City and in the town auditorium in Erwin in Tennessee, the Bristol meeting began on Thursday, April 16, 1931, with the topic "Not What I Believe, But Whom I Believe" and a brief address from Bristol, Virginia, mayor Walter Robertson. Rev. S. B. Vaught of the Methodist Ministerial Alliance introduced Dr. Ham to the packed crowd. The following day, the *Bristol Herald Courier* noted that hundreds of people who had attended previous meetings in East Tennessee "swelled the attendance," and a chorus of *amens* were heard from the ministers' section in the wooden sanctuary. Practically all protestant churches in Bristol participated in the six-week campaign, many moving all but their Sunday morning services to the tabernacle.

Ham's unique method of conducting a meeting was unlike that of other evangelists and aided in its unusual success. The services were broken up in

small segments of singing, preaching, praying, varied special music, and testimonials by local pastors and dignitaries. Such was the Bristol meeting, where even the most pagan attendee would find the service more interesting than that found in most churches. And to that end, the Ham-Ram team endeavored to meet in factories and with civic clubs, and they engaged in street visitation throughout their stint in Bristol.

Many factories and downtown merchants closed their doors early and sat together as special guests of the evangelist. The H. P. King Company, the Massengill Company, Enterprise Wheel & Car Corporation, Intermountain Telephone, and Big Jack Overall Company were some of the numerous businesses that took advantage of the special invitation from Dr. Ham. Both city post offices and other governmental agencies reduced their hours to allow their employees to attend the compelling services.

At the first meetings of the series, those attending filled every seat in the building, and by the climax four weeks later, it was recorded that the tabernacle was packed with well over 8,000 people. They overtaxed the building with standing room only, stacked five and six people deep around the open-sided structure. Hundreds were turned away.

When a meeting reached a fever pitch, the evangelist offered his first invitation. People "forged their way through the dense crowd to the special inquiry room" where Dr. Ham and his team, along with local pastors, conducted prayer and counseling sessions. One of his last sermons, "Repentance and Faith," resulted in hundreds pressing through the crowd, making decisions for Christ, with an audible evidence of weeping and shouting. The large crowd remained for hours after the meeting was over, and Dr. Ham and those counseled remained throughout the night. According to many who attended the services and those who listened to the live services broadcast on the radio by WOPI, there had never been such an outpouring in Bristol.

On Sunday, June 7, Dr. Ham met with the entire Sunday school department of State Street United Methodist Church, preached at First Presbyterian Church at 10:45, and then he went on to First Methodist Church for the morning worship hour. After final services at the tabernacle at 2:30 and 7:30, he closed his revival with the highest compliment to the city, declaring: "In none of my campaigns, I believe, have we reached the entire section so effectively as we have here. Individuals, firms, groups, newspapers, and the radio have all cooperated in helping us in our message." The revival resulted in 3,500 recorded additions to local churches and was a long-lasting influence to the entire region.

Following the meeting, Calvary Baptist Church acquired the abandoned tabernacle and used the pine lumber in the construction of their new sanctuary on Broad Street in Bristol, Tennessee. To that generation of Bristolians, the tabernacle location became synonymous with a biblical "burning bush" experience, where God spoke to an entire city. If there was ever a Bristol Pentecost, in the eyes of those that attended the meetings, it was preceded by the preaching of Dr. Mordecai F. Ham.

Mordecai F. Ham • 1933

Convinced that Bristol could again support a successful evangelistic campaign, an idea supported by the Bristol Ministerial Association, Ham returned again in 1933. Following a meeting in Huntington, West Virginia, where there were 2,700 conversions, Dr. Ham began another revival at the Bristol Virginia High School auditorium on Piedmont Street on November 19. He was assisted by Rawley Tredway, director of the campaign.

The auditorium quickly met capacity, and after the first five days, the services were moved to the largest available auditorium in Bristol, at State Street United Methodist Church. Limited by space, the three-week revival was extended to a fourth week, climaxing with Dr. Ham speaking to a capacity crowd, with many seated on the platform, railing, steps, and every other available space. Sunday school rooms were equipped with speakers for the overflow, and many other people were turned away.

Bristol resident Julian Moorman was selected to direct the chorus choir, an accumulation of voices representing all churches in Bristol. The musical programs featured singing of the old-time gospel hymns and choruses, special selections by Mr. Moorman and Dr. Ham, and solos and duets from vocalists from throughout the city. Numerous times, Dr. Ham sermonized the text of a hymn or climaxed his sermon with a special old-time number. His evening foundation messages on the Christian home, backsliding, and eternal punishment led to his well-known sermon, "God's Last Call," which resulted in over 150 men filing down the aisle, indicating a conversion experience. At the end of the revival on December 17, 1933, there were over 1,500 in attendance at the evening service, with over 5,000 in attendance overall for Dr. Ham's four or five services throughout the day. There were 900 decisions throughout the course of the month.

Mordecai F. Ham continued to visit Bristol for revival meetings in local churches, and he attained quite a following from some of Bristol's business leaders. One such person was Mr. E. B. Cox, a deacon at Euclid Avenue Bap-

tist Church and owner of Cox Wholesale on Moore Street. He was an avid supporter of evangelists and of mission work in general. Ruth Cox Keller, his daughter, spoke of how her parents entertained many noteworthy evangelists at their home on Lindsey Street. Billy Sunday, Hyman Appleman, B. R. Lakin, and E. Howard Cadle were some that visited, many often.

Ms. Keller remembered the day D. L. Moody came to their home. Her mother prepared country ham biscuits, gravy, and fried apples. She and her siblings, Mary Pippin, Willie Rich, and E. B. Cox, Jr., were brought up on the hands-on side of evangelistic work, but they were not told until their father was 90 years old of another memorable connection. Eleven months after Dr. Ham's Bristol meeting, Ham called his friend E. B. Cox to help cover his personal expenses at his next meeting in Charlotte, North Carolina. With the large Charlotte meeting days away, Ham stopped off at the Cox home for the generous contribution, and then he was on his way to North Carolina. At the Charlotte revival, a young man named Billy Graham answered Ham's invitation to the altar. Graham went on to become one of the most famous religious leaders in American history. Though E. B. Cox was partly responsible for Ham's success in Charlotte, he never publicly mentioned or acknowledged his anonymous gift. He lived his 100 years as a model businessman, deacon, and benefactor.

DAN GRAHAM TENT MEETING • 1934

With a long history of ministering in area churches, evangelist Dan H. Graham opened a tent revival on Shelby Street between Eighth and Ninth streets. The month-long campaign began on Sunday evening, September 16, 1934, and was one of Graham's more aggressive and controversial meetings. Rev. J. Alson Boyd of Atkinson, North Carolina, conducted the singing service and directed the 150-voice choir representing Presbyterian churches in the Bristol area. Crowds of 1,500 to 1,700 people were reported to have attended the first meeting, and by the next weekend, over 2,500 people crowded the 2,000-seat tent. Hundreds were standing in and around the circumference of the canvas sanctuary. Several Bristol churches, including First Presbyterian and Central Presbyterian, dispensed with all evening services to encourage participation in the tent meeting. State Street United Methodist, Fairmount Presbyterian, and numerous churches in Sullivan County also indicated their support of the campaign.

Controversy was not uncommon to Dan Graham; years earlier he had gained a reputation as a dynamic temperance preacher. With the Bristol meet-

ing, Graham again showed his religious fortitude by preaching against the state liquor industry. The referendum on abolishing liquor in Bristol, Virginia, came up for a vote on October 10, and Graham was one of the leading opponents to the "devil's brew."

Numerous attacks on the dry and wet issues focused on Graham, and it culminated with a slanderous letter to the editor in a Bristol newspaper. The writer attacked the infamous pastor, saying that Graham was "a reckless man running wild in the pulpit, the radio, and the press." A local religious newspaper distributed in the streets of Bristol, the *Watchman-Trumpet,* counteracted the claim with editorials in support of the evangelist, and the paper fortified support for abolishing the Virginia ABC dispensaries. Graham's leadership from the pulpit, combined with neighborhood canvassing organized by three Bristol pastors, Sullins Dosser, O. G. Porch, and J. E. Hicks, the citizens of Bristol, Virginia, soundly abolished liquor and wine in the city by a vote of 707 to 352. The tent meeting was a brilliant success for the prohibitionist community and for the hundreds who answered the invitation to the altar extended at the close of the services.

Graham was one of the most prominent evangelists that called the Bristol area home. He attended King College in Bristol and the Union Seminary in Richmond before being ordained by the Abingdon Presbytery at Pulaski, Virginia, on October 8, 1918. For nearly 60 years he served as a Presbyterian minister, coming to East Tennessee in 1927 and serving at Walnut Hill, Blountville, Arcadia, New Bethel, Thomas Memorial, Weaver's, Paperville, Belmont, and

The Rev. Dan H. Graham was a noted revivalist in the Bristol area for more than 50 years. Pictured with him is his musical assistant, Rhea Anderson.

other church outposts. Through his evangelistic leadership and organizational efforts, he founded more than 20 church congregations over the years. He was widely known for his 30-year radio ministry, but his living legacy is his namesake, Graham Bible College, which he founded in Bristol in 1951.

Dr. George T. Stevens Tabernacle • 1937

Another revivalist seeing the Holston region as fertile soil for an extended series of meetings was Rev. George T. Stephens. A prominent itinerate evangelist in the northern United States, Stephens had preached across America and Canada for over 25 years. The erection of a rough-hewn tabernacle on Piedmont Avenue in March of 1937 announced the coming of the Stephens evangelistic campaign to Bristol. The large structure was typical of traditional tabernacles, through not as tall, and closed on four sides like a barn or warehouse. It was located on Piedmont Avenue—which years earlier was constructed over Beaver Creek—one of the busiest streets in Bristol, Virginia. The tabernacle site was later the location of the Greyhound Bus terminal and Harkrader's Service Station. Though those businesses have closed, the buildings remain there today.

Assisting Dr. Stephens was his wife, who was herself an accomplished speaker. Their daughter, Eleanor, and Stephens's assistant, Jack W. Murray, directed the featured children's and youth meetings. Miss Stephens and Jack Murray were both graduates of Wheaton College. Murray also graduated from the Bible Institute in Los Angeles, California. The flamboyant Russell A. Case, a noted soloist and trumpeter who graduated from the Moody Bible Institute of Chicago, was the team's music director.

The revival opened on Monday, April 4, 1937, to a "large and enthusiastic crowd," with special music from the Calvary Baptist Church Male Quartet. Opening remarks and Dr. Stephens's introduction were conducted by Rev. Roy O. Arbuckle, the pastor at Calvary Baptist. Dr. Stephens launched his series of meetings with a topic from II Chronicles 7:14, "The Prescription of Revival."

There were few revivals as well organized as the Stephens campaign. Cottage prayer meetings were held throughout Bristol, with the primary emphasis toward ministering to the children and the youth. To that end, five meetings for the youth and three for the children were held each week of the revival, which climaxed with a morning children's street parade through downtown Bristol. It was due to the emphasis with the children that so many—now senior adults—have remembered Dr. Stephens's campaign.

Russell Case brought along other highlights in the form of special music

presentations by the Men's Musical Trio of Chicago, the Moody Musical Messengers of Moody Bible Institute, and gospel renditions on Case's "golden trumpet," which became a favorite of the audience. By the midpoint of the revival, the seating capacity of the tabernacle was enlarged with extensions on either side of the structure. This addition added several hundred seats, yet many of those who attended had to sit in their cars in the downtown area and listen to the live services over the radio.

Though considered by most as a very successful revival, it was not far from controversy. Stephens's comments at area factories, with the climax at the Big Jack Plant, concerning plant conditions and labor's association with communism brought out critical remarks from labor leaders throughout Tennessee and Virginia. A mass meeting, held at the Reynolds Arcade Building on May 1, was quickly organized to rebut the pastor's critical comments. This was a contentious time on the issue of labor unions nationwide, and some evangelists and pastors openly confronted the topic along with liquor and moral issues. For Stephens, the more divisive shoe fell the last week of the revival, casting a black cloud on the entire endeavor.

Stephens, following some counseling sessions, accused two unnamed pastors of the city of "conduct unbecoming of a minister." A special meeting of the Bristol Ministerial Association was called to review the accusations. Rev. J. Randall Farris, pastor of Central Christian Church, determined that he himself was one of the accused and stated that he had just returned to town and was unaware of the exact charges against him.

The next day, Sunday, May 23, the board of deacons and elders of the Central Christian Church met in a special conference at 4:30 P.M. for proof of the charges against Pastor Farris. A resolution was made by the board to invite Stephens, with all involved parties, to attend a meeting on the following day to establish the facts. Pastors from throughout Bristol were also invited to attend.

On the following day, a five-hour meeting ensued. Members of the congregation and numerous other people crowded into the church auditorium. Following prolonged bickering and verbal attacks from Dr. Stephens, the only facts that came to light were that the affidavits that were presented were hearsay and a misunderstanding of the fatherly Pastor Farris, who had served the church for over 36 years. Farris was totally absolved by the congregation, and the accusations were dropped by the Stephens party.

The Ministerial Association held another meeting, where members restrained verbal condemnation of Dr. Stephens but demanded a public apol-

ogy by the evangelist before he left the city. Stephens apologized on the last day of the revival, Tuesday, May 25, stating that he should have taken the complaints directly to Pastor Farris. Rev. W. D. Wilkinson of the First Methodist Church, speaking of Stephens, stated, "I am convinced great good has been done as well as great damage. I think he has saved many souls," echoing the sentiments of many pastors throughout Bristol.

The tabernacle was removed shortly after Dr. Stephens's party left the city, but Russell Case returned within several months to accept the call by Calvary Baptist Church to be their associate pastor and music director. The next summer, he returned to the revival circuit with Dr. B. R. Lakin, George T. Stevens, Dr. H. H. Savage, and other evangelists before coming back to Bristol in 1942 with his new wife as the successful associate pastor of Euclid Avenue Baptist Church.

THE BOWERY TABERNACLE • 1940

In April 1940, the opening of a new tabernacle on Tennessee Avenue under the direction of Rev. John Bowery was announced. C. G. "Tip" Casteel directed the music, and Miss Arnita Leonard (Thomsen) and Miss Delila Lowe played the twin pianos. Three Bristolians were instrumental in the preparation of this endeavor—George L. Greene, Hugh Carrier, and C. R. Leonard. A successful extended series of meetings was held, and the location became a permanent place for Rev. Bowery and evangelist T. B. Freeman to hold services. Regular revivals were held in the structure, then known as the Bowery Mission, until it officially organized with 20 charter members in 1942. It was established as a Missionary Baptist church, later to become Tennessee Avenue Baptist Church. Many residents will remember this structure, since it remained a place of worship until 1954, when the church erected a new sanctuary. Rev. John Bowery was the first pastor. Later, Rev. Willard Tallman served the church for 43 years.

THE MCBIRNIE BIBLE CONFERENCE • 1940

Dr. William S. McBirnie brought one of the largest and most memorable crusades to Bristol in June of 1940. Primarily supported by the Euclid Avenue Baptist Church in Bristol, the month-long Bible conference was held in a tent on Commonwealth Avenue, the site of the 1931 Mordecai F. Ham revival. Dr. Paul Roberts, an evangelist converted under Dr. Ham, was pastor of the church. The church's former pastor, Dr. B. R. Lakin, later pastor of the famous Cadle Tabernacle in Indianapolis, assisted in the meetings.

Crowds like the one pictured here came nightly to the McBirnie Bible Conference.

McBirnie, a veteran evangelist and native of Belfast, Ireland, had long spoken of end-time prophecies in tent meetings and pulpits across America. Now with the approach of World War II, his message on Bible prophecy received renewed interest, with scores of people packing his tents to find some meaning to the current turmoil in the world. With the beginning of the Bristol meeting on June 9 came word of the fall of Paris to the Nazis, and Mussolini's declaration of war on the Allies. The conference topic, "The Great World Change Now Taking Place," was a timely theme that attracted standing-room-only crowds for the meetings, held at 7:30 each evening and 2:45 each Sunday afternoon. The rise of the Antichrist, thought to be Mussolini, and the impending rapture of the church were presented through preaching, drama, radio clips, and photographs projected on a screen behind the pulpit.

Henry Cross, a longtime resident on Euclid Avenue, vividly remembered walking to the meeting while the service was in progress and hearing the sound of Dr. McBirnie's unique voice blaring from car radios within blocks of the tent. With many people unable to attend due to the crowd, they gathered around the automobiles, listening to the Irish evangelist's prophetic message to the city on their radios.

McBirnie's son, Robert, assisted his father, as did Marian, Raymond, and John Ashman, a sister and two brothers from Fremont, Nebraska. Marian Ash-

man served as the secretary and often music director for the ministry team, and her brothers were secured to prepare the tent for each meeting. Marian well remembered the Bristol revival, considering the 5,000-seat tent was completely filled to overflowing each evening, which drew a great number of converts and those desiring full-time Christian service. She also could not forget that the entire ministry team, though itinerate, joined Euclid Avenue Baptist Church, where Robert McBirnie was ordained at the conclusion of the month-long revival. Marian's brother John was also licensed to the ministry.

On October 31, 1940, Marian married Howard Estep, who had left the Navy and joined the McBirnie team. He took over the responsibilities of making advance arrangements and setting up the tent prior to each meeting. Later settling in Colton, California, knowing that the days of tent meetings had passed, McBirnie disbanded the team in 1949 and further developed his national radio ministry, which he had begun in Norfolk, Virginia. Howard and Marian then began a new radio venture in January 1950, the World Prophetic Ministry. Howard took over the well-known McBirnie Prophetic Newsletter as a ghostwriter prior to William McBirnie's death in 1967. Their ministry flourished, and in the 1960s they developed a television program, "The King Is Coming," which is still broadcast nationally by the Trinity Broadcasting Network.

BRISTOL PREACHING MISSION • 1949–1974

The development of the Bristol Preaching Mission is further evidence of the interdenominational evangelistic movement in Bristol. With inspiration from the early 20th-century revival meetings, Dr. William E. Hudson of Staunton, Virginia, originated the idea of an interdenominational "Preaching Mission." A graduate of both Hampden-Sidney College and Union Theological Seminary, Hudson devoted most of his time to evangelism, Christian education, and conference work after a brief pastoral career. Beginning a Bible conference in Harrisonburg, Virginia, he visualized the Preaching Mission concept and discussed the idea with Norman Vincent Peale of the Marble Collegiate Church in New York and Dr. John Sutherland Bonnell of the Fifth Avenue Presbyterian Church, also in New York.

Having seen the initial success of three of the earliest mission meetings in Norfolk and one in Richmond, clergy and layman throughout Bristol organized the Bristol Preaching Mission, which to date was one of the biggest ventures of its kind in the city. Sponsored by the Bristol Ministerial Association, the organization elected Norman Lake, pastor of First Presbyterian Church,

as general chairman, and established a committee of distinguished citizens to organize every aspect of a successful series of meetings.

Bristol's first Preaching Mission, held February 12-19, 1949, was an outstanding success, numerically and financially. The attendance for the eight-day meeting, held in the Virginia High School gymnasium, was estimated at 36,500. Even though there were 2,600 seats available per meeting, people were turned away at more than one of the evening services. Afternoon meetings were held at State Street United Methodist Church. Twelve prominent speakers from throughout the nation represented a diversity of denominations. The cost of the series of meetings was approximately $7,000, and generous contributions more than paid expenses. It was one of the most highly promoted religious campaigns held in Bristol at that time.

The enthusiasm for the annual Preaching Mission continued, and by 1955 local committees were established in nearby Kingsport and Johnson City under the name of the Appalachian Preaching Mission. A separate committee, made up of committees throughout the Tri-Cities, managed the overall organization. The success of the Preaching Mission was incredible, bringing to Bristol some of the most well-known pastors and laymen from throughout America. Dr. R. G. Lee, president of the Southern Baptist Convention, Rev. Ben Haden, later to be a well-known Methodist pastor, and numerous football icons spoke at the Mission. One of the most noted speakers in the early years was Mr. J. C. Penney, founder of the famous department stores that bear his name. He spoke to numerous organizations while in Bristol and visited his State Street store, which advertised the occasion in the local media as "Founder's Day."

The Bristol Preaching Mission had a long run of over 25 years. Low attendance eventually drew the curtain upon one of Bristol's most successful religious traditions.

Greater Bristol Layman's Crusade for Christ • 1962

Another national evangelistic movement found common ground in the Bristol community. In the early 1960s, a group of Bristol businessmen founded a local chapter of the Christian Business Men's Committee (CBMC), which met for a prayer breakfast every morning at 7:00 at the Hotel General Shelby. Its charter stated that it was an interdenominational organization to witness to businessmen about Jesus Christ. The primary difference with this organization and that of other ministries is that this was an effort of laymen and not the clergy. In fact, ministers were not received as members of the CBMC.

Numerous local entrepreneurs were founding members of this organization, including: Charles Lowery, Charlie Hatcher, Earl Webb, Sr., Bob Gurley, and Bobby Griffin. Among other pursuits of this organization, CBMC also supervised the Haven of Rest Mission, then located on State Street.

Ted DeMoss, director of CBMC International, supported the local committee in organizing the Greater Bristol Layman's Crusade for Christ. Bobby Griffin became the chairman of this effort, with William Bennett as vice-chairman and E. L. Sellstrom as secretary-treasurer. Set for October 7-14, 1962, this citywide crusade gathered at the Vance Junior High School gymnasium and met for eight days, from Sunday to Sunday.

A kick-off banquet was held at the Hotel General Shelby, where Jimmy Karam, a former all-American football star and businessman from Little Rock, Arkansas, was the keynote speaker. The banquet began an aggressive revival that headlined 16 lay speakers. Henderson Belk, vice president of the 400-store Belk department store chain, spoke of his conversion in a Charlotte, North Carolina, Billy Graham crusade. He was a Presbyterian lay leader and a member of the Gideons. Another prominent lay speaker was R. G. Letourneau of Longview, Texas, who was the builder of the world's largest earthmoving equipment. Dallas Jones of Durham, North Carolina, led the all-male choir, which became another highlight of the well-attended meetings. During the course of the meeting, other functions were planned. A noonday rally was held each day at the Paramount Theatre, and street meetings were held at different locations throughout the city. The prominent and influential speakers at the crusade also addressed organizations and churches during their brief visits.

The revival was considered an encouraging success for the local CBMC members. At the meeting held on the fifth night of the crusade, 50 young people accepted the call at the invitation, and overall 200 decisions were made. With this success under their belt, the CBMC scheduled another series of meetings for October of the next year.

In Conclusion

Prior to and during World War II was the most prevalent time in the 20th century to find visiting evangelists bring their message to Bristol. Many other well-known speakers came to the city, many more than could be detailed in this chapter. E. Howard Cadle, radio pastor and founder of the Cadle Tabernacle in Indianapolis, visited Bristol numerous times. At least twice, in 1938 and again 1940, he spoke to large audiences at the Tennessee High School Auditorium.

An Invitation to the Faithful

Bascom R. Lakin, who served as pastor at Euclid Avenue Baptist Church for several years, was another evangelist who led large tent and tabernacle meetings in the Bristol area. Lakin became one of the most well-known radio pastors in America following his local pastorate. Upon the death of E. Howard Cadle, Lakin took the pulpit of the Cadle Tabernacle, which was a radio church that seated 10,000 and had a choir of 1,400 people.

The local Baptist churches brought young Billy Opie to the city for a large tent meeting in August of 1943. It was located behind the post office in Bristol, Tennessee. Trombonist Hal T. Marona and music director Earl Opie assisted him.

Hyman Appleman is still remembered in Bristol for his tent meeting on the James Street playground at the current site of the Bristol Public Library. A Russian by birth, he was trained in the Jewish faith and was later converted to Christianity. He had a commanding voice and had overflow interdenominational crowds in his Bristol meeting.

Bristol's religious heritage in the 20th century is due in large part to the evangelistic efforts of its churches and the generosity of the Christian community. This community has long ministered to the physical and spiritual needs of the city. The Union Mission, founded in 1938 by Mr. and Mrs. J. M. Ripley, was for years the center of city-wide evangelistic efforts while also furnishing room and board to the needy of Bristol. Similar to the mission efforts of Dwight L. Moody in urban Chicago, the Union Mission had regular, highly publicized gospel meetings at their auditorium at 617 Shelby Street. Ma Sunday, widow of Billy Sunday, spoke to packed crowds on her visit in 1940, and many noted evangelistic teams set up four-week revivals there, which continued throughout the life of the Union Mission. They were associated with the International Union of Gospel Missions, which assisted in supplying many well-known speakers and musicians. The poem that identified the Bristol mission, "Soap, Soup & Salvation," became the rallying cry in the community for meeting the spiritual needs of individuals by providing for their physical needs.

The Bristol Salvation Army, having served a similar purpose for 110 years, is another Christian organization established to evangelize people not reached by local churches. Many Bristol residents will remember the Army kettle campaign on State Street and the Salvation Army Band, which often performed in many of Bristol's World War I- and World War II-era parades.

Finis

This is the end of volume one but it is not the end of my sesquicentennial history of Bristol. Number two will soon be on the way, and number three shouldn't be far behind. History is being made every day, and there is yet much to be uncovered. It is my delight to seek and write it. I hope it will be your pleasure to read it.

Index

Abingdon, Virginia, 6, 64
Abingdon Virginian, 180
Adair and Jones, 93
Adair, Crate, 93
Adair, Hugh H. (Dr.), 93
Adair's Hospital for Animals, 93
Adams, C.V., 133
Adams, Walter C., 112, 121, 122
Ager, Elmer, 114
Ager, John, 114
Ager, W.E., 127
Anderson, James King, 157
Anderson, John C., 34, 54, 157, 192, 197
Anderson, Joseph R., 4, 5, 6, 36, 48, 54, 71, 86, 140, 156, 157, 188, 189
Anderson, Melinda King, 99, 186
Anderson, Rhea, 225
Anderson, Robert, 73
Andes, Michael D., 44
Andrews, Emma Glover, 40
Andrews, Ernest Linwood, 37, 40, 41
Andrews, H.H., 176
Andrews, Jack, 40
Andrews, Lola Mae Steele, 40
Andrews Manufacturing Company, 40, 46
Andrews Sales Agency, 41
Appleman, Hyman, 224, 233
Arcade Drug Store, 52
Armstrong Hospital, 59, 60, 61
Armstrong, N.F. (Mrs.), 59, 60, 61
Arnold, Betty, 186
Arnold, Reginald V., 86
Arthur J. Connor Company, 45
Ashman, John, 229, 230
Ashman, Marian, 229, 230
Ashman, Raymond, 229
Aven, Charles G. (Dr.), 29
Bachelor, Rosetta, 186
Bachman, Agnes, 21
Bachman, Harry (Dr.), 21
Bachman, Hattie Brewer, 22
Bachman, Joseph S. (Dr.), 17, 21, 22, 56, 61, 62, 64, 66, 68, 69, 72, 109, 129

Bailey, D.F., 24
Bailey, David F., 32, 178
Bailey, John P. (Dr.), 30
Baker-Fickle, 114
Barger, Dorothy McQueen, 44
Barger, G.S., 113
Barger, Howard, 44
Barker, J.M. (Col.), 99, 162
Barker, James M. Jr., 113
Barker, Kelley W., 172
Barker, Kelly, 174
Barker, William, 127
Barker, William S. (Dr.), 29
Barker's Supermarket, 172, 174
Barkley Anne J., 134
Barr, Johnny, 166
Barr, W.F., 127
Barringer, Harriett, 70
Barry, Jud, 198
Baumgardner, J.D., 113
Baumgardner, John B., 43
Baumgardner, Sarah, 149
Bays, Dan, 66
Beaver, C.F., 221
Beaver, Laura, 220
Bell, Jewel (Mrs.), 84
Bennett, William, 232
Berry, H.T. (Dr.), 23
Berry, Rebecca, 202
Bewely, Jake, 176
Bibb, Robert, 187
Big Hell Bottom, 57
Big Jack Overall Company, 222
Big Stone Gap, Virginia, 82
Black Shawl, 31, 34
Blackley, George W., 48, 92
Blankenship, Alma, 202
Blind Alfred Reed, 205
Blue Bird Taxi, 135, 136
Bolling, Abe, 114
Bolling Chandler, 116
Bolling, W.I., 114
Bond, Helen G. (Dr.), 20
Booher, William R. (Dr.), 58
Bosang, John N. (Mrs.), 14
Boswell, Robert C., 80
Bouton, J.E., 171
Bowers, Thaddeus R. (Dr.), 21, 22
Bowery, John (Rev.), 228
Boyd, J. Alson (Rev.), 224

Boyer, Henry Quincy Adams (Dr.), 15, 16, 56
Boyle, Ken, 112
Bradley, Thomas W., 52
Bradley's Drug Store, 52
Bray, N.T., 102
Brewer, Hoge, 108
Brewer, James King, 77, 104
Brewer, King James, 108
Brewer, Olive Carlock, 108
Bridgeman, Minnie Faidley, 97, 106
Bristol (Daily) Courier, 179
Bristol Auto Laundry, 116
Bristol Banner, 178
Bristol Brick Company, 78
Bristol Courier, 145, 179, 180
Bristol Drug and Gum Corporation, 47
Bristol Drug Corporation, 53
Bristol Drug Manufacturing Company, 47
Bristol Enterprise Trading Company, 167, 169
Bristol Evening Bulletin, 180
Bristol Evening News, 180
Bristol Grocery Company, 175, 176
Bristol Herald, 77, 191
Bristol Herald Courier, 178, 179, 180, 181, 182, 183, 184, 203, 204, 215, 221
Bristol Laundry Company, 19
Bristol Memorial Hospital, 81, 82
Bristol Motor Company, 117, 125
Bristol Motor Speedway, 154
Bristol Nash Motor Company, 114
Bristol News, 27, 160, 178, 179, 180, 187
Bristol News-Bulletin, 180, 183
Bristol Produce Market, 175
Bristol Public Library, 11, 195, 199, 201
Bristol Radio Cab Company, 136
Bristol Regional Medical Center, 82
Bristol Reporter, 178

Bristol Taxi Service, 129
Bristol Transfer Company, 127
Bristol Virginia-Tennessean, 182
Brown, Blessing S., 29
Brown, Eugene, 84
Brown, G.T., 44
Brown, James A. (Dr.), 18
Brown, Jerry, 169
Brown, Stephen J. (Dr.), 21
Brown, Susie, 19
Brown's Funeral Home, 84
Buchanan, Tim, 169
Bull Mountain Moonshiners, 205
Bunn, H.O. (Mrs.), 29
Bunting & Son, 48
Bunting and Pepper Drug Store, 35
Bunting, Jeremiah, 48, 92
Bunting, Lindsay, 48, 50, 52
Bunting, Mary, 48
Bunting's drugstore, 48-56
Burroughs (Parson), 106
Burroughs, Parson, 27
Burrow, Thomas J., 195
Burrow, W.M., 179
Burson, Z.L. (Maj.), 158
Bushkirk, J.B., 39
Butler, B.H., 167
Butler, B.H. (Mrs.), 168
Butler, Matthew Moore (Dr.), 16, 17, 18, 32, 56, 75, 76, 79
Cadle, E. Howard, 224, 232, 233
Caldwell, George A. (Rev.), 188
Caldwell, John H., 111
Caldwell, Joseph A., 91
Caldwell, Virginia, 32
Cameo Theatre, 31, 125, 200
Canter, Eddie, 92
Canter, Laverne, 92
Captiva Island, 47, 48
Carmack, Jacob Susong, 164
Carmack, Jane, 219
Carmack, Lucille, 197
Carmack, Martha Ellen (Ella), 164
Carnegie, Andrew, 191
Carreras, W.C. (Dr.), 22
Carrier, Hugh, 228
Carrier, Nathaniel, 167
Carroll, George, 167
Carroll, Landon S., 134
Carroll, Louis, 134
Carroll, Mary C., 167, 168
Carson, John, 203
Carter, Alfred M. (Dr.), 17, 71, 95, 163
Carter, Alvin Pleasant Delaney (A.P.), 204, 205, 206

Carter, Anita, 207
Carter, George L., 180
Carter, Helen, 207
Carter, Janette, 208
Carter, June, 207
Carter, Maybelle, 205, 207
Carter, Nannie Zimmerman, 71, 95
Carter, Sara, 204, 205
Carter's Taxi Service, 84
Cartwright Motor Company, 114
Carty, W.D., 197
Case, Russell, 228
Case, Russell A., 226
Cash and Haul Company, 177
Cash, Johnny, 207
Cass, W.W., 127
Casteel, C.G. (Tip), 228
Caudle, Earl C., 53
Caudle, Ella, 53
Cawood, Hugh M., 170
Cawood, Marian, 170
Chalmers, Carter R., 102
Checker Cabs, 135
Chensey, Kenny, 207
Chestnut, Judy, 197
Childers, Margaret Alberta, 38
Childress, J.J., 162, 163
Cin-Co-Lery Chemical Company, 38, 40
Citizens Cemetery, 26, 34, 35
City Cab Company, 136
City Drug Corporation, 53
City Drug Store, 50
City Service Oil Company, 114
Clarence P. Moore & Company, 101, 113
Clark, Ann, 197
Clark, Samuel, 61
Classic Recording Studio, 206, 207
Clyce, George H., 108
Clyce, Samuel P., 167
Coalson, E., 197
Coalson, Winnie F., 197, 198
Cochran, Benjamin C., 50
Cohen, E.H., 52
Colbert and Reser, Druggists, 50
Colbert, George N., 50
Colbert, Henrietta Minor, 50
Colbert, Newton M., 48, 50
Cold Springs Presbyterian Church Cemetery, 88
Coleman, Richard M. (Dr.), 12, 16, 48, 92
Connelly, Henry D., 43, 48
Connelly, Joseph, 43
Connelly, Stella Dickey, 43
Copenhaver, Amelia Slack, 21

Copenhaver, Nat (Dr.), 21, 84, 91
Copenhaver, William (Dr.), 17
Cornett, Harold (Bugs), 206
Cornett, Michael, 206, 207
Cornett, Stephen J., 167
Cornish, L.E. (Miss), 64
Cosby, Lewis (Dr.), 149
Cowan, B. Young (Dr.), 23
Cowan, Charles F., 52
Cowan, Conley M. (Dr.), 18, 58, 59, 62
Cowan, I.B., 50
Cowan, Janette, 52
Cowan, Moses Rutledge, 52
Cowan, Taylor O., 52
Cowan-Sams Company, 112
Cox Wholesale, 224
Cox, Abijah Jerome (B.J.), 127, 128, 129, 130, 133
Cox, E.B., 64, 177, 223, 224
Cox, E.B. Jr., 224
Cox, Mary, 64
Cox, Victoria Smith, 128
Craven, W.J., 47
Crawford, A.L., 127
Crawford, H.D., 127
Creggar, Kyle (Rev.), 91
Crockett, James A., 52
Crockett, Mary L., 52
Cross, Henry, 229
Cross, Oscar L., 101
Crude Drug Company, 47
Cruikshank, C.G., 115
Crumley, Jacob L., 168
Crumley's Alley, 74, 75
Crymble, Carter, 149
Crymble, E.K., 113, 115
Cumberland Square Park, 3
Curtain and Haynes, 146
Cut Rate Store, 170
Cut Rate Taxi Service, 134
Daab, Henry, 169
Daab, Zera, 169
Daggs, Helen, 26
Daily Argus, 178
Daily Courier, 179
Daily Herald, 180
Daily News, 180
Daily Times, 179
Daily Tribune, 179
Daily Tribune and Times-Courier, 179
Dan Graham Bible Institute, 80
Daniels, Alda Carr, 86
Daniels, Harry, 86
David Blustein and Brother, 46
Davis and Sparger Auto Company, 112
Davis-Bedwell, 116, 117
Davis, Carolyn E., 79

Davis, Cecil, 112, 114
Davis, Cecil (Mrs.), 38
Davis, Edith, 102
Davis, Mary E., 102
Davis, W.W., 194
Dawson, Frank G., 93
Deery Inn, 162
DeFriece, Frank W., 80, 91
DeFriece, Frank W. (Mrs.), 193
Delaney, J.R., 112
Delaney, James A. (Dr.), 17, 56, 58, 62, 66
Delaney, Jim (Dr.), 86, 88
Delaney, William T. (Dr.), 17, 19, 56
DeMoss, Ted, 232
Dempsey, Aaron W., 134
Devault, Chambers, 39
Devault, Laura, 39
Devault, R.H., 108
Dickey Drug Company, 43, 44
Dickey, Carl, 44
Dickey, Dorothy Douglas, 43, 44
Dickey, Ernest H., 43, 47
Dickey, Evelyn, 43
Dickey, Florence, 44
Dickey, Herman, 43
Dickey, James A. (Dr.), 17, 19
Dickey, John R., 41, 42, 47, 86
Dickey, John R. Jr., 43
Dickey, Maude, 43
Dickey, Sarah James, 42
Dickey, Stella, 43
Dickson, C.A., 113
Dickson, J.M., 113
Dixie Tannery, 219
Donovan, 208
Doriot, Victor, 190
Dosser, Sullins, 225
Dove, Herschel, 179
Dr. Yi's Chemical Company, 39
Driver, Leslie R., 80
Droke, Virginia, 197
Drugan, Frank, 117, 118
Dulaney, Nat T. (Dr.), 17, 21
Dunford, Eck, 205
Dunn, A.J. (Dr.), 28
Dunn, I.B., 185, 187
Dykes, Arthur L. (Dr.), 19
Dykes, Bessie McCrary, 19
Dylan, Bob, 208
Easley George H., 177
Easley Grocery Company, 177
East Hill Cemetery, 29, 34, 54, 72, 73, 86, 97, 124, 148, 152, 167, 169
East Tennessee and Virginia Railroad, 4, 5
Easy Way Grocery, 171
Eaton, Albert, 196

Eaton, Anna J., 196
Eaton, Bertie, 196
Eaton, Ethel J., 196
Eaton, H.H., 196
Eaton, Sarah, 196
Eaton, Victoria, 192, 196
Echols, Josephine, 21
Echols, R. McRae (Dr.), 21
Economy Store, 171
Edmondson, H.B. (Dr.), 19
Edwards, Arthur J. (Dr.), 19, 22
Elizabethton Star, 182
Eller, Q.E., 112
Elliott, Arthur, 114
Emergency Hospital, 57
Emmert, Ernest, 20, 72
Emmert, D.S., 127
English, Arthur B. (Dr.), 86
English, C.C., 191
English, John, 27, 28
English, John Goodson (Col.), 27, 138, 148
English, Juanita, 190, 191
English, Margaret (Maggie) Rhoda, 72, 106, 111, 148, 149, 151
Ensor, John J. (Dr.), 16, 17, 56
Enterprise Wheel & Car Corporation, 222
Estep, Howard, 230
Evan Shelby Hospital, 56, 58
Everett's Café, 218
Eversole, Linda, 27
Faidley, Ed, 100, 106
Fain, James Rhea, 196
Fain, Lillian Lukehart, 196, 197
Fain, Marjorie, 196
Fairfax, G.P. (Mrs.), 190, 191
Farmer's Protective Union Store, 37
Farris, J. Randall (Rev.), 227, 228
Farris, Sally, 72
Faucette, J.D., 168, 215, 218
Faucette, J.H., 150
Faust, J.D., 115
Ferguson, Robert, 114
Fields, R.E., 116
Fifty-Three Cab Company, 133
Flat Hollow Cemetery, 34, 35
Fleenor, C.W. (Dr.), 13
Fleenor, Carita Whitlock, 87
Fleenor, Charles Warren (Dr.), 86, 87, 88, 89, 90
Fleenor, Charles Warren Jr., 87
Fleenor, Mary Lou, 87
Fleenor, Robert, 133
Fleenor's Private Hospital, 86
Fleming, Betsey Butler, 79
Fleming, Joe, 111
Foran, C.J., 127

Ford, Ernest Jennings (Tennessee Ernie), 204, 208, 210
Fort Shelby Hospital, 92
Forward, Alexander, 180
Fourteen Hundred Taxi Service, 133, 134
Fowler Drug Store, 50
Fowler, Elbert, 178
Fowler, Isaac C., 141, 160, 178, 188, 190
Fowler, Martin L., 50
Francisco, Earl, 80
Fred Hayes Plumbing and Heating, 78
Freeman, T.B., 228
Frost, G.W., 186
Frye, J.H., 134
Fuller Bus Line Company, 135
Fuller, D. Wayne, 53
Fuller, Malcolm (Dr.), 78
Furrow's Market, 175
Gaines, William Henry Harrison, 142
Galliher, Roland, 80
Galloway, Hunter H., 176
Gammon, Landon Haynes (Dr.), 18, 22
Gammon, William (Dr.), 22
Gannon, James, 109, 194
Gaylor, Walter R. (Dr.), 22
Gemmell Brothers Electric, 78
General Shelby Hotel, 52, 117, 146
General Shelby Pharmacy, 52
German Manufacturing Company, 40
Gerstle Medicine Company, 40
Gerstle, Leopold G., 40
Gibson Candy Company, 176
Gibson, Herman D., 101
Gibson, William H., 176
Gibson-Helms Company, 176
Gilbert, John C. Jr., 80, 81
Givan, John F. (Dr.), 30
Glade Spring, Virginia, 53, 151, 189
Globe Nurseries Company, 38
Godsey's Market, 174, 175
Goforth, Bill (Rev.), 136
Goforth, Juanita Offield, 136
Goodell, E.G., 109
Goodpasture, Frank, 115
Goodson Democrat, 178
Goodson Gazette, 178
Goodson, Samuel E. (Col.), 4, 5, 6, 23, 139
Goodson, Virginia, 6
Goodsonville, 4, 6
Goodwyn Motor Company, 120
Goodwyn, P.A., 120, 121

Grace Memorial Hospital, 88, 89, 91, 91
Graham, Billy, 224, 232
Graham, Dan H., (Rev.), 80, 224, 225
Grand Ole Opry, 207
Graves, H.E., 191
Graves, Patsy, 190, 191
Graves, William (Dr.), 22
Gray, Elizabeth, 190
Gray, Joseph, 172
Gray, Mary Preston, 97, 190, 193
Gray, Robert, 190
Great Atlantic & Pacific Tea Company, 174
Green, James T. (Dr.), 17
Greene, George L., 228
Greeneville, Tennessee, 5, 37
Greever, Charles A., 52
Griffin, Bobby, 232
Grigsby, Bernard C. (Dr.), 92
Grigsby's Hospital, 92
Gurley, Bob, 232
Guthrie, Ada M., 84
Guthrie, Ernest A. (Mrs.), 84
Guthrie, Neal, 130
Guy L. McCroskey's Market, 175
H.P. King Company, 194, 216, 222
H.P. King Store, 70
Hagan, Charles F., 37, 38
Hagan, Hugh, 39, 65
Hagan, Patrick, 38
Hagey, James A., 169
Hagey, Martha Alice, 169
Hale, Pocahontas
Hale, Pocahontas (Ole Pokey), 31, 32, 33, 34, 35, 186
Hall, Bill, 184
Ham, Mordecai Fowler (Dr.), 219, 220, 221, 222, 223, 228
Hamilton Hotel
Hamilton House Hotel, 18, 19, 26, 38, 59, 147, 164
Hamilton's Grocery, 175
Hammer, Tom, 52
Hammer's Drug Store, 52
Hammer-Lynn-Kaylor, 170
Harkrader, Charles J., 91, 111, 113, 114, 180
Harmeling Opera House, 50
Harmeling, George H. (Mrs.), 79
Harper, Helen, 26
Harrington, Ruby, 84
Harris, Alexander B., 190
Harris, Alexander B. (Mrs.), 190

Harrison, Margaret King, 170
Harrison, Roscoe F., 170
Hart, Carmack Ellen, 97
Hart, David Jenkins, 146, 159, 164, 165
Hart, D.J. (Mrs.), 219
Hart, Martha Jane, 31, 165
Hartfield Dairy, 146, 164
Hartman, Flavius (Dr.), 12
Hast, Noah, 24
Hatcher, C.A., 130
Hatcher, Charlie, 232
Hawley, Irvine C., 53
Hawley, Kate A., 53
Hawley's Drug Store, 53
Hayes, Buck, 116
Hayes, Dave, 116
Hayes, Fred, 60
Hayner, Henry, 91
Hayter, Thomas, 59
Hazard, Kentucky, 125
Hearon, Charles O., 180
Hearst, E.H. (Dr.), 91
Hearst, Elvin (Dr.), 21
Henderson, Grace, 89
Henderson, Harvey, 114
Henderson, Hiram F. (Dr.), 29
Henderson, Nat, 97
Hickory Tree Community, 116
Hicks, Hugh T., 164, 165
Hicks, J.E., 225
Hicks, James Franklin (Dr.), 189, 194
Hicks, John F. (Dr.), 17, 41, 42
Hicks, Mary McCormick, 189, 190, 193
Hill, Hugh M., 167
Hobbs, Virginia, 39
Hoekstra Raymond (Maj.), 51
Hoffman, Julia, 43
Holston Consruction Company, 78
Holston Garage, 114
Holston Institute, 87
Holston Valley Medical Center, 82
Holt and Snapp, 102
Holt, John F., 101
Hooks and English Infirmary, 86
Hooks, Arthur (Dr.), 86
Hotel Bristol, 107, 218
Hotel General Shelby, 232
Hotel Hull, 39
Howard, Nora (Mrs.), 84
Huddle, J.D., 78
Huddle, Jefferson D., 78
Hudson, William E. (Dr.), 230
Huling, Charles, 52
Humphrey, Mary (Miss), 64
Hunt, Betty (Mrs.), 19

Hunt, R.M., 101
Huntsman Brothers Wholesale Grocers, 167, 168, 176
Huntsman, B. Lee, 176
Huntsman, John N., 92, 168
Hurt, William Whitsitt (Dr.), 30
Hyatt, James H. Jr., 184
Hyder, Jack (Dr.), 30
Hyder, Jane Wood, 30
Hyler, Mark, 184
Intermountain Telephone, 222
Interstate Body Company, 116
Interstate Hardware and Supply Company, 113
J.A. Wilkinson Company, 109
J.D. Faucette and Company, 168
J.J. Smith's Grocery, 174
Jabaz (slave), 28
Jackson, Stonewall, 18
James, James King, 102, 103, 104, 105, 106, 107, 110, 112, 113, 197
James, Julia Kendrick, 103, 107, 197
James, Laura Lucretia, 42, 102
James, Marie, 61
James, Mary E. Davis, 102
James, Mary Jones, 103
James, Sarah, 42
James, W.W., 32, 33, 42, 102
Janie Hammitt Children's Home, 167
Jeems, Uncle, 94, 95
Jefferson, India Harper, 26
Jefferson, James, 170
Jefferson, Peter, 99
Jefferson, Roxie, 26
Jefferson, Thomas (President), 26
Jenkins, Kentucky, 125
Jett, Curtis Lee, 39
Jett, John W., 39
Jobber's Candy Company, 176
Joe Barker Motor Company, 116
Johnson City Staff, 180
Johnson, Andrew (President), 16, 179
Jones, Carl A., 91, 109, 111
Jones, Dallas, 232
Jones, Edward T. (Dr.), 29
Jones, F.A. (Dr.), 93
Jones, H.E., 51
Jones, Joseph W., 48, 52, 194
Jones, Madison, 48, 92
Jones, Mary, 103
Jones Mill, Alabama, 39
Jones Pharmacy, 52
Jones, Sam, 219
Jones Wholesale, 177

Karam, Jimmy, 232
Kearfott, C.B., 78
Keebler, A.C., 69
Keebler, V., 99
Keebler, Victor, 69
Keesling, Louis, 114
Kegley, J. Henry, 177
Keith, Edward (Mrs.), 190, 191
Keithley, Laura B., 26
Keller, Ruth Cox, 224
Kelton, (Mr.), 12
Kennedy, James, 39
Kenny, C.D., 177
Kernan, Charles K. (Dr.), 18, 19
Kernan, Paul (Dr.), 19
Keys, John (Dr.), 27, 187
Kilgore and Graham, 114
Kilgore, Frank, 114
Kilgore, Laura, 102
Kilgore, W.B., 102
Kimmons, Albert J. (Dr.), 88, 89, 90, 91, 92
Kimmons, Grace Henderson, 89
Kimmons, J.D., 89
Kimmons, Mary Cowan, 88, 91
Kimmons, Nannie Salts, 88, 89
King, Arthur W., 80
King, Clarence G., 109, 110
King College, 14, 29, 84, 165
King, E.W., 51, 77, 78
King, H.P., 170
King, James (Col.), 139, 140, 187
King, James (Dr.), 29, 30
King, James (Rev.), 3, 4, 27, 28, 99, 103, 138, 139, 140, 148, 187, 194
King, James III, 140, 188
King, Joseph L., 194
King, Margaret, 170
King Pharmaceuticals, 45, 46, 47
King Printing Company, 194
King Rogers Grocery, 176
King, Viola, 51
Kings Meadow, 3, 4
Kings Mountain Memorial Hospital, 64, 65, 66, 75, 76, 79, 80, 148, 194, 200
Kingsolver and Huddle, 78
Kingsolver, David M., 78
Kingsport Lumber Company, 109
Kingsport Times-News, 184
Kinnamon, Jim, 65
Kinzer, Michael B. (Dr.), 18
Kinzer, Carp S. (Dr.), 18
Kiplinger, Nancy (Miss), 58
Kite, Joe S., 113, 114, 118

Kite-Barker Motor Company, 113
Knight, H.M., 135
Knoll, Tommy, 148
Knott, Robert L., 168
Knott's Bakery, 168
Koty's Garage, 126
Krauss, Alison, 207
L. Gerstle Company, 40
Lake, Norman, 231
Lakin, Bascom R., 224, 228, 233
Lancaster, R.T., 92
Leaman, Mel (Rev.), 219, 220
Ledger-Star, 182
Lee, R.G. (Dr.), 231
Leonard, Arnita, 228
Leonard, C.R., 228
Leonard, J. Sullivan, 134
Leonard, S.A. (Mrs.), 168
Leonard, Simpson, 66
Letourneau, R.G., 232
Liberty Motor Company, 113, 114
Linwood Drug Company, 46
Little, Jim, 24
Livesay, C.B. (Rev.), 215
Livesay, J.S., 42
Lockett, Kate J., 190, 191
Lockett-Reeves Company, 44, 47, 168
Lockett, W.B., 168
Lockett, Walton W., 168
Loggins, Dave, 204, 208, 209
Lonesome Pine Hospital, 82
Long, J. Ernest, 48
Long, William G. (Dr.), 29
Louisville City Hospital, 59
Louisville Medical School, 87
Loving's Food Market, 174
Loving's Market, 174
Loving's Super Market, 175
Lowe, Delila, 228
Lowery, Charles, 232
Lukehart, Lillian, 196
Lynch, Agnes, 79
Lynn-Kaylor, 170, 175
Maden, Ernest J., 80
Maden, Margie, 80
Marcy, John O. (Dr.), 22
Marion, Ed, 114
Marion, Val, 114
Marona, Hal T., 233
Marshall, R.T., 64
Martin, Robert H., 171
Maryland Motor Company, 119
Massengill Company, 222
Massengill, David, 46
Massengill, Eula, 46
Massengill, Norman, 45, 46

Massengill, Pauline, 193
Massengill, Samuel Evan (Dr.), 45, 91
Matthews, Robert, 217
Matthews, Dorothy A., 79
McAfee, Charles M., 44
McArthur, Rutherford B. (Dr.), 20, 82, 83, 84, 85
McBirnie, Robert, 229, 230
McBirnie, William S. (Dr.), 228, 229
McCarty Holsaple McCarty, 201
McClellan, John G. (Dr.), 19, 20, 21
McClure, Roy C., 80
McCormick, Mary, 189
McCrary, Bessie, 19
McCrary, James F., 61
McCrary, Jim, 127
McCroskey, J.M., 172
McCroskey, R.M., 170
McCroskey, Ray Jr., 170, 176
McCue, J.H., 76
McCue, J.H. (Mrs.), 76, 79
McEntire, Reba, 209
McFarland, Margaret, 195
McGoldrick, Ida, 62
McGoldrick, Jen, 62, 63, 64, 65, 66, 67, 74, 75, 68, 83
McGoldrick, Lavalette, 62, 63, 64, 65, 66, 67, 83
McGoldrick, Permelia, 62
McGoldrick, Thomas, 62
McIntyre, John T. (Dr.), 30
McIntyre, John T. Jr. (Dr.), 30
McIntyre, T. (Dr.), 29
McKee, Eufaula Bickley (Mrs.), 197
McLaughlin, K. Dale (Dr.), 30, 62
McNeil's Funeral Home, 66
McQueen, Dorothy, 44
McQueen, Florence Dickey, 44
McQueen, Joseph M., 44
Mendota, Virginia, 64, 128, 138
Mercy Hospital, 20, 82, 84, 85
Mick or Mack, 175
Middlesboro, Kentucky, 39
Miles, Waldo (Mrs.), 198
Milk Depot, 172
Millard, S.L., 101
Miller Brothers, 175
Miller, Jean, 197
Miller, Jesse H., 142
Minor, C.C., 48, 93
Minor, Henrietta, 50
Minor, Nanie J., 49
Minor's Drug Store, 48, 50, 53, 72

Mitchell-Powers Hardware Company, 196
Moneyhun, James J., 174
Montgomery, Gordon A., 52
Montgomery, Janette, 52
Moody, D.L., 224
Moody, Dwight L., 233
Moore and Hart, 100, 101
Moore Street Taxi Company, 127, 129
Moore, A.K., 178
Moore, C.N., 127
Moore, Charles B., 64
Moore, Charles B. Jr., 64
Moore, Charles N., 134
Moore, Clarence P., 93
Moore, Louise Brewer, 108
Moore, Stella Rebecca St. John, 64
Moorman Motor Company, 113
Moorman, Julian P., 79, 223
Moorman, Minnie, 79
Morley, W.L., 177
Morris, Henry H., 135
Morrison, Aubrey L., 171
Morrison, James Sr., 69, 113
Mort's Gun Store, 180
Morton's Market, 176
Mosby, John S. (Col.), 48, 92
Mosley, Vera, 84
Mottern, R.J., 91
Mountain View Cemetery, 22
Mrs. Ferby Roberts and Company, 168
Mulberry Grove, 3
Muldoon, Byron, 197
Muller, Pamela, 198
Muller, William (Bill), 197, 198, 199
Mumpower, Della, 177
Mumpower, William, 177
Murray, Anne, 209
Murray, Jack, 226
Music, Bert, 102
Mystic Wine of Life Company, 44, 45
Nelms, Charlotte, 197
Nelms, Willie, 197
New Hope Bed and Breakfast, 44
Newland, Charles, 71
Newland, Joseph Mitchell (Mitch), 66, 71
Newland, Rebecca Anderson, 71
Nickel House Hotel, 161
Nickels Manufacturing Company, 38
Nickels, G. Emmit, 37
Nickels, Isaac A., 187

Nickels, Myrtle, 37
Nickelsville, Virginia, 37
Nitty Gritty Dirt Band, 209
Noon Grove, 3, 4
Norment, Bessie, 84
Northside Drug Center, 55
Odell and Poore, 116
Odell, Joseph D., 116
Offield, Bryant, 134, 135, 136
Offield, Nina, 135
Opie, Billy, 233
Opie, Earl, 233
Osborne, Bishop (Bish), 123
Overland Company, 116
Overstreet, George W. (Dr.), 71
Owl Drug Company, 50
Owl Drug Store, 51, 53
Pace, Eliza, 25
Page, Siota, 65
Painter, Carrie, 105, 130, 166, 196
Painter, David O., 87
Painter, Philip, 87, 105
Palace Hotel, 142, 146
Palmer, Jessie, 197
Palmer, Will, 152
Paperville, 4
Paramount Center for the Arts, 210, 211, 212
Paramount Drug Store, 52
Paramount Theatre, 14, 16, 232
Parlett, Albert (Mrs.), 190
Parlett, Albert Sr., 195, 196
Patrick, Lee P., 172
Patton, Hugo, 162, 163
Patton, W.H. (Mrs.), 190
Peach Bottoms, Virginia, 41
Peale, Norman Vincent, 230
Pearson, M.M. (Dr.), 17
Peavler, Eileen, 197
Peavler, George M. (Dr.), 17
Peavler, Rutledge, 197
Peer, Ralph, 203, 204, 206, 210, 211
Penley, Earl, 134, 135
Penney, J.C., 231
People's Service Drug Store, 53
Pepper Drug Store, 14
Pepper, John G. (Dr.), 32, 35
Perkins, Harvie, 81
Peters, Annie, 74, 75, 69
Peters, Herb (Mrs.), 97
Peters, J.B. (Col.), 142
Peters, N.S. (Dr.), 18, 109
Peters, Nancy, 62
Phelps, Stephen, 184
Phillipi, Forest M., 135
Phillips, Frank, 122
Phillips, Richard, 122
Phillips, Virginia, 66
Phillips, William (Dr.), 24

Phipps, W.E., 134
Piedmont Market, 175
Piggly Wiggly, 174, 175
Piper, Harry M., 197, 215
Piper, Margaret, 197
Pippin, Ellen Hayes, 64
Pippin, Harmon L. (Dr.), 64
Pippin, Harmon L. Jr., 64
Pippin, Mary, 224
Pippin, Mary Cox, 64
Pistol Packing Mabel, 131
Plaster, Scott, 65
Poe's Market, 175
Poore, Arthur J., 116, 119
Porch, O.G., 225
Powell Botanic Company, 46
Powell, Joseph, 46
Powers, Art, 184
Preston, Thomas W., 195
Price, John W., 179
Price, Julian L. (Dr.), 21
Princeton, West Virginia, 38
Pritchett, John I., 117
Pritchett, Margaret, 117
Pure Food Grocery, 172
Puri-Tone Medicine Company, 47
Purity Grocery, 172
Quailes Brothers, 116
Rader, J.P., 144
Ramsey, William, 219, 220, 221
Rapp, Fred W., 215
Rawley, Frederick, 170
Rayburn, James M., 53
Ream, Edwin H., 59, 61
Ream, Nell Armstrong, 62
Red Bird Taxi Service, 134
Red Top Taxi Company, 134
Redford, John Bell, 193
Reece, Carroll, 183
Reeve, Nathan H. (Dr.), 17, 62, 64, 104, 109
Reeves, W.P., 44, 168, 176
Reporter, 179
Reser and Cowan, 50
Reser, Clyde, 50, 54
Reser, Viola King, 51
Reser, W.C., 48, 50, 51
Restless Heart, 209
Revolutionary War, 76
Reynolds Arcade Building, 17
Reynolds, A.D. (Maj.), 17, 66, 69, 85, 86, 99, 112
Reynolds, Ethel Romph, 112, 113
Reynolds, Hardin W. (Dr.), 17, 112, 113
Reynolds, R.J., 17, 112
Reynolds, Sue, 86
Reynolds, Thomas F. (Dr.), 86

Rhea, Samuel W. (Dr.), 29, 30
Rhea, William F., 179
Rhodes, Ida McGoldrick, 62
Rich, Willie, 224
Richmond Times-Dispatch, 184
Riddle, Douglas (Dr.), 30
Riggs, Dudley G. (Dr.), 84
Riggs, Georgia, 84
Rio Grande Valley, 100
Ripley, J.M., 233
Ripley, J.M. (Mrs.), 233
Roanoke Times, 184
Roanoke, Virginia, 109
Roberson, William F., 176
Roberts, C.W., 215
Roberts, Paul (Dr.), 228
Robertson, Eck, 203
Robertson, Nanie J. Minor, 50
Robertson, Walter H., 195, 221
Robinson, Frank, 182
Robinson, Harvey (Dr.), 93
Rock, Marvin (Dr.), 21, 53
Rodeheaver, Homer, 217
Rodgers, Jimmie, 203, 204, 205, 206, 210
Rogers, Earl S., 221
Rogers, William R. (Dr.), 18, 22, 24, 25, 56, 57, 58, 60, 61, 62, 63, 67, 72, 84, 109
Roller, Alvin J. (Dr.), 18, 111
Rouse, W.H. (Mrs.), 195
Royston, A.P., 127
Rutherford Transfer and Storage Company, 116
Rutherford, Pierce, 116
S.E. Massengill Company, 41, 45, 47
S.S. Car Laundry, 116
Salem, Virginia, 27
Salts, Eulalie, 88
Salts, J.M., 88
Salts, Nannie, 88, 89
Salts, Susan Kern, 88
Sams, W.E., 112
Sams, W.T., 112
Sanitary Market, 172
Sapling Grove, 3, 4, 6, 7
Savage, H.H. (Dr.), 228
Sawyer Brown, 209
Scales, J.H. (Dr.), 28, 35, 36, 37
Schieren, Arthur, 209
Scott, E.P., 45
Scott, Edward, 101
Scott, J.M., 44
Scott, John E., 45
Sellstrom, E.L., 232
Seneker, E.H., 96, 159
Shafer, Christine Maxim, 198
Sheen, Fred, 197
Shelby Automobile Company, 112

Shelby Hill Cemetery, 86
Shelby, Evan (Gen.), 2, 3
Shelbyville, 89
Shelton, Eugene, 167
Shelton, Martha, 167, 168
Shumaker, David, 173
Sixty-Four Cab Company, 129, 133
Slack, Amelia, 21
Slack, Charles H., 179
Slack, John, 178, 179, 180
Slack, Munsey, 180
Slagle, Fred, 176
Slagle, Horace, 24
Slagle, Lucy S., 176
Slagle's Supermarket, 175
Slaughter Law Firm, 18
Smith and Satterwhite, 160
Smith and Waskey, 169
Smith, George D. (Dr.), 29
Smith, H.E., 115, 117
Smith, Joseph Lindsey Coleman, 169
Smith, Martha Alice Hagey, 169
Smith, Nathaniel, 127
Smith, Victoria, 128
Smith's Drug Store, 52
Smithfield, Virginia, 40
Smythe, Clarence A. (Dr.), 30
Snapp, Alfred J. (Dr.), 19
Snapp, James, 101
Snapp, L.B. (Dr.), 20, 24
Solar Hill, 3
Southern Democrat, 178
Spanish-American War, 89
Sparger, Sam, 111, 112, 114
Sparks, J.L. (Dr.), 37
St. Ann's Infirmary, 85
St. John, Josephine, 87
St. John, Matthew (Dr.), 19
St. John, W.B. (Dr.), 17, 19
St. Lawrence Hotel, 57, 142, 146
St. Lukes Hospital, 18, 24, 58-75, 77, 79, 82, 83, 129, 151
Stafford, Tim, 207
Staley, Alda Carr Daniels, 86
Staley, Sue, 85, 86
Staley, Thomas F. (Dr.), 17, 85, 86, 130
Staley's Hospital, 85
Standard Motor Company, 113
Stant, Donald T., 177
State Line Drug Company, 52
States Motor Company, 116, 121
Statler Brothers, 207
Steadham, Elbert (Capt.), 51
Steadham, Elbert (Mrs.), 51
Steele, Lola Mae, 40

Stephens, Doris, 197
Stephens, George (Rev.), 226, 227, 228
Sterchi Brothers Company, 129
Stevens, George T., 228
Steward, Lucy, 61, 63
Stewart, Betty, 88
Stockton, E.C., 133
Stokley, Irene, 52
Stone Lumber Company, 78
Stone, Jack, 80
Stone, James A., 179
Stone, W. Riley (Mrs.), 195
Stone, William, 80
Stone-Huling Lumber Company, 52
Stoneman, Ernest V. (Pop), 204
Stoots, Willie, 110
Stop and Shop, 175
Strong, Judith, 21
Strother Drug Company, 47
Stuart, George, 219, 221
Stull, M.A., 109
Sublet, B.F., 127
Sullins College, 164
Sunday, Ma, 217, 233
Sunday, William A. (Billy), 215-219, 224, 233
Swadley, R.A., 176
Swadley-Galloway Company, 176
Swan, F.C., 115
Swan, Mary J., 168
Tallman, Willard (Rev.), 228
Tampa Tribune, 184
Tartar, Ulysses S. (Dr.), 19
Tate, James D., 112
Taylor, John, 2
Taylor, N.M., 191
Taylor, Polly, 14
Teeter, Ella Whitten, 23
Teeter, William (Dr.), 23, 24
Tennessee Colored Cemetery, 84
Tenneva Frozen Foods Company, 177
Terry, William, 186
Thirty-Eight Taxi Company, 127, 134
Thomas Drug Store, 53
Thomas House Hotel, 16
Thomas, Alfred W. (Dr.), 21, 84
Thomas, Alice, 26
Thomas, Dad, 12, 20, 34, 35, 95, 96, 105, 106, 143, 144, 161
Thomas, J. Gaines, 53
Thomas, Lelia M.L. (Dr.), 21, 84
Thomas, Paul, 166
Thomas, Theophalus, 87
Thomas, Theophalus (Mrs.), 87

Thompson Laboratories, 30
Thompson, H.H. (Dr.), 91
Thompson, James M., 101
Thraxton, Osceola A. Jr., 197
Three Way Market, 175
Thrift Auto Supply, 114
Thrifty Market, 171, 174
Tiller, Vincent S. (Dr.), 30
Timber Grove, 3
Times-Courier, 179
Tip Top Hotel, 61, 148
Townsend, David (Dr.), 79
Townsend, Frances, 79
Travelers Hotel, 128
Tredway, Rawley, 223
Trigg, Daniel (Dr.), 85
Trigg, Mary, 85
Trigg's Hospital, 85
Troutdale Restaurant, 50
Tulip (cook), 28
Tuner, Grant, 205
Turner Chemical Company, 47
Turner Drug Company, 47
Turner, Allen K. (Dr.), 21, 92
Turner, George M., 47, 50
Turner, Pearl, 92
Twin City Boiler Works, 78
Two Hundred and Two Taxi Station, 127
Umberger, Ellis R., 52
Umberger, Irene Stokley, 52
Umberger's Drug Store, 52
Umholtz, C.W., 109
Underwood, Barney L. (Dr.), 20
Uneeda Carriage Company, 116
Union Station, 207
U-Tote-Em, 172, 175
Valdosta, Georgia, 73
Valleydale Plant, 4
Vance, Doug D., 21
Vance, Marie Doriot, 21
Vance, Mary, 190
Vance, W.K. (Mrs.), 75
Vance, W.K. (Dick) Jr. (Dr.), 20, 21, 22, 88
Vance, W.K. Sr. (Dr.), 17, 20, 21
Vance, W. Nicholas (Dr.), 21
Vanderbilt University School of Medicine, 89
Vaught, S.B. (Rev.), 221
Vaught, Sallie, 53
Vaught, Sydney G., 53
Victor Motors, 125
Victor Talking Machine Company, 203
Virginia and Tennessee Railroad, 4, 5
Virginia Hotel, 66
Virginia House Hotel, 33

Virginia Institute, 189
Virginia Intermont College, 43, 189, 193, 217
Virginia Motors, 125
Virginia Woodworking, 78
Virginian-Pilot, 184
Virginia-Tennessean, 181, 182, 183, 184
Virginia-Tennessee Motor Company, 113
Virginia-Tennessee Motor Corporation, 115, 116
W.B. Kilgore and Son, 102
W.B. Lockett and Company, 167, 168, 176
W.W. Fain Motor Company, 114
Wade, Blaine, 167
Wagner, Douglas W. (Doug), 172
Wagner, Rogert F., 172
Walker, Ada M., 84
Walker, Felix, 114
Walker, Rives, 50
Wallace, Virginia, 3, 23, 24
Walls, Carmage, 183
Walnut Grove, 24
Walnut Grove Cemetery, 25
Warren, George M., 91
Washington Star, 111
Waskey, Robert P., 169
Watauga Sand Company, 43
Watson, Cecil G., 53
Watson, Mary, 53
Weaver Funeral Home, 99
Webb, D. Grant (Mrs.), 38
Webb, Earl Sr., 232
Weems, Jacob, 31, 34
Wellmont Health System, 82
Wexler, H.B., 45
Wheeler, David A., 167
Wheeler, Zenas W., 53
Whitaker, A.B. (Bo), 74
White Star Market, 176
White, Alfred W. (Dr.), 29, 30, 82
White, Frank, 147
White, Geurna B., 30
White, Tim, 210
White, Volley, 173
White, W.A., 84
Whitman, James, 27
Whitt, Sue Francisco, 198
Whittaker, Helen DeWitt, 197
Whitten, William (Dr.), 16, 79
Whitter, Henry, 205
Widner, Douglas P. (Mrs.), 197
Wilbar, W. T. (Dr.), 27
Wilburn, J.J., 127
Wiley, George E. (Dr.), 18, 64, 109

Wiley, Susie Brown, 19
Wiley, William S. (Dr.), 18, 19
Wilford, W.D., 172
Wilkinson, Ellis H., 109, 111
Wilkinson, W.D. (Rev.), 228
Williams, Don, 209
Williamson, William M., 170
Winslow, Jack, 24
Winston-Salem Journal, 184
Wolf, George (Mrs.), 24
Women's Exchange, 172
Wood Drug Company, 37, 40
Wood, Bertie, 37
Wood, Carolina Gray, 38
Wood, E. Preston (Dr.), 17
Wood, Ethel M. (Dr.), 17
Wood, Hagan E. (Dr.), 38
Wood, Henry Clinton (Maj.), 99, 145
Wood, J.H. (Capt.), 30, 37, 50, 103
Wood, J. Logan Jr., 38
Wood, John W., 38
Wood, Jonathan Logan, 37, 38
Wood, Juliet, 99
Wood, Laura Lucretia James, 42, 102
Wood, Logan, 38
Wood, Margaret Alberta Childers, 38
Wood, Mary, 73
Wood,-Nickels Company, 38
Wood, Patrick H., 37
Wood, Sally, 99
Woodward, Edward O. (Dr.), 18
Worley, Charles L., 101
Worley, J. Parks (Senator), 130
Worrell, T. Eugene (Gene), 181, 183, 184
Wright, Ella Mae, 24
Wyndale, Virginia, 3, 24
Wytheville, Virginia, 15, 109
Yellow Cabs, 133, 134, 135
Yellow Coach, 135
Yopp, A.J., 93
Yopp's Sanitarium, 93
Zimmerman, B.F. (Dr.), 112, 157, 188